The Artful Eye

EDITED BY

RICHARD GREGORY

Department of Psychology, University of Bristol

JOHN HARRIS

Department of Psychology, University of Reading

PRISCILLA HEARD

Department of Psychology, University of Bristol

DAVID ROSE

Department of Psychology, University of Surrey

Oxford New York Tokyo

OXFORD UNIVERSITY PRESS

1995

Oxford University Press, Walton Street, Oxford OX2 6DP

Oxford New York
Athens Auckland Bangkok Bombay
Calcutta Cape Town Dar es Salaam Delhi
Florence Hong Kong Istanbul Karachi
Kuala Lumpur Madras Madrid Melbourne
Mexico City Nairobi Paris Singapore
Taipei Tokyo Toronto
and associated companies in
Berlin Ibadan

Oxford is a trade mark of Oxford University Press

Published in the United States
by Oxford University Press Inc., New York

© Oxford University Press, 1995

A catalogue record for this book is available from the British Library

Library of Congress Cataloging in Publication Data
The artful eye / edited by R. L. Gregory, J. Harris, P. Heard, and D. Rose.
Includes bibliographical references.
ISBN 0 19 852195 2 (Hbk)
1. Visual perception. 2. Perceptual-motor processes.
3. Neuropsychology. I. Gregory, R. L. (Richard Langton)
II. Harris, J. (John) III. Heard, P. (Priscilla) IV. Rose, D. (David).
BF241.A78 1995 152.1–dc20 94-34839
ISBN 0 19 852195 2

Typeset by EXPO Holdings, Malaysia

Printed in Hong Kong

Pretext

RICHARD GREGORY

We are fascinated by the cunning brain and the artful eye. Here are thoughts of scientists and artists working on many aspects of visual perception: the physiology of the brain, development of sight and communication in infants, how form and motion and colour are coded and represented, effects of drugs and brain chemicals, the physics of images, and the mathematics of the impossible. The arts are represented by essays on perspective, especially Vermeer's use of the camera obscura, the art of the forger, portraits of artists and scientists, and, finally, the personal statement of, most sadly, the late Dame Elisabeth Frink.

We start with the concept of a black box. This is guessing, from experience and experiment, how the brain might work in engineering terms. It turns out that the brain is itself guessing! Here the black box is called a betting shop, for it assesses probabilities and predicts the immediate future. Sometimes it wins, sometimes it loses. Whether this or *any* scientific attempt to characterize the wonder of vision, merely makes the mind wander is a matter of taste and choice. The black box notion challenges later contributors to reveal hidden processes contributing to seeing the significance of objects of nature and works of art. How sight-for-survival became adapted to seeing and creating beauty is anyone's guess. This is part of the mystery of why we have brains that are far larger, far more intelligent, than are needed for survival — except that products of human intelligence sometimes make things more difficult and more dangerous!

The structure of the book takes us from black boxes illuminated by recent discoveries of anatomy, physiology, psychology, and clinical findings, to cast the eye of science on art. But there is a great deal that is beyond such explanation. Indeed the scientist can learn at least as much from the artist as the other way round.

Starting to see — development of perception in babies — takes us back to our tantalizingly not-remembered origins. How did we come to recognize faces, reach out for things, explore the world? How does aesthetic appreciation start? The pioneer of child development, the Swiss

psychologist–philosopher Jean Piaget, inspired a great deal of research on evocative questions which link philosophy and psychology.

Behind the eyes lie processes for seeing the incredible richness of the artist's palette and our everyday experience. Physic and physics are the bases of the machinery of brain and eye. This is optically, electrically, chemically, and mathematically wonderful — depending upon the incredibly complex anatomy of pathways and brain cells carrying out in some ways computer-like functions.

Artistry has two senses — intelligence and aesthetic appeal. Here we learn of line drawings, perspective, the perverse art of the forger, remarkable works such as the wonderful sculpture of Elisabeth Frink, to whose memory this book is dedicated.

Probably no expert will agree with *everything* in this book. The editors do not agree with all the contributors, however distinguished. One of us doubts whether perspective depth and associated distortion illusions, do disappear at isoluminance when there is colour but no brightness contrast. In fact he published just the contrary several years ago![1] Some of us question whether reduction (surely not complete loss) of Kanizsa-type illusory surfaces at isoluminance is evidence against the 'postulated eclipsing object' theory; for if indeed there are many parallel channels in vision, we can hardly assume that all object-features will be lost, when, for example, brightness information is removed. These are technical questions. The answers lie beneath appearances, where only experiments can reach. Controversy-inspired experiments are the heart of science and art.

Albert Einstein said, 'The most beautiful thing we can experience is the mysterious. It is the source of all true art and science.'[2] He was not, of course, defending ignorance. Einstein would be the first to say that the more we know and understand the more fascinating the world becomes, with ever further questions and new mysteries to explore.

Something of this was expressed four centuries ago by the playwright Ben Jonson:[3] 'Art hath an enemy called Ignorance.' At that time science and art were not so sharply distinguished as now, so he could have been and most probably was referring to both. But they have grown apart since the time of Shakespeare, Ben Jonson, and Leonardo who was indeed both artist and scientist as well as engineer.

Why is it that — of all animal species — only man draws pictures and only man carries out the systematic shared experiments of

[1] Gregory, R. L. (1977). Vision with isoluminant colour contrast: 1. A projection technique and observations. *Perception*, **6**, 55–6.
[2] *What I believe* (1930).
[3] *Every man out of his humour.*

science? Is language the key? Is it that our brain is anatomically special, including Broca's and Wernicke's language regions in the left hemisphere or is it that, once gained, language is so powerful a tool that it magnifies quite modest brain power, so that we are superhumans? The notion here is that, like an electric drill or saw, language is a power tool that takes some skill to use, but gives us unique creative abilities. The ratio of skill needed to the extra skill conferred is, perhaps, the key to art and science.

Visual skills and verbal skills are different. They are handled by different brain processes. Yet there are bridging symbolisms, such as graphs, allowing us to *see* results of calculations and conclusions that may be clumsily expressed in words or figures.

Computers both calculate and display. Heaven alone knows what they will do when they think! Will they take off from us, producing their own art and science? Will they go beyond our comprehension? Presumably computers will explain themselves. Meanwhile they are our slaves and generally helpful friends.

As computers become more user-friendly and more powerful, so they extend our abilities — helping us to write, draw, design buildings, compose music, do advanced mathematics. Already, without too great a cost, we can see all the paintings of the National Gallery on our personal computers, look up data from the libraries of the world, and employ such powerful programs and huge databases for the physical and biological sciences that our brains are again enhanced by symbols, this time of computer languages, bridging art and science.

What are the origins of art and of science? Studies of babies are suggestive. Colwyn Trevarthen discusses 'Visual arts and a child's brain' in terms of the child's communication with its mother. This is subtle and intriguing. Just to survive, babies have a desperate need to control their environment — including their mothers. There are two ways open to them: children might persuade an adult to pick up the fallen mug or mend a broken toy, or they might do it themselves. The first needs symbols for persuasion, the second essentially needs technology to solve the problem. For picking up a mug needs physical knowledge of how solids and liquids behave. We have learned from artificial intelligence how hard it is to pick up a mug of milk, or initiate or understand speech. It is easy for us because, over millions of years, we have become so clever!

Could the seeds of art and of science be the two ways by which young children gain control: persuading others, or doing it themselves? The first is essentially the power of symbols — *art*; the second is essentially the power of mechanisms — *science*. And one might think that religion is persuading the universe, as though it is a parent, through charm and promises to be good, while engineering

is manipulating the universe as though it is a toy, through understanding how it works.

How different are art and science? Without doubt their procedures are very different, but what of their aims? It might be said that art aims to evoke emotional experiences, by playing upon our responses to sights and sounds. Science aims to discover processes behind appearances. This has very gradually evolved from the Greek classification of the sciences from the senses (light, heat, and sound) to abstract formal descriptions which leave out experience. The observer was essentially discarded in seventeenth-century mathematical physics, but now he/she is putting in an appearance again.

Both art and science claim to seek and sometimes to find the truth. This is where beauty comes in. When Keats quoted the Grecian Urn as saying: 'Beauty is truth, truth beauty — that is all ye know on earth, and all ye need to know' he was being satirical, for it is the Urn speaking and the Urn is portraying only beautiful things, ignoring ugliness and falsehood. Although one somehow assumes it, Keats did not say 'Beauty is truth, truth beauty.' Keats was not equating truth with beauty. He was right to stop before this, for unfortunately there are ugly truths. Mathematicians do, however, quite often speak of the beauty of their equations. As Bertrand Russell put it:

Mathematics, rightly viewed, possesses not only truth, but supreme beauty — a beauty cold and austere, like that of sculpture, without appeal to any part of our weaker nature, without the gorgeous trappings of painting or music; yet sublimely pure, and capable of stern perfection, such as only the greatest art can show.[4]

It is an interesting question how far artists seek beauty and also how far aesthetics guides the search for truth in science and mathematics. Is beauty a *criterion* for accepting mathematical proof? Is it part of the 'Aha!' experience of sudden recognition of truth? Are 'Aha!' revelations reliable? Surely not — for false 'Aha!'s are all too common.

If neither the sudden sense of recognition of rightness, nor the magic brush of the beautiful, are signs of truth — what can we accept as valid in art or in science? An important point, here, is that we have just recently given up the search for certainty. Now we settle for *hypotheses*, that work and look right on a given paradigm. This even applies to Euclid's axioms of geometry, accepted for two millenia as unquestionable truths, but now, following alternative non-Euclidean geometries, they are seen as postulates that may or may not be true. We have come to expect science, even mathematics, to suffer revolutions. The fashions of art are not so different from the

[4] *The study of mathematics* (1902).

paradigm shifts of science. For both, what looks inevitably 'right' can change to become merely quaint.

Yet both artists and scientists are seduced by beauty. An important question is: Do scientists and mathematicians prefer and select *beautiful* alternatives — even when they are not true? This could be answered by scientific method. It could be discovered whether those ideas that are seen as beautiful tend to turn out to be true. This experiment could link art and science empirically, to determine when and how beauty is a temptress into error or a tropism towards truth.

A well-known example of beauty misleading is Kepler's rejection, for many years, of elliptical orbits for the planets. The beautiful symmetry of the ellipse looked to him marred, ridiculous, if only one focus were filled with the Sun, the other lying absurdly empty. This would be like drawing an ellipse with a string and only one pin! For a long time Kepler rejected the symmetrical ellipse in favour of a less beautiful egg-shaped orbit, which avoided the absurdly ugly empty second focus. Here he was deflected from truth by aesthetics. Finally, Kepler was convinced, by the observational data of Tycho Brahe and his own heroic calculations, to accept one-pin ellipses for the planets. So he overcame the pull of beauty to found modern astronomy. His Laws of Planetary Motion based on conic sections and particularly ellipses, are the foundation of Newton's *Principia*. Now the missing pins in the solar system seem natural, inevitable, even beautiful.

Computer-drawn fractals of Chaos are widely attractive, because some are beautiful. Does this mean that fractals have deep scientific meaning? Are the more beautiful examples also the more mathematically significant? Again this is a question that could be tested by experiment: examples could be ranked for beauty and rated on mathematical criteria. It would be remarkable if their beauty is found to correlate with truth. How this would appeal to Plato!

Certainly art is more personal than science. This is expressed by the celebrated nineteenth-century French physiologist, Claude Bernard:[5] 'Art is myself; science is ourselves.' Although much of science is specialized, it shares its answers and its problems, as new discoveries and ideas sweep across race and creed. We can only hope that science's unique power to persuade against prejudice may extend to all human concerns. It is unfortunate that the general ignorance of science limits its appeal to those with unusual understanding. It is a mystery why it is shameful to be unable to hum the slow movement of Beethoven's Seventh Symphony, yet be unabashed at not knowing Kepler's discoveries. Art has immediate appeal to the senses, but it is senseless to reject science.

[5] Introduction, '*a l'étude de la Médecine Expérimentale*' (1865).

According to Oscar Wilde 'All art is useless'.[6] Here, though, we will follow the counter-opinion of Jonathan Swift, when he said, 'Vision is the art of seeing things invisible.'[7] For we hope to make visible the art of seeing.

[6] Introduction to *The picture of Dorian Gray*.
[7] *Thoughts on various subjects*.

Acknowledgements

Thanks are due, especially, to Mrs Janet John for her indefatigable work on the manuscripts and picture research. The Press have been enthusiastic and helpful beyond measure. This has made the project a delight for all of us — which we hope will be shared with our readers.

Contents

Contributors

Stuart ANSTIS University of California. San Diego, Department of Psychology, 9500 Gilman Drive, La Jolla, California 92093, USA.

Janette ATKINSON University College London, Department of Psychology, Gower Street, London WC1E 6BT.

Michael BERRY University of Bristol, Department of Physics, H.H. Wills Physics Laboratory, Tyndall Avenue, Bristol BS8 1TL.

Oliver BRADDICK University College London, Department of Psychology, Gower Street, London WC1E 6BT.

Richard GREGORY University of Bristol, Department of Psychology, 8 Woodland Road, Bristol BS8 1TN.

John HARRIS University of Reading, Department of Psychology, Whiteknights, Earley Gate, Reading RG6 2AL.

Anthony HAYES University of Melbourne, Department of Psychology, Parkville, Victoria 3052, Australia.

Priscilla HEARD University of Bristol, Department of Psychology, 8 Woodland Road, Bristol BS8 1TN.

David HUBEL Harvard Medical School, Department of Neurobiology, 220 Longwood Avenue, Boston, MA 02115, USA.

Glyn HUMPHREYS University of Birmingham, Cognitive Science Research Centre, School of Psychology, Edgbaston, Birmingham B15 2TT.

Janus KULIKOWSKI U.M.I.S.T., Visual Sciences Laboratory, Department of Optometry and Vision Sciences, P.O. Box 88, Manchester M60 1QD.

Richard LATTO University of Liverpool, Department of Psychology, Liverpool L69 3BX.

Margaret LIVINGSTONE Harvard Medical School, Department of Neurobiology, 220 Longwood Avenue, Boston, MA 02115, USA.

Ian MURRAY U.M.I.S.T., Visual Sciences Laboratory, Department of Optometry and Vision Sciences, P.O. Box 88, Manchester M60 1QD.

Roger PENROSE University of Oxford, Mathematical Institute, 24–29 St. Giles, Oxford OX1 3LB.

David PERRETT University of St. Andrews, Department of Psychology, Fife KY16 9JU, Scotland.

David PHILLIPS University of Manchester, History of Art Department, Manchester, M13 9PL.

V. S. RAMACHANDRAN University of California San Diego, Department of Psychology, 9500 Gilman Drive, La Jolla, California 92093, USA.

David ROSE University of Surrey, Department of Psychology, Guildford GU2 5XH.

John ROSS University of Western Australia, Department of Psychology, Nedlands, Western Australia 6009, Australia.

Adam SILLITO University of London, Institute of Ophthalmology, 11–43 Bath Street, London EC1V 9EL.

Philip STEADMAN The Open University, Faculty of Technology, Walton Hall, Milton Keynes, MK7 6AA.

Colwyn TREVARTHEN University of Edinburgh, Department of Psychology, 7 George Square, Edinburgh EH8 9JZ.

Nicholas WADE University of Dundee, Department of Psychology, Dundee DD1 4HN, Scotland.

Vincent WALSH University of Oxford, Department of Experimental Psychology, South Parks Road, Oxford OX1 3UD.

Credits

Permission to reproduce figures and plates from the sources and copyright holders specified has been obtained in respect of:

Fig. 4.1a (© 1994 Mondrian Estate/Holtzman Trust. Licensed by ILP); **Fig. 4.1b** (Collection Haags Gemeentemuseum, The Hague); **Fig. 4.2** (Stedelijk Museum, Amsterdam); **Fig. 4.3** (© DACS 1994); **Fig. 4.4** (Oxford University Press, from R. Jung in *Oxford companion to the mind*, ed. R. Gregory, 1987); **Fig. 4.5** (© Man Ray Trust/AGADP, Paris, and DACS, London 1994); **Fig. 4.6** (National Gallery, London); **Fig. 4.7** (Copyright 1988 by the AAAS); **Fig. 4.8** (© by Wadsworth, Inc., from E. B. Goldstein, *Sensation and perception*, 3rd edn, with permission of Brookes/Cole Publishing Co., Pacific Grove, California); **Fig. 4.10** (© Springer-Verlag, from K. Albus, *Experimental Brain Research*, **24**, 181–202); **Fig. 4.11** (© Bridget Riley); **Fig. 4.12** (Whitman Richards, *The fortification illusions of migraine*, © 1971 by Scientific American, Inc. All rights reserved); **Fig. 4.13** (illustration by Patricia J. Wynne from Margaret Livingstone, *Art, illusion and the visual system*, © by Scientific American, Inc. All rights reserved); **Fig. 4.14** (© Demart Pro Arte BV/DACS 1994); **Fig. 4.15** (The Hermitage, St Petersburg/Bridgeman Art Library, London © Succession H. Matisse/DACS 1994); **Fig. 4.16** (The Royal Society of London, from Marr and Nishihara, *Proceedings*, **B 200**, 269–94, 1978); **Fig. 4.17** (Tate Gallery, London © ADAGP, Paris, and DACS, London 1994); **Fig. 4.18** (© DACS 1994); **Fig. 5.2** (Elsevier Science Publishers, Amsterdam, from Perrett *et al.*, *Behavioural Brain Research*, **29**, 245–58, 1988) **Fig. 5.6** (Springer-Verlag, from Perrett *et al.*, *Experimental Brain Research*, **47**, 329–42, and the Company of Biologists Ltd); **Figs 5.8** and **5.9** (Perrett *et al.*, *Journal of Experimental Biology*, **146**, 87–114, and the Company of Biologists Ltd); **Fig. 5.10** (Springer-Verlag, from Heitenan *et al.*, *Experimental Brain Research*, **89**, 157–71); **Fig. 5.13** (Copyright Pergamon Press Ltd, from Young *et al.*, *Neuropsychologia*, **28**, 391–415); **Fig. 8.2** (Vasudevi Reddy, photographs by Kevin Bundell); **Fig. 9.1** (Museum of Modern Art, New York); **Fig. 9.2** (illustration by Alan D. Iselin from Gunnar Johansson, *Visual motion perception*, © 1975 by Scientific American , Inc. All rights reserved); **Fig. 9.3** (Philadelphia Museum of Art: Louise and Walter Arensberg Collection); **Fig. 9.4** (Albright-Knox Art Gallery, Buffalo, New York, bequest of A Conger Goodyear and George F. Goodyear, 1964); **Fig. 9.6** (Philadelphia Museum of Art: Louise and Walter Arensberg Collection); **Fig. 9.7** (Pushkin Museum, Moscow/Bridgeman Art Library, London © DACS 1994); **Fig. 16.1** (Collection Haags Gemeentemuseum, The Hague, © 1994 M. C. Escher/Cordon Art, Baarn, The Netherlands); **Fig. 16.3** (Elsevier Science Publishers, Amsterdam, from M. C. Escher, *Art and Science*, 1986); **Fig. 16.4** (Springer-Verlag, from 'Pentaplexity: a class of non-periodic tilings', *Mathematical Intelligence*, **2**, 32–7, 1979); **Figs 16.6** and **16.7** (Oxford University Press, from *The Emperor's new mind*, 19); **Figs 16.9** and **16.10** (Elsevier Science Publishers, Amsterdam, from M. C. Escher, *Art and science*, 1986); **Fig. 16.12**

Plates

PART I: *Into the brain*

introduced by DAVID ROSE

Introduction to Part I: Into the brain

DAVID ROSE

If we are to see eye-to-eye with the world, that is, to understand what is happening around us so we can function harmoniously within our environment, we need to have some grasp of how communication between the world and the brain takes place, or fails to take place, of how information flows from the one to the other, and how they interact. The eye is, after all, a communication channel, bridging the outer and inner worlds of reality and experience. The vehicles that pass over that bridge are many and various, ranging from mere skeletal glimpses of things and events, like racing bicycles stripped to make them as light and fast as possible, to heavily laden lorries, dragging their equally loaded trailers behind them, replete with detail and meaning. For the communications that cross over are not just from natural environment to brain; some are passing from brain to brain, from the world of one person's experience to another's, in the form of messages deliberately transmitted. These may be stripped-down, like news flashes, or deliberately overloaded with multiple shades of meaning; yet the perceiver has to unpack the load and interpret the message(s) therein. The act of sending effective communications is an art — and one not easily learned. Artists may spend a lifetime perfecting their art of packaging messages and those of us who follow hope to emulate their success by imitating their techniques. Whether we draw stripped-down cartoons or paint layer upon layer of carefully thought-out detail, we all try to bridge the gap from mind to mind, via the eye.

Why is it so difficult? The traffic that flows through the eye can take many routes on the road to perception and the choice is determined at least in part by the nature of the message. Some signals find ready-made tracks where similar previous traffic has inscribed ruts into the very fabric of the brain, but others have to forge their own pathway like explorers entering the wild, relying on finding some friendly natives to help show them the way. For the adult brain is no *tabula rasa*; it is already inhabited by semi-intelligent beings,

cognitive demons who make what they want of the messages they come across. So an artist's message may be short-lived there; it will almost certainly be distorted, but at best it will be assimilated into the universe inside someone else's head, merged into a view of the world that is not that of the artist — although now that view may resemble yours a little bit more closely than before. Even such limited communication is an achievement to be proud of.

Gregory and Rose introduce us to the creatures we should find in the brain, why they are there, how they behave and cooperate and what they are made of. Livingstone and Hubel and Perrett and his colleagues approach the same question the other way up, describing first what nerve cells in the brain actually do and then how these tie in with how the brain performs as a whole to give us perception. Humphreys considers what happens if some of the brain's denizens die: the whole system is disturbed and malfunctions bizarrely. We need our mental demons — it seems they are not so wicked after all! As Richard Latto says, art is what they do and they are all artists themselves!

1 Black boxes of artful vision

RICHARD GREGORY

Prologos

Let's start at the beginning. The first explanations of the universe placed mind in the heavens. The constellations of the stars formed pictures of dramas of the gods. The planets were individual intelligences wandering among the stars, playing with kings and with lesser mortals at their whim. Astrologers applied the science of astronomy to read the mind of the universe to predict human destiny.

The world of matter was controlled by magic, much as children charm their parents with the appeal of song and promises to be good. Now we seldom talk or sing to stones or flowers — though artists paint them — as quite generally we believe that the only mindful matter is the substance of brains. This is challenged by the enterprise of artificial intelligence (AI) to make silicon-based machines understand and see.

Ancient technologies challenged magic by controlling matter with tools and machines. Over many centuries of finding out by trial and error what worked, the experience of technologies grew into the questioning experiments of science. Surprising results led to new technologies and to new philosophies. So the magical, child-like notion of persuading the universe with offers of gifts and promises was very gradually and not entirely replaced by exerting our will with tools and machines. Yet symbols remained important, through the amalgam of magic ritual with empirical experiment of alchemy to the still-mysterious powers of the symbols of mathematics in science. It is still not clear whether the symbols of mathematics work through the mind of the universe, as Plato and Newton believed or whether mathematics confers 'artificial' powers on the human brain and computing machines.

Looking back to the Greeks, especially to Plato's cosmology in the *Timaeus*: the universe was seen to be designed by the mathematically-minded 'framer', to be constructed with familiar tools by craftsmen. Plato saw the universe as a living machine

designed on mathematical principles to embody intelligence and perception. This is just how *we* see robots!

The notion that brains might be machines seemed absurd when machines were crudely repetitive, but now, with the increasing sophistication of computers that can make decisions and see with their glass and metal eyes, it is hardly possible to protect the uniqueness of the biological mind. The American philosopher John Searle has made a brave attempt (Searle 1984), but what philosphical argument could possibly distinguish between protoplasm and silicon? Here we have reached an empirical question of mind: how far manmade machines can be mind-like must be discovered by designing and building machines to think and to see. Successes in AI prove what is possible; failures are not so much refutations, as tests of patience. On this account much of the philosophy of mind hangs upon the future of technology.

If our brains are machines — what kind of machines? The key analogy for Greek philosophers was their string-controlled puppets and automata. The Greek word for string lives on in our 'neurone'. The Greeks delighted in gadgets (Brumbaugh 1966) and they attempted to make lifelike automata, so they set the way to the mechanized mind. In the seventeenth century, when water technologies came to the fore, Descartes saw the nervous system in terms of pumps and pipes and controlling taps. For Descartes, the body is a machine, though the mind is not a machine and so cannot be described by analogy with what we know of the workings of physical objects. This is the essence of his mind–matter duality. Descartes described the control systems of the body in terms of the current technology of elaborate garden fountains and especially the waterworked automata of the royal gardens in Paris. But for him, mechanical models stopped short of the mind. For Descartes there was an irreconcilable dualism between matter and mind, which we have inherited. In spite of the best efforts of philosophers, most of us find it very hard to break free of Descartes's mind–brain dualism. Gradually though, especially following Pascal's wheeled calculating machine of 1642, capable of 'mental' arithmetic and the French physician Julian Offray de Lamettrie's banned book *L'homme machine* (1748), the uniqueness of the biological mind has been challenged. In the last century, telephone exchanges became the model for a century of reflexology; over the last 30 years our model has been the hardware and software of digital computers, the physical brain being 'hardware' and the symbolic processes it carries out 'software'. AI has gained, even if not as yet entirely earned, the temerity to explain mind in terms of man-made machines.

An essential question is: Are the secrets of mind already known, in our existing technologies? If so, we can use what we have already

discovered and invented to explain mind, to understand the 'artful eye'. If not we must wait for future technologies for accounts of what lies behind the ability of eyes and brains to see. For we cannot see this inside ourselves. It is tantalizing that we have all that is needed within our heads, yet we cannot see how our own brains work. They might as well be infinitely distant black holes, in which the truth is trapped. So our brains are *black boxes*.

Black box accounts are engineering accounts where the internal components and what they do are unknown. It is necessary to guess what lies inside, from observing what the system does and applying engineering knowledge 'backwards' to infer the design. If the brain has entirely unknown tricks up its sleeve, these will have to be invented.

Looking backwards to see forwards

Black box accounts work backwards as they guess what is inside from knowledge of past technology. This is the only way, when the inside of the box cannot be investigated directly. The brain is so complicated and for various reasons so hard to investigate, that we need already-familiar concepts for descriptions and explanations, though with recently available far more powerful techniques for experiments this situation is changing. It is now becoming possible to see into the black box, with electrical recording (both invasively and with surface electrodes) and with non-invasive brain-scanning techniques which are yielding entirely new knowledge. But it remains true that principles that might explain intelligence and perception can be easier to investigate with digital computers and analogue nets made of matter that one can control at will and that does not die. So we seek to see basic principles of living systems in technologies of the non-living. This takes the action away from *substance* to *functions*. This is the essential move away from the traditional concept of vitalism — that life is uniquely bound to biological substances — towards looking for principles of life in inanimate matter. So secrets of the brain are sought in engineering, even though, it must be confessed, engineers have so far failed to produce effective seeing machines.

Engineering accounts are of several kinds, and they have several 'levels' of description and explanation. Over 30 years ago, in a paper called 'The brain as an engineering problem', I described three levels of description and explanation that seemed appropriate for thinking about engineering systems including the brain. These were (Gregory 1961) as follows:

- **Blueprints**: showing the *appearance* of components — the anatomy.

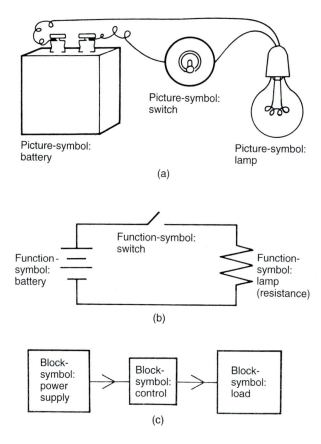

Fig. 1.1. Three levels of
'engineering' brain-description.
(Descriptions of a circuit
corresponding to 'engineering'
accounts of brain structure and
function: Gregory 1961.)

- **Circuit diagrams**: showing the *functional properties* of the components — the physiology.

- **Block diagrams**: showing the *flow of power or information* (or general operating procedures or rules).

These were illustrated with the example of a simple circuit.

This was written before digital computers were at all common place, when we were thinking in analogue terms, with the concepts of cybernetics. I shall go on to suggest that the analogue–digital distinction is fundamentally important, but is too often misunderstood and even ignored.

These levels give very different kinds of descriptions. Each kind or level of description is intimately related to very different kinds of explanations. The crucial question is: Which are most appropriate for understanding intelligence and the artful eye?

In his important and highly influential book *Vision* (1982), David Marr set out why levels of description are needed. He introduces his

'levels' from considering B. K. B. Horn's mathematical account (Horn 1975) of determining shape from shading (Marr 1982, p. 19):

By carefully analysing the way in which the illumination, surface geometry, surface reflectance, and view-point conspired to create the measured intensity values in the image, Horn formulated a differential equation that related the image intensity values to the surface geometry. If the surface reflectance and illumination are known, one can solve for the surface geometry (see also Horn 1977). Thus from shading one can derive shape. [Cf. Chapter 11 by Ramachandran in this volume, p. 249.]

The message was plain. There must exist an additional level of understanding at which the character of the information-processing tasks carried out during perception are analysed and understood in a way that is independent of the particular mechanisms and structures that implement them in our heads. This is what was missing — the analysis of the problem as an information-processing task. Such analysis does not usurp an understanding at other levels — of neurones or of computer programs — but it is a necessary complement to them, since without it there can be no real understanding of the function of all those neurones.

David Marr then set out his three levels: (Marr 1962, p. 25).

- **Computational theory**: what is the goal of the computation, why is it appropriate, and what is the logic of the strategy by which it can be carried out?

- **Representation and algorithm:** how can this computational theory be implemented? In particular, what is the representation for the input and output and what is the algorithm for the transformation?

- **Hardware implementation:** how can the representation and the algorithm be realized physically?

This account is rightly regarded as important and it has stimulated and guided a great deal of research in human and machine vision over the last 20 years.

It does, however, assume that brains are digital computers. But are they? The rather similar levels of description I submitted in 1961 did not assume that brains are digital computers, but allowed that they might be analogue. The brain was not thought of as necessarily a digital computer — no doubt because analogue devices were much more common at that time! Regarding it as an analogue system would mean that it does not go through the steps of computing. On this account, strictly speaking the brain is not a computer. It is not a computer if it does not go through the steps of computations. Analogue systems avoid the algorithmic steps of computing, so they are not computers.

Following Donald Hebb's (1949) *Organization of behaviour* the brain seemed likely to be some kind of analogue neural net. Nets went out of fashion with the onset of the power and flexibility of

digital computers working with algorithms. However, neural nets have returned, now called parallel distributed processing (PDP). It is important to note that they do not *work* by algorithms — though they may be *described* with algorithms.

It is perhaps unfortunate that David Marr assumed that the brain functions by carrying out mathematical algorithms, digitally. A safer, more minimal, claim would say that, although algorithms are useful for us to *describe* what may be going on, it does not follow that this is how the brain actually *works*. On the other hand, David Marr's emphasis on the need for rigour is all to the good.

It is important to decide whether the brain is digital or analogue. Neurones would have very different tasks, so physiological findings would have to be interpreted very differently according to which is true. What is inside the black box *functionally* would be very different for a digital or for an analogue system. They work and they go wrong in very different ways. So these curiously entwined philosophical–engineering questions have theoretical and practical significance for how we may see inside ourselves.

If analogue, the brain is not a computer, so we are not computers — until we learn mathematics at school! If the brain is analogue it is not surprising that, compared to a simple digital calculator, we are feeble at arithmetic.

The flat box

A black box description may be intended as no more than a skeleton account. It may be useful, but it is not sufficient. No doubt for the brain it must be fleshed out with physiological and with cognitive processes. You can't walk without a skeleton — but a skeleton is not capable of walking without muscles and a great deal more. Similarly, we should not expect a computer simulation of the mind to be a completely functional mind. So perhaps it is odd that AI computer models of vision are actually expected to see!

In spite of the very bright people working on them, current computer-based vision systems are nothing like as good as even simple biological eyes and brains. Why are computer simulations so poor? There are several possibilities. One is that they have not yet got the right concepts for an adequate working box for vision. Another possibility is that digital computers are too slow, so it takes minutes or centuries to solve the problems brains accomplish in a fraction of a second. Another possibility is that, although existing hardware is reasonably adequate and the software is on the right lines, the simulating black box is simply *not complete*. For even though essentially correct, an incomplete system will not run. It may not run for trivial

reasons, so functional failure may not show that the account is significantly wrong.

All this suggests that we may be asking too much of a simulation in expecting it actually to work. But what good is it if it doesn't work? The answer is very clear: it is a *theory* — and theories can be very useful even though they don't altogether work. Theories usually incorporate simplifying assumptions and are seldom complete descriptions. Theories can illuminate how things work, without themselves working, in the object world. So we may seek illumination from black boxes that are too simple or inadequate actually to function. I shall not claim that any black box that I shall mention here is going to be anything like adequate, yet it may help to guide the seeking of necessary principles of function. A skeleton box, for future fleshing out, may lead the way though it is blind.

A full black box description should have at least the three kinds of levels of structure and function given above (p. 7–8). But here I shall not discuss the anatomy or the physiology, but only the rules or general operating principles. These are interesting if only because they may bridge biological and artificial brains. But rules (or algorithms) are not by themselves adequate actually to work. They must be implemented by AI hardware or biological 'squishy ware', to be tested by performance.

As this rather abstract box cannot work and has nothing to be seen inside, we may call it a *hollow box*. But let's start with something even simpler, even less adequate: a *flat box* of vision (Fig. 1.2). This only gives the ins and outs, not what might be going on inside. It has *bottom-up* sensory signals from the eyes and *top-down* stored knowledge of the world of objects. To these, I have added *sideways* rules. We may think of these as inserted somewhat like the floppy disks of a (very!) personal computer at any level of processing, from sensory signals to stored knowledge, according to the task in hand. We can attribute many errors and illusions to lack of appropriate rules for certain situations. A key point is that there are not enough floppy disks.

The flat box has the following.

- **Bottom-up signals**: from the eyes; but behaviourally important features of objects are non-optical.

- **Top-down knowledge:** of familiar objects. This enriches visual signals, converting them into useful data for the eyes to 'read' non-optical properties of objects.

- **Sideways floppy disks**: analogue rules or digital algorithms. Inserted according to need for interpreting bottom-up sensory signals and top-down stored knowledge.

- **Take-away commands**: for controlling behaviour.

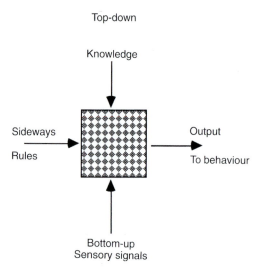

Fig. 1.2. Ins and outs of a flat box of vision.

A general consideration is that patterns of light in the eyes are almost useless unless read in terms of non-optical properties of things. This must be so, because patterns of light are not in themselves food, threat, or mate, yet they may warn of non-optical dangers and signal promises of reward.

The 'proximal' senses, touch and taste, can directly monitor important features of the world — hard or soft, hot or cold, food or poison — which are immediately significant for survival. So bottom-up signals from the proximal senses are immediately useful; they do not need a lot of information processing. Lower animals and sometimes we ourselves can be driven by bottom-up stimuli — especially from those that indicate probable dangers. A sudden noise is likely to be due to something that is dangerous and maybe threatening to the eyes: if I clap my hands you blink with a protective reflex, without identifying the cause of the sound. Reflexes act from stimuli directly, not from knowledge or assumption of the sources of stimuli. So simple reflexes, though faster than full perceptions, are far less subtle and far less specifically appropriate. Perceptions are rich *hypotheses* of what is out there. Reflexes are not anything like so creatively artful.

Traditionally, we think only of bottom-up signals and (sometimes) top-down knowledge for perception. Here I have added 'floppy disks': *sideways* rules. Why should this notion be useful? Let's look again at the bottom-up and top-down contributions to vision. In primitive organisms, bottom-up signals drive behaviour, which in the limit may be entirely controlled — indeed tyrannized — by their sensory inputs and almost fixed reflexes. Most robots work like this; making them reliable but dull, for there is no scope for initiative or intelli-

gence. Intelligence requires stepping away from signalled reality —
to create internal representations, which can be richer and more
useful than the available sensory data. This allows visually con-
trolled behaviour to be appropriate to non-optical characteristics of
objects. This is so even for such simple behaviour as picking up an
object such as a glass. The brain's representations are the inspiration
and substance of art.

Muscle force is set according to whether a perceived object is
heavy or light — yet its weight cannot be monitored by the eyes. It
has to be guessed by the intelligence of vision. Clearly the (uncon-
scious) judgement is a guess based on past experience of similar
kinds of objects, and of the materials of which the object is made.

Yet the importance of top-down knowledge of objects is controver-
sial — many theorists denying it. There is, however, strong evidence
for the importance of top-down knowledge for seeing, including mis-
leading effects when it is wrong or not appropriate. Some illusions
are powerful evidence of the power of top-down knowledge and side-
ways rules. Examples are the 'size–weight' illusion, that small objects
feel heavier than large objects of the same scale weight (because the
muscles are set for a heavier object) and the 'hollow mask' illusion (a
hollow face appears to be a normal nose-sticking-out face). For many
visual illusions, we may suppose that there is not an appropriate
sideways 'floppy disk' available for the situation. Thus, we do not
have an available set of rules for such odd objects as hollow faces, or
for that matter perspective pictures, which often appear distorted,
because though actually flat they are processed as for objects in
three-dimensional space. There is a lack of special 'floppy disks' for
pictures, presumably because the visual errors are not behaviourally
significant for writing special rules for seeing pictures.

When you are walking you need different processing of sensory
signals and knowledge from when you are reading or looking at
faces or whatever. It is striking that people dislike reading while
looking carefully at objects in a museum or in a hands-on science
centre or using tools. This may be because the perceptual procedures
for reading are switched out, as they are not appropriate floppy disks
for seeing or handling objects. This has implications for museums
and art galleries. It is important for education, as perceptual learn-
ing is highly dependent on feed-back from the results of action. This
is indicated in Fig. 1.2, with its feed-back arrow from output behav-
iour to top-down knowledge.

I conclude that top-down knowledge is essential for the intelli-
gence of vision, though there are not always appropriate sideways
floppy disks to make suitable use of it. Occasionally we are driven
purely top-down, as in hallucinations. But 99 per cent of the time
we are neither driven bottom-up nor top-down — for we generate

novel solutions to perceptual problems. This freedom from the tyranny of stimulus-initiated reflexes and domination by knowledge are essential for the intelligent perception of the artful eye.

This separation of perception from sensory signals has significant implications for visual experiments. It makes experiments and explanations rather different from those of physics. For perception creates — perceptions are — descriptive *hypotheses* about the world of objects. As physics also creates hypotheses, the *methods* of physics can be more like perception than the *world* physics describes! To understand perception, we need to know its cunning tricks of forming and testing hypotheses very much as we do for appreciating methods of science. For understanding how we see, we need to develop hypotheses of hypotheses!

What is clearly necessary for survival is the remarkable speed of perception. Yet the boxes of vision are surrounded by *conceptual* knowledge which develops and is applied slowly. A few instances are dangerous for gaining inductive knowledge, so learning must be slow, just as scientific method is slow, to discover reliable generalizations from experience. The box of vision is only slowly and sometimes not at all affected by conceptual knowledge. No doubt perceptual learning and learning from perception are also slow because extensive reorganization is required through the 'spreadsheet' of the mind to assimilate new data and ideas. It is hardly surprising that we are not fully consistent in our knowledge and beliefs. Fortunately, this very necessary separation of perception from knowledge can allow new experience and ideas to overcome the inertia of wisdom.

The knowledge for vision is shown as separate from and smaller than general *conceptual* knowledge (Fig. 1.2). For there is strong evidence that perception cannot tap anything like all of our conceptual knowledge and understanding. For example, we are fooled *perceptually* by visual illusions, though *conceptually* we know the eye is being fooled, and even in detail how and why it is fooled.

Why are perception and conception largely separate? We have already seen a likely answer: perception must work extremely fast, in a fraction of a second, for survival; but conceptual thinking, often in words, can be and often needs to be much slower. A second is a long time perceptually, but thinking things out may take minutes, even years. It would take far too long to have to access our total store of knowledge for perception, which must find answers in a fraction of a second to be useful in real time. So top-down processing is from a restricted knowledge-base. Evidently because it has to work so fast, there are inadequate checks and corrections, so that perceptual conflicts with conceptual knowledge can remain unresolved. Thus are we fooled every time by illusions that we recognize and under-

stand. Does this mean that art is neurologically beyond reason? If so, this is no essential criticism of art.

We are not attempting here to describe anatomy or physiology. These are tackled in later chapters. In no way can the flat box as described here be complete and it could not actually work. We should go on to look at the components and physiology in the box to understand it, but in this chapter we are only attempting a sketch account. For the brain's physiology, see the contributions by David Hubel and Margaret Livingstone, Adam Sillito, and others in this book.

We may try to develop the flat box into something a little more adequate, but for lack of components it will be hollow.

The hollow box

The underlying philosophy is that perceptions are but indirectly related to stimulus inputs from the senses, and that perception involves betting on what they may mean. So knowledge is very important. As perception has to work very fast to be useful it can only use limited knowledge, mainly of the interactive properties of objects; while conceptual understanding, which is slow and can be much deeper, develops more abstract knowledge. Perceptions are seen to be *hypotheses*, rather like the hypotheses of science, for continuing through data gaps and predicting unsensed properties of objects and the immediate future.

- **Bottom-up sensory signals:** from the eyes and the other sense organs.

- **Top-down conceptual knowledge:** all we know or think we know.

- **Top-down perceptual knowledge:** allowing non-optical characteristics of objects to be read from optical features, and prediction to the immediate future.

- **Sideways 'floppy disks' operating rules**: inserted for processing sensory signals and knowledge according to need. (Rules such as perspective apply to virtually all objects. When inappropriate, they can produce systematic errors — illusions — such as distortions of size and distance in pictures)

- **Put-in task:** selecting operating floppy disk rules and knowledge, according to need.

- **Take-away hypothesis**: the best bet as to what is out there.

- **Consciousness:** Awareness, qualia. (Is this so mysterious because it fits no known engineering 'boxes'?)

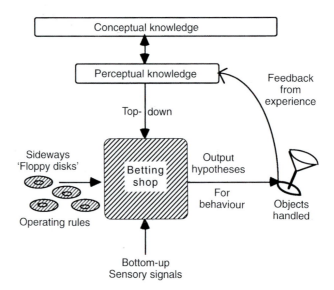

Fig. 1.3. Ins and outs of a hollow box.

The final 'output' — consciousness — will not be found in any engineer's black box. Perhaps because consciousness is not to be found in engineer's boxes, we lack analogies for any understanding. So it is hard to know what experiments could light the gloom in the black box of vision.

When all is going according to plan, as predicted by the running hypotheses of predictive perception, there is minimal or even no awareness. Consciousness seems to be given by mismatches between take-away advice and the resulting behaviour, for we are most aware of surprises. But would a surprised engineer's black box be conscious? It is not even clear that it could be surprised!

Inside the hollow box?

A large amount of processing of information is needed for the artful eye to be able to read, from optical data, very different characteristics of objects. But what kind of computing is going on? Is it *digital* computing? Or some kind of *analogue* processing? In recent years it has generally been assumed that the brain is a digital super-computer. This may be a major mistake.

Digital and analogue devices are constructed very differently; they work very differently and they have different advantages and disadvantages. Analogue processors are generally *continuous*. Digital computers are always *discontinuous*. But this is not the fundamental

distinction. The fundamental distinction is at the deeper level of function, rather than components. The point is that digital computers go through steps of computation following algorithms, while analogue systems avoid carrying out computation and do not follow algorithms.

A familiar example is graphs. With graphs, answers can be read off without the need for computing. Let's have a name for this. Let's call finding answers without having to go through digital steps 'commuting'. (For the dictionary tells us that *commuting* means 'moving', 'substituting', and 'turning to gold'.) So let's call analogue processors 'commuters'.

Digital computers and analogue commuters follow very different kinds of rules. Computers work by carrying out the steps of algorithms. An example, is the tedious procedure of long division. Analogue commuters arrive at somewhat rough and ready answers by avoiding the computing steps of algorithms. They work by following the input–output function of a model of the problem.

To summarize: digital *computers* work by carrying out computational steps of algorithms. Analogue *commuters* work by following the input–output functions of some physical process or some conventional restraint, such as the line of a graph, that is accepted as having a meaning.

Analogues can take many physical forms: in mechanical devices specially shaped cams, which like graphs, can have any shape; or electrical components may be used, such as a capacitor with a leak resistance across it for an analogue integrator. This integrates fast, but only approximately, without performing the calculational steps of integrating — so it is a commuter, not a computer.

It is often said that, for example, filters, early in the vision system, work by *algorithms*, but this, I submit, is a muddled and a muddling notion. It is far more likely that eyes and brains have interacting neurones which do not carry out the steps of computing: far more likely that the visual brain is a commuter. Perhaps the confusion arises because analogue processes can generally be *simulated* on a digital computer, but this loses the speed and simplicity of analogues.

There are suggestions of analogue systems in the brain which create 'graphs' without computing. These are neural nets of interacting neurones. They may achieve the discovery of learning generalizations and the recognition of patterns without algorithms. This approach was considered, over 40 years ago, by the Canadian psychologist Donald Hebb (*Organization of behaviour* 1949); but it was dropped in favour of digital computing. But over the last few years it has been re-established, in more powerful forms. Building and investigating interconnected neural nets for parallel distributed processing (PDP), is now a major activity of brain research, which has more

than potential engineering applications. So, from the starting point of the ancient Greeks' exorcising of mind from matter, AI is now investing matter with mind.

The net result

Let's look at nets as candidates for the black boxes of mind. The American neurologist, psychiatrist, and philosopher Warren McCulloch (1899–1969), held that each brain cell is an elaborate computing element, affected by its many inputs (electrical and chemical), with a subtly regulated threshold for firing. In the early 1940s McCulloch, with the logician Walter Pitts, saw the brain's nerve cells as working co-operatively in small groups, forming 'psychons', which were units of thinking that could be analysed in detail (McCulloch *et al.* 1943). They drew hypothetical circuits for the psychons and these could actually be made with artificial neurones. But, of course, a few artificial psychons could not make a pyche, so the general appropriateness of their notions was hard to test. The cells' activities in the nets were not supposed to vary linearly, but to fall off gradually with use, in association with learning, or else the net would soon have become saturated. This non-linear feature made mathematical analysis and predictions to larger nets, very difficult.

Hebb's randomly interconnected nets forming internal patterns of activity, modelling thoughts and objects, he called 'phase sequences'. The key notion is that cells become more active or more conductive as they are stimulated more often. This is the prototype for all the recent PDP (parallel distributed processing) neural nets. Attempts were made early on to construct seeing machines with artificial nets. Most famous was Frank Rosenblatt's *Perceptron*, with excitatory and inhibitory connections (synapses), which could begin to generalize patterns. There were two layers of artificial neurones, generally with every input (retinal receptor) connected randomly to every output. With the cells adapting to frequency of use, this system could give some generalization of patterns. Minsky and Pappert (1969) showed, however, that there must be severe limitations to Rosenblatt's perceptrons. Largely as a result of their valid criticisms the idea was dropped. Interest declined also because of the evident power and flexibility of the digital computer, though its inventor, John von Neumann, did accept that there were potential advantages in adaptive nets.

If the interest in perceptrons had not died, it might have been realized much sooner that adding more layers between its inputs and outputs can make a fundamental difference. These 'hidden units' allow inner patterns to develop, which are not driven by the input or

closely related to the output. Protected from input and output, they are hidden and secret — rather as mind is hidden and secret.

The hidden units can abstract and learn, and discover and create generalizations. They can recognize patterns or objects from just a small visible part of them. And, perhaps suggestively, they need periods of rest to sort themselves out — to dream!

The new nets are inspired by the work of John Hopfield (Hopfield 1982), Hinton (1981), Hinton and Sejnowski (1986), and McClelland *et al.* (1986). Michael Arbib, who was a student of Warren McCulloch, has also developed interesting ideas (Arbib 1989); Ivor Aleksander worked for years developing the impressive WISARD — **Wi**lKie, **S**tonham, and **A**leksander's **R**ecognition **D**evice (Aleksander and Morton 1990) and there are many others in this very active research area.

Terence Sejnowski has devised a net that can learn to read English, very much as children do, starting with random babbling. His artificial net is faster than babies at learning from examples, though one does not know how sophisticated these can become. This is a general query. Many nets work well for small problems, but become inadequate when having to deal with a large number of alternatives. How best to teach artificial neural nets presents unsolved problems, but here may lie helpful hints for human education. The essential point of PDP nets is that analogue interactive systems can learn from successive presentations of faces, letters, sounds of words, or whatever to recognize new objects of the same class and build up new classes. Unlike digital devices, they go on working though a large proportion of their components are

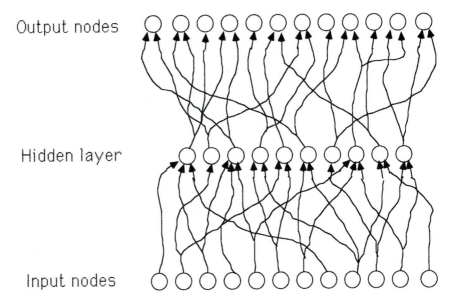

Fig. 1.4. A three-layer neural net. The lower nodes are inputs; the upper nodes are the outputs. The central 'hidden layer' develops secret mind-like generalizations.

destroyed. And they can cope with partial or mangled input signals
— as we can. Is this where the answer lies for how the brain works?
Or does the brain work with digital programs of algorithms, as classi-
cal AI supposes?

We know that there are many visual processes of filtering and so on,
which are certainly analogue — though, confusingly, they are often
called computational. This can be quite seriously misleading, as *ana-
logue* systems arrive at answers without computing. At least it seems to
me confusing to conflate *working with* algorithms with *describing by*
algorithms. So I am taking a somewhat different tack from David Marr
(1982) and also from John Searle (1984), who assume that vision
works throughout with digital algorithms. Thus, David Marr's (1982)
classification of levels of visual function (cf. p. 9): *the hardware imple-
mentation; the algorithms; the computational theory* — assumes digital
computing. If the visual system is basically *analogue*, this needs drastic
modification, for in analogue processing there are no algorithms —
though the analogue system may be *described* with algorithms.

This is generally so. Thus, a steam engine may be *described* by
algorithms, but this is very different from saying it *works* with algo-
rithms. It works with steam and metal rods and cylinders and wheels
and so on. Although these can be simulated with algorithms on a
digital computer, that is no way to run a railway!

Are there practical, empirical consequences distinguishing *analogue*
(including PDP nets) from *digital* computing for the brain? At first
sight we might expect no differences, as Turing (1937) showed that
all clearly statable functions or processes can be simulated by algo-
rithms. But in practice we do find differences: actual digital and ana-
logue systems have different advantages and failings. Computer
scientists choose algorithms which may not be maximally efficient
through favouring robust algorithms which work over a wide range of
conditions without breaking down (Sedgewick 1989). But the ways
algorithms break down when they do, is typically different from ana-
logue failures. So there should be phenomena of illusions which
would distinguish between them. For example, perception is never
entirely accurate, and it is fast though its components are slow. These
features suggest analogue rather than digital processing.

Digital systems may not run well with the biological components
of brains. At the component level, a more likely solution is adaptive
analogues, switched in according to need. They will lack the flexibil-
ity of a general-purpose digital computer, but, for vision, the early
stages have to work much the same whatever the object, so the sim-
plicity and speed of analogue modules seem far more appropriate.

Neural nets of parallel distributed processing might be the basis of
fully working AI black boxes; but annoyingly, because PDP nets are
highly interconnected and non-linear, what is going on is exceed-

ingly hard to analyse or to understand in detail. So, even though we design and build intelligent nets perhaps like our brains, they may remain impenetrably opaque black boxes.

Will man-made machines have inevitable intelligence limits? The American philosopher John Searle's influential philosophical attack on 'hard AI' assumes, like David Marr's account of human vision, computing that follows digital algorithms. Searle (1984, p. 36) says:

> The question isn't: "Can a machine think?" or: "Can an artefact think?" The question is: "Can a digital computer think?" But again we have to be very careful how we interpret the question. From a mathematical point of view, anything whatever can be described *as if* it were a digital computer. And that's because it can be described as instantiating or implementing a computer program. In an utterly trivial sense, the pen that is on the desk in front of me can be described as a digital computer program "Stay there." ... Of course our brains are digital computers, since they implement any number of computer programs.

He continues, by trying to persuade us that digital computers can only obey procedures of algorithms (*syntax*), with no knowledge of meanings (*semantics*):

> The question we wanted to ask is this: "Can a digital computer, as defined, think?" That is to say: "Is instantiating or implementing the right computer program with the right inputs and outputs sufficient for, or constitutive of, thinking?" And to this question, unlike its predecessors, the answer is clearly "no". And it is "no" for the reason that we have spelled out, namely, the computer program is defined purely syntactically. But thinking is more than just a matter of manipulating symbols, it involves meaningful semantic contents. These semantic contents are what we mean by "meaning".

Is Searle right to say that computers will never ever appreciate meaning? The claim depends on showing that man-made computers must be essentially different from biological brains. He claims that:

> Mental states are biological phenomena. Consciousness, intentionality, subjectivity and mental causation are all part of our biological life history, along with growth, reproduction, the secretion of bile, and digestion.

Are all these essentially and forever uniquely biological? Searle's is a *vitalist* creed — assuming special principles for biological brain matter; yet the story of biology, for over a century, has been quite against this requirement of special substances for life. Indeed, this postulation was shown to be false when 'organic' chemistry became associated with carbon, rather than with special substances for life, following the artificial production of urea by Friedrich Wohler in 1828. Darwinism, the whole of physiology, and the identification of DNA as the basis of heredity are all dramatic moves away from vitalism. This is important, as vitalism confers no explanation and blocks the analogies that are so important for science. There is no experimental evidence for vitalism or for limiting intelligence to protoplasm, so it is quite surprising that anyone now supports it. Surely

the interesting question is how should we make computers or commuters more richly semantic than they are at present. This is a research project into the meaning of meaning.

Illuminating black boxes with illusions

We started off with two quite similar suggestions for kinds or levels of description (Gregory 1961; Marr 1982). Each level carries its own sort of explanations and all are needed for completeness. However, sometimes phenomena can be attached to a particular level — when it is safe to ignore the rest.

We have been considering the rather abstract level of rules or algorithms. Obviously neither can do anything without hardware to implement them — this would be like an unread book — but we can often to advantage ignore the electronics of computers and the physiology of the nervous system, when the phenomena can be attributed to properties of the rules or the algorithms.

The curious, sometimes magic-looking phenomena of illusions serve the artist well and they can serve as powerful probes for teasing out and investigating processes of perception. For example, neural channels that signal orientations, colours, or movements can be identified and their characteristics can be measured, by selective adaptations. These are straightforwardly 'component-level' physiological illusions. There are other illusions that seem to be high-level cognitive effects. These are particularly interesting for exponents of AI, as they are general principles which may transfer to man-made seeing machines. They truly link artificial with biological intelligence.

Distinguishing 'physiological' from 'cognitive' is full of traps for the unwary — and for the wary! It may help to consider a familiar example such as a wrong answer from a pocket calculator. It may have given a wrong answer for two very different kinds of reasons: a component may have failed (hard to track down if due to failing batteries) or, very differently, the error may have been due to selecting inappropriate instructions. Thus, if the instrument is set to divide instead of multiply, the answer will be wrong, though the components are all working just fine. For the brain this would be a 'cognitive', rather than a 'physiological' error. This would be so, also, if false data, were introduced. Both inappropriate rules or algorithms, and false data give cognitive errors and have nothing relevant to do with the components.

So, in explaining the error when the operating rules or the accepted data are not appropriate, we can ignore the components in explaining the illusory phenomenon. Although the components are essential for *any* answer, the reason for why this answer is wrong

does not lie in their function, but only in what they are set to do. This gives a *cognitive* explanation.

We should expect accounts of visual illusions to be very different, according to which level of functioning is responsible.

Although I cannot embark on lengthy explanations of illusions here, I will present a classification in terms of levels of descriptions of brain function.

Given that perceptions are descriptive hypotheses (Gregory 1970, 1980, 1981), we might try looking for classes of illusions by analogy with errors of language. It may indeed be that the structures of language derived from pre-human perceptual classifications. The main kinds of errors of language seem to be ambiguities, distortions, paradoxes, and fictions.

For example,

Ambiguity: 'John is looking up.'

Distortion: 'John is miles taller than his father.'

Paradox: 'John's sister is a dark-haired blond.'

Fiction: 'John's brother is a green robot from Mars.'

It is suggestive that visual (and other) illusions seem very naturally to fall into these categories.

Now we should look for kinds of causes. First, there are sources of illusion before the eyes are reached. Examples are mirrors and mirages. Explanations for these lie in physics, so I shall call these *physical* illusions.

Illusions due to errors in the components of the nervous system we may call *physiological* illusions.

Illusions due to misleading knowledge or to misleading rules or algorithms, we will call *cognitive* illusions.

It turns out that examples of visual ambiguity, distortion, paradox, and fiction can very easily be found for each of these kinds of causes. The most important, and sometimes the most difficult distinction to make, is between physiological or cognitive causal origins. Sorting all this out for each phenomenon presents an interesting challenge for research.

Putting illusions into categories should increase our understanding beyond the study of individual phenomena. So we may hope that by pursuing this endeavour, illumination will be cast to throw light into black boxes of the brain, where lie the secrets of artful eyes.

It is most important to recognize that understanding of these — as of any — phenomena depends on careful observations and controlled experiments. Here experiments are needed for 'litmus tests' to assign the phenomena into their proper categories. Examples will now be given of each kind of illusion. *ambiguities, distortions, para-*

doxes, and fictions — for each of the three kinds of suggested causes — *physical, physiological, and cognitive.*

Here is a tentative classification of phenomena of illusions of the artful eye:

ILLUSIONS CLASSIFIED

I
Physical
Ambiguities
Mist, Shadows
Distortions
Of space: Stick-in-water
Of velocity: Stroboscope
Of colour: filters, refraction, diffraction, scattering
Paradoxes
Mirrors (seeing oneself in the wrong place, duplicated)
Fictions
Rainbows, Moiré patterns

II
Physiological
Ambiguities
Size-distance for a single stationary eye. Real–apparent motion
Distortions
Space: Adaptations to length or tilt or curvature. The Café Wall
Brightness and colour: Simultaneous and sequential contrast
Paradoxes
When visual channels disagree
After-effect of motion (moving yet not changing position or size)
Fictions
After-images, Autokinetic effect, Migraine patterns

III
Cognitive
Ambiguities
Necker Cube, Jastrow's duck–rabbit, Rubin's vases
Distortions
Ponzo, Poggendorff, Orbison, Hering, Müller–Lyer, Zöllner figures
Paradoxes
Penrose Impossible Triangle, Escher's pictures
Fictions
Kanizsa's Triangle, filling-in the Blind Spot, filling-in scotomas

It is a sound principle to explain as much as possible with the fewest and simplest assumptions. So, it is correct strategy here to explain as much as possible with *physical* and *physiological* concepts before resorting to the more complicated and perhaps more speculative *cognitive* notions. In spite of this, I have for many years maintained that some distortion illusions, and illusory contours and several other phenomena of illusion, do have cognitive origins or causes. This is a complicated and ultimately a technical business, so a brief, incomplete summary must suffice.

Distortion illusions

Some distortions are clearly *physical*, such as a spoon bent in water. Some, such as the 'café wall' Illusion (Gregory and Heard 1979) are clearly 'component' *physiological*. Such findings as the generalization that distance-signalled features look too large in pictures, that the Müller–Lyer and the Ponzo distortions disappear when presented and seen, in correct perspective depth (Gregory and Harris 1975) are evidence for a cognitive origin of these distortions.

This may be based on the misapplied size constancy scaling theory (Gregory 1963, 1970). There have, however, been many attempts (this is the course that has traditionally been assumed) to explain illusions such the Müller–Lyer distortion as immediately *physiological*, for example (Ginsburg 1971). This is not a simple issue and mere appearances do not give the answer. It requires specific experiments, which, like any other experiments, have to be interpreted from various assumptions. As in any other science, phenomenalism is only a beginning.

Shape-from-knowledge

The most dramatic example of knowledge affecting vision is an inside-out mask — which looks like a normal nose-sticking-out face, though it is hollow (Gregory 1970). This occurs even though the mask is known *conceptually* to be hollow: it is visual, not conceptual, knowledge that is important here.

This effect is interestingly different from effects of shadows, as in Horn (1977) and Ramachandran's *shape-from-shading* (see p. 249). For the hollow-mask reversal does not depend on shading or shadow, but does depend on *knowledge of faces*. So this is *shape-from-knowledge*.

Both are *cognitive*, but shape-from-shading is a sideways, and shape-from-knowledge is a top-down error.

How does this relate to black boxes? The hollow box (even the flat box) is sufficient for the complete explanation of many well-known visual phenomena. For many phenomena of perception can be explained before the components and inner workings of the brainbox are reached.

The ins-and-outs (Fig. 1.2) give the clue for many phenomena of the artful eye. *Physical* illusions occur bottom-up, before the eye is reached. Ilusions due to false or inappropriate knowledge are *cognitive*. Another kind of cognitive illusion is due to inadequate or inappropriate rules. These cognitive illusions are essentially different

and should be distinguished from misleading knowledge of objects. Following the hint from language (p. 23) the first we may call *syntactic*, and the second *semantic* cognitive illusions.

It is *physiological* illusions that demand explanation from structures and components within the black box. Here it matters a great deal how the brain works. It makes a big difference whether the brain is a digital computer or an analogue commuter, as they go wrong in very different ways. This matters not only for *physiological* illusions, but more generally for the clinical ills of body and mind. Fortunately, physiology is developing ever more powerful tools for understanding the neurology of the brain and what can be done when its components go wrong.

There is rivalry for who 'owns' phenomena of the artful eye. They are claimed by physicists, physiologists, psychologists, computer scientists — and artists. With present progress in understanding, we may hope quite soon to see eye-to-eye.

References

Aleksander I. and Morton H. (1990). *Neural computing*. Chapman and Hall, London.

Arbib, M. A. (1989). *The metaphysical brain 2: neural networks and beyond*. Wiley, New York.

Brumbaugh, Robert S. (1966). *Ancient Greek gadgets and machines*. Greenwood Press, Westport, Conn.

Ginsburg, A. P. (1971). Psychological correlates of a model of the human visual system. *Proceedings of the IEEE NAECON*, (1971), Dayton, Ohio, 283–90.

Gregory, R. L. (1961). The brain as an engineering problem. In *Current problems of animal behaviour*, (ed. W. H. Thorpe and O. L. Zangwill). Methuen, London. [Reprinted in: Gregory, R. L. (1974). *Concepts and mechanisms of perception*, pp. 547–65. Duckworth, London.

Gregory, R. L. (1963). Distortion of visual space as inappropriate constancy scaling. *Nature*, **199**, 678–80.

Gregory, R. L. (1970). *The intelligent eye*. Weidenfeld and Nicolson, London.

Gregory, R. L. (1980). Perceptions as hypotheses. *Philosophical Transactions of the Royal Society*, **B 290**, 181–97.

Gregory, R. L. (1981). *Mind in science*. Weidenfeld and Nicolson, London.

Gregory, R. L. and Harris J. P. (1975). Illusion-destruction by appropriate scaling. *Perception*, **4**, 203–20.

Gregory, R. L. and Heard P. (1979). Border locking and the café wall illusion. *Perception*, **8** (4).

Hebb, D. O. (1949). *Organization of behaviour*. Wiley, New York.

Hinton, G. E. (1981). A parallel computation that assigns object-based frames of reference. *Proceedings of the Seventh International Joint Conference on Artificial Intelligence*.

Hinton, G. E. and Sejnowski, T. J. (1986). Learning and relearning in Boltzmann machines. In *Parallel distributed processing*, 2 Vols. MIT Press, Cambridge, Mass.

Hopfield, J. J. (1982). Neural networks and physical systems with emergent collective properties. *Proceedings of the National Academy of Sciences USA*, **79**, 2554–8.

Horn, B. K. P. (1975). Obtaining shape from shading information. In *The psychology of computer vision* (ed. P. H. Winston), p. 115. McGraw-Hill, New York.

Horn, B. K. P. (1977). Understanding image intensities. In *Artificial Intelligence*, **8**, 201–31.

McCulloch, W. S. Warren, S. and Pitts, W. H. (1943). A logical calculus of the ideas immanent in nervous activity. *Bulletin of Mathematical Biophysics*, **5**, 115–33.

Reprinted in: Warren S. McCulloch (1988) *Embodiments of mind* (MIT Press Cambridge, Mass.) 19–39.

McClelland, J., Rumelhart, D. E. and the PDP Research Group. (1986). *Parallel distributed processing*. MIT Press, Cambridge, Mass.

Marr, D. (1982). *Vision: A computational investigation into the human representation and processing of visual information*. Freeman, San Francisco.

Minsky, M. and Papert, S. (1969). *Perceptrons: an introduction to computational geometry*. MIT Press, Cambridge, Mass.

Searle, J. (1984). *Minds, brains and science*. BBC, London.

Sedgewick, R. (1988). *Algorithms*. Addison Wesley, Reading, Mass.

Turing, A. M. (1937). On computable numbers, with an application to the *Entscheidungsproblem*. *Proceedings of the London Mathematical Society*, **42**, 230–65.

2 A portrait of the brain

DAVID ROSE

Filling in the hollow box

The principles of brain function have been introduced by Richard Gregory in the first chapter. Perception is first conceived as a black box, whose workings can perhaps be reconstructed by a rationalist process of 'reverse engineering': that is, from knowledge of how mechanical devices work, we may attempt to deduce what the constituents of the brain might be, on the assumption that systems that solve similar problems might do so by using similar principles of operation.

Every system or black box can be described at three levels (cf. Gregory 1961; Marr 1982):

(1) the problem the black box has to solve, the function it has to carry out, the rules it has to apply.

(2) the procedures available within the black box, which may be analogue processes (probable) or digital algorithms (improbable); and

(3) the structures that exist to carry out the above procedures.

In Chapter 1, the contents of the black box were not described in detail and the term hollow box was therefore used in that context. The contents of the hollow box of perception were suggested to be analogue rather than digital, for example because of the way the box reacts to visual illusions or to brain damage and because of its speed of operation. In this chapter, I will do more to fill in the hollow box, to put flesh on (or in this case, in) the skeleton. The evidence comes partly from direct observation of the anatomy, biochemistry, and physiology of the visual system and partly from top-down knowledge of the system's function, provided by psychology and by art. The interplay between these two sources of scientific knowledge, bottom-up and top-down, is analogous to the interplay between the two sources of personal knowledge, bottom-up and top-down, described

in the last chapter (cf. Gregory 1981). In recent decades there has been much convergence of scientific evidence from these two sources, so that now psychologists feel confident as to which anatomical and physiological structures and processes they are tapping into when they study perception (see for example Chapter 12, by Walsh and Kulikowski, Chapter 9, by Braddick, and Chapter 7, by Atkinson of the present book); while physiologists can similarly link on to the perceptual functions carried out by the structures inside the brain that they are examining (see for example Chapter 3, by Hubel and Livingstone, and Chapter 13 by Kulikowski and Murray of the present book). This interplay has been exciting to watch, as well as to participate in, and the progressive accumulation of understanding is again analogous to the growth of personal knowledge about the world, as described in Fig. 1.3 in the first chapter.

Emergences for emergencies

Within the hollow box are numerous procedures that can be applied in different combinations, according to the task and the situation, to solve the problem of perception. Combinations of systems of procedures give overall abilities to the black box as a whole — abilities that are not possessed by any of the procedures in isolation and which therefore can be called *emergent properties* (see the glossary to this chapter). In general, any adaptive system may be described as a set of elements or primitives (for example, procedures, mechanisms, or structures) interconnected in some way so as to generate new properties that subserve some overall function, aim, or goal (see for example, von Bertalanffy 1968; Pattee 1973; Weiss 1973; Wimsatt 1976; Miller 1978; Bechtel 1986; Jacobs 1986; Bigelow and Pargetter 1987; Zylstra 1992). For us to be able to say we have complete understanding of a system, we require all levels of explanation to be available and to be connected to one another (vertically linked: Darden and Maull 1977; Maull 1977). Thus, for every system in vision, we need to know its functional role, the procedures it uses *and* the mechanisms that subserve it. So, for example, colour constancy has the function of maintaining colour identification despite changes in environmental lighting, it does this by comparing the relative lightnesses of different wavelengths of light in different parts of the visual scene and it uses neural mechanisms in visual area V4 (see Chapter 12 by Walsh and Kulikowski). Similarly for stereoscopic depth perception: its role is vital for fine distance perception, it proceeds by finding matching pairs of stimuli in the two eyes, and it is subserved by neural mechanisms in visual area V1 (Poggio 1984).

In summary, our goal as inquirers must always be to ensure that our concepts are coordinated and consistent with ideas at higher and lower levels.

Levellers and subservients

An important consideration is how many conceptual levels or stages there are in the brain. At one extreme, traditional philosophical approaches (for example, Churchland 1988) treat the problem of the relationship between mind and body as though there is only one step between the level of mind and the level of biology/physics/ chemistry; they attempt to explain the emergence of 'mental states' (feelings, beliefs, and attitudes) as stemming directly from 'material states' (nerve cells and molecules). This, I suspect, is a gross over- simplification and one reason why the problem has proved so intractable.

An alternative view is that there are multiple levels embedded within one another. Every system contains a number of interacting elements that when combined give the system its overall properties. However, each element, when examined more closely, proves to be also a system in its own right. Each element is composed of a

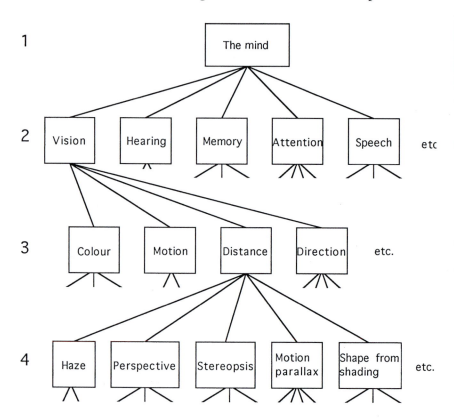

Fig. 2.1. A hierarchical analysis of mental functions.

number of subelements that interact with each other to give the element its characteristic properties. Furthermore, we can continue and apply the same logic to the subelements. To give a simplified example, the mind contains several subsystems, one of which subserves the function of seeing, while others subserve hearing, memory, thinking, feeling, and all the other mental faculties that must necessarily go together to form the whole 'mind'. The process of seeing in turn requires submechanisms, including ones to analyse colour, motion, location, shape, and so on (Fig. 2.1).

The overall picture we have, then, is that the mind consists of a nested hierarchy of systems, a series of black boxes within black boxes, rather like a Russian doll (Attneave 1960; Dennett 1983; Lycan 1991). Each system is composed of interacting subsystems, which in turn are composed of subsubsystems, and so on. For a system at any given level, its properties are created by the subsystems within it and the way they interact; these subsystems and interactions constitute the *mechanism* that gives the system its properties. Conversely, the given system is itself embedded in a meta-system to which it contributes by interacting with other systems at its own level. The *function* of the given system is to perform that task, giving the meta-system its emergent properties in turn.

At each level we should thus look for descriptions of:

(1) the functional role that a system subserves in its meta-system or environment;

(2) the arrangement of and interactions between its constituent elements or subsystems; and

(3) the properties of those elements.

All such descriptions are needed.

Scientific discovery of the contents of a black box can, as was stated above, proceed either bottom-up, from empirical observations of the detailed content of the system or top-down, from hypotheses as to the functional role played by the system. In fact, it is important to emphasize that the top-down route has epistemological priority (Dennett 1983; Rose and Dobson 1985; Jacobs 1986). From knowledge of the functions that a system must perform we may deduce what elements or subsystems must necessarily exist within that system in order for it to be able to perform appropriately. We can then look inside the system to see if our predictions are correct and, if they are not, we must adjust our deductions appropriately. (For a detailed application of this procedure to the visual system see Rose and Dobson (1985, 1989).) The converse method is more difficult: empirical observations can be interpreted in an infinite number of ways and we need top-down *functional hypotheses* to guide us into

fitting our observations into a meaningful framework (Gregory 1959). Gregory asks us to consider a Martian who, upon descending to Earth and observing the exhaust gases emitted from a motor car, might conclude that the motor car is a kind of hair-drier. (In contrast, a rationalist Venusian would deduce *a priori* that Earthlings would need a method of transport and would thus not make the same mistake as the Martian!)

Levels in the visual system

At issue, then, are firstly the number of levels that exist in Nature (and their identities) and, secondly, the mechanisms to be found at each level. Figure 2.1 shows one way in which the brain may be divided; a more detailed summary is given in Table 2.1.

Even this analysis is a simplification and only one possible way the mind might be divided. For example, several of the levels may be subdivided still further and some details of the levels as I present them may be controversial or unclear at the current stage of research. Nevertheless, it is the general principles that I wish to convey here. Once these are grasped, I think it will be easier to comprehend and organize the concepts and theories in vision research and to manipulate and extend them as new hypotheses and new empirical findings come about.

Levels 1 and 2: brain and modules

There is a long debate in psychology as to whether the mind operates as a single mechanism that performs various functions at different times (rather like a computer running different software on the same hardware) or whether permanently dedicated faculties exist. (This debate is known as the functionalism versus structuralism debate.) The current weight of evidence is that several processes are more or less distinct from one another, subserved by separate modules, such as those for vision and speech. The evidence comes from a wide range of sources, including brain damage and brain scanning (Zeki 1993) and electrical stimulation of the brain (Penfield and Perot 1963). Some thinkers maintain that these modules can be entirely closed to one another (for example, Fodor 1983); however, some interaction and feedback must occur and cross-modal integration does happen (i.e. some parts of the brain receive converging visual, auditory, and touch information).

On the other hand, long-term memory seems to be distributed over wide areas: there is no single anatomical location that contains a 'filing cabinet' of memories. Consciousness too seems to be a prop-

Table 2.1 A detailed analysis of the levels and subsystems in the brain

Level	Name	System	Structures	References
1	Me!	Mind	Brain	Churchland (1988)
2	Modules	Vision	Visual system	Zeki (1993)
		Hearing	Auditory system	Buser and Imbert (1992)
		Memory	Memory mechanisms	Dudai (1989)
		Attention	Attention mechanisms	Posner and Petersen (1990)
		etc.	etc.	
3	Domains	Colour	M and P ... V4 system	Livingstone and Hubel (1987)
		Motion	Magno ... V5 system	Livingstone and Hubel (1987)
		Distance	M and P systems	Tyler (1991)
		Direction	Parietal lobe pathway	Mishkin *et al.* (1983)
		Shape	Inferotemporal path	Mishkin *et al.* (1983)
4	Cues	Haze	?	
		Perspective	?	
		Stereopsis	V1	Blake and Wilson (1991)
		Texture gradient	?	
		Shape-from-shading	?	
5	Channels	Orientation selectivity	Orientation selective cells	Cagenello and Rogers (1993)
		Spatial frequency selectivity	Spatial frequency cells selective	Julesz and Miller (1975)
		Phase selectivity	Phase selective cells	Ohzawa and Freeman (1986)
		Disparity selectivity	Disparity selective cells	Poggio (1984)
6	Physiology	Signal transmission	Axons and synapses	Nicholls *et al.* (1992)
7	Chemistry	Electric current flows	Ions and ion channels	Nicholls *et al.* (1992)
8	Physics	Electrostatics	The weak force	Davies (1979)

erty of the whole brain, not one of any of its parts alone (for instance, damage to many areas can change the quality of consciousness without rendering the sufferer unconscious).

Figure 2.2 shows the parts of the brain that form the 'visual system'. This probably takes up some 40 per cent of the human *cerebral cortex* (the massive layer of nerve cells that forms the outer layer

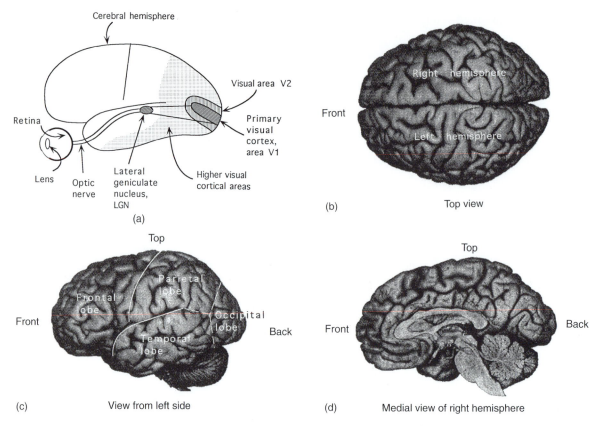

Fig. 2.2. (a) Layout of the visual pathway from retina to LGN to cortex. The shaded area represents the higher visual areas of the cortex. Division of the brain into (b) hemispheres and (c) lobes. (d) A cross-section taken between the two hemispheres. The surface of the hemispheres is convoluted: the crevices are called sulci (singular: sulcus) and the crests, gyri (singular: gyrus).

around the left and right *cerebral hemispheres*) as well as several other, smaller structures in other parts of the brain.

Level 3: stimulus domains

How may the visual system be further subdivided? Subcomponents of the visual system could be proposed phenomenologically, for example, colour vision does not seem at all like the perception of distance. However, more objective evidence comes from quantitative *psychophysical* studies. One technique we commonly use is *adaptation*: exposure to an intense stimulus for a period of time renders the human observer less sensitive to that stimulus. Moreover, recovery from this process of adaptation also takes some time, during which the observer is said to be suffering an *after-effect* from the adaptation. One question we can ask is: how specific is the effect of adaptation for the exact stimulus we used? Does exposure to bright red light render us less sensitive to pink, to blue, or only to red? Well, a more obvious point is that exposure to a coloured light does not make us less sensitive to movement or to how far away a stimulus is. Nor does exposure to movement *per se* affect our colour or depth perception, nor does inspection of a static stimulus at a given distance away

from us affect our colour or motion vision at any distance. To this extent, then, we conclude that colour, motion, and distance are different *domains* or dimensions, that is, that they are at least partially independent subsystems.

There is now a growing school of evidence that anatomical subsystems exist that subserve these functional domains (and possibly also other functions, such as face perception) more or less separately (see Chapter 3, by Hubel and Livingstone, Chapter 13, by Kulikowski and Murray, and Chapter 5, by Perrett, Benson, Hietanen, Oram, and Dittrich in the present book). In detail there is a lot of anatomical and physiological cross-talk between these subsystems (see for example, van Essen *et al.* 1992; Merigan and Maunsell 1993) and, functionally, too, the division of labour is not clear-cut (see for instance, Kovács and Julesz 1992; Chichilnisky *et al.* 1993; Dobkins and Albright 1993; Gorea *et al.* 1993). However, the broad existence of these subdomains has been a central topic of research in the past decade.

The subsystems start to function in the retina, where the nerve cells that convey information to the lateral geniculate nucleus (LGN; Fig. 2.2) turn out to be of two types, commonly called magno and parvo (or M and P for short, meaning large and small). The magno cells are very sensitive to visual stimuli, especially to fast-moving broad patterns. The parvo cells are the opposite, preferring slow or stationary fine patterns, to which they give sustained (continuous) responses. The parvo cells also convey signals about stimulus colour, in that their responses indicate the difference between the amounts of red and green in the stimulus array, or blue and yellow, whereas the magno cells are more sensitive to differences in luminance.

Both systems convey information to the LGN: the parvo system cells in the retina transmit to cells in the LGN with similar parvo properties and the magno cells to magno cells. The magno and parvo cells are segregated into separate layers in the LGN, whereas retinal magno and parvo cells are anatomically intermingled. (A more detailed exposition is given in Chapter 3 by Hubel and Livingstone.)

Both systems then transmit information to the primary visual cortex (area V1, the striate cortex). The signals they send remain partially segregated, but in part they are combined. Thus, the magno cell signals pass to a layer of cells about half-way through the thickness of the cortex, layer 4Cα (Fig. 2.3). Thence, they pass upwards in the cortex, to layer 4B. From here, they are transmitted out of area V1 to other areas of the cortex. The parvo signals are sent first to layer 4Cβ, just below the layer receiving magno input. The next steps are upwards to the combined layers 2 and 3 and from there to other cortical areas. In layers 2 and 3, however, are embedded blob-shaped regions that receive input from both the magno and parvo

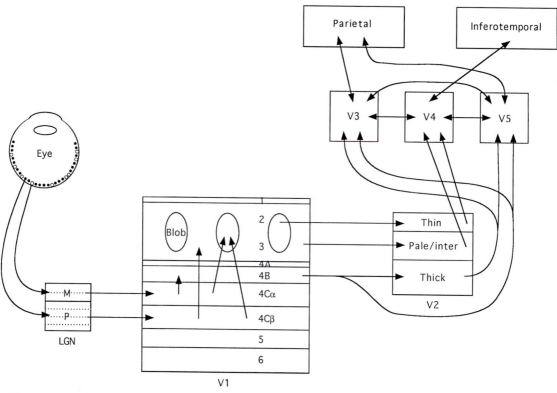

Fig. 2.3. Diagram of the neural systems in 'early' visual processing. The LGN and area V1 are shown in cross-section to reveal their layers, while area V2 is shown in plan view to indicate its striped arrangement. Simplified from Livingstone and Hubel (1987), Zeki and Shipp (1988), and van Essen *et al.* (1992), omitting, for example, the reciprocal connections back to V1 and V2, the connections between the stripes in V2, directly between the parietal lobe and V1 and V2, between V1 and V4, the subdivisions within the higher areas, and so on.

systems and then transmit this combined information on to other areas of cortex. Hubel and Livingstone thus show that the dual input from the LGN is converted by V1 into a triple stream of outputs: magno, parvo, and combined. Moreover, the physiological properties of the nerve cells in these streams indicate that the streams function to subserve motion and depth perception, detailed shape or form perception, and colour perception, respectively (Livingstone and Hubel 1987). There is thus at this level the beginning of a division of the information from the retina into the various subsystems that are necessary for vision. Motion and depth have not been entirely segregated at this stage, but presumably may be so at higher levels in the visual system.

From V1 signals are sent to several other sites in the brain. The second visual area V2 surrounds V1 and maintains the triple functional division — but here each type of information is dealt with in long straight strips of cortex; seen from above the surface, these form repeating parallel stripes approximately 1 mm wide.

From V1 and V2 the information passes to several other nearby areas of cortex that form a mosaic surrounding V2. These areas, called V3, V4, V5, and so on, were first discovered anatomically and then confirmed physiologically. Their existence in humans was later supported by interpretation of the effects of brain damage and by the

use of modern brain scanners (Zeki 1993). There may also be subdivisions within each, as there are in V1 and V2, but the details of these remain to be clarified. At the moment, these 'higher' areas seem to be parts of separate subsystems dealing with different stimulus domains: V3 for pattern, V4 for colour and shape, and V5 for motion (or, more specifically, direction of motion) and gross distance.

The final frontier

A Cinderella domain that has not been considered in such detail neurobiologically is stimulus localization (left versus right, up versus down, straight ahead). The mechanisms of fine detail vision (acuity and 'hyperacuity') have been studied closely (see for example, Morgan 1991; Levi and Klein 1992), yet not the gross layout of visual space. The representation of space is central to much of art, yet it is mainly philosophers who maintain interest in the topic in a neurobiological context. The paintings of Vincent van Gogh, for example, show curvatures and distortions away from linear perspective that Heelan (1983) suggests indicate an awareness on the part of the painter that visual space is not Euclidean (see the glossary to this chapter): distant spaces appear compressed and only near space conforms to Euclidean geometry. Empirical evidence for such non-Euclidean metrics in human observers is extensive (for a review see Indow 1991). The degree of distortion varies with the background context in the visual scene, becoming more Euclidean as the complexity and naturalness of the background increase. French (1987) presents a dualistic explanation of this dissociation between phenomenal and physical space. However, Morgan (1979, 1980) argues that this dichotomy is fallacious: the phenomenal metric of space can only be assessed by making measurements and performing actions in physical space, which must therefore be the sole medium (cf. Kant 1781–7, who thought that all space is phenomenal). Morgan (1980) concludes by adopting Richard Gregory's ideas about perceptual hypotheses: perceived space is a hypothesis about the layout of physical space. Heelan (1983) similarly, though from a different tradition, describes perception as a matter of interpretation of the cues present in the environment.

I suspect that most neuroscientists have ignored gross visual space perception and localization in part because there is in the visual system a gross topographic layout of the visual scene that contains information about stimulus direction implicitly. Thus, consider Plate 1. The visual field is focused on to the retina, where a distorted and 'upside-down' image is formed. Nerve cells in the centre of the retina (the *fovea*) convey information to a particular locus in the LGN, whence the information passes to a particular location in the

primary visual cortex. The edges of the retina send information up to other places in the LGN and visual cortex. There is a topological ordering of these loci, which means that as a stimulus moves steadily through the visual field it creates a 'hot-spot' of activity that moves steadily and progressively across the visual cortex (as across the retina and LGN), without sudden jumps, discontinuities, or divisions into more than one 'hot-spot'.

Now, the first lesson of brain science is that we do not see the layout of the visual scene because of these topological projections and neither do we recognize shapes because the patterns of electrical activity in the brain are identical in shape to the outside objects (iso-morphism): there is no *man-in-the-head* to look at these maps and patterns. Further lessons teach us

(1) that on a finer scale the maps are fuzzy and asymmetrical and do have discontinuities (for example, jumping every 0.5 mm in V1 between the images in the left and right eyes);

(2) that in higher areas such neat topographic layouts become even more fuzzy or non-existent; and

(3) that the maps are there just because it is then easier to grow, maintain, and use the lateral connections between nerve cells (Cowey 1979).

So where does this leave localization? A parietal lobe site for a sub-system that localizes stimuli is suggested by evidence from brain damage (see for example, De Renzi 1983; and Chapter 6, by Humphreys, of the present book) and from physiological recordings and simulations (Andersen *et al.* 1990; Mazzoni *et al.* 1991). The higher levels of the visual system are divisible into two broad streams. One stream passes information towards the parietal lobe (Fig. 2.2); it functions to determine *where* an object is and feeds into mechanisms that control how to move the body in relation to the object. The second stream flows towards the *inferotemporal* cortex (the lower regions of the temporal lobe); it functions to determine *what* the object is and connects with stored memories for objects (Mishkin *et al.* 1983; Newcombe *et al.* 1987).

Level 4: features and cues

Postulating the existence of this level is somewhat speculative on my part. Psychological evidence for its existence is strong, yet physiologi-cal and anatomical localization of most of the mechanisms remains to be determined. Consider first the perception of distance (Fig. 2.1, p. 30). There can be numerous *cues* or clues in the visual scene as to how far away an object is: linear perspective, aerial haze, colour and

contrast, stereopsis, motion parallax, shape from shading, etc. (Gregory 1990; Fig. 2.1). Ramachandran has argued that under most circumstances each cue individually yields a rough indication of distance, but the information from all the cues together gives a precise estimate that far surpasses the usefulness of any cue in isolation. He likens this to two or more drunks succeeding in staggering along the road by supporting each other, when none of them individually would even be able to stand. Colour, motion, and the other domains similarly depend upon or can be signalled by multiple feature cues. To put it another way, the same problem may be solved independently and in parallel in different domains, for example, depth can be signalled by motion parallax or by cues extracted from coloured lines and the orientation of a line can be extracted from the motion, colour, texture, or luminance attributes of the stimulus (Cavanagh 1989).

However, the anatomical location of most of these feature-level processes is problematical. Colour constancy (the maintaining of colour appearance despite changes in the environmental lighting) is probably subserved in cortical area V4 (see Chapter 12 of the present book by Walsh and Kulikowski) and motion parallax (the awareness of distance from the relative movement of objects, particularly when you move yourself) in area V5 (Allman *et al.* 1985; Born and Tootell 1992); however, most other features cannot be so located. A notable exception is *stereopsis*. As an object varies in distance, the *relative* locations of its images in each eye will change (assuming constant eye position: Plate 1). This cue can be used to determine distance by analysing the differences between the images in the two eyes. The primary visual cortex is thought to hold primary responsibility for stereopsis. It is in this area that information from the two eyes first converges, so that some nerve cells there can be aroused by a stimulus presented to either eye. In fact, many cells respond better when both eyes are stimulated simultaneously than when either eye alone is activated. Moreover, they are often sensitive to the relative locations of the left- and right-eye images of the stimulus object, responding only within a narrow range of image relative locations or *disparities* (Poggio 1984; Blake and Wilson 1991).

Level 5: information channels

The breakdown of feature and cue analysers into subordinate mechanisms is difficult for us to understand at present. There may be several sublevels within 'level 5', the exact number depending on the system we are investigating. For example, stereopsis may be decomposed into two problems: find corresponding stimuli that match in the two eyes and suppress false matches. For the correspondence

problem to be solved requires submechanisms to ensure matching items have similar orientation, size, and so on. Another cue for depth is haze, which conceivably might depend more simply on a single subsystem that detects gradients of contrast. However, there is also a deeper conceptual problem. Some theories suggest that only critical features are important for vision and redundant background information should be discarded or filtered out. In contrast, other theories presuppose that (at early stages in the visual system) there is a need to encode as much information as completely and efficiently as possible, before transmitting it on to other parts of the brain for analysis according to whatever are the ongoing needs of the higher-order task or situation. This dichotomy shows that the way scientists conceptually decompose the visual system into submodules depends on their metaphysical ideas about how the brain works overall (Dobson and Rose 1985).

Whichever type of approach is adopted, there is a need at a low level in the system for mechanisms to detect spatial discontinuities in luminance or colour such as occur at the edges of natural objects, i.e. for *orientation-selective* mechanisms (Craik 1943; Marr 1982; Rose and Dobson 1985). Evidence for just such a mechanism has been found in the primary visual cortex, originally by Hubel and Wiesel (1959). They found that single nerve cells there respond to straight lines or edges only at particular orientation: some cells respond only to vertical lines, others to horizontal, and so on for all the other angles round the clock.

Another issue is that for some theories the presence of a feature is signalled by the activity of nerve cells specialized to detect that particular feature (or at higher levels, a particular object). Opposing theories, however, posit that it is the pattern of activity across an array or *network* of cells that is uniquely related to the stimulus feature or object (Koenderink 1993; see the glossary to this chapter). This creates a tension between the single-unit approach and the network or PDP approach (see Chapter 1 by Gregory of the present book). Under the latter, the activity of any single nerve cell shows only a fragment of the process occurring in the network. So bearing in mind (!) the caveat that this issue is not yet fully resolved, we can now consider the evidence from physiology as to what actually happens at this level of analysis of the central nervous system.

The visual world is first focused on to the retina that coats the inside of the back of the eyeball. The retina contains numerous *receptor cells* that are sensitive to light, in that light entering them triggers a chain of biochemical activity within the cell, leading to the generation of an electrical signal. There are approximately 100 million *rod* receptor cells in each eye that function best in very dim environments, and approximately 6 million *cone* receptors that operate in

daylight. Imagine an instant in time when the eyes are still and viewing a static scene. Each of the receptor cells is only able to 'see' a small fraction of the image focused on the retina — in other words it has a limited view or 'window' within which it can detect light. Only a small part or 'pixel' of the visual scene is inspected by any given cell at any one time. This region of the world is known as the cell's *receptive field*. By recording the electrical activity of a cell while positioning stimuli at different places in front of the eye, physiologists can map the receptive field and find out what kinds of stimuli arouse the cell. (This is actually difficult to do for receptors, because they are so small, but for larger cells it is routine.)

Within the retina there are several kinds of nerve cell and the signals from the receptor cells are carried through these until they arrive at the *retinal ganglion cells*, which are the cells that transmit information out of the retina, along the optic nerve, and up to the LGN (Fig. 2.2, p. 34; for more details see Fig. 14.2(b) of Chapter 14 by Sillito of the present book). There are only approximately 1 million ganglion cells in each eye, so the information from the 106 or so million receptor cells has to be funnelled down or condensed in some way. In the fovea, a ganglion cell may be activated by only one or two receptor cells, but towards the edges of the retina there is increasing convergence of information from many receptors on to each individual ganglion cell. This convergence is not however a simple process of summing the signals. Procedures have been implemented in the intervening layers of nerve cells that enhance the responses to change in the visual environment: to increases or decreases in illumination and to differences in light intensity at different locations. Spatially, the receptive fields of ganglion cells are approximately circular and are divided into two regions: the circular *centre* and its concentric annular *surround*. Some ganglion cells are activated by an increase in light intensity in the centre *or* by a decrease in light intensity in the surround (*ON-centre* cells). Stimulation of an ON-centre cell by increasing light in both centre and surround simultaneously leads to a weaker response than the same increase in light in the centre alone. Hence, bright spots and edges in the visual field evoke stronger signals than uniform areas of illumination. For other ganglion cells activity is enhanced by decreasing the illumination of the centre or increasing it in the surround (*OFF-centre* cells); these cells thus respond well to dark spots and lines.

Parvo ganglion cells have an additional property relating to colour selectivity. Cone receptor cells come in three types, each of which responds best to light of different wavelengths. These are commonly referred to as red, green, and blue cones, although there is extensive overlap in the ranges of wavelength to which each of the three types

responds. Some ganglion cells have centres driven by red cones, while their surrounds are driven by green cones; for others it is vice versa. Others have both red and green cones driving the centre ('yellow') and blue driving the surround. Ganglion cells thus signal, to a first approximation, the difference between the amounts of red and green, or blue and yellow, within their receptive fields.

In the LGN the receptive fields are quite similar to those in the retina. In area V1 however we find some remarkable changes. Orientation selectivity is common, as was mentioned above. So too is binocularity and stereoscopic disparity selectivity. Another common property is direction selectivity: many cells prefer movement of the stimulus in one direction rather than another. For example, one cell might respond only to vertical lines moving to the left across its receptive field and another cell to vertical lines moving right, while yet other cells respond to vertical lines moving in either direction. In the blobs in layers 2 and 3, however, orientation and direction selectivity are weak or absent and the cells' responses are determined mainly by the wavelengths of the light falling on the receptive fields. Similar properties abound in area V2, although an interesting new property reported there is the ability to fill in across gaps in contours, such as those caused by one object occluding another. These cells have been suggested to underlie illusions of the Kanizsa triangle type (Peterhans and von der Heydt 1991).

In higher areas the receptive field properties of cells change in many ways and a full account cannot be given because research here is still at an early stage. As we proceed towards the inferotemporal cortex, receptive fields become much larger, so the cells respond to stimuli anywhere within a large sector of the visual field. Thus, information about stimulus location is de-emphasized, but at the same time the cells become more choosy about what turns them on (although when they find it they don't care so much where it comes from). In V3, V4, and V5 there is increasing emphasis on shape, colour, or direction of motion. For example, in V4 some cells can compensate for changes in environmental lighting when choosing to respond only to objects which reflect certain wavelengths of light (Zeki 1983; Chapter 12 by Walsh and Kulikowski of the present book). The motion of the stimulus is not particularly important there. Over in V5 it is differential motion between an object and its background that is crucial for the firing of certain cells or the cohesiveness of a cluster of apparently individual stimuli, all moving in the same direction at the same speed (for example, a flock of birds or a speckled or pebbly texture on a surface as we walk by: Allman *et al.* (1985); Albright (1992); and Born and Tootell (1992)). These and many other selectivities are continually being discovered as new areas of the brain are explored physiologically.

The inferotemporal cortex is a large and still relatively unexplored area. Some cells there respond to complex constellations of features, so that small groups of these cells could signal the presence of whole, three-dimensional objects (Desimone *et al.* 1984; Tanaka *et al.* 1991; Miyashita 1993). Other cells respond only to faces, parts of faces, people walking to and fro, and so on (see Chapter 5 of the present book by Perrett and colleagues). Finally, the parietal lobe contains networks of cells with finer localization abilities. These are selective for object direction in extrapersonal space or at least relative to the head rather than the eye. For example, cells sensitive to a stimulus directly in front of you would respond regardless of whether or not you look directly at it (Andersen *et al.* 1990; Mazzoni *et al.* 1991). In other words, there is a mechanism that corrects retinal image location for changes in eye position, which is necessary if we are, for example, to be able to reach out and touch an object without having always to look directly at it. Thus, information about 'what' and 'where' is preserved, though in separate anatomical sites.

Level 6: cellular physiology

How is information represented, encoded, and transmitted around the system, from functional unit to functional unit, from one nerve cell (or *neurone*) to another, within the network? There are a number of ways this might be done, but the principal mechanism involves the sending of electrical impulses along nerve fibres and the emitting of chemical signals from one cell to another.

Thus, growing out of each nerve cell is a long fibre or *axon* (Fig. 2.4) that consists essentially of a hollow tube, typically less than a hundredth of a millimetre across, filled with a salty solution. The axon is formed by an extrusion of the cell *membrane* that forms the outer boundary of the cell. Messages pass along the axon in the form of a series of brief electrical impulses called *action potentials*. Each impulse lasts less than a millisecond and is always the same size (perhaps a tenth of a volt) in any given cell. The intensity of the signal conveyed by the axon is encoded in the rate at which action potentials occur (the *firing rate*), which is at most 1000 per second, and normally much lower.

When an action potential reaches the far end of the axon it causes the secretion of a small amount of chemical from the tips of the axon (the axon normally branches, to pass its message on to several other nerve cells, not just one). The tips of the axon are swollen (*terminal boutons*) and lie only a fraction of a micrometre away from the nerve cells that receive the message; the site of communication is known as the *synapse*. The chemical released, which is referred to as the *neurotransmitter*, thus reaches the target cell very quickly. There it inter-

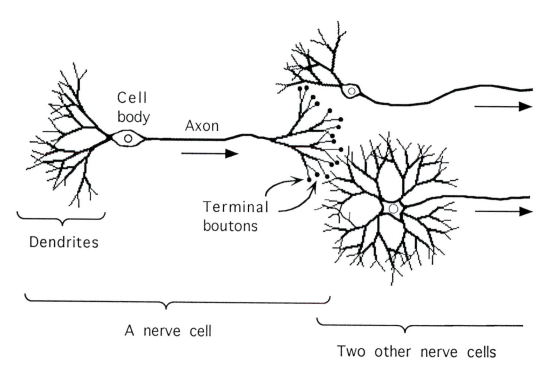

Cell body

Axon

Terminal boutons

Dendrites

A nerve cell

Two other nerve cells

Fig. 2.4. Schematic diagram of three nerve cells, illustrating their main functional parts. Dendrites can form a variety of patterns around the cell body and the axons too can split in a variety of ways to form synapses on to many other nerve cells. Every bouton contacts a dendrite or cell body; only two recipient cells are drawn in here. Arrows show the direction of information (action potential) flow.

acts with the outer surface of the target cell to initiate a new electrical signal in that cell. However, this signal is not sufficient in itself to cause the recipient neurone to fire off an action potential along its own axon. Each neurone receives thousands of synapses onto the cell body and its branch-like extensions (*dendrites*) and many of these synapses must be activated at once to wake the cell up from its resting state.

An important advantage of using chemical neurotransmission is that the signal conveyed at a synapse can be of more than one type. For example, the electrical potentials set up within the target cell can be positive or negative, that is, they can increase or decrease the probability that the target cell will fire off an action potential along its axon or in other words they can be *excitatory* or *inhibitory*. The probability that a cell will fire thus depends upon the balance between the number of active excitatory inputs and the number of active inhibitory inputs it receives. Finally, note that the neurotransmitter emitted from every terminal bouton of a nerve cell is the same: a given cell is thus able either to arouse other cells and, hence, is called an excitatory neurone or is able to suppress firing activity and is thus an inhibitory interneurone. (Because the latter often have short axons they are usually called *inter*neurones, meaning they intervene between two other nerve cells; although in fact all neurones except those to the muscles do this, so the nomenclature is

somewhat obsolete, though it is still in common use. See Chapter 14 of the present book by Sillito for more on the subtleties of chemical neurotransmission.)

Level 7: physical chemistry

We do not need to examine this level in detail here. Suffice it to say that action potentials can be conveyed because the salt solution inside an axon differs from that outside. The latter contains mainly sodium ions, which are positively charged particles and chloride ions, which carry negative electrical charge. (Similar ions occur in seawater or after dissolving common table salt in tap-water.) Inside the cell, however, the ions are mostly positive potassium ions plus a whole range of negatively charged molecules such as sugars, proteins, and fats. When an electrical signal arrives along an axon it opens pores or *channels* in the membrane that allow sodium ions to flow into the axon and then potassium ions to flow out, hence briefly altering the electrical balance between the inside and outside of the axon. The pores soon close and a special 'pump' slowly pushes the sodium back out of the cell and the potassium back in to restore the *status quo*. Meanwhile, however, the electrical imbalance has disturbed the next region along the axon and initiated another round of channel opening and ion flows there, thus moving the action potential along to that region, which in turn will pass it along to the next region and so on along the length of the axon.

At the synapse the neurotransmitter is stored in many spherical *vesicles* inside each terminal bouton. An arriving action potential causes channels to open that allow calcium ions into the bouton. These trigger biochemical processes that move the vesicles across to the membrane that forms the outer boundary of the cell. The membrane is penetrated and the vesicles empty their contents outside the cell (Fig. 2.5). When the transmitter reaches the dendrite of the target cell (the *post-synaptic* cell) it interacts with special *receptor molecules* in the dendrite's membrane, like a key fitting into a lock. This causes pores to open and thus allows ions to flow and hence electrical changes to occur in the target cell. (Excitatory neurotransmitters usually open pores for sodium ions, whereas inhibitory transmitters open pores for potassium or chloride ions.)

Level 8: physics

Obviously, there must be molecular and atomic-level mechanisms by which ion channels are opened and closed (in axons by voltage change, at synapses by chemical neurotransmitters) and by which

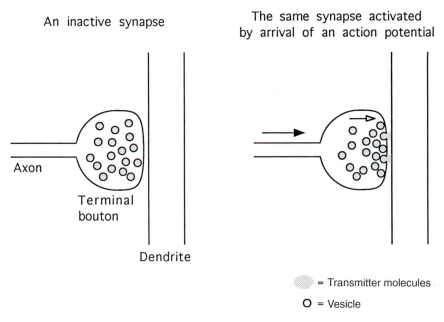

Fig. 2.5. Diagram of a terminal bouton, showing the transmitter normally stored in vesicles. When an action potential arrives the vesicles move to the cell membrane and release the transmitter, which diffuses across to the dendrite of the target cell.

they select which ion to allow through. The mechanisms involved are beyond the scope of this chapter, however!

Advantageous adventitiousness

The picture presented is thus of a series of levels, each of which imposes demands upon its subordinate mechanisms. How does this hierarchy originate? If this top-down analysis were to be taken literally and continued *ad infinitum*, it could be misinterpreted to mean that very low-level systems, including nerve cells (and even atoms), would need to evolve independently to serve each and every high-level system. However, that is not how evolution works. New mechanisms do not always have to evolve *de novo* from primordial soup (or new Big Bangs). Nature is adventitious and opportunistic and adapts existing structures and systems to serve the needs of the moment (Gould 1980; Jacob 1982). Functional demands constrain the survival of variations on old pre-existing mechanisms. This is how higher-level systems supervene over the growth of their lower-level constituents (Jacob 1982; Sober 1984; Salthe 1985; Sattler 1986; Zylstra 1992).

Thus, nerve cells can evolve out of other nerve cells. There are many different types of nerve cell in the retina and brain, because pressure has existed, at one time or another in evolutionary history, for those different types to evolve, to subserve the various needs of

the moment. Functional groups of cells also develop through evolutionary pressure (Ebbesson 1984; Edelman 1987). There are multiple mechanisms for extracting edge orientation from an image, one within each of a number of different domains: luminance, colour, motion, stereopsis, and texture (Cavanagh 1989). Presumably, orientation selectivity has evolved many times, to analyse edges within each of these domains. In addition, stereopsis itself may have evolved three times, once within each of the three pathways described by Livingstone and Hubel (1987). These three stereopsis mechanisms differ in their spatial resolution and their use of interocular differences in spatial frequency, but they nevertheless are all capable of subserving depth perception under one environmental condition or another (Tyler 1990).

Hence, we *appear* to get convergence as well as divergence as we go down the hierarchy in Table 2.1. For example, all the channels at level 5 rely on signal transmission by nerve cells, but they are not the same signals. Several level 3 domains contain mechanisms to extract edge orientation (Cavanagh 1989) or stereoscopic depth (Tyler 1990), but these are not all the same mechanism: they exist independently within each domain. Whether a process of convergent evolution generated each of these parallel systems independently or whether they all diverged from the same common ancestor mechanism, remains a matter for future consideration.

Portraits of the brain

Table 2.1 (p. 33) summarizes the picture I have presented, in which I have first attempted a rational breakdown of part of the brain hierarchy that deals with vision, categorized according to functional needs. Although functional systems need not be anatomically separate, in some cases they are, so I have tried as far as possible to correlate the functional black boxes with corresponding anatomical structures, although this may sometimes have been at the cost of oversimplification.

Alternative breakdowns are also possible and it remains to be seen which will best fit the empirical evidence. For example, mind could be interpreted first as containing systems that ask who or what, where, when, how come, why, and so what? Visual, auditory, and other mechanisms would then be subservient to the first three of these, memory the third, reasoning the fourth, forward planning and imagination the fifth, and emotion the last. What I wish to emphasize is that many styles of portrait are possible. The choice between them depends on the portrait's context and the purpose of composing it. Yet it is still the same subject!

A portrait is intended to convey more than just the surface appearance of the subject. The brain as I have tried to portray it here has near-infinite depth: dimensions nested within one another that open out every time one approaches closer to examine the detail and open out yet again as we move in to study further. There are more than three dimensions to the brain and that is what makes it so fascinating.

References

Albright, T. D. (1992). Form-cue invariant motion processing in primate visual cortex. *Science*, **255**, 1141–3

Allman, J., Miezin, F., and McGuinness, E. (1985). Direction- and velocity-specific responses from beyond the classical receptive field in the middle temporal visual area (MT). *Perception*, **14**, 105–26.

Andersen, R. A., Bracewell, R. M., Barash, S., Gnadt, J. W., and Fogassi, L. (1990). Eye position effects on visual, memory, and saccade-related activity in areas LIP and 7a of macaque. *Journal of Neuroscience*, **10**, 1176–96.

Attneave, F. (1960). In defence of *homunculi*. In *Sensory communication* (ed. W. Rosenblith), pp. 777–82. MIT Press, Cambridge, Mass.

Bechtel, W. (1986). Teleological functional analyses and the hierarchical organization of nature. In *Current issues in teleology*, (ed., N. Rescher) pp. 26–48. University Press of America, Lanham.

Bigelow, J. and Pargetter, R. (1987). Functions. *Journal of Philosophy*, **84**, 181–96.

Blake, R. and Wilson, H. R. (1991). Neural models of stereoscopic vision. *Trends in Neuroscience*, **14**, 445–52.

Born, R. T. and Tootell, R. B. H. (1992). Segregation of global and local motion processing in primate middle temporal visual area. *Nature*, **357**, 497–9.

Buser, P. and Imbert, M. (1992). *Audition*. Bradford Books, Cambridge, Mass.

Cagenello, R. and Rogers, B. J. (1993). Anisotropies in the perception of stereoscopic surfaces: the role of orientation disparity. *Vision Research*, **33**, 2189–2201.

Cavanagh, P. (1989). Multiple analyses of orientation in the visual system. In *Neural mechanisms of visual perception*, (ed. D. M-K. Lam and C. D. Gilbert), pp. 261–79. Portfolio Publishing, The Woodlands,

Chichilnisky, E-J., Heeger, D., and Wandell, B. A. (1993). Functional segregation of colour and motion perception examined in motion nulling. *Vision Research*, **33**, 2113–25.

Churchland, P. M. (1988). *Matter and consciousness*, (rev. edn). MIT Press, Cambridge, Mass.

Cowey, A. (1979). Cortical maps and visual perception. *Quarterly Journal of Experimental Psychology*, **31**, 1–17.

Craik, K. J. W. (1943). *The nature of explanation*. Cambridge University Press.

Darden, L. and Maull, N. (1977). Interfield theories. *Philosophy of Science*, **44**, 43–64.

Davies, P. C. W. (1979). *The forces of nature*. Cambridge University Press.

Dennett, D. (1983). Artificial intelligence and the strategies of psychological investigation. In *States of mind*. (ed. J. Miller), pp. 66–81. BBC, London.

De Renzi, E. (1983). *Disorders of space exploration and cognition*. Wiley, Chichester.

Desimone, R., Albright, T. D., Gross, C. G., and Bruce, C. (1984). Stimulus-selective properties of inferior temporal neurons in the macaque. *Journal of Neuroscience*, **4**, 2051–62.

Dobkins, K. R. and Albright, T. D. (1993). What happens if it changes color when it moves?: psychophysical experiments on the nature of chromatic input to motion detectors. *Vision Research*, **33**, 1019–36.

Dobson, V. G. and Rose, D. (1985). Models and metaphysics: the nature of explanation revisited. In *Models of the visual cortex*, (ed. D. Rose and V. G. Dobson), pp. 22–36. Wiley, Chichester.

Dudai, Y. (1989). *The neurobiology of memory*. Oxford University Press.

Ebbeson, S. O. E. (1984). Evolution and ontogeny of neural circuits. *Behavior and Brain Science*, **7**, 321–66.

Edelman, G. M. (1987) *Neural Darwinism*. Basic Books, New York.

Fodor, J. A. (1983). *The modularity of mind*. Bradford Books, Cambridge, Mass.

French, R. E. (1987). *The geometry of vision and the mind body problem*. Peter Lang, New York.

Frisby, J. P. (1979). *Seeing*. Oxford University Press.

Gorea, A., Papathomas, T. V. and Kovacs, I. (1993). Motion perception with spatiotemporally matched chromatic and achromatic information reveals a 'slow' and a 'fast' motion system. *Vision Research*, **33**, 2515–34.

Gould, S. J. (1980). *The panda's thumb*. Norton, New York.

Gregory, R. L. (1959). Models and the localisation of function in the central nervous system. In *Symposium on the Mechanization of Thought Processes*, pp. 669–89. HMSO, London.

Gregory, R. L. (1961). The brain as an engineering problem. In *Current problems in animal behaviour*, (ed. W. H. Thorpe and O. L. Zangwill), pp. 547–65. Methuen, London.

Gregory, R. L. (1981). *Mind in science*. Weidenfeld and Nicolson, London.

Gregory, R. L. (1990). *Eye and brain*, (4th edn). Oxford University Press, Oxford.

Heelan, P. A. (1983). *Space-perception and the philosophy of science*. University of California Press, Berkeley.

Hubel, D. H. and Wiesel, T. N. (1959). Receptive fields of single neurones in the cat's striate cortex. *Journal of Physiology*, **148**, 574–91.

Indow, T. (1991). A critical review of Luneberg's model with regard to global structure of visual space. *Psychological Review*, **98**, 430–53.

Jacob, F. (1982). *The possible and the actual*. Pantheon, New York.

Jacobs, J. (1986). Teleology and reduction in biology. *Biology and Philosophy*, **1**, 389–99.

Julesz, B. and Miller, J. (1975). Independent spatial-frequency-tuned channels in binocular fusion and rivalry. *Perception*, **4**, 125–43.

Kant, I. (1781–7). *Critik der reinen Vernunft*. Hartnoch, Riga.

Koenderink, J. J. (1993). What is a 'feature'? *Journal of Intelligent Systems*, **3**, 49–82.

Kovács, I. and Julesz, B. (1992). Depth, motion and static-flow perception at metaisoluminant color contrast. *Proceedings of the National Academy of Sciences (USA)*, **89**, 10390–4.

Levi, D. M. and Klein, S. A. (1992). 'Weber's law' for position: the role of spatial frequency and contrast. *Vision Research*, **32**, 2235–50.

Livingstone, M. S. and Hubel, D. H. (1987). Psychophysical evidence for separate channels for the perception of form, color, movement, and depth. *Journal of Neuroscience*, **7**, 3416–68.

Lycan, W. G. (1991). Homuncular functionalism meets PDP. In *Philosophy and connectionist theory*, (ed. W. Ramsey, S. P. Stich, and D. E. Rumelhart), pp. 259–86. Erlbaum, Hillsdale, NJ.

Marr, D. (1982). *Vision*. Freeman, San Francisco.

Maull, N. L. (1977). Unifying science without reduction. *Studies in the History and Philosophy of Science*, **8**, 143–62.

Mazzoni, P., Andersen, R. A., and Jordan, M. I. (1991). A more biologically plausible learning rule for neural networks. *Proceedings of the National Academy of Sciences (USA)*, **88**, 4433–7.

Merigan, W. H. and Maunsell, J. H. R. (1993). How parallel are the primate visual pathways? *Annual Review of Neuroscience*, **16**, 369–402.

Miller, J. G. (1978) *Living systems*. McGraw-Hill, New York.

Mishkin, M., Ungeleider, L. G. and Macko, K. A. (1983). Object vision and spatial vision: two cortical pathways. *Trends in Neuroscience*, **6**, 414–17.

Miyashita, Y. (1993). Inferior temporal cortex: where visual perception meets memory. *Annual Review of Neuroscience*, **16**, 245–63.

Morgan, M. (1979). The two spaces. In *Philosophical problems in psychology*. (ed. N. Bolton), pp. 66–88. Methuen, London..

Morgan, M. J. (1980). Phenomenal space. In *Consciousness and the physical world*, (ed. B. D. Josephson and V. S. Ramachandran), pp. 177–91. Pergamon, Oxford.

Morgan, M. J. (1991). Hyperacuity. In *Spatial vision*, Vision and visual dysfunction, Vol. 10, (ed. D. M. Regan), pp. 87–113. Macmillan, London.

Newcombe, F., Ratcliff, G. and Damasio, H. (1987). Dissociable visual and spatial impairments following right posterior cerebral lesions: clinical, neuropsychological and anatomical evidence. *Neuropsychologia*, **25**, 149–61.

Nicholls, J. G., Martin, A. R., and Wallace, B. G. (1992). *From neuron to brain*, (3rd edn.) Sinauer, Sunderland.

Ohzawa, I. and Freeman, R. D. (1986). The binocular organization of simple cells in the cat's visual cortex. *Journal of Neurophysiology*, **56**, 221–42.

Pattee, H. H. (ed.) (1973) *Hierarchy theory*. Braziller, New York.

Penfield, W. and Perot, P. (1963). The brain's record of auditory and visual experience. *Brain*, **86**, 595–696.

Peterhans, E. and von der Heydt, R. (1991). Subjective contours — bridging the gap between psychophysics and physiology. *Trends in Neuroscience*, **14**, 112–19.

Poggio, G. F. (1984). Processing of stereoscopic information in primate visual cortex. In *Dynamic aspects of neocortical function*, (ed. G. M. Edelman, W. E. Gall, and W. M. Cowan), pp. 613–35. Wiley, New York.

Posner, M. I. and Petersen, S. E. (1990). The attention system of the human brain. *Annual Review of Neuroscience*, **13**, 25–42.

Rose, D. and Dobson, V.G. (1985). Methodological solutions for neuroscience. In *Models of the visual cortex*, (ed. D. Rose and V. G. Dobson), pp. 533–45. Wiley, Chichester.

Rose, D. and Dobson. V. G. (1989). On the nature of theories and the generation of models of the circuitry of the primary visual cortex. In *Seeing contour and colour*, (ed. J. J. Kulikowski, C. M. Dickinson, and I. J. Murray), pp. 651–8. Pergamon, Oxford.

Salthe, S. N. (1985). *Evolving hierarchical systems*, Columbia University Press, New York.

Sattler, R. (1986). *Biophilosophy*. Springer, Berlin.

Sober, E. (1984). *The nature of selection*. Bradford Books, Cambridge, Mass.

Tanaka, K. Saito, H. A., Fukuda, Y. and Moriya, M. (1991). Coding visual images of objects in the inferotemporal cortex of the macaque monkey. *Journal of Neurophysiology*, **66**, 170–189.

Tyler, C. W. (1990). A stereoscopic view of visual processing streams. *Vision Research*, **30**, 1877–95.

Tyler, C. W. (1991). Cyclopean vision. In *Binocular vision*, Vision and visual dysfunction, Vol. 9. (ed. D. M. Regan), pp. 38–74. Macmillan, London.

Van Essen, D. C., Anderson, C. H., and Felleman, D. J. (1992). Information processing in the primate visual system: an integrated systems perspective. *Science*, **255**, 419–23.

von Bertalanffy, L. (1968). *General system theory*. George Braziller, New York.

Weiss, P. A. (1973). *The science of life*. Futura, New York.

Wimsatt, W. C. (1976). Reductionism, levels of organization, and the mind-body problem. In *Consciousness and the brain*, (ed. G. G. Globus, G. Maxwell, and I. Slavodnik), pp. 205–67. Plenum Press, New York.

Zeki, S. (1983). Colour coding in the cerebral cortex: the reaction of cells in monkey visual cortex to wavelengths and colours. *Neuroscience*, **9**, 741–65.

Zeki, S. (1993). *A vision of the brain*. Blackwell, Oxford.

Zeki, S. and Shipp, S. (1988). The functional logic of cortical connections. *Nature*, **335**, 311–17.

Zylstra, U. (1992). Living things as hierarchically organized structures. *Synthese*, **91**, 111–33.

Glossary

Emergent properties

An everyday example of an emergent property is the ability of a motor car to move: its constituent parts — the engine, gears, bodywork, and petrol — are unable to move individually, but, connected together in the right way, they form a coherent system that can do something none of them can alone. Similarly, the engine can convert petrol and oxygen into kinetic energy, which is something no single component among the pistons, the fuel injector, the distributor, the spark plugs, the flywheel, etc., could do on its own. The brain is composed of nerve cells, none of which can think, see, or feel on its own, but, when connected together in the right way, they form a brain which does possess such properties.

Euclidean geometry

The crucial axiom of Euclidean geometry broken in many paintings is that spatial intervals are constant in size and angles remain the same, whatever distance away from us they are, in whatever direction, and at whatever velocity we travel.

Network or cross-fibre encoding

Encoding information in a network is rather like encoding messages in a language: thus, given the 26 letters in the English alphabet, there are 26^2 combinations of two letters that can be formed, each of which could stand for one of 676 different concepts; similarly, 26^3 or 17 576 three-letter combinations can be formed and so on for longer and longer words. Thus, many more concepts can be represented by multiletter symbols (words) than can be encoded if every concept is represented by only one letter each — in that case only 26. Brains might handle information similarly, that is, in terms of a pattern of activity across a number of cells, because the number of patterns (of cells active or inactive) that can occur far exceeds the number of cells. This method is thus more flexible and efficient. A good analogy is colour vision: we can distinguish hundreds of different hues, yet at the level of the cone receptors in the retina there are only three types of cell, which are activated in different ratios by different wavelengths of light. At this level each hue may be represented by a ratio, not by any single cell.

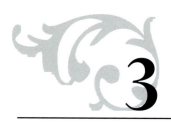

3 Through the eyes of monkeys and men

MARGARET LIVINGSTONE AND DAVID HUBEL

Intuitively, our visual experience seems to us to be unitary. We look out on the world and the scene we see with all its colour, shapes, depth, and movement, appears as one. Nevertheless, it seems that our eyes and brain process the information in the scene along a number of surprisingly separate channels. It turns out that many of the illusions we find in psychology texts, as well as many phenomena we take for granted in art, especially pop art, arise because of this separation of functions in our visual pathways.

Anatomical evidence for parallel channels

The subdivision of the primate visual system begins in the retina and is perpetuated into the first, most preliminary region of the cerebral cortex concerned with vision, the primary visual cortex, or cortical area V1. The subdivision is anatomically most obvious, however, in an intermediate state deep within the brain, that receives its input from the retina and sends its output fibres to the cortex, the 'lateral geniculate nucleus' (LGN). Just glancing at a cross-section of the LGN we can see that it is divided into two large subdivisions, the first composed of two layers, and termed 'magnocellular' because the cells are relatively large and the second composed of four small-cell layers and called 'parvocellular'. Large retina ganglion cells project (that is, transmit) to the magnocellular LGN layers, while smaller ganglion cells project to the parvocellular layers.

A third subdivision, specifically concerned with colour information, probably originates in a third group of retinal cells called W-cells. In the LGN, this system may be represented by a set of cells mainly concerned with colour that are found in or near the thin leaflets between the parvocellular layers of the LGN and that project directly to structures in the upper layers of V1 called 'blobs' (Livingstone and Hubel 1982, 1984, Fitzpatrick *et al.* 1983; and unpublished observations). This tangle of connections is diagrammed in Fig. 3.1.

Fig. 3.1. Diagram of the functional segregation of the primate visual system, showing the projection of large ganglion cells in the retina to the magnocellular layers of the LGN and thence to layer 4Cα of the primary visual cortex, while small ganglion cells project to the parvocellular layer and thence to layers 4Cβ and 4A of area VI.

Magno-recipient layer 4Cα projects to layer 4B, which in turn projects to the next visual area in the cortex, visual area 2 and to still another area, MT, also called V5, while parvo-recipient layer 4Cβ projects to layers 2 and 3 and from there to visual area 2; both 4Cα and 4Cβ also send less dense projections to the deeper layers in V1.

The visual pathway from eye to brain is complex, but enough of the details of its organization have been unravelled to make it clear that it contains several distinct subpathways. These pathways also differ in their function (see Box).

Despite many gaps, the picture beginning to emerge from the anatomy and physiology is that the segregation apparent at very early stages of the visual system gives rise to separate and independent parallel pathways. At early stages, where there are two major subdivisions, the cells in these two subdivisions exhibit at least four very basic differences: in their colour selectivity, speed, acuity, and contrast sensitivity. At higher stages the continuations of these pathways are selective for quite different aspects of vision: for form, colour, movement, and stereopsis — thus generating the counterintuitive prediction that different kinds of visual tasks should differ in their colour, temporal, spatial, and contrast characteristics. To test this prediction we asked whether the differences seen at the early stages of the visual system can be detected in conscious human visual perception by comparing the colour, temporal, spatial, and contrast sensitivities of different visual functions. Many of these questions have, not surprisingly, already been asked and the answers

Box 3.1 Functional differences between the channels

In the LGN, the magno and parvo subdivisions differ in their
(1) colour selectivity, (2) temporal characteristics, (3) contrast
sensitivity, and (4) spatial resolution. Most parvocellular cells
respond to visual stimuli in such a way as to make it clear that
they are very interested in colour, whereas magnocellular cells are
not. For example a typical parvocellular geniculate neurone might
be excited over a small region of its receptive field by red light and
inhibited over a larger surrounding region by green light, whereas
a typical broad-band magnocellular neurone would be excited by
all wavelengths in the centre and inhibited by all wavelengths in
its surround.

 Magno cells are much more sensitive than parvo cells to lum-
inance contrast, that is, to the difference in brightness across a
dark–light border. The third difference between magno and parvo
cells is the sizes of the areas in the visual world to which they give
responses — regions known as their 'receptive field centres'. For
both systems the average receptive field centre size increases with
distance from the centre of gaze, which corresponds to the fovea
of the retina, and these increases are consistent with the differ-
ences in acuity between foveal and peripheral vision. Yet at any
given distance from the fovea, magno cells have larger receptive
field centres than parvo cells, by a factor of 2 or 3. Lastly, magno
cells respond faster and more transiently than parvo cells. This
sensitivity to the temporal aspects of a visual stimulus suggests
that the magno system may play a special role in detecting move-
ment. As we will see, many cells at higher levels in this pathway
are indeed selective for direction of movement.

are strikingly consistent with the anatomy and physiology. For
several decades psychologists have accumulated evidence for two
channels in human vision, one chromatic and the other achromatic,
by showing that different tasks can have very different sensitivities to
colour and brightness contrast. Given what we know now about the

physiology and the anatomy of the subdivisions of the primate visual system, we can begin to try to correlate the perceptual observations with these subdivisions. In our discussion of human perception and the appreciation of art, we will stress the distinctions between functions that seem to be carried exclusively by the magno system and those that seem to be carried by the parvo-derived pathways.

Human perceptual correlates

Temporal differences in colour and brightness discrimination

From the fact that the magno system is colour-blind and is faster than the parvo system, we can predict that discrimination of colour and discrimination of brightness should have different temporal properties. This is indeed so: Ives (1923) showed that brightness alternations can be followed at much faster rates than can pure colour alternations. In other words, changing between black and white, leads to a sensation of flicker at up to 60 Hz, but between red and green only up to 25 Hz.

Movement perception

The high incidence of movement and direction-selective cells in MT or V5 suggests that this area may be particularly concerned with movement perception. Because anatomically MT receives its major inputs from the magno pathway, one would predict that human movement perception should somehow reflect magno characteristics: colour-blindness, quickness, high contrast-sensitivity, and low acuity. Perceptual experiments indicate that movement perception does indeed have these characteristics. First, it is impaired for patterns made up of equiluminant colours: Cavanagh *et al.* (1985) found that if they generated moving red and green sine-wave stripes (gratings) of equal luminance, 'the perceived velocity of equiluminous gratings is substantially slowed ... the gratings often appear to stop even though their bars are clearly resolved ... the motion is appreciated only because it is occasionally noticed that the bars are at some new position'. Second, movement perception is impaired at high spatial frequencies, which is consistent with the lower acuity of the magno system.

Campbell and Maffei (1981) viewed slowly rotating gratings and found a loss of motion perception at the highest resolvable frequencies (Fig. 3.2). 'At a spatial frequency of 16 and 32 cycles/deg. a strange phenomenon was experienced, the grating was perceived as rotating extremely slowly and most of the time it actually appeared

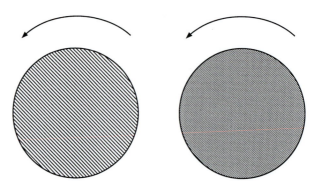

Fig. 3.2. Loss of movement perception with high spatial frequency patterns.

'stopped motion'

stationary. Of course, the subject could call upon his memory and deduce that the grating must be moving, for he was aware that some seconds before the grating had been at a particular "clock-face position". Even with this additional information that the grating must be rotating, the illusion of "stopped motion" persisted'. What is most surprising about the perception of both the equiluminant stripes and the very fine stripes is that even though the sensation of movement is entirely or almost entirely lost, the stripes themselves are still clearly visible — they are clear enough that changes in their position can be seen, even though they do not seem to be moving.

Lastly, movement can be vividly perceived with very rapidly alternating or very low contrast images. Thus, as summarized in Table 3.1, the properties of human movement perception are remarkably consistent with the properties of the magno system.

Stereopsis

In humans and monkeys, the eyes are in the front of the head. Because the eyes occupy different positions, side by side, in space, they have slightly different views of the world. This means that in a scene of objects at different distances each eye's images are slightly different. Distant objects in the scene are shifted towards the right in the right eye and to the left in the left eye. This difference is called retinal or binocular disparity. Some neurones in visual area 2 and in MT have been found to respond selectively to particular disparities, that is, to be tuned to respond to stimuli at different distances. This finding suggests that the magno system is also involved in stereoscopic depth perception. In a random dot stereogram, each eye sees a (typically square) array of randomly positioned dots. The array seen by the left eye is identical to that seen by the right eye, except that a central region of the array has been moved sideways. Because of its

Table 3.1. Summary of the correlations between human psychophysical results and the physiological properties of the three subdivisions of the primate geniculo-cortical visual system. A check indicates that the psychophysical results are consistent with the physiology and a blank indicates that such an experiment has not been done (Livingstone and Hubel 1988)

Magno system

Physiology / Human perception	Colour selectivity — No	Contrast sensitivity — High	Temporal resolution — Fast	Spatial resolution — Low
Movement perception				
Movement detection	√	√	√	√
Apparent movement	√	√	√	√
Depth cues				
Stereopsis	√	√	√	√
Interocular rivalry	√			√
Parallax	√			
Depth from motion	√	√		
Shading	√	√		
Contour lines	√		√	
Occlusion	√			
Perspective	√	√	√	
Linking properties				
Linking by movement	√	√		
Linking by collinearity (illusory borders)	√	√	√	√
Figure–ground discrimination	√			

Parvo system

Parvo → Interblob pathway

Physiology / Human perception	Colour selectivity — Yes	Contrast sensitivity — Low	Temporal resolution — Slow	Spatial resolution — High
Shape discrimination				
Orientation discrimination	√	√	√	√
Shape discrimination				

Parvo + (magno?) → **blob pathway**

Physiology / Human perception	Color selectivity — Yes	Contrast sensitivity — High	Temporal resolution — Slow	Spatial resolution — Low
Colour perception				
Colour determination	√		√	√
Flicker photometry	√		√	

binocular disparity with respect to the surrounding dots, this region is seen at a different distance from that of the surrounding region.

In accordance with this finding, Lu and Fender (1972) found that subjects could not see depth in equiluminant colour random-dot stereograms, which would stimulate the magno system very weakly even though the dots making up the stereogram remained perfectly clear. This finding has been disputed, perhaps because an individual's red–green equiluminance ratio changes with distance from the centre of gaze, so that it is difficult to achieve equiluminance across the visual field. Like movement perception, stereopsis fails for stereograms containing only high, but resolvable, spatial frequencies, but it is not diminished for rapidly alternating or very low-contrast stereograms.

Deduction of further magno or parvo functions from perceptual tests

Since the functions that physiological studies had suggested should be carried by the magno system did indeed show all four distinguishing characteristics of that system, we decided to ask whether other visual functions — ones not predicted by single-cell response properties — might also manifest some or all of these properties.

Consider a particular magno cell which sums red and green inputs. There will be a red–green ratio at which the red and green will be equally effective in stimulating the cell, so a red–green border will appear as a uniform field to the cell and will, therefore, activate it minimally. This need not imply that every magno cell has the same ratio of red to green inputs and therefore necessarily the same equiluminance point. Nevertheless, the fact that movement and stereopsis fail at equiluminance implies that, for a given observer, the null ratio must be very similar for the majority of their cells responsible for that function. Kruger (1979) and later we ourselves (Hubel and Livingstone 1990) found that magnocellular LGN cells are unresponsive to a moving colour-contrast border at a particular relative brightness and, moreover, that this brightness ratio is very close to a human observer's equiluminant point. Cells in the parvocellular layers also show response weakening at some colour ratio, but this ratio varies from cell to cell, depending on the cone inputs to the receptive field centre. In the cortex, cells in magno-derived divisions also show loss of responsiveness at equiluminance and many cells in parvo-derived regions do not. Thus not only do individual cells in the magno system seem to be colour-blind, but the properties of stereopsis and movement perception indicate that the magno system as a whole is colour-blind.

Depth from motion

Since both motion perception and stereoscopic depth perception are lost at equiluminance, we suspected that the ability to use relative motion as a depth cue (motion parallax) might also be lost. Relative motion is a very powerful depth cue: when an observer moves his or her head back and forth or moves around in his or her environment, the relative motion of objects provides information about their distance. In the experiment shown in Fig. 3.3, the position of the middle bar was connected to head movement and the middle bar appeared to be either behind or in front of the reference bars, depending on whether its movement was the same as or contrary to the head movement. When the bars were made equiluminant with the background, all sensation of depth disappeared.

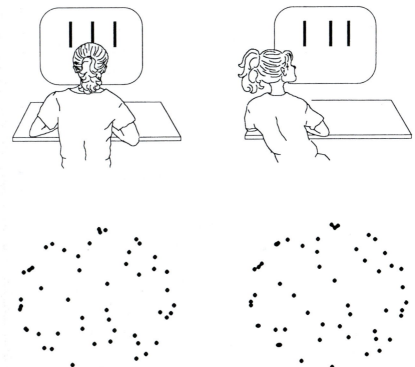

Fig. 3.3. Loss of depth from parallax at equiluminance. The position of the middle bar is correlated with the observer's head position. In this case, the centre bar appears to lie in front of the reference bars, except when the bars are made equiluminant with the background.

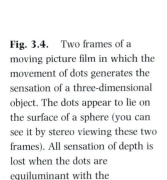

Fig. 3.4. Two frames of a moving picture film in which the movement of dots generates the sensation of a three-dimensional object. The dots appear to lie on the surface of a sphere (you can see it by stereo viewing these two frames). All sensation of depth is lost when the dots are equiluminant with the background.

Relative movement in the flat projection of a three-dimensional object is also a powerful depth cue. Figure 3.4 shows two frames of a moving picture film in which random dots move, some to the right and some to the left, as if they were pasted on a rotating spherical surface. The film gives a powerful sensation of a rotating spherical surface — except when the dots are equiluminant with the background and then all sensation of depth is lost and the dots seem to dance aimlessly.

Thus depth from motion, both from viewer parallax and from object motion, seems also to depend on luminance contrast and could well be a function of the magno system. Consistent with this idea, we could see depth from motion at very low levels of luminance contrast.

Depth from shading

The retinal image is of course two-dimensional and to capture the three-dimensional relationships of the objects the visual system uses many kinds of cues besides stereopsis and relative motion perspective, for example gradients of texture, shading, occlusion, and relative

position in the image (see Chapter 11, by Ramachandran, of the present work). We wondered whether the sensation of depth from any of these other cues might also exhibit magno characteristics.

It seemed especially likely that the ability to perceive depth from shading might be carried by an achromatic system, because shading is almost by definition purely luminance-contrast information, that is, under natural lighting conditions a shaded region of an object has the same hue as the unshaded parts and is simply darker. But in biology, just because something could or seemingly even should be done in a certain way does not mean that it will be. Nevertheless, Cavanagh and Leclerc (1985) found that the perception of three-dimensional shape from shading indeed depends solely on luminance contrast. That is, in order to produce a sensation of depth and three-dimensionality, shadows can be any hue as long as they are darker than unshaded regions of the same surface. Many artists seem to be aware of this, for example in some of the self-portraits of Van Gogh and Matisse the shadows on their faces are green or blue, but they still convey a normally shaped face. Black and white photographs of these paintings (using film that has approximately the same spectral sensitivity as humans) confirm that the shadows are actually darker than the unshaded parts.

Depth from perspective

Perspective was well known to artists by the time of the Renaissance and is a powerful indicator of depth. Converging lines or gradient of texture are automatically interpreted by the visual system as indicating increasing distance from the observer. We found that when images with strong perspective are rendered in equiluminant colours instead of black and white, the depth sensation is lost or greatly diminished, as are illusions of perspective (Plates 2 and 3).

As with movement and stereopsis, the most startling aspect of this phenomenon is that even though the sensation of depth and the illusory distortions due to inappropriate size scaling are reduced at equiluminance, the lines defining the perspective and the individual elements in the image are nevertheless still clearly visible. This seems to rule out high-level, cognitive explanations for depth from perspective and the illusions of perspective — if you see depth because you merely know that converging lines mean increasing distance, you should be able to perceive the depth from the converging lines at equiluminance. Thus, at a relatively low level in the visual system some simple interactions must initiate the automatic interpretation of a two-dimensional image into three-dimensional information; moreover, these operations seem to be performed only in the achromatic magno system, not in the parvo system.

Figure–ground discrimination and linking features

Why should the depth and movement functions described above all be carried by the magno system and not by the parvo system? We at first assumed that it was because they might all be performed best by a system with the special characteristics of a magno system. But later we wondered if these various functions might be more related than they seemed at first — whether they could all be parts of a more global function. We were struck by the similarity between the list of functions we had ascribed to the magno system and the *Gestalt* psychologists' list of features used to discriminate objects from each other and from the background — figure–ground discrimination (Rubin 1915, Figure 6). Most scenes contain a huge amount of visual information — information about light intensity and colour at every point on the retina and the presence and orientation of discontinuities in the light pattern. The *Gestalt* psychologists recognized that one important step in making sense of an image must be to correlate related pieces of visual information, that is, to decide whether a series of light–dark discontinuities forms a single edge, whether adjacent edges belong to the same object, whether two parts of an occluded edge are related, and so on. They determined that several kinds of cues are used in this way, and to organize the visual elements in a scene into discrete objects — to distinguish them from each other and from the background. Barlow (1981) has called these 'linking features', because they are used to link or join related elements. These linking features include *common movement* (contours moving in the same direction and velocity are likely to belong to the same object, even if they are different in orientation or not contiguous), *common depth* (contours at the same distance from the observer are likely to belong to the same object), *collinearity* (if a straight or continuously curved contour is interrupted by being occluded by another object, it is still seen as a continuous contour), and *common colour or lightness*. The results described below suggest, however, that only luminance contrast, and not colour differences, can be used to link parts together.

Linking by collinearity is seen in the phenomenon of illusory contours — figures that produce a vivid perception of an edge in the absence of any real discontinuity (Fig. 3.5).

When these figures are drawn in equiluminant colours, the illusory borders disappear, even though the elements defining them (the pacmen, the spokes, the lines, or the circles) remain perfectly visible. Because the perception of illusory borders also manifests fast temporal resolution, high contrast sensitivity, and low spatial resolution, we suspect that it too may represent a magno function. Illusory borders have been called 'cognitive contours' because of the sugges-

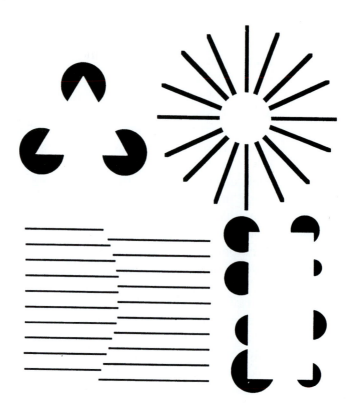

Fig. 3.5. Linking by collinearity. It is clear which edges are part of the same object, even when it is occluded by another object. At equiluminance this linking disappears and the composition looks like a jumble of lines instead of a pile of blocks. After Barlow (1981).

Fig. 3.6. Illusory borders which disappear at equiluminance. After Kanisza (1979).

tion that the perception of the border is due to a high-level deduction that there must be an object occluding a partially visible figure (Gregory 1972). We suspect that this is not the case, because the illusory borders disappear at equiluminance, even though the real parts of the figure are still perfectly visible.

Fifty years ago the *Gestalt* psychologists observed that figure–ground discrimination and the ability to organize the elements in a scene decrease at equiluminance. Equiluminant figures have been

described as 'jazzy', 'unstable', 'jelly-like', or 'disorganized' (Liebmann 1926; Gregory 1977). Examples in art include the paintings of Bridget Riley. Koffka (1935) pointed out that luminance differences are strikingly more important than colour differences for figure–ground segregation: 'Thus two greys which look very similar will give a perfectly stable organization if one is used for the figure and the other for the ground, whereas a deeply saturated blue and a grey of the same luminosity which look very different indeed will produce practically no such organization.' Rubin's (1915) popular demonstration of the problem of figure–ground discrimination is the vase/face (Plate 3).

At non-equiluminance the percept is bistable, so that one sees either the faces or the vase, but usually not both at the same time. At equiluminance the two percepts reverse rapidly and one can occasionally see both the vase and the faces simultaneously. The distinction between figure and ground thus gets weaker or even disappears entirely.

Why should the visual system be subdivided?

Physiological studies suggest that the magno system is responsible for carrying information about movement and depth. We extended our ideas about the possible functions of the magno system with perceptual studies and concluded that the magno system may have a more global function of interpreting spatial organization. Magno functions may include deciding which visual elements, such as edges and discontinuities, belong to and define individual objects in the scene, as well as determining the overall three-dimensional organization of the scene and the positions of objects in space and movements of objects.

If the magno system covers such a broad range of functions, then what is the function of the 10-fold more numerous parvo cells? The colour selectivity of the parvo system should enable us to see borders using colour information alone and, thus, borders that might be camouflaged to the colour-blind magno system. But defeating camouflage may be only a small part of what the parvo system is specialized for. Experiments indicate that the magno system is not capable of sustained scrutiny, since images that can be seen by only the magno system disappear after a few seconds of voluntary fixation (for references see Livingstone and Hubel 1987). Thus, while the magno system is sensitive primarily to moving objects and carries information about the overall organization of the visual world, the parvo system seems to be important for analysing the scene in much greater and more leisurely detail. These postulated functions would

be consistent with the evolutionary relationship of the two systems: the magno systems seem to be more primitive than the parvo system (Guillery 1979; Sherman 1985) and is possibly homologous to the entire visual system of non-primate mammals. If so, it should not be surprising that the magno system is capable of what seem to be the essential functions of vision for an animal that uses vision to navigate in its environment, catch prey, and avoid predators. The parvo system, which is well developed only in primates, seems to have added the ability to scrutinize in much more detail the shape, colour, and surface properties of objects, creating the possibility of assigning multiple visual attributes to a single object and correlating its parts. Indeed, if the magno system needs to use the various visual attributes of an object in order to link its parts together, this could preclude its being able to analyse the attributes independently. It thus seems reasonable to us that the parvo system is especially suited for visual identification and association.

Is the existence of separate pathways an accident of evolution or a useful design principle? Segregating the processing of different types of information into separate pathways might facilitate the interactions between cells carrying the same type of information. It might also allow each system to develop functions particularly suited to its specialization. If the parvo system did evolve after the magno system, by duplication of previously existing structures, it should nevertheless not be surprising to find some redundancy in the properties of the two systems. Indeed, both seem to carry information about orientation, and perceptual experiments indicate that both systems can be used to determine shape.

The implication of these studies of the neurobiology of vision is that as we gaze at a painting of a landscape, different aspects of the painter's message are processed by different regions of our brains. The spatial relationships between different objects in two and three dimensions seem to be handled by the magno system. The fine detail of the trees and houses and the colours of the flowers come from the parvo system. Perhaps different artists could be characterized by their ability to appeal to different parts of our visual systems.

References

Barlow, H. B. (1981). Critical limiting factors in the design of the eye and visual cortex. The Ferrier Lecture, 1980. *Proceedings of the Royal Society of London*, **B212**.

Campbell, F. W. and Maffei, L. (1981). The influence of spatial frequency and contrast on the perception of moving patterns. *Vision Research*, **21**, 713–21.

Cavanagh, P., Boeglin, J., and Favreau, O. E. (1985). Perception of motion in equiluminous kinematograms. *Perception*, **14**, 151–62.

Cavanagh, P. and Leclerc, Y. (1985). Shadow constraints. *Investigative Ophthalmology and Visual Science*, Suppl., **26**, 282.

Fitzpatrick, D., Hoh, K., and Diamond, I. T. (1983). The laminar organization of the lateral geniculate body and the striate cortex in the squirrel monkey (*Saimiri sciureus*). *Journal of Neuroscience*, **3**, 673–702.

Gregory, R. L. (1972). Cognitive contours. *Nature*, **238**, 51.

Gregory, R. L. (1977). Vision with isoluminant colour contrast. 1. A projection technique and observations. *Perception*, **6**, 113–19.

Guillery, R. W. (1979). A speculative essay on geniculate lamination and its development. In *Development and chemical specificity of neurons*, Progress in Brain Research, Vol. 51 (ed. M. Cuenod, G. W. Kreutzberg, and F. E. Bloom), pp. 403–418. Elsevier/North-Holland Biomedical Press, Amsterdam.

Hubel, D. H. and Livingstone, M. S. (1990). Colour contrast sensitivity in the lateral geniculate body and primary visual cortex of the macaque monkey. *Journal of Neuroscience*, **10**, 2223–37.

Ives, H. E. (1923). A chart of flicker photometer. *Journal of the Optical Society of America, Review of Scientific Instruments*, **7**, 363–5.

Kanizsa, G. (1979). Organization in vision. In *Essays on Gestalt perception*. Praeger, New York.

Koffka, K. (1935). *Principles of Gestalt psychology*. Harcourt Brace, New York.

Kruger, J. (1979). Responses to wavelength contrast in the afferent visual systems of the cat and rhesus monkey. *Vision Research*, **19**, 1351–8.

Liebmann, S. (1926). Über das Verhalten farbiger Formen bei Helligkeitsgleichheit von Figur und Grund. *Psyholische Forschung*, **9**, 300–53.

Livingstone, M. S. And Hubel, D. H. (1982). Thalamic inputs to cytochrome oxidase-rich regions in monkey visual cortex. *Proceedings of the National Academy of Sciences USA*, **79**, 6098–101.

Livingstone, M. S. and Hubel, D. H. (1984). Anatomy and physiology of a color system in the primate visual cortex. *Journal of Neuroscience*, **4**, 309–56

Livingstone, M. S. and Hubel, D. H. (1987). Psychophysical evidence for separate channels for the perception of form, color, movement and depth. *Journal of Neuroscience*, **7**, 3416–68.

Livingstone, M. S. and Hubel, D. H. (1988). Segregation of form, color, movement and depth: anatomy, physiology, and perception. *Science*, **240**, 740–9.

Lu, C. and Fender, D. H. (1972). The interaction of color and luminance in stereoscopic vidion. *Investigative Opthalmology*, **11**, 482–90.

Rubin, E.(1915). *Synsoplevede Figure*. Glydendalska, Copenhagen. Sherman, S. M. (1985). In *Progress in psychobiology and physiology psychology*, Vol. II, (ed. J. M. Sprague and A. N. Epstein), pp. 233–322. Academic Press, New York.

4 The brain of the beholder

RICHARD LATTO

Here is the painter who wants to conceive only new structures, whose aim is to draw or paint nothing but materially pure forms.

Guillaume Apollinaire on Juan Gris, *Les peintres cubistes*, 1921

1 The importance of form

Aesthetic interest within the visual arts is generated through the forms created by the artist on the surface of a canvas or in the three-dimensional space of a sculpture. Even with representational art, narrative content is not usually central to its appreciation and is often indeed not fully understood by the viewer, particularly if the art originates in a different historical period or a different culture. The meaning that does persist in representational art often concerns emotions, grief or happiness, fear or anger. These are communicated by the visual forms which characterize facial expressions and body posture and, as we shall see, in this case too it may be the form itself rather than the emotion it represents which is responsible for the aesthetic experience.

The move to abstraction in the visual arts at the beginning of the twentieth century was a recognition of this dominance of form over narrative content. In abstract painting, as with most music, form is all we have. Artists like Mondrian and Kandinsky tried to identify the primary features of stimuli that were aesthetically rewarding and soon critics were talking about 'significant forms' (Bell 1958), which made up a 'purely abstract language of forms — a visual music' (Fry 1920).

There are two sources for these abstract forms. There is the simplification of nature into its component parts, exemplified by Mondrian in his *Pier and Ocean* sequence of drawings and paintings (Fig. 4.1). The abstract pattern of Fig. 4.1(b) was derived from the sketches of Fig. 4.1(a), where in the earliest version the real object being represented is clearly visible. Alternatively, there is a rejection

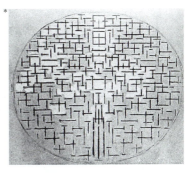

(a)

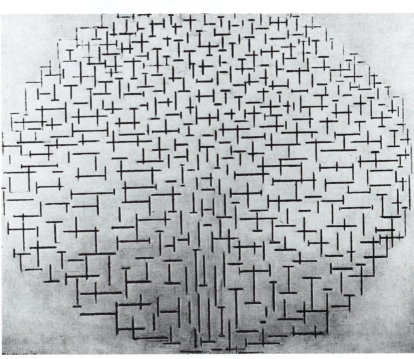

Fig. 4.1. Piet Mondrian (a) *3 Sketches for Pier and Ocean*, 1914. * *Pier and Ocean*, 1914. Charcoal and white watercolour on buff paper, 34 5/8 × 44" (87.9 × 111.2 cm); oval composition 33 × 40" (83.8 × 101.6 cm). The Museum of Modern Art, New York. Mrs Simon Guggenheim Fund. (b) Composition No.10, *Pier and Ocean*, 1915. © 1994 Mondrian Estate/Holtzman Trust. Licensed by ILP.

(b)

of representation followed by a process of experimentation and intuitive judgements in which the artists play with abstract forms until they recognize something striking. This was the approach of the Suprematists (Fig. 4.2).

Either way, the question then arises as to why some forms are more effective than others. Artists talk of truth and purity, but these, though powerful descriptors, do not really advance our understanding. This chapter attempts to answer the question by proposing that a form is effective because it relates to the properties of the human visual system. To describe this process I have coined the term 'aesthetic primitive' which, using 'primitive' in the sense of primary or

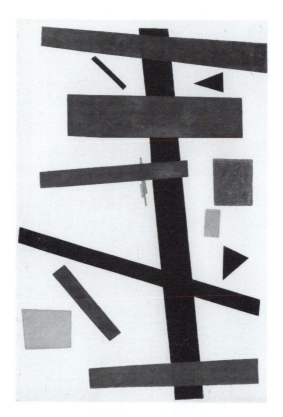

Fig. 4.2. Kazimir Malevich 1915, *Supremus No.50*. Courtesy of the Stedelijk Museum, Amsterdam.

fundamental, is defined as a stimulus or property of a stimulus that is intrinsically interesting, even in the absence of narrative meaning, because it resonates with the mechanisms of the visual system processing it. Examples which have arisen in the exploration of visual perception by both artists and scientists include patterns of lines and geometrical shapes, stylized organic forms (the biomorphs of the surrealists), the human body, the human face, the human hand, stick figures, monochromatic blocks, and landscape features. Some aesthetic primitives may be universal because they are genetically determined, while others may depend on particular learning experiences and would therefore be culturally determined. Whatever their origin, they provide the vocabulary of Roger Fry's language of forms. Purely abstract works consist of isolated aesthetic primitives with no semantic or affective overtones.

So the techniques used by artists and the forms they select succeed because they exploit the properties of the visual system and, through their work, artists have indirectly been defining the nature of visual processes, often before these processes have been investigated scientifically. Particular forms are aesthetically moving not because they reflect the properties of the world, but because they reflect the properties of our brains. However, the visual system has

evolved to construct representations of the particular world we live in, so an aesthetic primitive that reflects the processes of the visual system will also often incidentally reflect the properties of the world that visual system was designed to analyse. What is being proposed is a radical shift in the viewpoint of aesthetics similar to that which occurred in the science of colour at the end of the seventeenth century, when Isaac Newton observed that colour was a property of the visual system rather than of the physical world.

Much of the evidence to support this thesis is discussed elsewhere in the book. In Section 3, I shall use these and other sources to compare directly artists' manipulations of pictorial and sculptural forms with the transformation of the retinal image by the visual system in order to demonstrate that artists are mimicking and elaborating these transformations to produce their effects. But before considering specific examples, I want to discuss a general property which both artists and the visual system have in common.

2 The importance of selection

Artists are concerned with selecting from among the infinite possibilities which geometry offers those forms which will be most effective. As the sterility of much commercial art demonstrates, graphical skills are not sufficient. They may not even be necessary, at least within a particular work. The ubiquitous complaint against modern art that 'my 3-year-old could have done that' may be a correct assessment of the drawing or painting skills in, for example, some late Picassos. Where Picasso excels over the 3-year-old, and most adult, painters is in his selection of the forms to represent (Fig. 4.3).

Interestingly, though their works do not always demonstrate exceptional graphical skill, it does seem to be the case that great artists like Picasso always seem to possess that skill. Perhaps high graphical skill *is* necessary for the selection of successful forms.

Artists are centrally concerned with selection and so is visual perception. It is the central and fundamental property of our visual system, as with all our senses, that it provides very selective information about the external world. As with all the best scientific 'facts', this is paradoxically both so obvious that it is almost a truism and so counterintuitive that it cannot be discovered from our own experiences without logically devised scientific experiments, because, generally speaking, we are simply not aware of the limitations of our perceptions. Sometimes the necessary experiments are so simple that they hardly seem to justify the name. But mapping the boundaries of the visual field by fixating a point straight ahead and moving a finger around is just as much an experiment as the technically more

Fig. 4.3. Pablo Picasso 1960,
La Muse. © DACS 1994.
Reproduced by permission.

complex ones from which most of the evidence I shall be discussing
comes.

By adjusting stimuli we can determine the boundaries to our per-
ception of space, size, wavelength, intensity, movement, and so forth.
The goal of all experiments like this is in general terms the same. It is
to define the *limits* of our sensory capacities. And all dimensions of
vision have boundaries or limitations. They have boundaries defining
extremes and they also have limitations within them. We cannot dis-
criminate between a yellow light which is monochromatic and one
which is a mixture of green and red light. To a physicist these stimuli
have nothing in common; to us they look identical. We cannot see
the flickering of a light being switched on and off at more than about
50 times a second. We cannot see stripes of less than about
0.1 cycle/degree or more than about 50 cycle/degree.

Our view of the world is therefore very selective. Yet we experience
it as complete and whole. Without investigation and experiment we
are unaware of our limitations. And, in a crucial sense, these limita-
tions are not important, are not even really limitations. Our every-

day experience of completeness in perception is in some ways a more accurate account than the psychologist's and physiologist's description of a visual system with a perhaps rather worryingly limited capacity. Our window-on-the-world may be a very narrow one, but it is exceptionally well focused. For natural selection has ensured that it has evolved to match our needs exactly. In everyday life our visual system provides us with a picture of the world that is complete — for our biological needs.

There are two kinds of situations that undermine this completeness. The first and less interesting, are those produced by new technologies. It is arguable that we do not have the sensory capacities to drive fast cars adequately. Certainly by the time we progress to fast aeroplanes we begin to be heavily dependent on the artificial senses provides by instruments. (The technology of artificial sensation is much older than that of artificial intelligence.) We have to devise new technologies (speedometers) or new social constraints (speed limits) to cope with our sensory inadequacies. And often our technology is carefully, though sometimes unknowingly, designed to match our sensory capacities. Television is a good example. Normally, cats and dogs do not respond to television pictures. This is not because they are not interested in the content of the pictures, but because these are presented in a way that does not match their sensory capacities. They are simply unable to form meaningful representations from the information on the screen. And the more like ours an animal's brain is, the more it will enjoy watching television. Monkeys find it of some interest; the Great Apes are gripped by it almost as painfully as we are.

Moreover, because we are organisms that have evolved in a particular environment, we have a particular kind of visual system different from those of other animals, different from the one we would have had if we had evolved in a different universe and, therefore, not necessarily suited to coping with visual stimuli from new environments.

Just as the technology of the television display is carefully designed to feed information through the rather narrow window-on-the-world which humans have, so the techniques and processes of the artist have developed to match the properties of our visual systems: sometimes, like television technology, to give as realistic a representation as possible, but often, particularly in recent years, to explore and exploit those properties to produce novel and moving effects.

This latter endeavour presents the second kind of situation where our sensory limitations are tried, those where we are deliberately investigating the nature of our perceptions — an activity undertaken by artists as well as by scientists. By playing with colour and shape and the arrangement of objects in the visual field, artists have

defined and exploited the properties of our visual system, often long before they became the subject of scientific investigation.

The next section will illustrate this last point by looking at some actual examples of paintings or techniques used in paintings that can be related to what we know of neural mechanisms. The examples will be structured by working up the mammalian visual system, starting at the level of the eye, picking out important features of the way it seems to work, and relating these to particular paintings and techniques.

3 Neural transformations and the visual arts

3.1 Lateral inhibition and the creation of edges

One of the most fundamental properties of the visual or indeed any other sensory system is the process of lateral inhibition. The principle, first discovered by Hartline and Ratliff (Hartline *et al.* 1956) working on the compound eye of limulus or horseshoe crab, but applying also to the mammalian eye, is that the response of any particular unit is reduced or inhibited by light falling on neighbouring parts of the eye. The implication of this finding is that the eye enhances the edges or contours present in the visual input and minimizes responses to areas of constant brightness (Fig. 4.4). As Fig. 4.4 makes clear, lateral inhibition is the beginning of an explanation for the emphasis on lines in the representation techniques used by artists, despite the fact that lines are relatively rare in nature, where boundaries are usually defined by a single shift in brightness from one level to another. (For a fuller explanation see Chapter 17 of the present book by Hayes and Ross.)

Fig. 4.4. The manipulation of a representation to simulate the process of lateral inhibition. The original photograph (a) corresponding to the retinal image, has been subjected to contour enhancement (b) similar to that produced by lateral inhibition in the retina. From R. Jung 'Art and Visual abstraction', in *Oxford companion to the mind* (1987).

Because of this process, a line in a sketch (Fig. 4.18, p. 91) or a cartoon is sufficient to define an object even if the original contrast differences between the object and its background are absent. And lateral inhibition also explains or at least partially underlies the fascination of a photographic technique known variously as solarization or the Sabattier effect after Armand Sabatier [*sic*], who discovered it in 1862, in the very earliest days of photography (see Wade 1990). It was used most successfully by the surrealist Man Ray when he moved into photography in the twenties and thirties (Fig. 4.5). Here we have an example of a technique that feeds into our visual processing system at the stage where lateral inhibition is reducing brightness differences except across the actual point of change at the contour.

The other effect of lateral inhibition is an enhancement or exaggeration of the change of luminance across contours. This results in simultaneous brightness contrast effects like the Hermann and Hering Grids. These were widely exploited by Victor Vasarély, Patrick Caulfield, Bridget Riley, and the other op artists of the fifties and sixties.

The Mach band effect, another consequence of lateral inhibition, has also been mimicked by artists, using a technique now known as irradiation (Riley 1991), at least since Leonardo da Vinci. Seurat,

Fig. 4.5. Man Ray 1929, *Portrait of Lee Miller*. © Man Ray Trust/ADAGP, Paris, and DACS, London, 1994. Reproduced with permission.

Fig. 4.6. Georges Seurat,
1883–4, *Bathing at Asnières*
(detail). Courtesy of the Trustees
of the National Gallery, London.

who used irradiation more than most, quotes a contemporary of
Mach:

Observe a white wall standing out against the sky: you will see a white line
lighter than the surface of the wall and a blue or grey line darker than the
mass of the sky. This line of irradiation remains unnoticed by the majority
of painters but nevertheless it is of the greatest importance to copy it
exactly (David Sutter 1880).

The border between the boy's arm and the water in Fig. 4.6 is an
example of its use by Seurat. The cubists, Picasso and Braque, who
were obsessed with contours and boundaries, referred to this tech-
nique as Seurat's 'beautiful edges' and used it widely themselves.
Irradiation, then, is a technique developed independently by painters
to sharpen edges and contours that is effective because it mimics a
neural mechanism, lateral inhibition, which was identified many
years later.

　There is also a nice paradox here that I shall return to in the next
section. Lateral inhibition exaggerates brightness differences and pro-
duces the simple simultaneous brightness contrast effect (Fig. 4.7
left). So why does the effect known as bleeding (Fig. 4.7 right) occur?

Fig. 4.7. Simultaneous contrast (left) in which the central spot looks lighter against the black background than against the white, versus bleeding (right), in which the bricks look darker against the black mortar than against the white. Reproduced with permission from Livingstone and Hubel (1988). Copyright 1988 by the AAAS.

This is the technique used to achieve light and dark areas in engravings, where solid shading cannot be produced. With a fine pattern of lines on a background, the contrast is not enhanced but reduced and the background to the closely spaced black lines looks darker than the background to the white lines or to widely spaced lines — exactly the opposite of the effect predicted by lateral inhibition.

As we move up from the retina, the next stage in the visual system, the lateral geniculate nucleus (Fig. 4.8), is similar in its basic mechanisms. So I shall skip this and continue on to what is the central processor for visual perception, the visual cortex, to discuss the next important concept: the idea that cells have trigger features (stimulus properties) which are particularly good at driving them (making them fire), so that the cell acts as a detector for that particular trigger feature in the visual environment. And the most important of these are the orientation detectors first discovered in the mammalian visual cortex by Hubel and Wiesel (1959).

3.2 Orientation detectors in the visual cortex and the importance of lines

At the end of the 1950s Hubel and Wiesel began recording from single neurones in the primary visual cortex and found, after many false starts, that they responded best to lines or edges of a particular

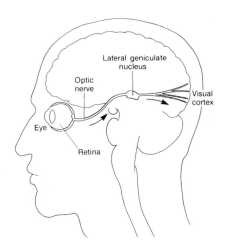

Fig. 4.8. The human visual system, showing the three major sites along the primary visual pathway where processing takes place: the retina, the lateral geniculate nucleus, and the visual cortex. From Goldstein (1989), p. 74. Copyright © 1989 by permission of the Brookes/Cole Publishing Company, Pacific Grove, California.

Fig. 4.9. Stimulus used in early electrophysiological experiments for driving visual cortical cells. A board of this kind was moved in the visual field as the electrode was lowered. It stimulated a high proportion of the normally silent 'orientation detectors', allowing the rapid localization of a cell.

orientation. The most effective stimulus for activating large numbers of neurones was therefore a board covered with an array of lines of varying orientation (Fig. 4.9). Since then, these cells have been investigated by many groups in many different species of primates and other higher mammals, and they have been reclassified and regrouped in a variety of different ways. But the basic finding — that many of the cells in primary visual cortex responsible for analysing the input from the eye respond optimally to a line of a particular orientation lying in a specific region of the visual field — remains as valid as today as it was in 1959 (see, for example, Goldstein 1989). And the cortex is organized into columns of cells responding to the same orientation and sets of columns which between them cover all possible orientations within a larger but still small patch of visual field. If we look down on the surface of the cortex, we find a map like Fig. 4.10. This may be why lines are so powerful in the generation of

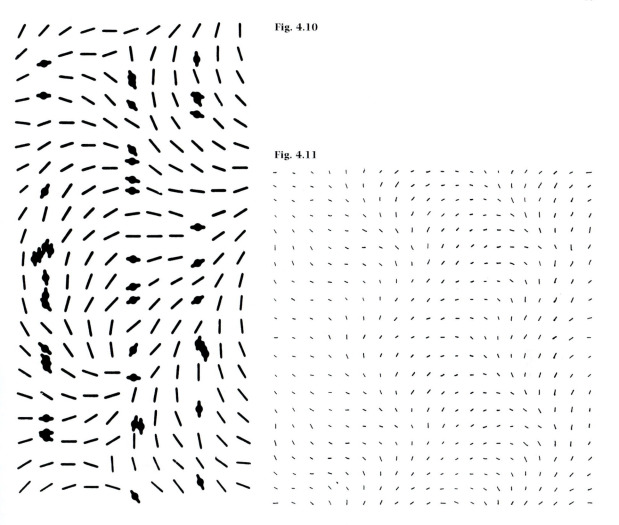

Fig. 4.10

Fig. 4.11

Fig. 4.10. A diagram of a small area (*c.*1.0 mm × 0.5 mm) of the surface of the primary visual cortex of a cat. Each short line represents an orientation at which an edge must appear in the visual field to stimulate the column of nerve cells lying below that point on the surface of the cortex. Reproduced with permission from Albus (1975). © Springer-Verlag, GmbH.

Fig. 4.11. Bridget Riley 1966, *Study for Static.*

images. Line drawings feed into the stage at which the visual system is breaking the retinal image down into component edges and lines. And it also means that lines themselves, without any semantic component at all, can generate powerful visual images (Figs. 4.2 and 4.11). As Vitz and Glimcher (1984) have pointed out, there are interesting resemblances between Figs. 4.10 and 4.11. Figures 4.2 and 4.9 are also strikingly similar.

Mondrian, like Riley, devoted almost his entire artistic life to exploring the power of lines (Fig. 4.1). Moreover, he limited himself to horizontal and vertical. He added the primary colours, red, yellow, and blue, but the lines were always horizontal and vertical, even when the canvases were diagonal. (Mondrian felt so strongly about this that when, in 1952, van Doesburg, another member of the De Stijl group which he had helped to found, insisted on using diagonal as well as horizontal and vertical lines, he formally left the group.)

Mondrian was influenced in his attempt to reduce the components of his paintings to primary forms by contemporary scientific theories, particularly of the Dutch religious philosopher Schoenmaeker (see Jaffé 1970; Vitz and Glimcher 1984). These guided him in his choice of colours and in his belief in the primacy of horizontal and vertical. The arguments for this primacy put forward by Schoenmaeker and others seem arbitrary and *posthoc* — much play was made of the fact that Christ was crucified on a cross made from a horizontal and a vertical line. But Mondrian's paintings clearly worked and we now know that there are good biological reasons to support his view that, just as some wavelengths are primary in the perception of colour, so horizontal and vertical are primary in the perception of orientation.

Both phylogenetically and ontogenetically, horizontal–vertical discriminations develop earlier than the ability to differentiate left and right oblique lines, something with which both young children (Rudel and Teuber 1963) and mammals below apes have enormous difficulty, made worse by problems with discriminating mirror images of all kinds (d *v.* b as well as \v./) (Corballis and Beale 1971; Bradshaw *et al.* 1976). Babies as young as 16 weeks spend longer looking at horizontal and vertical gratings than oblique gratings (Bornstein 1978). Children also have difficulty in *drawing* oblique lines, being able to copy a square a year or two before a diamond, even though this may be the same shape rotated. And, very consistently, children begin by drawing houses with flat roofs.

The reasons for these effects are certainly multiple (see Appelle 1972) and sometimes trivial (the edge of the paper may be a strong guiding frame when drawing (Naeli and Harris 1976)), but at least part of the explanation may be because, for humans at least, some orientations of lines are more powerful triggers and therefore more powerful aesthetic primitives, than others. It is well established that human perception is better for horizontal and vertical lines and edges than for oblique ones. This has been demonstrated both behaviourally, where subjects are consistently better at resolving and discriminating horizontal and vertical lines in a wide variety of perceptual tasks (for example Appelle 1972; Berkley *et al.* 1975; Essock 1982) and electrophysiologically, where horizontal and vertical lines generate larger cortical evoked potentials (for example Maffei and Campbell 1970; Zemon *et al.* 1983). The most likely explanation for this primacy is simply that there are more Hubel and Wiesel orientation detectors in the visual cortex tuned to horizontal and vertical than to oblique lines and edges. There is not enough evidence to confirm this directly in humans, though Marg and colleagues (Marg *et al.* 1968) found no obliquely oriented receptive fields in a sample of three cells, but it has been clearly demonstrated

in other primates (Mansfield and Ronner 1978; De Valois *et al.* 1982; Kennedy *et al.* 1985).

One piece of direct evidence that human brains work with lines comes from the visual effects that are commonly generated in migraine. Part of the process underlying migraines seems to be an area of suppressed neural activity in the cortex surrounded by an area of abnormal spontaneous activity caused by changes in the blood supply to the cortex. So a migraine in the visual cortex produces a patch of blindness or scotoma in the visual field and round this scotoma interesting visual images — usually called fortification illusions — are frequently generated (Fig. 4.12). These, like similar drug-induced effects (Siegel 1977), are physiological demonstration of one of the most important groups of aesthetic primitives, zigzags, stripes, and other patterns of lines, which occurs independently in much decorative and fine art. Abstract patterns of lines are fundamental to the art and artefacts of many cultures, from Navaho eye dazzlers to Australian dream paintings and from Neolithic bone carvings to the raffia weaving of Zaïre. In Western art, they have been used principally by abstract artists like Jasper Johns and Sean Scully or op artists like Bridget Riley and Victor Vasarély. But much earlier, Van Gogh used such heavy brushwork that he often generated rather similar effects within areas of colour and, like the op artists, Berthe Morisot used zigzag brush strokes to act as super-stimuli for Hubel and Wiesel edge detectors to mimic the shimmering effect of water.

3.3 Parallel processing, modularity, and the independence of perceptual dimensions

We have followed the visual pathway (Fig. 4.8, p. 76) up from the eye through the lateral geniculate nucleus to the primary visual cortex. From here visual information is sent forward into surrounding cortex, which is subdivided into many anatomically distinct

areas (for detail see Chapters 2 and 3 of the present book by Rose and by Hubel and Livingstone, respectively). The electrophysiological evidence (reviewed in Livingstone 1988; 1990; Livingstone and Hubel 1988; Zeki 1993) suggests that these pathways and the areas to which they project form a number of separate channels, each concentrating on a different property or dimension of the visual stimulus. Livingstone describes three distinct channels: one for processing form, one for colour, and one for movement and stereo depth. These three channels are intermingled initially in the pathway from the eye to the brain. But in secondary visual areas, the areas of cortex to which the primary visual cortex projects, there seem to be discrete areas responsible for handling the different dimensions. Each of these areas may operate as an independent module having a distinct, specific visual processing function: colour, movement, form, etc.

Like the narrowness of our window-on-the-world, the modularity of visual perception is counterintuitive. We experience our perceptions as single, homogeneous wholes. But, as with much else in perception, this is misleading. Perception is actually a set of distinct, heterogeneous processes, operating in parallel, which are somehow linked together to give an illusion of homogeneity. The fragmented nature of perception is most easily grasped when we look at the relationship between the different senses. We are not continuously aware of it, but it is clear that when, for example, we watch television we process the broadcast information through two distinct channels, visual and auditory. And the information coming through these two channels sometimes conflicts. Before stereo sound was developed, we quite happily sat watching someone speaking while our visual system told us the voice was coming from one place, the speaker's lips and our auditory system told us the voice was coming from another place, the set's loudspeaker. Despite these two pieces of contradictory information, we ended up with a comfortably homogeneous perception of a person talking. What happened was that the visual information on location dominated and the auditory information was ignored, so that we, falsely, heard the sound as coming from the speaker's lips — a process known as visual capture. Just as our ears and our eyes process different kinds of sensory information, so the different visual cortical areas process different aspects of visual information.

As the number of anatomically distinct areas in the secondary visual cortex suggests, there are certainly more than Hubel and Livingstone's three dimensions. But, limiting ourselves to their three dimensions of form, colour, and depth/movement, if we are looking at a scene each of the three channels will be concentrating on extracting information about only one of these dimensions (Fig. 4.13). And these three channels operate largely independently and in parallel.

Fig. 4.13. Schematic diagram showing the parallel analysis of a visual image by the three anatomically distinct pathways described in the text. Illustration by Patricia J. Wynne reproduced with permission from Livingstone (1988). Copyright © 1988 Scientific American, Inc. All rights reserved.

What are the implications of this for techniques of representation? There are two principal ones:

1. *Information in the different dimensions need be only rather loosely synchronized in a drawing or painting.* In the extreme, a small local patch of colour can be used to define the colour of a much larger bounded area and when the information from the form channel is put together with that from the colour channel, the missing information will be filled in to give an impression of a uniformly coloured bounded area. It has been shown experimentally (Treisman 1986) that when colour and form are arbitrary linked, that link is very easily broken. So, if three letters drawn in arbitrary colours, varying from trial to trial, for example a green X, a blue S, and a red T, are presented for 200 ms, on about a third of the trials illusory conjunctions occur and subjects report seeing, for example, a red S. Treisman argues that dimensional characteristics like colour are not initially associated with a particular stimulus, but are in some sense 'free floating'. The linkage occurs later, either through the sharing of a common spatial location, particularly one being attended to, or through a top-down process. If you have pictures of real objects with expected colours (orange carrots, green trees, etc.) then illusory conjunctions (green carrots) are very much less likely to occur.

So information in the different dimensions is initially rather loosely linked together or synchronized, allowing artists to create effective images with a very loose coordination between different

dimensions, particularly colour/form and outline/texture (see the discussion of different channels for low and high spatial frequencies later in this section).

The second implication of modularity for techniques of representation is more subtle, but just as important:

2. *Information in the different channels will be processed differently.* So there will, for example, be different abilities to discriminate spatial frequencies (or acuity) in the different channels. The form channel has high acuity; it is good at discriminating the high spatial frequencies of fine detail. But the colour channel has rather poor acuity. This may be why, if we want to define shape with colours, particular equi-luminescent colours, it is much more effective to have large areas of colour, as in the recent work of, for example, Patrick Caulfield. All fine detail has to be handled in non-colour systems. It is certainly why the phenomenon of bleeding occurs for brightness and colour (see Section 3.1). With sufficiently large areas, brightness or colour contrasts are exaggerated across boundaries (Fig. 4.7 left, p. 75), but with small areas of brightness or colour, exactly the opposite effect occurs and bleeding is observed (Fig. 4.7 right). (The phenomenon is also referred to as Von Bezold's spreading effect or assimilation.) The explanation is that form or shape is analysed by small (high-frequency) receptive fields, but colour, including black and white, is processed by cells with large (low-frequency) receptive fields and it is summation within these large receptive fields which causes spreading. This effect is used by artists in two ways. In drawing and engraving, it produces the appearance of areas of even shading using lines. And in the divisionist or pointillist paintings of Seurat it produces subtractive colour mixing between spatially discriminable spots of light. If the dots of paint in a divisionist painting are of just the right visual angle (i.e. both spot size and viewing distance are crucial), the high acuity of the form channel will allow the spots to be resolved and seen as dots while the low acuity of the colour channel will blur neighbouring dots together, as if the two paints were mixed, and the rules of subtractive colour mixing will therefore apply. Blue and yellow dots, for example, will appear greenish. More recently, Bridget Riley has made strong use of this effect in her coloured abstract paintings, where she describes 'three colours giving a palette of many different colours' (Riley 1993) and the crucialness of retinal angle provides the additional excitement to these pictures that the optical effects vary dramatically with viewing distance.

The different properties of different channels may also help us to understand the sometimes powerful effects of minimalist works which might otherwise seem counter to an explanation of aesthetic effect in terms of strength of neural stimulation. Minimalism works on a variety of levels and in a variety of ways. Sometimes it is, like

Carl André's bricks, primarily conceptual and so falls outside visual analysis. Sometimes the absence of a stimulus, as in Malevich's black square, may itself be a powerful trigger for neural processes which are always concerned with change, in either direction, rather than absolute levels. And sometimes, minimalist forms may strongly stimulate one dimension, for example colour in a Rothko, while providing weak stimulation of other channels. The magic of a Rothko may be due to the novelty and ambiguity of this dissociation of colour and form.

So we have a modular system, with separate and independent modules or channels handling different dimensions of perception. These dimensions might include:

VISUAL PERCEPTION MODULES
COLOUR
FORM/SHAPE
MOVEMENT
SIZE (SPATIAL FREQUENCY)
DEPTH
SPATIAL ORGANIZATION

There is almost certainly a nesting of this modularity. So that each of these modules contributes to a visual perception module and each is in turn made up of a set of smaller again fairly independent modules (see also Chapter 2 by Rose for a development of this argument). In the size or spatial frequency channel, it seems likely that there are separate channels looking at different ranges of size or frequency (Blakemore and Campbell 1968; Maffei and Fiorentini 1973; Goldstein 1989). This means that different, even conflicting, information can be carried in the different size channels, a phenomenon made use of by many different artists in many different ways. Andy Warhol's *Campbell's Soup Cans* 1962 carries the representational image of the can label in high frequency, but an abstract pattern of horizontal red and white stripes in the low frequency. In Salvador Dali's painting of Gala (Fig. 4.14) the high-frequency information, which dominates at normal viewing distances, defines Gala's body and the edges of the checkerboard window through which she is looking. The low-frequency information, which becomes evident when viewed blurred or from a distance or with peripheral vision, displays the block portrait of Abraham Lincoln first produced by Harmon (1973).

This phenomenon also partly explains why it is possible to use the technique employed by many Renaissance painters of having scenes within scenes. Low-frequency analysis gives the global structure, within which our high-frequency channels can identify various subplots.

Fig. 4.14. Salvador Dali,1976
*Gala Looking at the Mediterranean
Sea.* © Demart Pro Arte
BV/DACS 1994. Reproduced
with permission.

These last few examples have all exploited the apparent ability
of our visual systems to carry different information in high- and
low-spatial-frequency channels, enabling us to get two or more mean-
ings or events for the price of one painting. But there is another more
fundamental way in which nearly all painting exploits this phenome-
non. In any representation but the finest *trompe-l'oeil*, the working is
visible. And the working, the brush marks, the texture of the canvas,
and so forth are usually carried in the high-frequency part of the
spectrum. This is why the appearance of a painting often changes
dramatically with viewing distance. Close up, the high frequency
dominates and we may see a flat canvas with an almost abstract
pattern of brush marks on it. As we move back, the high-frequency
information drops out and we become more aware of the low-fre-
quency information carrying the overall form of the painting, the
cues to depth and meaning. Bridget Riley (1991) makes the point
that many painters exploit this ambiguity between the abstract
pattern of the high-frequency detail and the representational informa-
tion of the low-frequency form. She was discussing Seurat, but it is
even more true of Van Gogh, where, close up, the abstract pattern of

the brush marks can completely dominate. One of the excitements of a painting by Seurat or Van Gogh is the apparentness of this duality. Like a Richard Rogers building, the works are showing and at a certain viewing distance we have an ambiguous figure:

High frequency: abstract
Low frequency: representational

As with simpler ambiguous figures, like the Necker cube, our perceptions flip between the two interpretations.

Stepping back from a picture effectively filters out the high-frequency information. Screwing up our eyes or, with a projected reproduction, blurring it by defocusing has the same effect. And as we get older our eyesight deteriorates, again producing, among other things, a loss of the high-frequency detail. This applies to artists as well as their audience and, if we look at a series of paintings across an artist's career, for example Rembrandt's 40 year cycle of self-portraits, it is a very common pattern for the brushwork to get looser and much more evident, at least to those of us viewing with optically corrected eyesight.

3.4 High-level neural processes and the importance of the human body

Finally, in the discussion of neural mechanisms, I want to return to the idea of an aesthetic primitive with which I began by suggesting that there may be an electrophysiological basis to the enormous importance artists have always given to the human body and parts of the human body, particularly of course the face. As we have seen, one view of early cortical processes is that complex stimuli are analysed into lines and edges by a combination of Hubel and Wiesel orientation detectors, which provide the electrophysiological basis for our low-level aesthetic primitives postulate. But, for most stimuli, that is where the analysis ends. There is no further hierarchy leading to object-recognizing cells responding to or driven by the presence of a particular stimulus in the visual field, like a table. There are no table detectors; a table is represented in the brain by a particular set of lines. However, it does seem at least a very strong possibility that there *are* cells in the temporal lobes responding to the human body, both in whole and in part. Several groups have reported cells in monkey temporal cortex responding to hands (Gross *et al.* 1972), to faces and heads (Perrett *et al.* 1982, 1991; Young and Yamane 1992), and to different body posture and movement (Perrett *et al.* 1990). And there is direct evidence for similar cells in the right temporal lobe of the human brain (Ojemann *et al.* 1992). So perhaps this is why an artist like Dürer can spend most of his long life drawing just hands and faces.

The suggestion is that Dürer's drawings generate powerful images because they stimulate that special class of cells we have for analysing the human body. Monitoring our hand movements is essential for manipulating objects; recognizing faces, facial expressions, and direction of gaze is central to social interactions; analysing body posture and movements is vital in social situations, and, historically at least, in such activities as fighting and hunting. Nowadays, interactive sports like football often demonstrate supreme examples of the ability to 'read' another's body. For all these reasons it looks as if we have evolved specialized neural mechanisms for the visual processing of the human body.

Artists draw and paint the human body for many reasons, not least those to do with the kinds of scenes which representative artists have wished to portray. Religious or romantic or military scenes of course necessarily include the portrayal of the human body. But the fact that the portrayal of the body has so dominated painting even in the absence of any semantic context — and the semantic context does often seem a quickly forgotten excuse for the initial painting — is due in large part to the fact that we find the human body intrinsically beautiful. Just as lines and edges are low-level aesthetic primitives because they are powerful triggers of neural activity low down in the cortical visual pathways in primary visual cortex, so the human form is a high-level aesthetic primitive because it stimulates activity further along the cortical pathways in neuronal systems specialized for analysing the human body, probably in the temporal lobes. And the particular simplifications and transformations of the human face and form used by African art and by Brancusi, Giacometti, Picasso, Moore, Bacon, and many other twentieth-century artists are not arbitrary. They work because they correspond to the simplifications and transformations of the processes the brain uses to analyse and represent human anatomy.

Within the full range of possible facial expressions and body postures, there are some that carry special emotional significance — the characteristic posture of the aggressor or the vanquished, for example. It seems reasonable, if entirely speculative at the moment, to suppose that we have visual processes that are selectively tuned to these particular forms. So, like Mondrian's horizontal and vertical lines, the outlines of emotionally significant postures, for example Matisse's joyful figures (Fig. 4.15), are particularly powerful aesthetic primitives.

Of course, there is some circularity here. We have those processes not by chance, but because monitoring our hand movements and other people's facial expression and posture are of such enormous biological importance to us that we have evolved special neural mechanisms to deal with them. So painters paint what is important to us and, thanks to evolution, we have the neural mechanisms to respond to the stimuli they create.

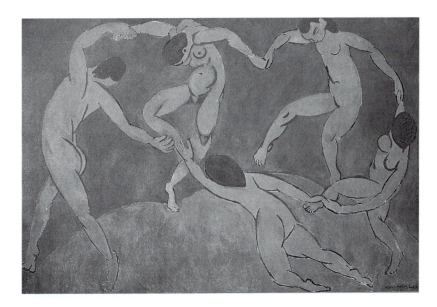

Fig. 4.15. Henri Matisse 1910, *La Danse*. Courtesy of the Hermitage, St Petersburg/ Bridgeman Art Library, London. © Succession H. Matisse/Dacs 1994.

This may also be true of the second most important subject of paintings, historically at least, the landscape. Our visual system evolved to analyse the particular environment in which we lived, so that we could operate within that environment as effectively as possible. Like all animals, we have had an evolutionary niche, albeit broader than most and our visual system has been tuned accordingly: we are less sensitive to light than nocturnal animals like cats, we are less sensitive to fine detail than predators of small animals like falcons, but we have above-average stereopsis and colour vision for rapid manipulations like the harvesting of fruit. Much of this tuning is innate, although one of the most exciting findings of visual electrophysiology has been that some of the fine tuning is almost certainly environmental (Blakemore and Cooper 1970; Blakemore and Mitchell 1973). In humans, the sensitivity to different orientations discussed in Section 2.2 can be modified by the abnormal early experiences generated by congenital astigmatism (Freeman *et al.* 1972) or by the unusually high incidence of horizontal and vertical lines in urban environments (Annis and Frost 1973).

Whatever its origin, this tuning of our visual systems to the environment means that landscapes are exceptionally powerful stimulants for our visual neurones. And perhaps the strengths of certain landscapes, the idealized worlds of Claude and the eighteenth-century British landscape gardeners or the English Lake District that inspired the nineteenth-century romantic poets, lies in their ability to act as super-stimulants.

This speculation can be carried further. The control over the environment achieved by humans and some other animals, like

bower birds, termites, or tunnellers (the mole's environment is almost entirely mole-made), allows for the operation of a positive feedback loop analogous to that operating for sexual selection (Dawkins 1986). Could it be that just as a peacock's tail has become more and more ornate because of a positive feedback loop driven by sexual selection, so animals construct an environment because they find it aesthetically pleasing and this in turn modifies the visual systems of subsequent generations so that they build to greater extremes, going beyond utilitarian properties to aesthetic ones? At a cultural level, this kind of process seems to operate in the world of fashion, which oscillates between utilitarian and non-utilitarian extremes like an unstable positive feedback system.

There is another example of animal behaviour that is helpful here. In many animals there are particular responses in their behavioural repertoire which occur only in the presence of particular stimulus features, usually referred to as sign stimuli (Russell 1943). Most examples come from insects and birds, but sign stimuli are found right across the evolutionary scale. Noiret (1964) showed that inexperienced female mice would respond to the cries of young mice by retrieving them. Experimental studies by Tinbergen and others showed that it was often possible to isolate and exaggerate a sign stimulus to produce a super-normal stimulus which elicited a super-normal response. Herring gull chicks who peck at the red spot on their mother's beak, peck even more vigorously at a red knitting needle with three white bands near the top (Tinbergen 1953). Similarly, it may be that the natural aesthetic response to stimuli like landscapes or the human face can be increased by exaggerating some of the characteristics of those stimuli. ET's appealing face, which exaggerates the features of a baby's face to which we are probably genetically programmed to respond, is a good example. Some of the distortions of primitive and twentieth-century representational art depend for their effect on the isolation and exaggeration of local features in this way.

There is also evidence that average or prototypical faces are optimally attractive (Langlois and Roggman 1990). It may be that there are two conflicting processes operating here: the attraction of the norm and the attraction of the exaggerated feature (Alley and Cunningham 1991). One speculative possibility is that the norm dominates when the whole Gestalt is being judged, but when a single feature is isolated, for example a West African mask featureless except for a pair of exaggerated lips, the mechanisms of the super-normal stimulus can operate.

4 Computational modelling and the simplification of form in representational art

The approach to vision of the artificial intelligence community is nowadays closely integrated into that of electrophysiologists and psychologists and shares with them the emphasis on parallel processing and modularity (Stillings *et al.* 1987). And it too has developed ideas about the processing of visual stimuli which reflect and illuminate the concerns of artists. In particular, it shares with artists the need to simplify the stimulus so that it can be handled more effectively — computationally in one case, perceptually in the other. Marr (1982), for example, suggests that we begin with the difficult problem of generating an object-centred description which is independent of any particular viewpoint by setting up coordinate systems for objects based on the principal axes of the shapes being represented, creating a pipe-cleaner model of it (Fig. 4.16). Evidence from the arts is called on to support this approach, the Lowry argument. Matchstick figures are powerful generators of three-dimensional shapes and have been used for this purpose by artists and non-artists, since painting began. In recent years, the most powerful exploiter of this phenomenon has been Giacometti (Fig. 4.17). So the principal axes of objects are aesthetic primitives.

Having set up a coordinate system using the principal axes of the object, Marr's model fits cylinders or cones around these axes. Perhaps it was these generalized cones which Cézanne was referring to in his famous injunction to Emile Bernard: 'Treat nature by means of the cylinder, the sphere, the cone, everything brought into proper perspective' (Cézanne 1904). They are certainly reminiscent of the traditional techniques used for training in life drawing and they provide another aesthetic primitive, the stylized human form, much used by artists from the prehistoric Cyclades to Brancusi and Moore.

Having generated these object-centred representations, there must be a system for recognizing them. This is an area where artificial intelligence and cognitive psychology come together, but which remains speculative. Marr suggests it involves a process of describing and cataloguing in an organized hierarchy. This is done largely in terms of the component parts of the figures and generating these component parts involves segmentation. Hoffman and Richards (1984) suggest that we segment three-dimensional objects into component parts by finding contours of what they call concave discontinuity (Fig. 4.18). This is normally the innermost part of the concavity and its function in segmentation perhaps explains why we cannot see both versions of ambiguous figures, like the Rubin vase or

Fig. 4.16. Marr's pipe-cleaner figures demonstrating that a representation based on the principal axes of the shape is clearly recognizable even when no information is present about the surface of the shape. Reproduced with permission from Marr and Nishihara, *Proc. R. Soc. Lond.* **B 200**, 269–94 *(1978)*.

Fig. 4.17. Alberto Giacometti 1947, *Man Pointing*. Courtesy of the Tate Gallery, London. © ADAGP, Paris, and DACS, London 1994.

the reversing staircase, at the same time: the contours of concave discontinuities along which we segment the figure occur in different places in the two interpretations.

Artists of course have also used these techniques. Segmentation is a standard process in traditional life drawing: the human form is treated as a conglomerate of ovoid shapes, like 'a bag of melons' as Benvenuto Cellini is supposed to have called it. And arguably, the component parts, the stylized organic shapes or biomorphs produced by segmentation, which have contributed so powerfully to the visual language of the surrealists and others, are themselves aesthetic primitives.

5 Conclusion

An aesthetic primitive is a stimulus that stirs the emotions because if has an exceptional ability to excite our visual neurones. This can occur at any level in the visual system, from Hartline and Ratliff's lateral inhibition in the retina, through Hubel and Wiesel's orientation detectors in the striate cortex, to Gross and Perrett's body analy-

Fig. 4.18. Pablo Picasso 1920,
Nu Couché. © DACS 1994.
Reproduced with permission.

sers in the temporal lobes. Seurat's beautiful edges, Mondrian's horizontal and vertical lines, Cézanne's cylinders, spheres, and cones, Giacometti's stick figures, Dürer's isolated hands and faces, Claude's idealized landscapes, and Arp's biomorphs all work by isolating, and sometimes exaggerating, one of the processes our visual systems have evolved or developed to analyse the particular world we inhibit.

We can only speculate about why activating these processes is rewarding, but, staying within the biological framework, perhaps it is important for the visual system, occupying at least a third of our cerebral cortex, to be stimulated and sometimes pushed to the limit and so, as with other adaptive behaviours, we have evolved a mechanism for encouraging this.

Art may be the playing-field on which we exercise our visual neurones. But it is also much more than that. The object of both science and art is truth and the goal of the visual arts and the visual sciences is to establish the truth about the nature of our visual processes and, therefore, the truth about a central feature of our existence. Art defines our humanity by portraying the brain's representation of the world.

References

Albus, K. (1975). A quantitative study of the projection area of the central and the paracentral visual field in Area 17 of the cat, II. The spatial organization of the orientation domain. *Experimental Brain Research*, **24**, 181–202.

Alley, T. R. and Cunningham, M. R. (1991). Averaged faces are attractive but very attractive faces are not average. *Psychological Science*, **2**, 123–5.

Annis, R. C. and Frost, B. (1973). Human visual ecology and orientation anisotropies in acuity. *Science*, **182**, 729–31.

Appelle, S. (1972). Perception and discrimination as a function of orientation: the 'oblique effect' in man and animals. *Psychological Bulletin*, **78**, 266–78.

Bell, C. (1958). *Art*. Putnam (Capricorn). (Originally published 1913.)

Berkley, M. A., Kitterle, F. and Watkins, D. M. (1975). Grating visibility as a function of orientation and retinal eccentricity. *Vision Research*, **15**, 239–44.

Blakemore, C. and Campbell, F. W. (1968). Adaptation to spatial stimuli. *Journal of Physiology*, **200**, 11P–13P.

Blakemore, C. and Cooper, G. F. (1970). Development of the brain depends on the visual environment. *Nature*, **228**, 477–8.

Blakemore, C. and Mitchell, E. D. (1973). Environmental modification of the visual cortex and the neural basis of learning and memory. *Nature*, **224**, 467–8.

Bornstein, M. H. (1978). Visual behavior of the young human infant: relationships between chromatic and spatial perception and the activity of underlying brain mechanisms. *Journal of Experimental Child Psychology*, **26**, 174–92.

Bradshaw, J. L., Bradley, D. and Patterson, K. (1976). The perception and identification of mirror reversed patterns. *Quarterly Journal of Experimental Psychology*, **28**, 667–81.

Cézanne, P. (1904). Letters to Emile Bernard. In *Art in theory 1900–1990: an anthology of changing ideas*, (ed. C. Harrison and P. Wood, 1992), p. 37. Blackwell, Oxford.

Corballis, M. C. and Beale, I. L. (1971). On telling left from right. *Scientific American*, **224**, 96–04.

Dawkins, R. (1986). *The blind watchmaker*. Longman, Harlow.

DeValois, R. L., Yund, E. W. and Hepler, N. (1982). The orientation and direction selectivity of cells in macaque visual cortex. *Vision Research*, **22**, 531–44.

Essock, E. A. (1982). Anisotropies of perceived contrast and detection speed. *Vision Research*, **22**, 1185–91.

Freeman, R. D., Mitchell, D. E. and Millodot, M. (1972). A neural effect of partial visual deprivation in humans. *Science*, **175**, 1384–6.

Fry, R. (1920). *Vision and design*, Chatto and Windus, London.

Goldstein, E. B. (1989). *Sensation and perception*. (3rd edn). Wadsworth. Belmont, Calif.

Gross, C. G., Rocha-Miranda, C. E. and Bender, D. B. (1972). Visual properties of neurons in inferotemporal cortex of the macaque. *Journal of Neurophysiology*, **35**, 96–111.

Harmon, L. D. (1973). The recognition of faces. *Scientific American*, **229**, 70–82.

Hartline, H. K., Wagner, H. G. and Ratliff, F. (1956). Inhibition in the eye of *Limulus*. *Journal of General Physiology*, **39**, 651–73.

Hoffman, D. D. and Richards, W. A. (1984). Parts of recognition. *Cognition*, **18**, 65–96.

Hubel, D. H. and Wiesel, T. N. (1959). Receptive fields of single neurons in the cat's striate cortex. *Journal of Physiology*, **148**, 574–91.

Jaffé, H. L. C. (1970). *De Stijl*. Thames and Hudson, London.

Jung, R. (1987). Art and visual abstraction. In *The Oxford companion to the mind*, (ed. R. L. Gregory). Oxford University Press.

Kennedy, H., Martin, K., Orban, G. A. and Whitteridge, D. (1985). Receptive field properties of neurones in visual area 1 and visual area 2 in the baboon. *Neuroscience*, **14**, 405–15.

Langlois, J. H. and Roggman, L. A. (1990). Attractive faces are only average. *Psychological Science*, **1**, 115–21.

Livingstone, M. S. (1988). Art, illusion and the visual system. *Scientific American*, **256**, 78–85.

Livingstone, M. (1990). Segregation of form, colour, movement, and depth processing in the visual system: anatomy, physiology, art, and illusion. In *Vision and the brain*, Research Publications, Association for Research into Nervous and Mental Diseases, Vol. 67, (ed. B. Cohen and I. Bodis-Wollner), pp. 111–38. Raven Press, New York.

Livingstone, M. and Hubel, D. (1988). Segregation of form, colour, movement, and depth: anatomy, physiology, and perception. *Science*, **240**, 740–9.

Maffei, L. and Campbell, F. W. (1970). Neurophysiological localization of the vertical and horizontal visual coordinates in man. *Science*, **167**, 386–7.

Maffei, L. and Fiorentini, A. (1973). The visual cortex as a spatial frequency analyzer. *Vision Research*, **13**, 1255–67.

Mansfield, R. J. W. and Ronner, S. F. (1978). Orientation anisotropy in monkey visual cortex. *Brain Research*, **149**, 229–34.

Marg, E., Adams, J. E., and Rutkin, B. (1968). Receptive fields of cells in the human visual cortex. *Experientia*, **24**, 348–50.

Marr, D. (1982). *Vision*. Freeman, San Francisco.

Naeli, H. and Harris, P. (1976). Orientation of the diamond and square. *Perception*, **5**, 73–8.

Noiret, E. (1964). Changes in responsiveness to young in the adult mouse: IV. The effect of an initial contact with a strong stimulus. *Animal Behaviour*, **12**, 442–5.

Ojemann, J. G., Ojemann, G. A., and Lettich, E. (1992). Neuronal activity related to faces and matching in human right nondominant temporal cortex. *Brain*, **115**, 1–13.

Perrett, D. I., Rolls, E. T. and Caan, W. (1982). Visual neurones responsive to faces in the monkey temporal cortex. *Experimental Brain Research*, **47**, 329–42.

Perrett, D., Harries, M., Mistlin, A. J., and Chitty, A. J. (1990). Three stages in the classification of body movements by visual neurons. In *Images and understanding*, (ed. H. Barlow, C. Blakemore, and M. Weston-Smith), pp. 94–107. Cambridge University Press, Cambridge, UK.

Perrett, D. I., Oram, M. W., Harries, M. H., Bevan, R., Hietanen, J. K., Benson, P. J. *et al.* (1991). Viewer-centred and object-centred coding of heads in the macaque temporal cortex. *Experimental Brain Research*, **86**, 159–73.

Richards, W. (1971). The fortification illusions of migraine. *Scientific American*, **224**, 89–96.

Riley, B. (1991). The artist's eye: Seurat. *Modern Painters*, **4**, (2), Summer, 10–14.

Riley, B. (1993). Unpublished lecture, (28 January 1993). Tate Gallery, Liverpool.

Rudel, R. G. and Teuber, H. L. (1963). Discrimination of direction of line in children. *Journal of Comparative and Physiological Psychology*, **56**, 892–8.

Russell, E. S. (1943). Perceptual and sensory signs in instinctive behaviour. *Proceedings Linnaean Society of London*, **154**, 195–216.

Siegel, R. K. (1977). Hallucinations. *Scientific American*, **237**, 132–40.

Stillings, N. A., Feinstein, M. H., Garfield, J. L., Rissland, E. L., Rosernbaum, D. A., Weisler, S. E. *et al.* (1987). *Cognitive science, an introduction*. MIT Press, Cambridge, Mass.

Sutter, D. (1880). Les phénomènes de la vision. *L'Art*, **20**, 216–20.

Tinbergen, N. (1953). *The herring gull's world*. Collins, London.

Treisman, A. (1986). Features and objects in visual processing. *Scientific American*, **254**, 114–25.

Vitz, P. C. and Glimcher, A. B. (1984). *Modern art and modern science: the parallel analysis of vision*. Praeger, New York.

Wade, N. (1990). *Visual allusions*. Erlbaum, Hillsdale, NJ.

Young, M. P. and Yamane, S. (1992). Sparse population coding of faces in the inferotemporal cortex. *Science*, **256**, 1327–31.

Zeki, S. M. (1993). *A vision of the brain*. Blackwell, Oxford.

Zemon, V., Gutowski, W. and Horton, T. (1983). Orientational anisotropy in the human visual system: an evoked potential and psychophysical study. *International Journal of Neuroscience*, **19**, 259–86.

5 When is a face not a face?

DAVID PERRETT, P. J. BENSON,
J. K. HIETANEN, M. W. ORAM, AND
W. H. DITTRICH

Introduction

Faces evoke a variety of emotions and behaviours not only in humans but also in non-human primates, such as monkeys. The exact form of these behaviours may differ between different species, but the range of social responses in primates provides a naturally occurring measure of sensitivity to facial information (Dittrich 1990; see Perrett and Mistlin 1990 for a review). Faces are complex visual patterns: comparing how they are processed in different species may be a useful way to understand the underlying mechanisms.

Since the work of Gross and colleagues (Gross *et al.* 1972) it has become clear that the *temporal cortex* of the macaque monkey contains cells which respond selectively to the sight of biologically important objects (such as faces and hands). The properties of such cells, therefore, offer a unique opportunity to study directly brain mechanisms involved in processing the complex patterns of faces.

The general approach taken in this chapter is that it is possible to relate perceptual experience to neurobiological process (Barlow 1972; Ramachandran 1985). One way to investigate the relationship between perception of faces and information-processing in single nerve cells is to determine how neurones process images which have been changed to make face perception and recognition easier or harder. It turns out that image manipulations which affect face recognition also affect the activity of the individual neurones that respond to faces.

Another approach is to ask how brain damage may affect the perceptual experience of faces. If particular brain mechanisms are directly responsible for face perception, then disruption of the mechanisms or their inputs will necessarily affect face perception. This assertion allows two-way predictions to be made between the physiology of normal brain and perceptual experience in pathological conditions, so that: (a) the physiological properties of face-processing neurones in the intact brain can be used to predict perceptual and

recognition losses following damage and (b) reciprocally, the nature of perceptual dysfunction following brain damage can be used to predict the properties of the neuronal mechanisms which process faces in the intact brain.

Two assumptions underlie these predictions. The first is that the basic neural mechanisms underlying visual processing in humans and monkeys are similar. This appears at least partly justified on evolutionary grounds. The second and perhaps more tenuous assumption is that certain capacities for perceiving and discriminating faces are comparable across the primate species. Experiments comparing monkeys and humans support this assumption.

Physiological measures of face processing in the intact brain

Investigations into visual processing can be made by recording the activity of individual brain cells at different stages in the visual system of experimental animals. In the 1960s and early 1970s studies of the first cortical area (the *primary visual cortex* at the back of the brain) to receive visual information from the eyes revealed cells that responded to light in small regions of the retinal image. Moreover, these cells were found to respond to elementary properties of the image such as orientation, contrast, or colour (see Hubel and Livingstone, this volume, Chapter 3).

After leaving the primary visual cortex, visual information is processed in a large number of separate areas. The further these areas are from the visual input to the eye, the more elaborate become the visual features required to activate cells. This activity consists of a train of electrical pulses (action potentials), whose frequency rises when the appropriate pattern is projected on the appropriate part of the retina. In the lower parts of the temporal lobe, cells appear to respond to very complex images. Gross *et al.* (1972) reported that some cells responded to the sight of a monkey's paw. In one particular region of the temporal lobe (the superior temporal sulcus or STS), cells respond to faces (Bruce *et al.* 1981; Perrett *et al.* 1982).

While STS cells seem to respond better to faces than cells earlier in the visual pathways, selectivity for other visual dimensions, such as size, position, and colour, is reduced. Thus, the cells respond to many different examples of the same face where the position of the face within the retinal image, its size, and its colour vary (Bruce *et al.* 1981; Perrett *et al.* 1982).

The ease of perceiving stimuli as faces is not greatly affected by stimulus position, at least for moderately sized faces within the central 20° of the visual field. Likewise faces are easy to recognize

over a large range of sizes (20–22° on the retinal image, correspond-ing to the range of distances of most social interactions for macaque monkeys and man, 0.5–5.0 m). Thus, the STS cells' responses gener-alize across variables which do not greatly affect the ease of face per-ception and recognition. Of course, recognition of faces seen out of the corner of the eye or at a very small size is more difficult, but still possible. Such conditions may well have an impact on the magnitude of cell responses to faces, but these conditions have yet to be investi-gated physiologically. Other image changes, however, do have marked effects on face perception. The following sections consider several such manipulations and their impact on neural responses to faces.

Upside-down faces

It has been known for some time that human observers have difficulties in perceiving inverted faces (see for example, Yin 1969; Bradshaw and Wallace 1971). One would predict from this 'face inversion' effect that orientation should also have some impact on the processing of face images by cells in the monkey temporal cortex.

Before investigating the effects of face inversion at the single-cell level in the monkey brain it is important to establish at the behav-ioural level whether the monkeys also have difficulties in recognizing upside-down faces. Monkeys spend a lot of time hanging upside-down in trees, so perhaps they show no face inversion effect.

To compare the effect of orientation on face perception in man and monkey we devised a task which required discrimination of normal and jumbled-up faces with stimuli presented at different ori-entations. Experimental details are presented elsewhere (Perrett *et al.* 1988*a*). Briefly, two monkeys were trained to respond for a fruit-juice reward on trials where colour slides of normal faces were presented and to withhold this behavioural response on trials with slides of jumbled faces. To compare performance across species, human sub-jects were tested with the same task. Subjects responded by pressing a button on trials on which normal faces were presented and were instructed to ignore jumbled faces. (Human subjects had to wait till the end of the experiment for their reward of beer or fruit-juice tokens.) Once the task was learnt, both monkey and human subjects were tested with stimuli presented in upright, horizontal, and inverted orientations. The effect of orientation on reaction times for humans and monkeys was very similar (Fig. 5.1). For both species, decisions about the facial configuration were very quick when the faces were upright. When the face images were horizontal or inverted the reaction time was significantly slower. We can infer from these results that monkeys (like humans) find perception or recognition of face configuration more difficult when the face is

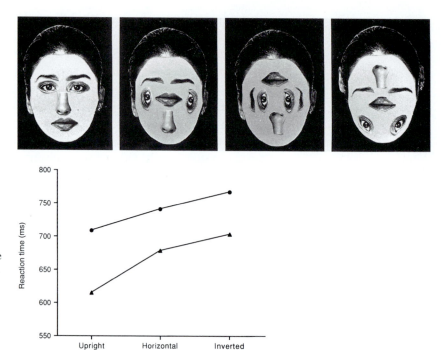

Fig. 5.1. Judging face configuration at different orientations. Reaction times to discriminate normal faces from symmetrically jumbled configurations. The reaction time for both human subjects (circles) and monkey subjects (triangles) increases as face orientation is changed from upright to inverted. Adapted from Perrett *et al.* (1988*a*).

upside-down. It should be noted that inversion does not abolish face perception in monkeys (Dittrich 1990); it may simply degrade or delay it. The effects may simply be due to a lifetime's experience of dealing with faces in the upright position and therefore they may reflect a strong underlying neural bias.

What happens to processing by single cells? Initial reports indicated that the stimulus orientation (upright horizontal or inverted) did not affect the magnitude of cells' responses to faces (Perrett *et al.* 1982). A closer inspection of the time-course of neuronal responses, however, revealed subtle differences in the processing. Cells in the STS begin responding to the sight of upright faces approximately one-tenth of a second (100 ms) after the presentation of the face. Individual cells respond with latencies commonly in the range of 80–150 ms. When rotated faces are presented, either horizontal or upside-down, neural processing can take extra time. Figure 5.2 illustrates the difference in time taken to respond to upright and rotated faces for STS cells. Most cells showed an increase in the latency of response to rotated faces. So there is a qualitative parallel between delays that can be measured in the responses of brain cells processing rotated faces and delays at the behavioural level in the perception or the recognition of rotated faces.

(The amount of extra time human (and monkey) subjects take to make decisions with inverted stimuli varies (10–1000 ms) in accordance with the task demands and the stimuli requiring discrimina-

Fig. 5.2. Delayed responses to rotated faces. Change in latency of cell responses with rotation of faces from upright to a horizontal or inverted orientation. Latency difference is defined for each cell as the mean time of response onset to rotated faces minus the response onset time to upright faces. From Perrett *et al.* (1988*a*), and reproduced with permission from Elsevier Science Publishers BV (Biomedical Division).

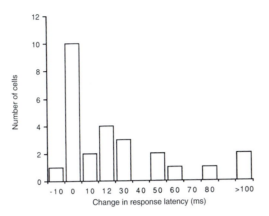

tion. It is therefore difficult to make quantitative comparisons between the magnitude of the increase in reaction times and the magnitude of the increase in cell response latencies.)

Colour and direction of contrast

The presence or absence of colour in photographs does not seem to affect face recognition. For almost a century, black and white photography has been quite sufficient to record the identity of faces. The advent of full colour photography has done little if anything to improve face recognition. Evidence for this is given by the fact that there is no legal requirement for colour photographs in identity documents (at least in the UK). Behaviourally, monkeys also appear to be unaffected by the presence or absence of colour in facial images (Dittrich 1990), recognizing either equally well.

The direction of contrast of an image does, however, affect ease of perception. Human subjects find faces rather difficult to recognize in photographic negative (see for example, Phillips 1972).

We have investigated the effects of colour and contrast direction on the neural processing of faces by comparing cell responses to normal colour and black and white photographs of faces with photographic negative images of the same faces. Such positive and negative stimuli are interesting because although they are exactly matched in terms of component edges, textures, feature sizes, etc., the stimuli differ in the ease of perceptual interpretation. As with human perception and recognition of faces, cells were found to respond equally to normal colour and black and white (positive contrast) images of faces (Perrett *et al.* 1984). However, changing the direction of contrast in colour or black and white images did affect cell responses, which were generally reduced to negative contrast faces (Perrett *et al.* 1984; Rolls and Baylis 1986).

In summary, the presence of colour does not appear to matter at the behavioural level for human or monkey face recognition, nor does it appear to affect cell responses to faces. The direction of contrast does matter for face recognition and it affects cell responses, negative contrast impairing recognition, and reducing neural responses.

Mooney faces

The effects of contrast direction can be studied in a related situation with more precise control over the images. Contrast in an image can be manipulated to compress or expand the tonal range between black and white. In the extreme, the range of lightness can be forced to only two levels, removing all intervening grey levels, thus converting the image to areas of black and areas of white. When this process is applied to faces which are lit with a single strong source of light, the shadows on the surface of the face blend with the dark facial features and become bounded by sharp contours; overall this has the effect of making the whole image difficult to perceive as a face (Mooney 1957).

Though such images are more difficult to recognize, recognition is still possible and even for unfamiliar faces the approximate age and gender can be judged (see Fig. 5.3). Face perception becomes just about impossible when these 'Mooney' faces are subjected to any further image manipulation which degrades recognition of normal images. Thus, contrast reversal or rotating images upside-down renders Mooney faces uninterpretable (Fig. 5.3).

Changing the direction of contrast of Mooney faces reverses the relationship between dark regions of the image and regions of the head that are naturally dark because of shadows (for example, the regions under the chin and the eyebrows). Similarly substituting colours (for example, red and green) of equal luminance for black and white makes the Mooney faces very difficult to recognize. Here

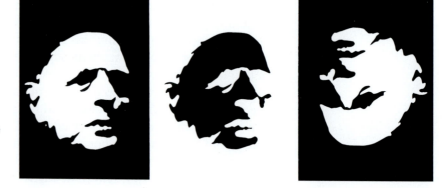

Fig. 5.3. Perception of two-tone Mooney faces. *Left*: positive contrast two tone image of a face. *Centre*: reversed contrast image. *Right*: inverted image.

again the perceptual impairment is probably due to disruption of the normal relationship between shadowed and bright areas.

The ease of recognizing Mooney faces has parallels at the single cell level. Cells responsive to faces and profile views of the head continued to respond to Mooney type images of faces and profile views of the head (Perrett *et al.* 1984). When the contrast direction was reversed to make a negative Mooney face, however, cell responses were reduced. Similarly responses were reduced to red–green versions of Mooney faces in which red and green were of equal brightness.

Physiological correlates of perception of Mooney faces have been observed not only at the single-cell level but also as a consequence of the activity of many thousands of cells that contribute to small voltage changes that can be detected at the scalp (electroencephalograms — EEGs). Voltage changes recorded in this way from human subjects reveal an evoked potential 150 ms after the presentation of a visual image. This potential appears to be associated with the perception of complex visual patterns as meaningful entities (Botzel and Grüsser 1989; Jeffreys 1989). Interestingly, the 150 ms potential occurs in response to the sight of Mooney faces, but is markedly reduced in magnitude when such images are presented upside-down. Inversion, as noted above, makes it extremely difficult to see the images as faces (Jeffreys 1989).

Block portraits (the Abraham Lincoln effect)

Harmon (1973) divided up the image of a face into large squares or blocks, in which the brightness of each square is set to the average of the image in that region. For example, a square overlying dark hair has a low average brightness and becomes evenly black, and a square overlying skin has a high average brightness and becomes evenly white; whereas a square straddling skin and hair becomes evenly grey. When we see the image as a series of blocks it is difficult and sometimes impossible to perceive or identity the face (see for example, Fig. 5.4). This image manipulation has been termed the 'Abraham Lincoln effect', because Harmon first performed the manipulation on a picture of Lincoln.

If the same block portrait is seen with less clear vision by viewing it at a distance, screwing up the eyes, or removing spectacles, then the face can be seen more clearly. The blurring can also be done optically with an out-of-focus camera or electronically by throwing away the fine details (Fig. 5.4, left). The blurred image contains no more correct information about the face than the block portrait, yet it is easier to perceive. Indeed the identity hidden in the block portrait of Fig. 5.4 may be evident in the blurred version.

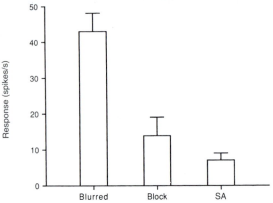

Fig. 5.4. Effects of coarse quantization on neuronal response to face images. Upper: examples of stimuli used for testing, (left) blurred image and (right) coarsely quantized image. Lower: mean response (+/-1 SE) of one cell response to blurred image and block portrait. SA, spontaneous activity (background firing rate). Adapted from Perrett *et al.*, (1984).

The presence of details at the edges of each square seems to inhibit the perception of the face in the block portrait. In other words, the incorrect high spatial frequencies (fine details) can inhibit perception of a shape defined by lower spatial frequencies (coarse details).

The effect of block portraits has not been extensively studied at the single-cell level. Figure 5.4 illustrates data from one early experiment (Perrett *et al.* 1984) which suggests interesting parallels between response magnitude and ease of face perception. The cell responded to face, presented as a normal picture. When the face image was blurred the cell continued to respond at a high rate, but the respond was reduced to the level of spontaneous activity (the frequency of firing in the absence of any visual input) when the image was made

into a block portrait. In this case, distortion of the image with the wrong kind of fine details (the edges of edge block) inhibited detection of the facial pattern both at the neuronal level and at the level of perceptual experience.

Again, the same image manipulations that make it difficult for human observers to perceive faces also reduce the responses to faces of cells in the monkey temporal cortex.

Rotation of shadow heads

Imagine the two-dimensional shadow cast by a three-dimensional model head. As the head is rotated about its central vertical axis the shadow changes, giving the impression of the three-dimensional object; the shadow 'looks like a solid head'. The perception of the changing two-dimensional shadow as a rotating three-dimensional object is called the kinetic depth effect (Wallach and O'Connell 1953).

In profile, the silhouette traces an image in which the nose and chin are maximally visible. The profile shadow is the only view for which there is an unambigous interpretation of the shadow as a solid head (there is an infinite number of three-dimensional objects which could give rise to the same two-dimensional shadow). For all other shadows, there are two possible situation in which the head could give rise to the same shadow. For example, the shadows produced when the shadow is of a full-face view or of the back of the head are identical. In these conditions it is impossible to know whether the head points towards or away from the observer. Thus, the direction of rotation of a rotating shadow head is ambiguous. One might expect that because of this ambiguity, we would fail to perceive any solid three-dimensional structure and perhaps see the shadow only as an amorphous two-dimensional pattern. Instead the observer's visual system is convinced that the head causing the shadow is rotating in one direction. After several rotations, the percept may change so that the head appears to rotate in the opposite direction. Different observers (and even the same observer at different times) see the head as rotating clockwise, anticlockwise, or oscillating through 180°, with the direction of rotation reversing at the profile.

Each observer entertains one and only one perceptual hypothesis about three-dimensional structure at one time and that hypothesis or interpretation is maintained at the expense of other equally valid interpretations. Observers will even believe that the head causing the shadow has suddenly changed its direction of rotation, rather than accepting that their own perceptual hypothesis has suddenly changed.

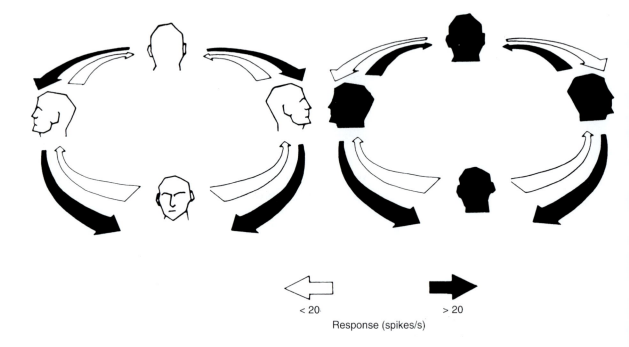

< 20 > 20

Response (spikes/s)

Fig. 5.5. Responses of one cell to the rotation of real and shadow heads. Left: under normal lighting conditions the surface pattern of a real face was visible, head rotation towards the observer from the back to left or right profile views and from profile views to the front view produce responses greater than rotations away from the observer (Neuman Keuls $p < 0.05$ each comparison; ANOVA $F = 17.5$, df = 3,38, $p < 0.05$). Right: when viewed as a shadow, head rotation from the profile views to the back or the front view, produce greater responses than other directions of rotation or spontaneous activity ($p < 0.05$ each comparison; $F = 12.5$, df = 4,43, $p < 0.01$).

One category of cells in the temporal cortex responds selectively to the sight of head rotation (Perett *et al.* 1985a; Hasselmo *et al.* 1989). Some of these cells respond only to rotation of the head towards the observer and others respond only to head rotation away (Perrett *et al.* 1985a, 1990a).

Figure 5.5 shows data from one cell selectively responsive to horizontal rotation towards the observer. Under normal lighting conditions with all the internal features of the face visible, the cell responded well to rotation from the back of the head to the left or right profile. The cell also responded well to head rotation from the left or right profile to the full face. Thus, four types of rotation, each bringing the face closer to the observer, elevated the cell's discharge rate. Rotation of the head away from the observer (from full face to left or right profile or from each profile to the back of the head) produced significantly less response. Overall, the cell was directionally selective for rotation of the face towards the observer.

When the shadow of a rotating head was presented the cell continued to be responsive, but the pattern of selectivity was modified. Change from the profile silhouette to a silhouette without nose and chin always produced a response. This change could have been caused by (or interpreted as) the head rotating from profile to face the observer, but it could equally well have risen from the opposite rotation, as the head turned away from the observer.

The neuronal processing seems to have adopted a 'default' mode whereby in the absence of internal facial features a decrease in the size of the outline from a profile with protruding nose and chin to a more symmetrical and round structure was interpreted as rotation towards and an increase in the size of the nose, etc., as a rotation away. While we do not know how the monkey perceived the stimulus, we do know that the changing shape of the two-dimensional shadow was interpretable by a human as a rotating head.

Other cells, which show consistent preferences for the direction of head rotation under normal lighting, do not show the same consistency for rotation of the shadow head. Even when the shadow head was rotated in the direction in which the real head gave a maximal response, a response did not always occur.

Thus, some cells responsive to head rotation continue to operate in the perceptually ambiguous shadow condition. In keeping with this perceptual ambiguity, it was not possible to predict directional selectivity of these cells to the shadow head from responses measured under normal lighting.

Line-drawings

An issue which is central to this book is that of representation in art. How do the sometimes quite abstract representations of art map on to the internal representations of objects in memory in such a way that the latter give rise to the perception of objects?

With cells responsive to faces this question can be addressed directly by comparing cell responses to real faces and to artistic depictions of faces. Figure 5.6 illustrates a highly schematic line-drawn representation of the monkey face. While no-one would consider this line drawing fine art, the depiction has at least the essential elements of a primitive or impoverished art. Though it is highly schematic, it can be perceived as a face. Jumbling up the lines, of course, destroys the representation of a face.

In a study of 30 cells which responded to real faces, the majority (90 per cent) were found unresponsive to the impoverished line-drawn monkey face (Perrett *et al.* 1982). Three cells did respond to the line drawing, but each cell less to the line drawing than to real faces (see Fig. 5.6). For these three cells their line drawing responses were abolished when the lines making up the drawing were rearranged into arrays of disorganized lines (see Fig. 5.6). This jumbling confirmed that the cells were responding to some aspect of the depicted face rather than to the orientation of particular lines (as cells might in the *primary visual cortex*).

The fact that a proportion of cells responsive to real faces also responded to a simplified schematic face is interesting. It means that

Fig. 5.6. Neuronal responses to a line-drawn representation of the monkey face. Upper: illustration of stimuli used; (left) face configuration and (right) lines rearranged to give a jumbled pattern. Lower: mean response (+/- 1 SE) to a real face, line-drawn face, and control patterns of disorganized lines. When the lines were organized into a face pattern responses were significantly larger than when the lines were jumbled. From Perrett *et al.*, (1982), and reproduced with permission from Springer-Verlag.

brain mechanisms designed through experience (or evolution) for the visual analysis of real faces can nevertheless process impoverished 'artistic' representations of faces, though real faces evoke stronger and more numerous responses than do schematic faces. Just how our perceptions of works of art are related to single-cell activity is an intriguing and unanswered question. Since single cells in monkey brain can apparently process line drawings, it is of interest to know whether the monkey can make use of this information. When line drawings of monkey faces depicting particular emotions (anger, fear, etc.) were shown to the macaque monkeys, the monkeys showed the same kind of behaviour as they did to pictures of real faces. When the lines in the schematic faces were jumbled up, none of the characteristic behaviour was shown (Dittrich 1990).

At perhaps a more intellectual level the interpretation of what is represented by a work of art can be compelling even though the depiction is abstract and low in realism. Indeed, facial caricatures can be constructed from a very few lines, yet give an extremely convincing depiction of a familiar face.

On a purely speculative note it may be that when the level of activation of visual representations in memory is low and therefore ambiguous, there is a greater need for top-down processing to guide the formulation of a perceptual hypothesis as to what is actually

present in the image (see Gregory, this volume, Chapter 1). It may well be that one reason humans enjoy art is precisely because it requires this extra interpretative effort. Natural images, with all the rich sources of information which make the perception of object structure unambiguous, are just too easy. We like the intellectual challenge that many forms of art offer.

It is not clear whether other primates could share our aesthetic reactions to art. Indeed, it would be surprising and amusing to find monkeys or apes squinting to see faces in block-portrait images such as Fig. 5.4. Interestingly, aesthetic preferences in monkeys can be personal, since when given a choice between pictures, they prefer to spend longer looking at some than others, just as we do (Humphrey 1972, 1983).

Relations of cell responses and ease of face perception

To summarize the image manipulations considered so far, cell responses to faces have been related to face perception in several ways, which can be broadly simplified as follows

1. In situations where human observers or monkeys find face perception easy, the populations of cells selective for faces in the monkey discharge at a high rate.

2. When the discharge rate of these cell populations is low, perception of faces by human observers is difficult.

3. When the cell discharges to images are unusually slow to start after the presentation of an image, face perception is delayed and/or difficult. At present there are no general principles suggesting why perceptual difficulty should in some cases be associated with low responses and in others be associated with delayed responses.

4. When perceptual interpretation of the image as a face is ambiguous, the discharges of cells responsive to faces are unpredictable.

Since these propositions are drawn from correlations between cell discharges and face perception, each proposition can be formulated in two directions. That is, when discharge rate is high perception is easy or, reciprocally, when perception is easy discharge rate is high. Of course, a causal link between perception and cell discharges (and

possible direction of causation) is not established by correlational study. It is a useful working hypothesis, however, that the cell activity 'causes' perception, in the same way that brains may be said to 'cause' minds rather than minds causing brains.

Facial caricatures

Not all image manipulations degrade perception. There are some that may actually enhance visual recognition. We have been exploring computer-generated facial caricatures as a possible instance in which perception can be enhanced by image manipulation.

On an image of Richard Gregory's face, a fixed number of points is used to mark the position and shape of the major facial features. A line drawing of Richard's face can be produced by simply linking up adjacent points around the edge of each feature. By repeating the process for other adult male faces, it is possible to determine where the tip of the nose lies on average. In this way a line drawing of a 'prototypical' adult Caucasian male can be formed by linking up the average positions of all the appropriate feature points.

Brennan (1985) invented an automated caricaturing process in which the position of each feature in a target face was compared with the position of the same feature in the prototypical or average face. To caricature the face, any differences between the target feature and the average were amplified. If the eyebrows of the target face are slightly larger than average, then the large eyebrow size is exaggerated in the caricature (Fig. 5.7). The degree of exaggeration is variable. A 50 per cent caricature is one in which all deviations are amplified by 50 per cent, for example eyebrows which are 5 mm broader than average are made 7.5 mm broader in a 50 per cent caricature.

Subjects prefer quite strong line-drawn caricatures of famous faces (42 per cent on average) to realistic line-drawings when asked to choose an ideal likeness (Benson and Perrett 1994). The more typical a face looks to start with, the greater the exaggeration subjects use to represent their identity. Caricatured line drawings of familiar faces are also named more quickly than realistic (unaccentuated) line drawings (Rhodes *et al.* 1987; Benson and Perrett 1994).

One explanation of the 'caricature advantage' is that stored representations of familiar faces are not accurate, but may themselves be selectively exaggerated in memory. In effect this amounts to storing caricatures inside our heads. Alternatively our memories may be accurate, but the preferences for caricatures may arise because line drawings contain so little detail that the distinctive facial aspects require enhancement in order to remain recognizable.

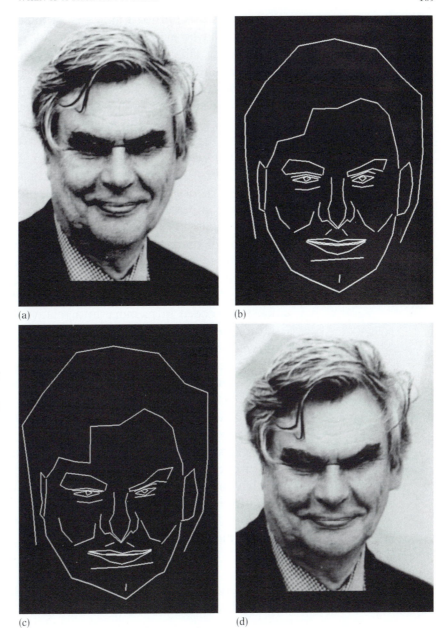

(a)

(b)

(c)

(d)

Fig. 5.7. (a) Original image of Richard Gregory. (b) Realistic line drawing. The points around the features of the face have been linked together to form a line drawing displaying the realistic shape of the features. (c) Line-drawn caricature. Deviations in the position of feature points from their position in an 'average' adult male Caucasian face have been exaggerated by 50%. (d) Photographic caricature produced by distortion of the original image in accordance with the line-drawn caricature.

It is possible that these results may tell us little about the processing of natural images. The caricature advantage may be specific to line drawings and reflect our experience with line drawing cartoons. To investigate this issue, we have extended the caricaturing process so that natural photographic images of faces can be manipulated in accordance with the computer-generated caricatures (Benson *et al.* 1992; Benson and Perrett 1991*a,b*, 1992). Figure 5.7 illustrates the results of the graphic processing and presents a 50 per cent carica-

ture (or 'super-normal') image of Richard Gregory. The caricaturing process can be exaggerated still further or it can be run in reverse, minimizing differences between the shape of Richard's face and the average (anticaricatures).

When required to choose the best likeness of famous faces from a range of distortions of those faces (caricatures and anticaricatures) subjects choose the real, original, image. Paradoxically, when asked to name a given famous face, subjects respond most quickly when presented with a caricature (50 per cent; Benson and Perrett 1991a). Providing subjects with distinctiveness-enhanced images can thus reduce the time taken for recognition, yet at the same time subjects can perceive that the caricatures are unreal.

The results from perceptual judgements imply that the metric proportions of the facial features for familiar faces must be accurately represented in memory, otherwise subjects would not be able to detect distortions. By contrast, superior performance with caricatures in recognition tasks suggests that the dimensions of familiar faces are coded in memory in a relative fashion. The shape of eyebrows, for example, may be specified as 'thicker and angled upwards more than normal'. On this explanation, caricatured images can be recognized more efficiently because they are in a form that is compatible with relativistic representations in memory (Benson and Perrett 1991a).

In conclusion, studies of caricature recognition suggest that internal representations of familiar faces may specify both the accurate dimensions of feature shapes and configuration and the way these features deviate from average. Caricaturing is an image manipulation which rather than impairing face recognition actually improves it. An untested prediction from this work is that caricatures may produce faster and/or greater activation of neurones involved in the recognition of familiar faces.

Relations between cells' responses and human face perception following brain damage

It has been known for more than a century that face recognition can be selectively impaired after brain damage (Wilbrand 1982). The condition referred to as prosopagnosia (Greek for 'non-recognition of faces') is particularly bizarre, since patients may fail to recognize their spouses or even themselves when they look in the mirror. Despite these difficulties, they may recognize other types of object and may even be able to recognize people from their clothing or voice, etc. (Bodamer 1947; Ellis and Florence 1990).

If problems of face perception in humans arise from damage to

brain systems processing faces that are equivalent to those studied in the monkey, then one should be able to make predictions from physiology to neuropsychology and vice versa. It should be possible to predict cell properties from symptoms of patients with prosopagnosia and reciprocally it should be possible to predict problems associated with prosopagnosia from cell properties.

Perceiving face identity

The overriding characteristic of patients with prosopagnosia is that they cannot recognize individuals from their faces. They may know that they are looking at a face, but do not know whose face it is. So far, cells that respond to faces have been described as if they respond equally to all faces. Since prosopagnosia is a deficit in recognizing identity, we might predict that particular cells might be sensitive to facial identity (Konorski 1967; Barlow 1972).

This prediction is interesting because it is perhaps incredible. Part of the neuroscience community has had or even still has difficulty accepting evidence that individual cells respond selectively to faces as a class of objects. It requires an even greater stretch of the imagination to accept that there might be cells selective for the identity of familiar faces. Even if one regards it as a theoretical possibility then one might still rationalize that it is improbable in the extreme that direct evidence for such selectivity could ever be obtained, simply because searching for such cells would be like looking for a needle in a haystack (Hofstader 1980). Despite the improbability of finding such tuning at the cellular level, the 1980s saw several research groups report cells in the temporal lobe which responded differently to different faces (Desimone *et al.* 1984; Perrett *et al.* 1984, 1987, 1989; Baylis *et al.* 1985; Kendrick and Baldwin 1987; Heit *et al.* 1988; Yamane *et al.* 1988). Approximately 10 per cent of the cells responsive to faces are sensitive to identity.

Different populations of cells in the temporal cortex respond to different views of the head. Some respond selectively to the left profile, others to the back of the head, etc. (Perrett *et al.* 1985a, 1989, 1991). Within each population a fraction of the cells again appear to be sensitive to the identity of familiar faces. Thus, cells have been found which respond to the left-profile view of one individual but not to the right profile of the same individual nor to any view of a second individual (see Fig. 5.8).

There is a further type of cell which responds to all views of the head but not to other objects. Again, amongst such view-general cells a fraction appear to be sensitive to the difference between familiar individuals. A dramatic example of a cell sensitive to identity

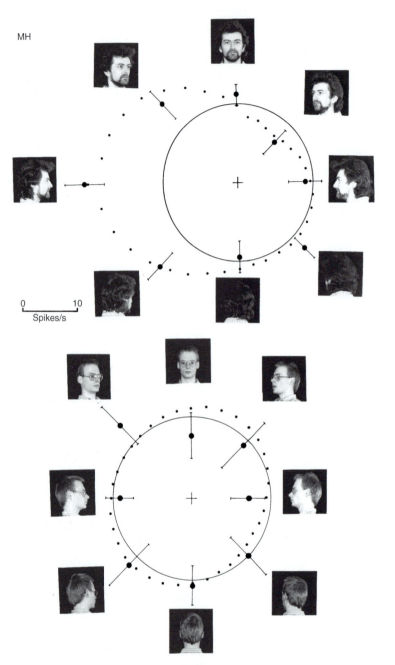

Fig. 5.8. Tuning for perspective view of a cell sensitive to face identity. Upper: the mean (+/-1 SE, *n* = 5) of responses to eight views of one experimenter (M.H.). Response magnitude to each view is depicted as the distance of large dot to central cross. The dotted line is the best fit second order cardioid function relating response to angle of view. The cell responds more to the right profile view of M.H. than the cell's spontaneous activity (central circle). Lower: the cell did not respond to any of the eight views of a second equally familiar individual. All stimuli were tested in random order. Reproduced with permission from Perrett *et al.* (1989), and the Company of Biologists Ltd.

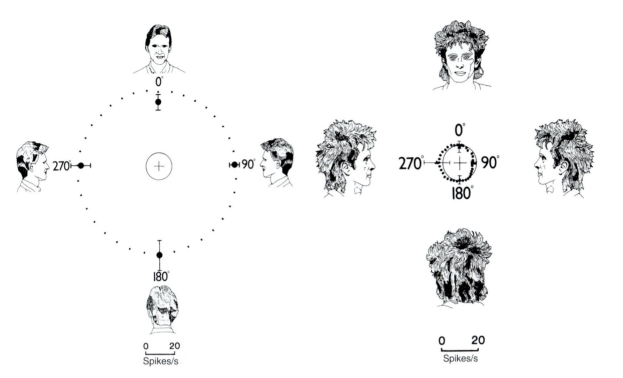

Fig. 5.9. Responses of cell sensitive to identity independent of view. Responses of one cell to four views of one experimenter (J.H.) were significantly greater than responses to the same four views of a second experimenter (D.P.). (Conventions as Figure 5.8. Reproduced with permission from Perrett *et al.* (1989), and the Company of Biologists Ltd.

independent of view is show in Fig. 5.9. The responses of this cell to four views of one experimenter (J.H.) were all significantly greater than responses to other changes and spontaneous activity of the cells. The cell was, however, unresponsive to a second experimenter (D.P.). The visual basis of this discrimination was not fully determined, but appeared to rely on combined cues from the head and the upper torso, since no responses were present to the head or body of J.H. presented in isolation. This indicates that the sensitivity for identity was unlikely to have arisen from any simple visual cue such as difference in hair style.

It is also worth noting here that visual information about the entire body appears to be processed in the STS (Perrett *et al.* 1984, 1985*b*, 1990*a*, 1992). In art, particular facial and body postures are used to suggest a range of personal attributions (strength, emotion, dominance, etc.). The perception of these qualities may be based in a visual analysis by cells such as is described here, but as yet the relation of cell discharges to such social signals or attributions has only begun to be studied (Perrett *et al.* 1992).

Figures 5.8 and 5.9 thus illustrate the level of selectivity that can be shown in the responses of cells within the temporal lobe. Such selectivity for face identity was an unlikely prediction from the deficit in face recognition which is the defining symptom of prosopagnosia.

Impairments in face perception across different lighting conditions

Visual recognition of someone's face is often complicated by the fact that viewing conditions change between encounters with that individual. One of the largest visual changes imposed on a face is that caused by a change in lighting, which can vary in strength, direction, and number of illumination sources. In general we are unaware of the sophistication of this perceptual ability, because recognition is carried out effortlessly. In everyday life we may be aware of the end-product of our recognition ('Oh, that's Laura Palmer'), but we do not contemplate the effect shadows have in obscuring facial features visible in other circumstances.

After brain damage, however, a patient may struggle with a perceptual task that is relatively straightforward for others. One test that is used regularly in clinical diagnosis of face-recognition problems examines what could be referred to as 'lighting constancy' (Benton and Van Allen 1968; De Renzi *et al.* 1968). In this test the patient is given a photograph of an unfamiliar face and is asked to choose which of four other face photographs depict the same target individual. On some trials the lighting of the target's face is changed. For instance, in the example the target's face may be lit evenly, but in the test choices the target's face may be lit from the side, with a strong light source casting heavy shadows.

Prosopagnosic patients can be broadly split into two categories by this one difficult perceptual task. Those failing the task are likely to have a perceptual disorder, while those performing the test well are more likely to have problems related to defective memory (Benton 1980).

Since in one variety of prosopagnosia patients suffer from high-level perceptual deficits typified by their failure to cope with lighting change, we are currently investigating whether the cells responsive to faces exhibit the capacity to generalize across different lighting conditions. The prediction is that, in addition to the capacity of the cells' responses to generalize across position, size, and orientation, they should show some degree of lighting constancy (that is, ability to respond to a face in a consistent way under conditions of changing illumination). Preliminary results indicate that this is so (Hietanen *et al.* 1992).

Figure 5.10 illustrates the responses of a cell tuned to the frontal view of the face. Under normal lighting this cell responds more to the full face than to the half-profile face (turned 45° away from the viewer). This capacity is maintained over a variety of lighting conditions which introduce harsh shadows. The face looks radically different under the different lighting conditions, yet the processing leading to the activation of this cell manages to detect the common

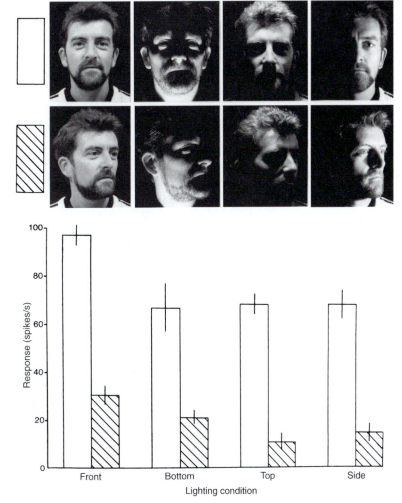

Fig. 5.10. Generalization in cell response across different lighting conditions. Upper: examples of stimuli used. Lower: the mean response (+/- 1 SE) of one cell to the face and half profile views of the same face under different lighting conditions with strong directional lighting from the top, side, and bottom. For each lighting condition response to the full face view was significantly higher than response to the half profile view and spontaneous activity (Neuman Keuls, $p < 0.001$ each comparison). (One way ANOVA $F = 67.9$, $df = 8,62$, $p < 0.0001$.) Reproduced with permission from J. K. Hietanen *et al.* (1992) and Springer-Verlag.

underlying three-dimensional surface (and its orientation to the viewer).

The impairment in coping with lighting change in Benton's task that is exhibited after brain damage can be seen as a 'mirror reflection' of the capacity of cell populations responsive to faces to generalize across lighting changes. The lighting constancy exhibited by cells responsive to faces is thus a second property predicted by considering the perceptual impairments following brain damage.

Impairments in perceiving face configuration

The relationship between the single-cell responses to faces and perceptual experience should allow predictions to be made about potential perceptual impairments in prosopagnosia. If we determine the

information that is processed by cells responsive to faces in the temporal cortex of monkeys, then it should be possible to predict losses in perception which should follow damage to an equivalent system in humans.

Most accounts of prosopagnosia claim that the patients are well able to recognize a face as a face, but that they simply fail to identify whose face it is. From this it has frequently been argued that the problem underlying prosopagnosia lies not in recognizing the general class of an object, but in the perceptual discrimination between (or recognition of) different exemplars of that class. It is therefore concluded that the perception of the basic attributes of a face is intact.

This conclusion may be unwarranted. Discriminating a face from other types of object is normally a very easy task. It can be performed using a variety of visual cues (the presence of hair, etc.) and may be helped by a variety of contextual cues (for example, that it is located on top of a body). If more subtle perceptual tasks are designed then it may well emerge that the perception of basic information about the face is deficient in many cases of prosopagnosia.

At the behavioural level monkeys, like humans, appear to be sensitive to face configuration (Dittrich 1990; see Fig. 5.1). Cells responsive to faces in the STS are not only sensitive to the presence of different parts of the face, but are also sensitive to the configuration of the features within the face (Perrett *et al.* 1982, 1988*a*, Yamane *et al.* 1988). One prediction from the cell properties is that patients suffering prosopagnosia should be impaired in making judgements about facial configuration.

To test this prediction a task was devised in which faces were presented with features in the normal position or in a jumbled configuration, with the positions of features rearranged into different symmetrical patterns. The stimuli were presented in different orientations (upright, horizontal, and inverted). The subject's task was to press one button for normal faces and another for jumbled faces. Control subjects were quicker to detect normal face configurations than they were to detect jumbled configurations. This advantage for the normal faces was found for all orientations tested. For simplicity the results have been pooled across orientation for Fig. 5.11. The advantage can be seen as reflecting the ability to perceive the overall configuration or *Gestalt* of the face.

The performance of one patient with long-standing prosopagnosia was tested on the same task (Newcombe 1979; Perrett *et al.* 1988*b*). R.B was able to perform the task with a high degree of accuracy, but this does not necessarily mean his perception of facial configuration was normal. The details of R.B's performance suggested otherwise. R.B's reaction times showed the opposite pattern to normal subjects,

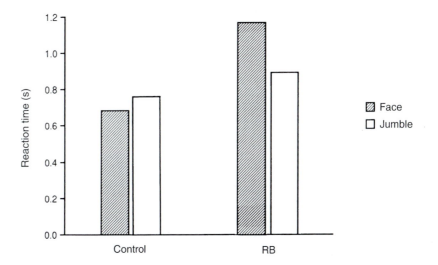

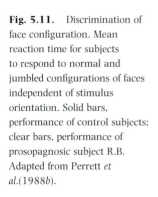

Fig. 5.11. Discrimination of face configuration. Mean reaction time for subjects to respond to normal and jumbled configurations of faces independent of stimulus orientation. Solid bars, performance of control subjects; clear bars, performance of prosopagnosic subject R.B. Adapted from Perrett *et al.*(1988*b*).

in that the was faster to identify configurations as jumbled faces than he was to detect faces with a normal configuration.

What may be happening here is that the patient can't 'see' or utilize the overall configuration of features. He therefore has to check every single feature, one by one, to determine whether it is in the right place. For example, he might adopt the strategy 'working away from the hair, the first feature should be a pair of eyebrows, than a pair of eyes, than a nose, and finally a mouth'. To give a 'yes' response (this is a normal face) he must check serially all features and only then can he deduce that the feature array is a normal configuration. By contrast he can terminate the scanning process whenever he detects a feature in the wrong place and give a 'no' response (this is a jumbled face).

In summary, R.B. appears to have lost the ability to use configurational information in perceiving facial structure. This forces him to use an unusual strategy when judging face configuration. The perceptual deficit was predicted from the cellular sensitivity to face-feature configuration and suggests that even the perception of basic qualities of the face can be impaired in prosopagnosia.

Impairments in perceiving gaze direction

Work at St Andrews revealed that many of the cells responsive to the face or profile face were sensitive to gaze direction. In fact 60 per cent were found sensitive to the direction of gaze (Perrett *et al.* 1985*b*, 1990*b*, 1992). If impairment in face recognition reflects damage to neural mechanisms equivalent to those studied in the temporal cortex of monkeys, then the perception of gaze direction should be affected by the brain damage.

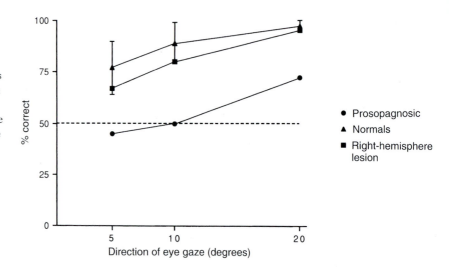

Fig. 5.12. Sensitivity to gaze direction. The mean level of accuracy for discriminating faces with eye contact from faces with laterally directed eye gaze is given for different degrees of gaze aversion. Triangles, performance of normal control subjects (*n* = 37, mean +/- 1 SD); squares, performance of a right hemisphere brain-lesioned control group (n = 19); circles, performance of prosopagnosic subject R.B. Adapted from Perrett *et al.* (1988*b*).

To test this hypothesis, a task was constructed in which a face was photographed either looking directly at the camera or looking away 5, 10, or 20° to the left or right of the camera. The pose of the head was also varied across photographs with three views: full frontal face and face rotated 20° to the left and right of the camera. The subjects had to choose those photographs in which the eyes are directed at the camera (and therefore at the subject). In this task, head view was irrelevant.

Figure 5.12 illustrates the performance on this eye-gaze task of the prosopagnosic patient (R.B.) (Newcombe 1979; Perrett *et al.* 1988*b*). R.B. performed the task relatively well for the easiest stimulus conditions. He was approximately 70 per cent correct when judging faces with the eyes deviated 20° away but for smaller angles of gaze deviation he was unable to tell whether or not the faces made eye contact or had averted gaze. R.B's performance was significantly worse than that of normal subjects and a group of control subjects with right-hemisphere brain damage (but no prosopagnosia). R.B. shows abnormally poor recognition of gaze despite his very good abilities in other visual tasks (Newcombe 1979).

Campbell *et al.* (1990, personal communication) have confirmed and extended the finding of impaired sensitivity to gaze direction in some cases of prosopagnosia. Campbell *et al.* (1990) also report that lesions in the STS produce an impairment in the ability of monkeys to discriminate gaze direction. This finding is important for the relation between cell activity and face perception that is being advanced here. Physiological studies of cells in the monkey STS suggest a correlation between visual dimensions of the face to which STS cells are

sensitive and impairments of face perception that may arise from lesions to an equivalent brain system in man. The causal link between cell responses to faces and face perception is further strengthened by the lesion studies. The work of Campbell *et al.* (1990) suggests that the brain area containing cells responsive to faces is necessary for perceptual discrimination of facial dimensions such as gaze direction.

Perceptual distortion of the face

From the evidence outlined above, it seems that in humans there are neural mechanisms selectively processing visual information about the face; these could well be located in the temporal lobe and be similar to those studied in the monkey. Brain scans of prosopagnosic patients often show lesions on the *ventral surface* of the brain between the *occipital* and *temporal* lobes. On this account some other bizarre symptoms related to prosopagnosia become interpretable.

Prosopagnosia is frequently related to memory problems, but there may be perceptual deficits which can accompany or cause the face-recognition problems. One perceptual dysfunction that occurs occasionally in patients with prosopagnosia is a spontaneous distortion of the shape of faces. In clinical reports patients often say things like 'All faces look like Picasso's paintings, they all look distorted' (Bodamer 1947; Whitely and Warrington 1977). Perceptual distortion or metamorphosis following brain damage can also occur without face-recognition problems. This section considers the potential source of perceptual distortions in face perception.

It is common for damage in the *right posterior parietal* cortex to produce a 'neglect' of the left half of the objects. Patients with right parietal lesions often fail to pay attention to the left half of objects. If such patients attempt to draw an object they may depict only the right half (cf. for example, Springer and Deutsch 1985); for example, drawings of a butterfly may display only the wings on the right side of the insect's body. Alternatively, the patient may crowd all the internal features to the right half of the depicted object. A clock may be depicted as a circle with all the numbers 1–12 written around the perimeter of the right side (rather than just the numbers 1–6).

Neglect following right posterior brain damage is not usually specific for faces. As was noted above, patients produce distorted depictions of a whole range of objects. Young *et al.* (1990), however, recently reported on a case with selective neglect. Figure 5.13 illustrates the patient's representation of a face. When given the individual features and asked to put them in the correct order, he misplaced the facial features on the left-hand side. The patient was, however, able to construct an accurate representation of other types of object,

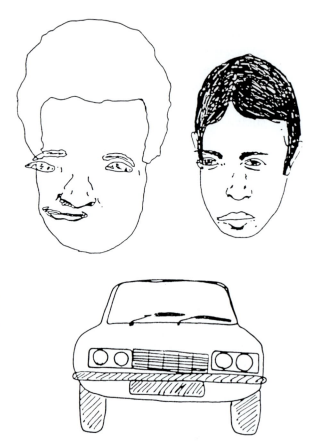

Fig. 5.13. Selective distortion of face configuration. Configurational arrangements made by a patient with perceptual distortion (metamorphopsia) of the left half of faces. *Upper*: Patient's arrangement of a face from facial features. *Lower*: Patient's arrangement of a car from component features. Reprinted with permission from Young *et al.* (1990). Copyright © 1990, Pergamon Press Ltd.

such as a car. This patient spontaneously complained that faces looked distorted (like fish heads), yet other objects looked normal to him. For this patient, the perceptual organization of faces was selectively disrupted.

One way of interpreting the selective distortion of faces is to propose, first, that there are mechanisms in the right parietal cortex controlling spatial attention and awareness, particularly towards the left side of objects. These mechanisms are not necessarily restricted to one sense (such as vision or hearing), but enable attention to be directed to the left-hand side of space. Secondly, it is necessary to propose that connections between parietal and temporal cortex become disrupted.

General visual neglect or distortion of the left side of all types of object may arise from the disturbance of pathways interconnecting spatial attention mechanisms in parietal cortex and object-recognition mechanisms in the temporal cortex. If this interpretation is correct then it is quite possible that a more selective disconnection between the parietal cortex and those specific regions of the temporal cortex processing faces would produce a selective neglect or distortion for faces.

The relationship between neglect and perceptual distortion is undoubtedly more complicated than that described here, but the explanation given here suggests a general principle. Once it is admitted that particular neural machinery is selectively responsible for processing visual information about faces, then it follows that a variety of face-specific syndromes may exist, each displaying the loss of one aspect of processing faces. If other brain systems are selectively involved in one type of cognitive operation (be it naming, revisualizing, or recalling the familiarity of an object), then selective disconnections may be possible between these brain systems and the cortical region which processes faces. The result would be a material (face)-specific loss in naming faces or revisualizing faces or recognizing faces as familiar.

Summary

The chapter has reviewed studies of neuronal responses to faces in situations in which the image of the face has been manipulated to make face perception difficult. The findings reviewed here indicate a number of relations between ease of perception and the magnitude and time-course of cell response. If the responses are reduced then perception is difficult. If the responses are delayed, then perception is delayed. This provides correlational or circumstantial evidence that the responses of the neural populations studied underlie perception of faces. The work on recognition deficits in monkeys following lesions to the brain areas containing cells responsive to faces supports a causal link between neural responses to faces and the recognition of facial attributes.

Not all image manipulations degrade perception; evidence from caricatures suggests that face recognition may be enhanced under certain conditions. The conditions for these enhancements are not yet fully understood. Moreover, just how such enhancements are reflected in the operations of the neural hardware of the brain remains a matter for speculation at present.

Studies of patients with face-recognition defects produce a number of parallels between the type of information about faces that the patients fail to perceive and the visual information about faces that the neural mechanisms are capable of detecting. It has been possible to predict perceptual deficits in prosopagnosia on the basis of the neural responses and, reciprocally, it has been possible to predict neural response properties on the basis of perceptual losses in prosopagnosia. All this leads to the speculative conclusion that the neural discharges provoked by faces are actually responsible for perception of the images as faces.

Acknowledgments

Physiological recordings were performed in collaboration with R. Bevan, K. Brierly, A. J. Chitty, A. S. Head, M. H. Harries, A. J. Mistlin, J. Ortega, D. D. Potter, P. A. J. Smith, and S. Thomas. Neuropsychological studies were performed in collaboration with E. de Haan and F. Newcombe. This research was funded by project grants from the MRC, SERC, ESRC, and NEDO (Japan). D.P. was supported by a Royal Society University Research Fellowship. W.D. was supported by the Deutsche Forschungsgemeinschaft and J.H. by the Pirkanmaa Cultural Foundation, the Kordelin Foundation, and the Aaltonen Foundation.

References

Barlow, H. B. (1972). Single units and sensation: a neuron doctrine for perceptual psychology. *Perception*, **1**, 371–94.

Baylis, G. C., Rolls, E. T., and Leonard, C. M. (1985). Selectivity between faces in the responses of a population of neurons in the cortex of the superior temporal sulcus of the macaque monkey. *Brain Research*, **342**, 91–102.

Benson, P. J. and Perrett, D. I. (1991*a*). Perception and recognition of photographic quality caricatures: implications for the recognition of natural images. *European Journal of Cognitive Psychology*, **3**, 105–35.

Benson, P. J. and Perrett, D. I. (1991*b*). Synthesising continuous-tone caricatures. *Image and Vision Computing*, **9**, 123–9.

Benson, P. J. and Perrett, D. I. (1992). Face to face with the perfect image. *New Scientist*, **1809**, 22 February, 1, 32–5.

Benson, P. J. and Perrett, D. I. (1994). Visual processing of facial distinitiveness. *Perception*, **23**, 75–93.

Benton, A. L. (1980). The neuropsychology of facial recognition. *American Psychologist*, **35**, 176–86.

Benton, A. L. and Van Allen, M. W. (1968). Impairment in facial recognition in patients with cerebral disease. *Cortex*, **4**, 344–58.

Bodamer, J. (1947). Die Prosop-agnosie. *Archiv für Psychiatrie und Zeitschrift für Neurologie*, **179**, 6–53.

Botzel, K. and Grüsser, O.-J. (1989). Electric brain potentials evoked by pictures of faces and non-faces: a search for "face-specific" EEG-potentials. *Experimental Brain Research*, **77**, 349–60.

Bradshaw, J. L. and Wallace, G. (1971). Models for processing and identification of faces. *Perception and Psychophysics*, **9**, 443–8.

Brennan, S. E. (1985). Caricature generator: dynamic exaggeration of faces by computer. *Leonardo*, **18**, 170–8.

Bruce, C. J., Desimone, R., and Gross, C. G. (1981). Visual properties of neurons in a polysensory area in superior temporal sulcus of the macaque. *Journal of Neurophysiology*, **46**, 369–84.

Campbell, R., Heywood, C. A., Cowey, A., Regard, M., and Landis, T. 1990. Sensitivity to eye gaze in prosopagnosic patients and monkeys with superior temporal sulcus ablation. *Neuropsychologia*, **28**, 1123–42.

De Renzi, E., Faglioni, P. and Spinnler, H. (1968). The performance of patients with unilateral brain damage on face recognition tasks. *Cortex*, **4**, 17–34.

Desimone, R., Albright, T. D., Gross, C. G. and Bruce, C. (1984). Stimulus-selective properties of inferior temporal neurons in the macaque. *Journal of Neuroscience*, **8**, 2051–62.

Dittrich, W. (1990). Representation of faces in longtailed macaques. *Ethology*, **85**, 265–78.

Ellis, H. D. and Florence, M. (1990). Bodamer's (1947) paper on prosopagnosia. *Cognitive Neuropsychology*, **7**, 81–105.

Gross, C. G., Rocha-Miranda, G. E., and Bender, D. B. (1972). Visual properties of neurons in the inferotemporal cortex of the macaque. *Journal of Neurophysiology*, **35**, 96–111.

Harmon, L. D. (1973). The recognition of faces. *Scientific American*, **229**, 71–82.

Hasselmo, M. E., Rolls, E. T., Baylis, G. C., and Nalwa, V. (1989). Object-centred encoding by face-selective neurons in the cortex in the superior temporal sulcus of the monkey. *Experimental Brain Research*, **75**, 417–29.

Heit, G., Smith, M. E. and Halgren, E. (1988). Neural encoding of individual words and faces by the human hippocampus and amygdala. *Nature*, **333**, 773–5.

Hietanen, J. K., Perrett, D. I., Oram, M. W., Benson, P. J. and Dittrich, W. (1992). The effects of lighting conditions on responses of cell selective for face views in the Macaque temporal cortex. *Experimental Brain Research*, **89**, 157–71.

Hofstader, D. R. (1980). *Gödel, Escher, Bach: an eternal golden braid*. Penguin Books, Harmondsworth.

Humphrey, N. K. (1972). 'Interest' and 'pleasure': two determinants of monkeys' visual preferences. *Perception*, **1**, 395–416.

Humphrey, N. K. (1983). *Consciousness regained*. Oxford University Press.

Jeffrey, D. A. (1989). A face-responsive potential recorded from the human scalp. *Experimental Brain Research*, **78**, 193–202.

Kendrick, K. M. and Baldwin, B. A. (1987). Cells in temporal cortex of conscious sheep can respond preferentially to the sight of faces. *Science*, **236**, 448–50.

Konorski, J. (1967). *Integrative activity of the brain*. University of Chicago Press.

Mooney, C. M. (1957). Age in the development of closure ability in children. *Canadian Journal of Psychology*, **11**, 219–26.

Newcombe, F. (1979). The processing of visual information in prosopagnosia and acquired dyslexia: functional versus physiological considerations. In *Research in psychology and medicine*, (ed. D. J. Osbourne, M. M. Grunberg, and J. R. Eiser). Academic Press, London.

Perrett, D. I. and Mistlin, A. J. (1990). Perception of facial attributes. In *Comparative perception*, Vol. II: Complex signals, (ed. W. C. Stebbins and M. A. Berkley), pp. 187–215. Wiley, New York.

Perrett, D. I., Rolls, E. T., and Caan, W. (1982). Visual neurons responsive to faces in the monkey temporal cortex. *Experimental Brain Research*, **47**, 329–42.

Perrett, D. I., Smith, P. A., Potter, D. D., Mistlin, A. J., Head, A. S., Milner, A. D., et al. (1984). Neurons responsive to faces in the temporal cortex: studies of functional organization, sensitivity to identity, and relation to perception. *Human Neurobiology*, **3**, 197–208.

Perrett, D. I., Smith, P. A. J., Mistlin, A. J., Chitty, A. J., Head, A. S., Potter, D. D., et al. (1985a). Visual analysis of body movements by neurons in the temporal cortex of the macaque monkey: a preliminary report. *Behavioural Brain Research*, **16**, 153–70.

Perrett, D. I., Smith, P. A. J., Potter, D. D., Mistlin, A. J., Head, A. S., Milner, A. D., et al (1985b). Visual cells in the temporal cortex sensitive to face view and gaze direction. *Proceedings of the Royal Society of London*, **3**, 293–317.

Perrett, D. I., Mistlin, A. J., and Chitty, A. J. (1987). Visual cells responsive to faces. *Trends in Neuroscience*, **10**, 358–64.

Perrett, D. I., Mistlin, A. J., Chitty, A. J., Smith, P. A. J., Potter, D. D., Broennimann, R., *et al.* (1988*a*). Specialized face processing and hemispheric asymmetry in man and monkey: evidence from single unit and reaction times studies. *Behavioural Brain Research*, **29**, 245–58.

Perrett, D. I., Mistlin, A. J., Chitty, A. J., Harries, M., Newcombe, F., and de Haan, E. (1988*b*). Neuronal mechanisms of face perception and their pathology. In *Physiological aspects of clinical neuro-ophthalmology*, (ed. C. Kennard and F. Clifford Rose), pp. 137–54. Chapman and Hall, London.

Perrett, D. I., Harris, M. H., Bevan, R., Thomas, S., Benson, P. J., Mistlin, A. J., *et al.*(1989). Frameworks of analysis for the neural representation of animate objects and actions. *Journal of Experimental Biology*, **146**, 87–114.

Perrett, D. I., Harries, M., Chitty, A. J., and Mistlin, A. J. (1990*a*). Three stages in the classification of body movements by visual neurones. In *Images and understanding*, (ed. H. B. Barlow, C. Blakemore, and M. Weston-Smith), pp. 94–108. Cambridge University Press, Cambridge, UK.

Perrett, D. I., Harries, M. H., Mistlin, A. J., Hietanen, J., Benson, P. J., Bevan, R. *et al.* (1990*b*). Social signals analysed at the single cell level: someone's looking at me, something touched me, something moved. *International Journal of Comparative Psychology*, **4**, 25–50.

Perrett, D. I., Oram, M. W., Harries, M. H., Bevan, R., Hietanen, J. K., and Benson, P. J. (1991). Viewer-centred and object-centred coding of heads in the macaque temporal cortex. *Experimental Brain Research*, **86**, 159–73.

Perrett, D. I., Hietanen, J. K., Oram, M. W., and Benson, P. J. (1992). Organization and functions of cells responsive to faces in the temporal cortex. *Philosophical Transactions of the Royal Society of London*, **335**, 23–30.

Phillips, R. J. (1972). Why are faces so hard to recognize in photographic negative? *Perception and Psychophysics*, **12**, 425–6.

Ramachandran, V. S. (1985). The neurobiology of perception. *Perception*, **14**, 97–103.

Rhodes, G., Brennan, S., and Carey, S. (1987). Identification and ratings of caricatures: implications for mental representations of faces. *Cognitive Psychology*, **19**, 473–97.

Rolls, E. T. and Baylis, C. G. (1986). Size and contrast have only small effects on the responses to faces of neurons in the cortex of the superior temporal sulcus of the macaque monkey. *Experimental Brain Research*, **65**, 38–48.

Springer, S.P. and Deutsch, G. (1985). *Left brain, right brain*. Freeman, New York.

Wallach, H. and O'Connell, D. N. (1953). The kinetic depth effect. *Journal of Experimental Psychology*, **45**, 205–17.

Whitely, A. and Warrington, E. K. (1977). Prosopagnosia: a clinical, psychological, and anatomical study of three patients. *Journal of Neurology, Neurosurgery and Psychiatry*, **40**, 395–403.

Wilbrand, H. (1982). Ein Fall von Seelenblindheit und Hemianopsie mit Sectionsbefund. *Deutsche Zeitschrift für Nervenheilkunde*, **2**, 361–87.

Yamane S., Kaji, S., and Kawano, K. (1988). What facial features activate face neurons in the inferotemporal cortex? *Experimental Brain Research*, **73**, 209–14.

Yin, R. K. (1969). Looking at upside down faces. *Journal of Experimental Psychology*, **81**, 141–5.

Young, A. W., de Haan, E. H. F., Newcombe, F., and Hay, D. C. (1990). Facial neglect. *Neuropsychologia*, **28**, 391–415.

6 When paying attention is too costly

GLYN HUMPHREYS

Neurological studies of visual perception are based on the idea that, by looking at how visual perception breaks down after brain damage, we can learn something about the intricate mechanisms normally involved when we recognize objects and when we attend to them in the environment. The history of neuropsychological studies of visual recognition and attention dates back quite a long way. For instance, at the turn of the last century the German neurologist Lissauer made a distinction between two general types of problems. He termed these problems in apperception and problems in associa-tion. Patients were said to have an apperceptive problem if they had difficulty forming stable perceptual representations about their world. In contrast, patients with an associative problem are able to form stable perceptual representations, but seem unable to link these rep-resentations to their knowledge about the world. That is, they have a specific problem in associating what they are seeing with what they know.

At a clinical level, the distinction between apperceptive and asso-ciative recognition problems captures some of the differences between separate groups of patients — a point I will illustrate with reference to three patients, H.J.A., S.A., and S.P..

H.J.A. suffered a stroke in 1981 which left him with profound problems in visual recognition. He was unable to recognize many common objects by sight, he could recognize no faces (not even those of his close family), his colour perception was disturbed, and he was able to read words only in a laborious letter-by-letter fashion. Nevertheless, many of his other faculties were quite undisturbed. His language skills were unaffected, he had no loss of motor function, and he could recognize people by their voices and objects from touch. The problem was selective to vision. When looking at objects he often failed to make any sense of them and made 'visual' naming errors, such as calling an onion a ball. His problem was one of recognition, rather than naming. Yet, despite his poor visual recogni-tion, H.J.A was able to copy objects, even when he had no idea what

(a) Eagle

(b) Guitar

(c) Owl

Fig. 6.1. Examples of H.J.A.'s copying.

(d) Bee

they were. Figure 6.1 illustrates a number of such copies. In each instance, H.J.A.'s copy is on the right. He was unable to identify all the target objects.

Interestingly, H.J.A. was also able to produce drawings from memory of what objects should look like. Figure 6.2 shows a drawing from memory of an aeroplane. H.J.A. was able to produce such drawings of objects even when he could no longer recognize the objects in real life; indeed, he was unable to identify the objects in his own drawings if shown them some time later.

Rudder

Tail fin
⊥
rudder

Upper wing

Canvas
covered body

Lower wing

Canvas
upper wing

Engine

landing wheels

Canvas lower
wing (not same span
as upper)

Airscrew

Inter wing struts

Rigging wires

Fig. 6.2. An example of
H.J.A.'s drawing of objects from
memory. An aeroplane.

H.J.A.'s case shows that visual recognition can be grossly dis-
turbed even when patients can show that they 'see' the objects in
front of them (by copying) and even when they have accurate mem-
ories of the objects concerned. The problem seems to reflect a break-
down in associating incoming information to stored visual
knowledge.

S.A. and S.P. contrast with H.J.A.. S.A. had cerebral atrophy, ini-
tially confined to the visual associative areas of the brain. S.P. had
suffered carbon monoxide poisoning, the effect of which can be to
produce multiple disseminated lesions throughout the cortex. Both
patients had difficulties recognizing visual objects. Both made errors
by apparently focusing on a part of an object and identifying that as
the whole. For instance, S.P. named a pencil with a rubber at its end
'an eraser'. S.A., when given a cup with a floral pattern on it, said
the object was 'an apple'. In addition, both patients were unable to
copy the objects they failed to identify (or indeed any objects). Figure
6.3 shows some of their attempts to copy simple line drawings. In
Lissauer's terms, such patients may be thought to have a kind of
apperceptive problem in establishing stable percepts, which prevents
them from either copying or identifying the objects.

(a) SA's copy

(b) SP's copy

Fig. 6.3. An example of S.A.'s
and of S.P.'s attempts at copying
simple two-dimensional figures.

However, despite the clinical utility of the apperceptive-associative distinction, elsewhere I have argued that we need finer-grained analyses if we are to understand the kinds of processes being affected in these patients (see Humphreys and Riddoch 1987*a*). I will present a case here based on a finer-grained analysis of the recognition disorder in patients S.A. and S.P. The case of H.J.A. has been dealt with in some detail in previous papers (for example, Humphreys and Riddoch 1987*b*; Riddoch and Humphreys 1987). My aim is to show that neurological disturbances of recognition and attention can only be understood with reference to a model of how such processes normally occur.

Balint's syndrome

Patients like S.A. and S.P. were originally described, again at the turn of the century, by the neurologist Balint. He reported patients with a 'psychic paralysis of visual fixation' in association with disturbances in visual attention and 'optic ataxia' (misreaching under visual guidance). Clinically, patients are said to have Balint's syndrome if they have a concurrence of two kinds of problems: optic ataxia and 'visual disorientation'. The term 'visual disorientation' is used when only that stimulus at the centre of the patient's vision seems to be seen at any one time; this leads to the patient often being disoriented in space. The work I will report is concerned solely with 'visual dis-

orientation' and my interest is with how visual disorientation relates to recognition problems the patients experience.

Visual disorientation can often lead to patients having marked problems in everyday life. For instance, when I first met S.P. he was across a ward from me. On being called across to meet me, S.P. attended only to me and walked across all the obstacles that lay between us — even when they were directly in front of him but below his gaze.

Visual disorientation also leads to problems in interpreting complex scenes. Both S.A. and S.P. had problems understanding pictures of scenes because they were unable to relate aspects of the scene together (for example, to tell whether there were two people having a conversation or just one person alone). In interpreting complex pictures it is very difficult for the patient to pick up the meaning of the whole scene, given that identification seems to be based on isolated objects in a serial fashion.

Attempts have been made to account for disorders such as these. In an influential paper in 1962, Kinsbourne and Warrington proposed that such patients have a prolonged 'refractory period' for recognition. That is, that having identified one item, the patients then need an abnormally long time before they can move their attention on to another item to recognize it. This is indeed an accurate description of such patients' behaviour, but it does not give us a clear idea of what visual processes are disturbed. What is needed is an account that maps on to our understanding of the basic mechanisms normally involved in visual attention and recognition.

I am going to present a very simple idea of one of the processes normally involved in attending to the world that seem to go wrong in patients like this. The argument is that our ability to attend to objects in the environment is based on interactions between parts of an attentional network. One part of this network is concerned with orienting attention to salient or new visual signals. However, to produce such orienting, there needs to be inhibition of the system that normally ensures that attention remains engaged on an object. Such inhibition is produced when there is strong activation of the orienting system. Similarly, when we are concentrating on an object, there may be inhibition of the orienting system so that we are not distracted by suboptimal visual signals. Thus, whether our attention is engaged or orienting away from an object depends on inhibitory interactions between 'orienting' and 'attentional engagement' mechanisms, which constitute part of an attentional network (see Humphreys and Riddoch 1993).

My suggestion is that in Balint's syndrome we witness disruption of this attentional network and that this can in turn affect object recognition. In particular, attention in these patients cannot be dis-

engaged from objects once they are attended. If attention is engaged on a part rather than the whole object, the patients misidentify the part as the whole. Thus, visual attention and object recognition are intimately tied together.

Disengagement problems in Balint's syndrome

That Balint's syndrome patients may have problems disengaging attention can be shown in several ways. With S.A. and S.P., it can be shown dramatically by contrasting their ability to find one target in a visual display with their ability to find two such targets. For instance, consider a task such as finding a blue letter set amongst a field of red and green letters. Providing the colour difference between the 'target' (the blue letter) and the 'distractors' (the other letters) is reasonably salient, the target can be found equally fast irrespective of the number of distractors present — the target seems to 'pop out' from the background. This is also true when, for example, the target is a large letter and the distractors small. Such 'pop out' effects can be understood in terms of the simple model of attention I suggested. The colour or size difference is discriminated by the orienting system, which inhibits the attentional engagement system and allows attention to be refocused on the target. For there to be no (or at any rate only small) effects of the number of distractors involved, the orienting system would need to respond to colour or size differences computed in parallel across the visual field.

Now consider the case when subjects have to respond only when they detect that both a blue and a large letter are present, so that detecting either target alone is not sufficient. Quinlan and Humphreys (1987) showed that normal subjects are a little slower in this case as against one in which they have only to respond to a single colour or size-defined target; however, the nature of the search process does not seem to change — there are again few effects from the number of distractors present and any effects that do occur are not increased by having to search for targets defined by two dimensions rather than just one (that is, by colour as well as by size). Thus, the rate of searching for each target did not change, though there was a constant increment in the time taken to decide that two targets were present. From this it appears that subjects can conduct simultaneous searches for two targets variously defined by colour and size, but that detecting the target along each of two dimensions has some cost associated with it. For instance, having detected a colour target first makes subjects a little slower in detecting a size target, compared with the time taken when subjects have only to search for a size target alone. We can think of this in terms of atten-

tion having to be disengaged from the colour target in order to become re-engaged on the size target. Since this is an extra step in detecting the size-defined target, responses are slower overall.

One interesting side point here is that our ability to conduct simultaneous searches along two or more dimensions may be something determined by the physiological organization of visual processing in the brain. Perhaps the dimensions that can be searched for simultaneously, without slowing the rate of search for targets along either dimension, are those that are represented in separate processing streams, with little cross-talk taking place between the streams. Search studies varying the dimensions that can be processed in this way may provide a useful source of converging evidence for physiological work on the independent processing of dimensions of visual stimuli (see, for example, Chapter 3 by Livingstone and Hubel in this volume).

We gave the colour and size search tasks to S.A. and S.P.. Both performed relatively well. Their reaction times (RTs) were slow compared with those found with non-brain-damaged control subjects, but this may be expected as a general consequence of brain damage. More interesting is that the pattern of data is the same as that found in controls — there were only small (and even then non-linear) effects of the number of distractors on their search performance. However, the patients were dramatically worse than the controls when asked to detect the presence of two targets in the displays (that is, in the colour plus size condition). In controls, the overall increment is approximately 10 per cent of the RT in the slowest single-feature condition. For S.A. there was an increment of approximately 70 per cent of her RT in the slowest single-feature condition (with size-defined targets). For S.P. the effect was even stronger. S.P. showed increments of the order of 8 s in detecting the second of two targets; this compared with an RT of approximately 2 s to detect either target alone. RT increments of 70 per cent are an order of magnitude worse than those found normally; in S.P.'s case, the increment was approximately 400 per cent, indicating the profound nature of his problem. Data for the two patients are shown in Fig. 6.4.

These results show two things.

1. When asked to detect a single target defined by a salient difference in some simple feature relative to the background (such as a colour or size difference), the patients produce a normal pattern of performance. Thus, the patients can orient to information computed in parallel across a visual display.

2. Their problems arise primarily when they have to disengage their attention from one target in order to detect a second.

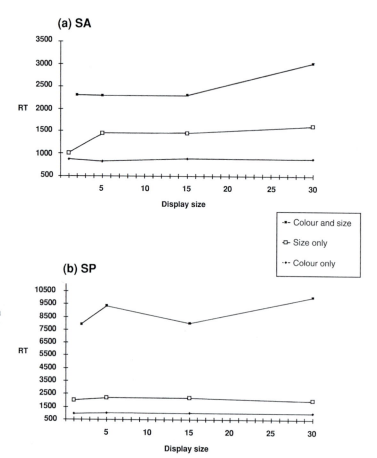

Fig. 6.4. RTs to respond that a target is present, as a function of the number of items in the display, in three different response conditions: respond to single colour target, respond to single size target, and respond only when both the colour and the size target are present. (a) S.A.; (b) S.P.

We can conceptualize this disengagement problem in terms of the simple account of attentional processes we have put forward. Providing their attention is not engaged on an object, the patients can orient to salient signals in their environment. However, once attention is engaged on a target, there is inhibition of the orienting system. In some patients, this inhibition may be sufficient to eliminate orienting, because the orienting system is itself partially damaged; in others, there may be abnormal inhibition, which prevents outputs being made available from an otherwise unimpaired orienting system. In each case, the net effect is that the patient's attention becomes fixed on the current target.

This proposal, that disengagement problems are fundamentally important in Balint's syndrome, can account for a wide range of the phenomena associated with the syndrome. For instance, the difficulties the patients have with copying can be linked to their problems in moving attention across a figure in order to allow accurate reproduction. Their difficulties in identifying objects can be

attributed to their attention sometimes being captured by a local part of an object, which they then take as the whole.

However, let us pause for thought. The last point, about whether the patients attend to whole objects or to their parts, prompts at least two questions.

1. What determines the relation between objects and their parts?

2. How does information about whole and part objects interact with the visual attentional system?

Patients such as S.A. and S.P. can help to throw light on such questions and, hence, help us understand the nature of object coding and its relation to visual attention.

Attending to objects

Recent accounts have stressed the importance of spatial coding for visual attention — of space as the medium for attentional acts. However, in real life we must attend to objects that are often not defined in a simple spatial manner. For example, the parts of an occluded object may often be closer to those of the occluding object than they are to other parts of the same (occluded) object. Attending to the parts that are in the same spatial area will be inconsistent with the objects that are really present. For reasons such as this, it may be computationally more useful for attention to be guided to **objects** rather than to **space**, with the objects for attention being defined by (for example) the presence of non-accidental features in images. (Non-accidental features are those that are unlikely to arise by chance as a result of 'noise' in the image; they include properties such as collinearity, symmetry, and continuation; Lowe 1987.)

Patients such as S.A. and S.P. allow us to investigate whether attention is object rather than space based. Since the patients are very poor at disengaging attention, we can assess the nature of the representation that they have difficulty disengaging from; for instance, do they find it easier to report two targets in displays if the targets are close together or if the targets form part of a single object (for example, as a result of continuation between the targets)?

We investigated this in a variation of the 'colour and size' experiment reported above. The patients were given brief (between 50 ms and 2 s) presentations of displays containing red and green coloured circles. On half the trials the circles were all of the same colour; on the other half they were of different colours. The patients simply had to decide whether all the circles were the same colour or not.

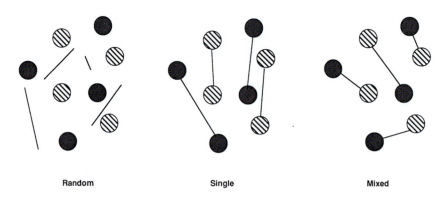

Fig. 6.5. Examples of the displays used to test whether attention was object rather than space based in S.A. and S.P. In the experiment, the circles were either all red, all green, or red and green. The figure illustrates the case when only two colours were present.

Though this task is trivially easy for normal subjects at the exposure times used, both S.A. and S.P. found the task difficult and made many errors (typically reporting that there was only one colour present when there were two; note, though, that they had no difficulty in discriminating red from green *per se* and that they could always name the colour of the circles when there was only one colour present). We then extended the study by incorporating black lines into the displays. The lines were either placed randomly in the field or they were drawn to circles of the same colour (the **single-colour** condition) or to circles of different colours (the **mixed-colour** condition). Figure 6.5 illustrates the three conditions. We were interested in whether drawing a line between circles of different colours would facilitate performance, because the different coloured circles would then be coded as single objects. In fact this was the case. The patients were better at reporting that two colours were present in the **mixed-colour** condition than in either the **random** or the **single-colour** conditions. This improvement occurred even though the circles were spaced the same distance apart in each condition. Thus the patients seem to attend to objects rather than to space. Their problems in disengaging attention are more pronounced when attention must be disengaged from one object and allocated to others in the field, as against when they report on the parts of a single object.

Neuropsychology and experimental psychology

The results of S.A. and S.P. thus illustrate the importance of object coding for visual attention. Non-accidental relations between parts allow the parts to be attended together (as a single object), supporting the idea that attention is object rather than purely space based. Such results indicate the utility of neuropsychological research for furthering our understanding of normal processes. However, models

of normal processes (such as our proposal for an interactive attentional network) are also needed so that we can better understand neuropsychological disorders. We suggest that neuropsychological research best benefits understanding when applied in this reciprocal way.

Acknowledgements

This work was supported by a grant from the Medical Research Council of Great Britain. The research was carried out in collaboration with Jane Riddoch, who also provided useful comments on the chapter.

References

Humphreys, G. W. and Riddoch, M. J. (1987a). The fractionation of visual agnosia. In *Visual object processing: a cognitive neuropsychological approach*, (ed. G. W. Humphreys and M. J. Riddoch). Erlbaum, London.

Humphreys, G. W. and Riddoch M. J. (1987b). *To see but not to see: a case study of visual agnosia*. Erlbaum, London.

Humphreys, G. W. and Riddoch M. J. (1993). Interactions between object and space systems revealed through neuropsychological. In *Attention and performance XIV*, (ed. D. E. Meyer and S. Kornblum). Erlbaum, Hillsdale, NJ.

Kinsbourne, M. and Warrington, E. K. (1962). A disorder of simultaneous form perception. *Brain*, **85**, 461–86.

Lowe, D. (1987). Three-dimensional object recognition from single two-dimensional images. *Artificial Intelligence*, **31**, 355–95.

Quinlan, P. T. and Humphreys, G. W. (1987). Visual search for targets defined by combinations of colour, shape and size: an examination of the task constraints on feature and conjunction searches. *Perception and Psychophysics*, **41**, 455–72.

Riddoch, M. J. and Humphreys, G. W. (1987). A case of integrative visual agnosia. *Brain*, **110**, 1431–62.

Technical terms

Apperceptive visual agnosia A deficit in visual object recognition due to problems in establishing stable perceptual representations.

Associative visual agnosia A deficit in visual object recognition due to problems linking perceptual representations with stored knowledge.

Balint's syndrome The classification used for patients who are visually disoriented and who have poor reaching to objects under visual guidance.

PART II: *Starting to see*

introduced by RICHARD GREGORY

Introduction to Part II: Starting to see

RICHARD GREGORY

An infant is a child too young to talk. It is hard enough to know—even to guess — what goes on in an adult's mind, let alone what an infant sees. Opinions range from William James's 'blooming, buzzing confusion' to Plato's notion that we start by knowing everything, which we forget through infancy, to learn essentially by remembering. The snag is, we can't remember what it was like to be an infant.

Janette Atkinson reports in 'Through the eyes of an infant' her ongoing experiments on which parts of the brain are active in the first few months of life. Recent technologies are not only giving new answers to ancient speculations, they are opening up unconsidered possibilities. So technology pushes back the boundaries of metaphysics.

In 'Mother and baby — seeing artfully eye to eye', Colwyn Trevarthen develops his work on the intimate communication between mother and baby, which seems to be highly significant for later life. He sees aesthetics as based on and evidence for our first responses to the world and to other human beings. Whether innate behavioural responses are appropriate and adequate for development, to live in unnatural civilization, and how far mothers should take account of the findings of psychology are important questions for future of humans.

7 Through the eyes of an infant

JANETTE ATKINSON

Finding out what infants see presents special problems, as they cannot talk. They do, however, initiate limited motor actions and they react to visual stimuli behaviourally and physiologically.

We will describe several methods of investigating the perception of infants, behaviourally and physiologically — and show how these change over age — and, particularly, will give details of the vision of our own daughter, Ione Biba, who was intensively measured on different tests during the first year of her life. Using converging evidence from these different types of methodologies, I want to argue, by analogy, that there are two plausible models to account for changes in early visual development. One model suggests that newborn vision is largely controlled subcortically, and is in some respects analogous to the system operating in 'blindsight' patients, (Atkinson 1984; Weiskrantz 1986). Blindsight patients have visual cortical damage and have regions within their visual fields without conscious awareness of seeing and so are 'blind', yet are able to direct their eyes and limbs to targets in the blind field. This blindsight function is thought to be mediated by subcortical pathways from the eyes to the superior colliculi (which are also called the tectum) in the midbrain. The second possible model is that, in addition to the subcortical–cortical dichotomy, there is differential development within the cortical pathway of two cortical streams — the magnocellular and parvocellular routes (Rose, this volume, Chapter 2, p. 28; Van Essen and Maunsell 1983; Maunsell and Newsome 1987; Zeki and Shipp 1988; Atkinson and Braddick 1990; Zeki 1990). These two streams control different aspects of visual analysis and originate in distinct subsystems: the magnocellular pathway processes the signals from the eyes to extract relative movement and stereo information; the parvocellular pathway extracts colour and static orientation information, (Livingstone and Hubel 1988).

Jean Piaget, the famous Swiss child psychologist and his followers argue that motor actions are overt manifestations of what the infant

is seeing and thinking. To reach for an object the infant must understand that the visual image corresponds to an object in the world and must therefore have an internal representation of it. According to this argument, only when an infant understands object existence will the appropriate action be made. The motor actions carried out by newborn infants are very limited; infants do not reach reliably until around 5 months of age, but they control their eye movements from birth and have physiological responses which can be measured and from which we can infer perceptual discriminations.

Behavioural techniques for measuring early infant development

The infants' behavioural response we have studied most is their looking behaviour. This may be monitored under a variety of different experimental paradigms, including tracking, habituation procedures, preferential looking methods, operant methods, optokinetic nystagmus, and photorefractive measures.

Tracking

Newborn infants will visually track a high-contrast schematic face-like pattern if it is slowly moved laterally outwards from the midline. They also track many high-contrast patterns, so it seems unlikely that the tracking behaviour *per se* is specifically linked to face recognition. Only by examining differential tracking responses to different patterns can we start to map changes in visual sensitivity. Even then, with such a global response it is difficult to know why the infant makes the tracking response over a limited part of the visual field and what the infant 'understands' from this behaviour. From reactions alone, we never know whether the infant is merely discriminating patterns or is in addition interpreting these patterns to give object qualities. However, if the infant generalizes to give the same reactions to the same object specified by a variety of patterns, we can argue that some perceptual (and possibly cognitive) processing is involved — the infant's brain is going beyond mere sensory discriminations. For example, Yonas and his colleagues (Yonas and Arterberry 1987) have shown that infants can discriminate a shape using either cues of binocular parallax (stereo vision from the two eyes' slightly different images, which can give depth) or kinetic motion (the different velocities of the near and further parts of the object, which can give depth) and can transfer learning between the two.

Habituation

One commonly used paradigm to gauge infant reactions is called 'infant control habituation' (for example, see Horowitz 1975). The same stimulus is repeatedly shown to the infant, with attention being monitored by recording each consecutive period of fixation on the stimulus. As the infant processes the pattern and becomes familiar with it, the looking times reduce in duration. When a certain reduction in looking time is reached, the infant is said to be *habituated*. The 'test phase' of the procedure immediately follows. In this phase, the stimulus is changed to a novel pattern and the infant's response to both the 'old' and the 'new' stimulus is measured. Any differential response can be taken as evidence of discrimination between the two stimuli. For example, the infant might fixate the 'new' stimulus for a longer period than the 'old'.

Preferential looking

Another behavioural method for looking at infants' reactions is to measure visual preferences (for example, see Teller 1979). Usually, paired stimuli are presented to the infant and the observer records whether one pattern is looked at for relatively more time or more often. The method is commonly known as forced-choice preferential looking (FPL). Sometimes both habituation and FPL are combined to provide a more sensitive measure of the infants' responses.

Operant procedures

Infants can be rewarded for making a particular response to the presentation of a stimulus. How the infants generalize their conditioned response can be used as measure of what they see.

Optokinetic nystagmus

Optokinetic nystagmus is rapid cyclical movements of the eyes evoked by a large field of moving stripes or pattern. In each cycle the eyes slowly track the pattern movement and then flick back in the opposite direction.

Photorefraction

In addition, we have developed a photographic and video technique to measure optical focus in infants' eyes. This is called isotropic photo or video refraction (Atkinson *et al.* 1981; Atkinson *et al.* 1983, 1984; Howland *et al.* 1983; Braddick and Atkinson 1984;

Braddick *et al.* 1988). The method has been calibrated against retinoscopy and so gives measures of refractive errors and accommodative ability. Because the method is fast, safe, reliable, and non-invasive, it can be used with infants and children of all ages to chart development. Of course, optical defocus can be caused by factors in the eye itself, such as the shape of the cornea or by neural feedback controlling optical parameters or by some combination of both. It is quite difficult to separate optical, retinal, and post-retinal neural factors, although models are now being developed to attempt this (for example, see Banks and Bennett 1989).

Physiological techniques for measuring early infant development

A non-behavioural and non-invasive method of investigating infant vision is to measure the brain's activity using the technique of the visual evoked response (VER). Electrical activity in the visual area of the brain is measured in response to visual stimuli by small surface electrodes placed on the infant's head and secured in position using a small version of a tennis band. When an infant is presented with repeated flashes of a patterned stimulus, the neural signals passing through the visual areas of the brain produce small voltage changes that are picked up by the electrodes. These are averaged and the resulting brain response to the pattern can be measured. VERs have characteristic functions over time — which can be divided into different components. The VER is described in terms of the amplitude of the voltage change and the delay after the stimulus.

We make bipolar recordings, using 'designer stimuli' which are constructed to stimulate particular parts or 'channels' within the visual system. For example, we can use dynamic displays of random dot correlograms and stereograms, stimulating cortical detectors, to plot the development of binocular vision.

Comparison of behavioural and physiological techniques for measuring early infant development

Using these various techniques, we have charted the course of infant visual development. By far the most convincing results are achieved when similar answers are found to questions posed to infants of the same age over different paradigms and techniques. It is, of course, very time-consuming to utilize multiple techniques combined with longitudinal methods, so well-controlled comparisons of this kind are rare in the literature.

The most basic measure of vision is acuity, the contrast sensitivity function being a more extensive version of spatial sensitivity. Many researchers have claimed that in the first year of life acuity estimates using VER methods are higher than acuity estimates using FPL behavioural methods (for example, Dobson and Teller 1978; Sokol 1978). This difference has been put down to different methods' tapping different underlying mechanisms, different criteria, and/or different levels of sensitivity. However, hardly any studies have tested the same infants with comparable stimuli and criteria across techniques. We attempted to rectify this paucity of data by carrying out extensive studies on one of our own children, Ione Biba, controlling as well as possible the stimuli and measures made across techniques. Contrast sensitivity was measured daily for the first 3 months of life (totalling approximately 250 testing sessions!) using three techniques, each with matched stimulus displays.

1. Visual evoked potentials to a phase reversing grating (gratings which switch from black to white stripes, and from white to black).

2. FPL (forced preferential looking) to a drifting grating and to a phase reversing grating, and

3. The optokinetic nystagmus response to a binocularly viewed drifting grating pattern.

Temporal and spatial parameters were matched across techniques. Fig. 7.1 shows an example of the estimates of contrast sensitivity obtained from different measures. Very comparable estimates were found across the different measures for acuity and contrast sensitivity over the first 3 postnatal months (Atkinson and Braddick 1989). This suggests the operation of a common limiting factor (or factors). One important limitation is set by the photon catch of individual retinal cones, which have been found to be immature in the early

Fig. 7.1. Longitudinal study of development of contrast sensitivity in Ione Braddick: contrast sensitivity function using the forced choice preferential looking method, forced choice optokinetic nystagmus, and VEP measures.

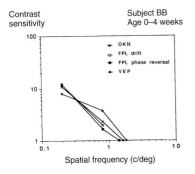
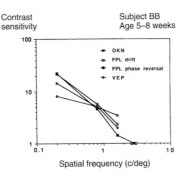
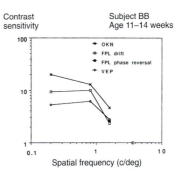

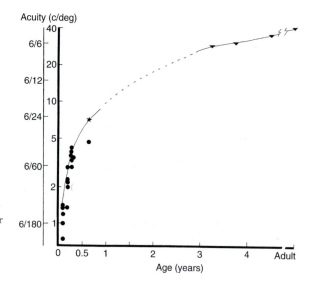

Fig. 7.2. Mean acuity measurements at different ages from studies in our laboratory. Solid circles are data from preferential looking tests; the star is from a tracking test; triangles are from a grating orientation discrimination task.

post-natal months (Abramov *et al.* 1982). Calculations vary as to how much of the difference between infant sensitivity and adult sensitivity depends on photoreceptor immaturity (Jacobs and Blakemore 1988; Banks and Bennett 1989). From these models it seems likely that neural as well as receptor limitations are involved. Figure 7.2 shows how the acuity of newborns compares with that of adults, and improves with age.

What was vision like for Ione Biba over the first 3 months? We can really only guess at what people and objects 'look' like to a young infant, as their perceptions are unlikely to be the same as those of adults who have developed a normal perceptual system but have reduced visual acuity and contrast sensitivity (for example, in elderly cataract cases). In Fig. 7.3(a) and (b) we have simulated the degradation in the sensory image for a 1-month-old and a 3-month-old infant. The main point that can be made from such an exercise is that even with degraded acuity and contrast sensitivity the main features, allowing personal identification, are still available so long as you have some rules that allow you to identify the image initially as a face. Some researchers argue that we are born with functioning 'face detectors', others that we learn distinguishing features of familiar faces very rapidly in the first few weeks of life. We still have very little idea as to what the critical 'face detecting' features might be in the newborn and to how they might develop in the first few months of life.

Acuity and contrast sensitivity are not the only important measures to be made in visual development. During the past 15 years we, together with a number of other research groups, have used these various techniques to map out development of many different

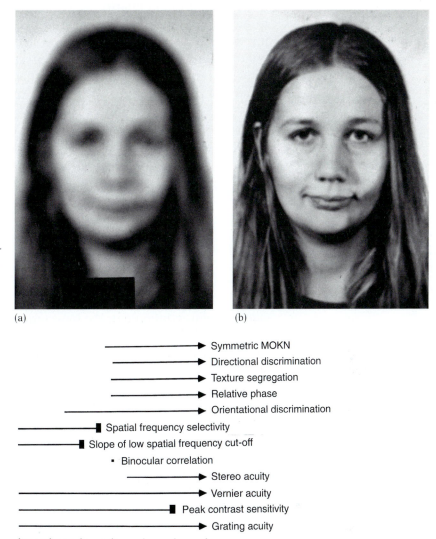

Fig. 7.3. Simulation of the image of a face for (a) a 1-month-old and (b) a 3-month-old infant, using our knowledge of contrast sensitivity and acuity at these ages.

(a) (b)

Fig. 7.4. Summary of the human infant's developing sensitivity to a number of visual attributes over the first 6 post-natal months. The arrows show that development is in progress. The starting-point of each arrow indicates the age at which discrimination of this attribute is first shown. The square block, at the end of some lines, indicates that measurements have not been made beyond this age.

Symmetric MOKN
Directional discrimination
Texture segregation
Relative phase
Orientational discrimination
Spatial frequency selectivity
Slope of low spatial frequency cut-off
Binocular correlation
Stereo acuity
Vernier acuity
Peak contrast sensitivity
Grating acuity

0 1 2 3 4 5 6
Post-natal age (months)

visual attributes. A summary of these results is shown in Fig. 7.4. The arrowed line, starting immediately after birth and continuing up to 6 months, represents a visual attribute which can be measured in terms of sensitivity at birth and which shows continuous improvement over the first post-natal months, for example contrast sensitivity. Sensitivity to other visual attributes, for example binocular disparity, cannot be demonstrated in newborns, but has an onset approximately 4 months postnatally. In Fig. 7.4, therefore, the arrow for this function only starts at 4 months. In general there are many improvements between birth and 4 postnatal months.

Three-month-old infants are very active users of vision compared to newborns. At 3 months the eyes are constantly moving, exploring the visual scene, making eye contact with others, and selecting, finding, and following objects of interest even when they move some distance away. This is very different from newborn visual behaviour. It is often quite difficult to attract a newborn's attention and, once attracted, attention can easily be lost if the object motion is rapid. Sometimes sight and sound together can elicit attentional shifts in newborns, but even then the switches can be quite tardy and hesitant. Although there is anecdotal evidence of these changes, reliable experimental evidence has only been gathered recently.

The blind sight hypothesis

One response dependent on neurons within the visual cortex is 'orientation discrimination' (the difference in tilt of stripes or lines that can just be discriminated). We have tested orientation discrimination using both behavioural and VER methods. In our first experiments we got very good agreement between the two techniques (Braddick *et al.* 1986; Hood *et al.* 1988). Newborn infants did not seem to discriminate between two obliquely oriented dynamic grating patterns, whereas 3-month-old infants did. This result, together with others on postnatal onset of sensitivity to binocular disparity, texture elements, and relative phase, led me to believe that the newborn infant has a relatively immature visual cortex and that vision in the first few weeks of life is controlled largely subcortically (Atkinson 1984, 1990; Braddick and Atkinson 1988). It looked as though as the cortex matures the infant is able to make more and more sophisticated visual discriminations. The general theory of two visual systems in infant development had been originally put forward by Bronson (1974), using evidence from hamster, cat, and primate studies. Data on binocularity and orientation allowed me to put forward more convincing evidence for lack of cortical functioning in the newborn than had been available at the time of Bronson's proposal. Many of the deficiencies we saw in newborn vision compared to 3-month-old vision looked similar to the deficiencies of blind sight patients (see for example, Weiskrantz 1986) and, indeed, to vision in other species relying on tectal rather than cortical systems. Like 'blind sight' patients, newborns can detect and localize objects without being able to make elaborate pattern discriminations. There is still debate about newborn colour discrimination with isoluminant (colour contrast without luminance contrast) patterns; some have argued for lack of true colour opponency until 3 months postnatally,

whereas others have evidence for these mechanisms operating at birth (Morrone *et al.* 1990). Some primates without a striate visual cortex show deficits in colour discrimination, although these deficiencies are likely to reflect damage in other visual cortical areas as well as the striate cortex. Human patients who have damaged striate visual cortex, but have functional pathways from the lateral geniculate nucleus to other visual cortical regions, can discriminate hues in isoluminant displays (Cowey and Stoerig 1991). Of course we have no way of knowing whether newborns are consciously aware of the targets they detect and so any analogies made between the vision of newborns and blindsight must be based on similarity of overt behaviour.

In my 1984 paper, the data on which I based my subcortical–cortical split was largely the lack of orientation and binocular disparity discrimination in newborns, the newborn's asymmetrical optokinetic nystagmoid response with monocular stimulation (MOKN), lack of smooth pursuit eye movements, and pilot data showing slow poor shifts of visual gaze to targets appearing in peripheral visual fields. However, some of our later experimental results, together with data from a number of other laboratories, allow us now to elaborate further on the original hypothesis.

First, from our own tests and those of Slater on orientation discrimination, we found that newborns can discriminate between static patterns of differently oriented gratings (Atkinson *et al.* 1988; Slater *et al.* 1988) and that a complex relationship exists between spatial and temporal parameters in detecting orientation change. It seems that younger infants show orientation discriminations if the spatial and temporal frequencies are low, while older infants (3 months and upwards) can detect finer and faster changes of orientation. At present we know that VER responses to orientation change are larger in general in 2–3-month-old infants than in 1-month-old infants (when optimum spatial and temporal parameters are used), but we do not know whether orientation specificity improves with age. This is a question we are currently tackling. So far the data are suggestive of improved orientation tuning over the first few months of life. Again, there may be similarities between newborn orientation discrimination and that of some blindsight patients, who are able to discriminate between two differently oriented static lines or gratings, but may not be capable of more complex shape discrimination.

Externality effects, attention, and cortical pathways

There are several published studies which examine whether or not the infant can discriminate between two faces. It has generally been

found that very young infants suffer from what has been called the 'externality effect'. This is an inability to discriminate changes in internal features if a surrounding border is placed around these features. For example, newborns have difficulty in discriminating between two faces if they are both given the same external contours (see Fig. 7.5). The externality effect is reduced or eliminated if the internal contours are dynamic rather than static and is generally reduced in older infants. A similar deficit was observed in Helen, the monkey whose visual striate cortex was removed, who failed to retrieve a raisin if it was surrounded by a ring (Humphrey 1974). The externality effect may be one example of limited attention capacity, at least in terms of the stimulus information gaining their attention, in newborns compared with 3-month-old infants. Another demonstration of improvements in attentional control with age is shown in experiments on shifts of gaze from targets presented in the central field and those presented peripherally (fixation shifts). In general, 3-month-old infants make rapid, accurate fixation shifts to peripheral targets, while 1-month-old infants are often slower and less reliable (Atkinson and Braddick 1985; Braddick and Atkinson 1988). Part of this difference can be accounted for in terms of improving peripheral contrast sensitivity with age. However, 1-month-old infants' fixation shifts are much more disrupted by additional targets in the field competing for attention than are the fixation shifts of 3-month-old infants. The 3-month-old infants tend to continue to refixate to patterns in the periphery, ignoring competing distractors and showing much smaller effects of competition than the 1-month-old infant, if the central target is still visible when the peripheral target appears. One-month-old infants have difficulty disengaging from the central foveal target, to switch attention to the peripheral target. We have suggested that these changes over the first few months indicate the onset of functioning in cortical pathways specifically involved in shifts of attention, such as those found in modules involving the parietal lobes. We are starting to investigate the development of selective mechanisms, using even more complex paradigms. For example, using an infant analogue to the adult paradigm demonstrating 'inhibition of return' (Posner et al. 1985), we have evidence that infants around 6 months of age show this effect (Hood and Atkinson 1990a). We are also starting to look at attentional deficits in neurologically impaired children and may in future be able to infer the site of brain damage from dissociations of failures on different attentional paradigms (Hood et al. 1989; Hood and Atkinson 1990b). There appear to be certain similarities between the behaviours in these selective attentional tasks of young infants and Balint's syndrome patients (Hecaen 1978). Further research on these ideas is in progress.

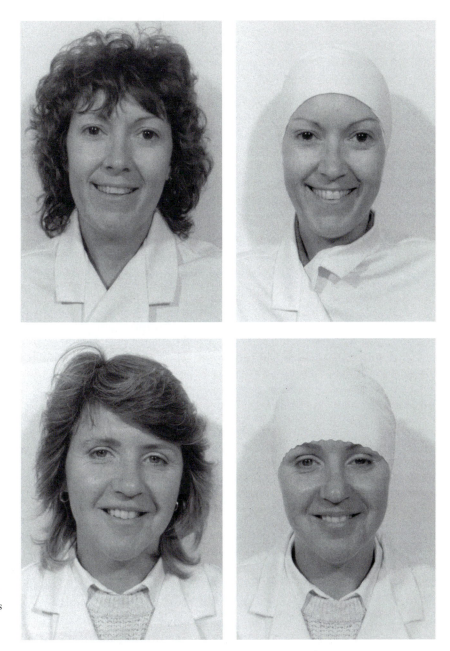

Fig. 7.5. One-month-old infants fail to show visual discrimination of the same faces if swimming caps are worn. This is an example of the externality effect.

We have just started to obtain results from studying two infants who have had hemispherectomies at around 6 months of life to relieve myoclonic seizures resulting from hemimegalencephaly. (This involves the removal of one of the cerebral hemispheres, so that half the visual field in both eyes is without a visual cortex and so is without visual awareness, but the subcortical pathways are intact. The other half field is normal.) Comparison of the responses of these

infants to stimuli in each half field allows us to compare subcortical and cortical control mechanisms. We have looked at these infants' ability to orient and make saccades to peripheral targets using a fixation shift paradigm similar to the one described above. For the simple refixation text with a single peripheral target, both infants are able to shift fixation to both hemifields. This result suggests that sub-cortical pathways, involving the superior colliculus, can subserve ori-enting. However, we have tested one of the infants extensively on the competition condition and here, just like a newborn, he has great difficulty in disengaging from the central target to fixate the periph-eral target when it is located in the subcortically controlled hemifield. This result supports the idea that newborns may be using a largely subcortical system to orient to peripheral stimuli and lack the cortical mechanisms to disengage from a central target.

However, another result from these hemispherectomized infants might mean a revision of the subcortical–cortical model. Both infants show marked asymmetry of OKN for binocular stimulation. OKN can be driven for stimulation towards the bad hemifield, but not in the opposite direction. This result would suggest that some cortically mediated response is operating whenever we see symmetri-cal binocularly stimulated OKN (as in the normal newborn) or that, in the case of hemispherectomies, development of one hemisphere has meant suppression of both subcortical ipsilateral control systems.

An alternative hypothesis for the mechanisms controlling early visual development is that there is differential development of certain visual modules over time. First, we can hypothesize that rudimentary visuomotor modules, which are likely to be subcortically controlled, are operational at birth and allow newborns to have a primary crude sense of space. This can be demonstrated in newborns by their ability to orient in the correct direction (albeit inaccurately) towards a light source or dynamic high-contrast toy and pre-reach (that is, crude arm waving in approximately the correct direction) for nearby objects. It seems likely that this system is supramodal, in some sense, rather than unimodal. Secondly, our data on static orientation detec-tion and data from others on colour discrimination in newborns are compatible with at least some parts of the parvocellular-based system being operational at birth (Atkinson and Braddick 1990). However, vision based on the magnocellular pathways appears to mature later, postnatally, in that some aspects of motion perception (Wattam-Bell 1988) and binocularity (Braddick *et al* 1980; Braddick and Atkinson 1983; Atkinson and Braddick 1988) do not appear to be discriminated until at least 3 months postnatally. Even later still, at around 6 months postnatally, certain attentional systems involv-ing parietal and frontal circuitry may become functional. As yet there is no firm evidence from developmental studies of other species

for prior development of parvocellular-based systems before magno-cellular-based systems. It is at present a working hypothesis, for which a good deal of data still needs to be collected.

When are the visual pathways fully developed?

From most of the data presented so far, it seems that 6 month old infants have relatively good sensitivity to many visual parameters, though we do not know what their perception is like or what they understand about changing visual stimuli. There are several indicators from older infants and young children which suggest that sensory and perceptual vision are not fully mature until at least several years of age. For example, using photorefraction, we find that many infants have astigmatic refractive errors which generally disappear by 18 months of age (Atkinson *et al.* 1980; Atkinson and Braddick 1988). Some astigmatisms persist and can contribute to meridional amblyopia (Atkinson *et al.* 1987a). In terms of spherical errors it would seem that many infants are adult-like by 1 year of age, but that many of the 5–8 per cent showing persistent refractive errors beyond 1 year end up with poorer vision by 4 years than their emmetropic (normal vision) controls. Certain refractive errors in infancy can be used to predict strabismus and amblyopia if no intervention is undertaken. However, in a recent randomized control trial, using spectacles worn throughout infancy to partially correct refractive errors we found that this practice is successful in significantly reducing the incidence of these common pre-school disorders (Atkinson *et al.* 1984, 1987a, 1988).

A second deficit in pre-school vision, compared to adults, we have called 'visual crowding' (Atkinson *et al.* 1986, 1987b). This is defined as the reduction in letter acuity produced by nearby letters or patterns. The crowding measure involves a comparison of single-letter acuity and multiple-letter acuity. Even adults show a small crowding effect, with 6-year-old children showing similar values of crowding to adults and pre-school children showing much larger effects than adults. Pre-school children find it quite difficult to pick out and select items from an array of similar items, but of course defining this similarity is not straightforward. We do know that it is not simply the presence of nearby contours which produces all of the crowding effect. A surrounding box around a letter produces less crowding in 3–4-year-old children than surrounding letters at the same spacing as the box (Atkinson 1991). Conversely, in adults the box produces similar or larger effects than do surrounding letters. It seems likely that one of the skills needed for reading might involve strategies both for putting letters together to form words and for

separating letters in different words. We know that if we measure crowding in dyslexic children, some show marked crowding effects similar to 4-year-old children unlike their age-matched non-dyslexic peers. However, we do not know whether delays in learning to overcome crowding effects are precursors of reading difficulties, or whether they are a correlated deficit. Future longitudinal research on pre-school crowding may allow us to identify at-risk children and relate it to the later development of reading skills.

Conclusion

In this chapter I have tried to show how vision changes rapidly in the first few months of life, but also that there are more subtle improvements, as late as 6 years of age, which depend on perceptuo-cognitive factors. The changes in vision in the first few postnatal months can be summarized as an improvement in sensitivity, controlled by particular cortical mechanisms, including the onset of function in systems for selective attentional control. The improvements in sensitivity are not uniform from birth, but show discrete abrupt changes, which can be related to functioning in particular modules. It seems that sensitivity to colour and form (orientation) may precede, in some sense, sensitivity to relative directional motion and disparity: parvocellular-based mechanisms may be functional before magnocellular-based mechanisms. Zeki (1993) has already, very elegantly, illustrated the chain of visual streams in adults, but we do not as yet have such data for human infants. Perhaps soon we will know whether the models I have been suggesting realistically represent how we develop such ARTFUL EYES.

References

Abramov, I., Gordon, J., Hendrickson, A., Hainline, L., Dobson, V., and La Bossière, E. (1982). The retina of the newborn human infant. *Science*, **217**, 265–7.

Atkinson, J. (1984). Human visual development over the first six months of life: a review and a hypothesis. *Human Neurobiology*, **3**, 61–74.

Atkinson, J. (1990). Development of cortical and precortical visual pathways in human infants. In *The neurophysiological foundations of visual perception*, (ed. L. Spillman and J. S. Werner), pp. 359–65. Academic Press, San Diego, Calif.

Atkinson, J. (1991). 'Review of human visual development: crowding and dyslexia'. In *Vision and visual dyslexia*, (ed. J. F. Stein), pp. 44–57. Macmillan Press, London.

Atkinson, J. and Braddick, O. J. (1985). Early development of the control of visual attention. *Perception*, **14**, A25.

Atkinson, J. and Braddick, O. J. (1988). Infant precursors of later visual disorders: correlation or causality? In *20th Minnesota Symposium on Child Psychology*, (ed. A. Yonas), pp. 35–65. Erlbaum, Hillsdale, NJ.

Atkinson, J. and Braddick O. J. (1989). Newborn contrast sensitivity measures: do VEP, OKN and FPL reveal differential development of cortical and subcortical streams?. *Investigative Ophthalmology and Visual Science*, **30**, Suppl. 311.

Atkinson, J. and Braddick, O. J. (1990). The developmental course of cortical processing streams in the human infant. In *Vision: coding and efficiency*, (ed. C. B. Blakemore pp. 247–253, Cambridge University Press, Cambridge, UK.

Atkinson, J. Braddick, O. J., and French, J. (1980). Infant astigmatism: its disappearance with age. *Vision Research*, **20**, 891–8.

Atkinson, J. Braddick, O. J., Ayling, L. Pimm-Smith E., Howland H. C., and Ingram, R. M. (1981). Isotropic photorefraction: a new method for refractive testing of infants. *Documenta Ophthalmologica Proceedings Series*, **30**, 217–23.

Atkinson, J. Braddick, O. J. and Atkinson, S. (1983). Photorefractive vision screening of infants. *Transaction of the Fifth International Orthoptic Congress*, 53–9.

Atkinson, J. Braddick, O. J., Durden, K., Watson, P. G. and Atkinson, S. (1984). Screening for refractive errors in 6–9 month-old infants by photorefraction. *British Journal of Ophthalmology*, **68**, 105–112.

Atkinson, J. Pimm-Smith, E. Evans, C., Harding, G., and Braddick, O. J. (1986). Visual crowding in young children. *Documenta Ophthalmologica Proceedings Series*, **45**, 192–200.

Atkinson, J. Hood, B., Wattam-Bell, J., Durden, K., Bobier, W., Pointer, J., and Atkinson, S. (1987*a*). Photorefractive screening of infants and effects of refractive correction. *Investigative Ophthalmology and Visual Science*. (Supp.), **28**, 399.

Atkinson, J., Anker, S., Evans, C., and McIntyre, A. (1987*b*). The Cambridge Crowding Cards for preschool visual acuity-testing. *The Transactions of the Sixth International Orthoptic Congress*, pp. 53–4. Harrogate, England.

Atkinson, J. Hood, B., Wattam-Bell, J., Anker, S., and Trickleband, J. (1988). Development of orientation discriminancy in infancy. *Perception*, **17**, 587–95.

Banks, M. and Bennett, P. J. (1989). Optical and photoreceptor immaturities limit the spatial and chromatic vision of human neonates. *Journal of the Optical Society of America*, **A5**, (No. 12, December).

Braddick, O. J. and Atkinson, J. (1983). Some recent findings on the development of human binocularity: a review. *Behavioural Brain Research*, **10**, 141–50.

Braddick, O. J. and Atkinson, J. (1984). Photorefractive techniques: applications in testing infants and young children. *Transactions of the British College of Ophthalmic Opticians (Optometrists) 1st International Congress*, **2**, 26–34.

Braddick, O. J. and Atkinson, J. (1988). Sensory selectivity, attentional control, and cross-channel integration in early visual development. In *20th Minnesota Symposium on Child Psychology*, (ed. A. Yonas), pp. 105–43. Erlbaum, Hillsdale, NJ.

Braddick, O. J., Atkinson, J., Julesz, B., Kropfl, W., Bodis-Wallner, I. and Raab, E. (1980). Cortical binocularity in infants. *Nature*, **288**, 363–5.

Braddick, O. J., Wattam-Bell, J. and Atkinson, J. (1986). Orientation-specific cortical responses develop in early infancy. *Nature*, **320**, 617–19.

Braddick, O. J., Atkinson, J., Wattam-Bell, J., Anker, S., and Norris, V. (1988). Videorefractive screening of accommodative performance in infants. *Investigative Ophthalmology and Visual Science*, **29** Suppl. 60.

Bronson, G. W. (1974). The postnatal growth of visual capacity. *Child Development*, **45**, 873–90.

Cowey, A. and Stoerig, P. (1991). The neurobiology of blindsight. *Trends in Neuroscience*, **14** (4), 140–5.

Dobson, V. and Teller, D. Y. (1978). Visual acuity in human infants: a review and comparison of behavioural and electro-physiological studies. *Vision Research*, **18**, 1469–85.

Hecaen, S. and Albert M. L. (1978). Balints. In *Human neuropsychology*, (ed. M. L. Albert). Wiley, New York.

Hood, B. and Atkinson, J. (1990*a*). Inhibition of return in infants. *Perception*, **A47**.

Hood, B. and Atkinson, J. (1990*b*). Sensory visual loss and cognitive deficits in the selective attentional system of normal infants and neurologically impaired children. *Developmental Medicine and Child Neurology*, **32**, 1067–77.

Hood, B., Atkinson, J., and Wattam-Bell, J. (1988). Infants' processing of orientation: the quest for newborn discrimination. *Perception*, **17**, 395.

Hood, B., Atkinson, J., Braddick, O. J., and Wattam-Bell, J. (1989). Visual attention shifts in infants and neurologically impaired children. *Ophthalmic and Physiological Optics*, **9**, 472.

Horowitz, E. D. (1975). Infant attention and discrimination: methodological and substantive issues. *Monographs of the Society for Research in Child Development*, **39**, 1–15.

Howland, H. C., Braddick, O. J., Atkinson, J., and Howland, B. (1983). Optics of photorefraction: orthogonal and isotropic methods. *Journal of the Optical Society of America*, **73**, 1701–8.

Humphrey, N. K. (1974). Vision in a monkey without striate cortex: a case study. *Perception*, **3**, 241–56.

Jacobs, D. C. and Blakemore, C. (1988). Factors limiting the potential development of visual acuity in the monkey. *Vision Research*, **28**, (8), 947–58.

Livingstone, M. and Hubel, D. H. (1988) Segregation of form, color, movement and depth: anatomy, physiology and perception. *Science*, **240**, 740–9.

Maunsell, J. H. R. and Newsome, W. T. (1987). Visual processing in monkey extrastriate cortex. *Annual Review of Neuroscience*, **10**, 363–401.

Morrone, M. C., Burr, C. D., and Fiorentini, A. (1990). Development of contrast sensitivity and acuity of the infant colour system. *Proceedings of the Royal Society of London*, **B242**, 134–9.

Posner, M. I., Rafal, R. D., Chaate, L. S., and Vaughn, J. (1985). Inhibition of return: neural basis and function. *Cognitive Neuropsychology*, **2**, 221–8.

Slater, A., Morrison, V., and Somers, M. (1988). Orientation discrimination and cortical function in the human newborn. *Perception*, **17**, 597–8.

Sokol, S. (1978). Measurement of infant visual acuity from pattern-reversal evoked potentials. *Vision Research*, **18**, 33–40.

Teller, D. Y. (1979). The forced-choice preferential looking procedure: a psychophysical technique for use with human infants. *Infant Behaviour and Development*, **2**, 135–53.

Van Essen, D. C. and Maunsell, J. H. R. (1983). Hierarchical organization and functional streams in the visual cortex. *Trends in Neurosciences*, **6**, (19), 370–5.

Wattam-Bell, J. (1988). The development of motion-specific cortical responses in infants. *Investigative Ophthalmology and Visual Science*, **29** (Suppl.) 24.

Weiskrantz, L. (1986). *Blindsight: a case study and implications*. Clarendon Press, Oxford.

Yonas, A. and Arterberry, M. E. (1987). Four-month-old infants' sensitivity to binocular and kinetic information for three-dimensional objects' shape. *Child Development*, **58**, 910–17.

Zeki, S. (1990). The motion pathways of the primate visual cortex. In *Vision: coding and efficiency*, (ed. C. B. Blakemore), pp. 321–45. Cambridge University Press, Cambridge, UK.

Zeki, S. (1993). *A vision of the brain*. Blackwell Scientific Publications, Oxford.

Zeki, S. and Shipp, S. (1988). The functional logic of cortical connections. *Nature*, **335**, 311–17.

8 Mother and baby — seeing artfully eye to eye

COLWYN TREVARTHEN

Creative and communicative roots of art

> The arabesque, properly speaking ... is the first fancy of the artist; he first plays with his material as a child plays with a kaleidoscope; and he is already in a second stage when he begins to use his petty counters for the end of representation. ... No art, it may be said, was ever perfect, and not many noble, that has not been mirthfully conceived.
>
> Robert Louis Stevenson, *Fontainebleau* (1882)

An artist's picture or graphic decoration is a message left by a creative 'act-seen-being-done'. It records emotion in the experience of making and in the imagination of its creator. In it are linked perceptions, movements, emotions, thoughts, and memories that occupied the artist as he worked. Anyone seeing the work can, if they will, share some of these lived motives and ideas. Its poetry or quality of creation makes the aesthetic appeal.

Psychological interpretation of a work of pictorial or graphic art may explore and comment on any part of this creative and receptive process. Consequently, there are many rival theories of aesthetics, all reflections of the way the logic and feelings of experience are interpreted. For example, Plato felt that art imitates divine messages of perfect form, and Freud interpreted art works as sublimations of past sexual desires and frustrations (Bornstein 1984*a*; OCM: 'Aesthetics'[1]). Symbol- and text-conscious post-modernists reject all notions of *Einfühlung*, a natural empathy in the mind of one who contemplates art (Dissanayake 1992). They assert that the creations and the judgements in art are artificial, self-consciously made up, and transitory; that such creations and judgements are constructs of a socialized aesthetic opinion — imitated Saussurean symbols, detachable from the referent and from any universal and timeless poetic needs

[1] References to Gregory (1987). *The Oxford companion to the mind* are abbreviated to OCM, followed by the entry title.

of communicators. For the semiotician Eco (1976), symbols are, by definition, unemotional.

Such sophisticated thinking sterilizes the psychology of art. From prehistoric decorations and cave paintings to the most modern gallery displays, art is actively expressive, not just informative and representational (Gombrich 1977). Moreover, in all cultures, at all times, artistry has been appreciated not just as the display of a learned technical or literary code commenting on reality, but as an inseparable part of legendary, spiritual, and ritual messages, giving them special intimate importance in the group (Dissanayake 1988). The messages are not necessarily symbolic of or 'standing for' anything, though art works can be descriptive and can powerfully carry emotive symbolic significance. Aesthetic emotional effects of art are not in their essentials conventional constructs, though the admission of them into sophisticated hyperliterate discourse *may* be. And symbolic messages in any kind of language, whether common or esoteric, may be devoid of aesthetic value. Rationalized realism and surrealism when its metaphors fail have demonstrated this. Art does not just make statements; it moves us.

We make immediately judgements about peace, lightness, vitality, beauty, drama, harmony, tension, balance, grace, violence, and so forth in the work of an artist. Could these reactions to a picture have a basis, not merely in the way cognition and symbolization have been constituted in individual brains by what they have learned, or even in fears and joys they have associated with analogous experiences, but in communicable affects (feelings or reactions) with which human brains must regulate their individual consciousness and by which they communicate to others the quality of their attitudes to people, objects, and events? Could these communicable effects be present from birth? Research on the exchanges of feeling, motivation, intention, and interest between infants and their mothers suggests some are. The discriminations and preferences of infants might give evidence on moods or modes in our consciousness that later in life may come to be felt and expressed in art.

If infancy gives us a glimpse of the original state of the human mind in communication, neuropsychology also informs current thinking about the creation and appreciation of art. Brain science has produced evidence for two kinds of consciousness that are anatomically separated in the two hemispheres of the brain. Intuitive response to experience and the evocation of imagery linked to phenomenal reality by metaphor, on the one hand, and verbal analysis and prescription of aesthetic judgements on the other, are two natural brain systems that work as complements in the making and communicating of art (Gardner 1982a, 1984; Levy 1988; Stephan 1990). I believe that our new concepts of infant intelligence, taken

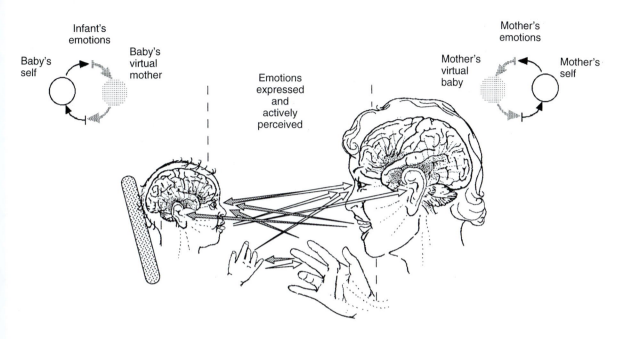

Fig. 8.1. Protoconversation; how a 2-month-old infant and a mother exchange expressions of feeling by eyes, voice, hands, and mouth, coordinating the motives and impulses in their brains and thus creating a dialogue of transitory emotions.

in the context of what we know about brain development before and after birth, can help explain how adult neocortical systems, and the subcortical motives to which they are linked, become specialized in this way (Trevarthen 1990; Trevarthen and Aitken 1994).

Infants' empathic transactions, face-to-face with their mothers, are rich and affective (Fig. 8.1). Their communicative expressions, distinguishable from the acts with which they regulate their mental schemata for objects, to which Piaget gave such importance, prove that humans are born with patterned and coherent motives to interact with other persons. This prolific communication of mind states offers a window on the innate, self-regulating structures and functions of attending, imagining, and remembering in all human brains, young and old. And it confirms the importance in communication of the feelings of pleasure or displeasure that objects may bring, especially objects presented or constructed by other human beings.

Note that the emotions and motives of a neonatal infant are not mental *effects* of sensory impressions. They are *causal and constitutive* in the dawning consciousness (Trevarthen 1993a). Feelings infants show in communication are powerful makers and breakers of friendships and enmities, joyful memories and phobias, preferences and aversions for objects, and discrimination or indifference in perception. The rationalist's belief that our feelings are caused or generated by stimuli is an illusion. This belief comes of an élitist empiricism and from the cultivated habit of using language to examine itself, and

especially from the detachment that self-conscious literacy brings. Scientific or metalinguistic awareness can, and does, obscure spontaneous emotions.

The creative choices of an artist and the aesthetic feelings of the perceiver of beauty in art begin deep in authentic motives; they arise from impulses for action seeking perceptual experience. At this level, where the mind is evaluating its conscious work and checking options for contact with reality, fantasies and recollections can become indistinguishable from reality. Far from being failures or distortions of awareness, mental fabrications of imaginative and metaphorical kind are needed to make the experiences of reality understandable, memorable, and, above all, communicable. Art communicates powerfully because it makes systematic expression of deep and spontaneous 'images' or 'impulses', that are subjective, emotional, and, therefore, immediately transferable.

Professor Gregory, who many years ago showed the devastating effects on visual consciousness and emotions of optical defects that blind a child to the world, and who examined how a recovery of vision of the world had to be arduously learned (Gregory and Wallace 1963), supports a theory of perception associated with the name of Hermann von Helmholtz. This is the theory that an individual's perception is organized out of sensations by concepts; that is, by a process of unconscious but intelligent inferential interest, a 'proving' of knowledge by reasoned understanding, a formulating and applying of hypotheses about reality extrapolated from past experience (Gregory 1980; OCM: 'Illusions', 'Perceptions as Hypotheses'). He praises the scientific empiricism of Francis Bacon.[2] Perception is cer-

[2] Bacon (OCM: 'Bacon, Francis (1561–1626') was a highly pragmatic English philosopher, Lord Chancellor for James I of England. His vigorous pronouncements against medieval metaphysics inspired the founding of the Royal Society in the seventeenth century. He set out to discipline the appeal of imagination, which he declared to have had a destructive influence in the philosophy and religion of his predecessors. He urged fresh enquiry, placing mental activity in the service of fact and experiment, as in science and the 'practical arts' (Anderson 1948). Helmholtz (Helmholtz (ed. Sarthall) 1862; Warren and Warren 1968; OCM: 'Helmholtz, Hermann Ludwig Ferdinand von (1821–1894')) was a great physicist who pioneered the optical geometry of vision and psychophysics of the visual image that he believed is explored, with unconscious purpose, by the thinking mind.

Neither of these men had any conceivable access to the physics we know of the mind in the brain. They had no 'hard' knowledge of what the substance and processes of imagination could be. Furthermore, Bacon and Helmholtz exemplify a tradition that would divide Science from Art and set the former in a position of greater authority. The psychology of art must, I believe, resist this bias. I should like to set the ideas of Bacon and Helmholtz beside David Hume's definition of beauty: 'Beauty is no quality of things themselves: it exists merely in the mind which contemplates them.' Hume goes on: '... each mind perceives a different beauty. One person may even perceive deformity where another is sensible of beauty' (Hume 1963, p. 234). While accepting Hume's essential idea that the aesthetic feelings are generated inside minds and can be intensely personal, I shall, unlike him, be looking for common neurogenic values in all minds, values that permit and encourage a shared sense of beauty. I see art to be the fabric of *communitas* (Turner 1982), celebrating shared rituals and myths and the mysteries behind them. The artist 'makes special' ideas or objects that thereby communicate some power or significance (Dissanayake 1992).

tainly intelligent, even in the very young, but I do not believe that
the machinery of intellect and experience *in the single mind* is where
we should look to explain why art appeals the way it does. Objective
facts about visual input, perception, and cognition — the filtration of
sensory excitations through analytical templates or feature detectors
of the nervous system that react selectively to elements in the shape,
texture, and colour of physical reality, the processing of separate
modes of information about objects to extract one kind of data for
guiding behaviour, even cognitive inferences from context that
objects have their own properties of symmetry, position, size, motion,
mobility, colour, and so forth — these are of technical interest to the
work of an artist, but peripheral to aesthetic appreciation (OCM:
'Aesthetics: some psychological approaches', 'Art and visual abstrac-
tion', 'Art as perceptual experience'). My analysis will try to work up
toward a thinking, knowledge-based, scientific level of consciousness,
from an understanding of a more internal and largely unconscious
'seeing-in-action' that is highly communicable.[3] The foundations of
consciousness in pragmatic motivations of individuals play an essen-
tial part in the ontogeny of human responses to shareable, culture-
relative meanings in a community. According to Bornstein (1984*b*),
they do so also in the development of an individual artist's themes
and expression.

Organization that the brain brings to experience

Principles of motivation show themselves in dynamics of consciousness
and thinking that are different in the two cerebral hemispheres:
anatomical systems in left and right halves of our heads that grow and
differentiate from fetal stages through to old age. The cerebral cortical
networks are built on top of and integrated into embryo brain maps of

I do not deny that artists, like scientists, enjoy rational exploration of the hard-won effects
and techniques of their work, nor do I seek to belittle the importance of individual discovery
and invention or, for that matter, individual personality expressing its 'uniqueness'. But
reason and private experience are neither sufficient nor most important in the motivation of
art. The artist is *communicating*, either with a 'muse', and unconscious, emotion-laden past or
with real other persons and their ideas and feelings. Aesthetic emotions are the essential
transmissible element, a common framework of feelings and intuitions, neither rationally
worked out, nor simply acquired by learning from the world of fact and cause-and-effect
outside minds.

[3] Core cerebral structures and processes couple attention and perception to motor patterns.
There is remarkable physiological and psychophysical evidence now for the primary role of
motor intention and imagery in consciousness (Jeannerod, 1994). Actions determine how
one subject's body-with-a-mind gets about and does things and seeks the useful information
that the environment 'affords' (Gibson 1979). This 'functional' approach to the study of the
neurology of perception was lucidly advocated by Roger Sperry in 1952 in an essay entitled
'Neurology and the mind–brain problem' (Sperry 1952). Sperry was following in the steps of
William James and John Dewey (q.v. OCM).

the body and its field of action and experience that were established earlier in the brainstem and spinal cord. Vital intrinsic aspects of our mental life are lodged in self-regulated, self-assessing, whole-body-coordinating, multimodal activity in the older subhemispheric brain, which constrains and deploys the cognitive processing of perception and memory in the cerebral cortex (Levy and Trevarthen 1976; Trevarthen 1979a, 1986a; OCM: 'Split brain and the mind'). The brain of a fetus growing *in utero* is constructing 'core regulator' systems of motivation before the cerebral hemispheres have begun to develop. These core neurones will weigh up and reward or punish the activities and awareness of the subject throughout life (OCM: 'Brain Development'; Tucker 1992; Trevarthen and Aitken 1994).

No amount of selective retention of cortical circuits from a disorganized excess by experience, or 'neuronal Darwinism' between competing neural assemblies (Changeux 1985; Edelman 1987) can bypass the guidelines and 'boundary conditions' set up by these intrinsic 'home-grown' neurogenetic principles. When a neuroscientist is trying to explain a 'self-related' or subjective activity like the creation and appreciation of art, such brain-generated intuitive emotions and motives must become part of the study.

By referring to particular works of art, I will try to point out how some essential, brain-related principles universal in human seeing have interesting effects in creations of pictures, in spite of the cultural codes, practices, and traditions that also shape what the artist does. First, however, let me summarize what has been learned about the powerful empathy of communication in infancy before the baby attempts to learn about objects or the symbolic conventions of culture.

Newborn human minds seeking dialogue with other human minds

Recent research with newborn infants has demonstrated that they have coherent and synaesthetic intentionality, a capacity for selective attention that orients the eyes, ears, and hands to certain favoured features of the baby's immediate environment, an emotional system that coordinates all these body parts in response to the emotions of other persons, and a most unexpected and portentous ability to identify and communicate with other persons' expressive bodies (Trevarthen 1993a). Furthermore, newborn babies have constant left–right leaning to their responses to sounds that other persons make, and their own expressive movements are asymmetric (Trevarthen 1990a; Locke 1993). Evidently left and right halves of their brains already have different feelings for communication at a

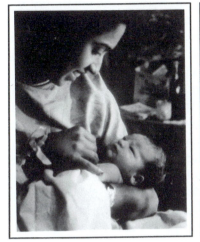

Fig. 8.2. A newborn girl imitating, less than 30 min after birth. (Courtesy of Vasudevi Reddy, photographs by Kevin Bundell.)

stage of development when there is no precise referential content in the messages.[4]

The emotional expressions are well-formed at birth. A newborn can move face, eyes, hands, and the whole body to express changing feelings in ways with which other people easily empathize. And the baby is extremely sensitive to the quality of vocalization, holding, moving, and facial expression of pleasure or indifference in a person giving care. But the communicative powers of newborns are not confined to the mirroring and exchange of emotions. They can imitate what seem like arbitrary gestures.

In recent years newborn infants have been recorded imitating seemingly pointless movements of another person's face or hands (Field *et al.* 1982; Maratos 1982; Meltzoff 1985; Kugiumutzakis, 1993). Figure 8.2 shows a baby girl, Shamini, approximately 20 min after she was born in a hospital in Hyderabad. She looked intently

[4] It has been suggested that infants, because their cerebral commissure, the corpus callosum, is immature and lacking the insulating sheath (myelin) that gives precision and power to conduction of nerve impulses, have 'split' brains, or separate hemispheric systems of learning (Gazzaniga 1970). However, the axons of the corpus callosum of a newborn infant are in the same condition and come from the same population of nerve cells as the long association fibres that link up cell populations within the hemisphere, and there are ten times as many axons in the corpus callosum of a newborn as in the brain of an adult. The excess is eliminated by a spontaneous selective 'pruning' of axon branches. The population of long association fibres divides within the first year into one set interconnecting the hemispheres and another interconnecting regions within each hemisphere. Myelinization begins after this sorting and parallels the differentiation of complementary functional systems in the neocortex on both sides (Innocenti 1986). Far from having a split brain, the newborn is developing greater hemispheric specialization *on a basis set down before birth and strongly regulated by connections to and from structures below the hemispheres*. New complementary relationships between cognitive and memory systems of the hemispheres are gained throughout childhood and these increase the capacity of the brain to have divided consciousness. Bornstein (1984*b*, 1985*a*, *b*) reviews the consequences of these developments in children for their artistic expression, and learning of skills to represent what adults around them accept as reality.

while her mother addressed her affectionately and invitingly and promptly imitated both tongue protrusion and mouth opening when invited to do so. Shamini also imitated her father opening his hand. Such responses, which are made with purposeful effort to achieve as close a match as possible, give striking proof of how well an infant is equipped to perceive another person as being equivalent to themselves (Kugiumutzakis 1993). And the ability of babies to join in intricate exchange of expressions shows more. It shows that they are intrinsically motivated to build and develop a process of mental cooperation or a traffic of changing human feelings and interests. In less than a year such communication will be essential for learning how to do things like other people, and for finding out how others perceive and evaluate objects and events (Trevarthen 1993*b*). It provides the foundation for cultural learning.

The two-brain, emotion-sharing system of protoconversation

For the first few months an infant is far better at interacting with persons than at dealing with objects and the layout of the world (Trevarthen 1974; OCM: 'Infancy, mind in'). Reaching for and manipulating objects is not effective until after 4 months and locomotion begins much later, but a 2-month-old infant can employ all the channels shown in Fig. 8.1, separately or together, in interaction with another human being who is in the right condition of affection (Trevarthen 1979*b*). From a physicalist 'information-processing' point of view, communication would seem to be much the more complicated cognitive task, but it is the one that is precociously developed. Later, the mother–infant dyad develops into a system that can empathize about objects.

The infant is seeking to see a person whose face and voice give positive emotional support, and the face, at least, has an aesthetic appeal from early weeks. Langlois has found that young infants can discriminate and prefer the photograph of an attractive young female full-face: that is, a picture of a person who has a configuration of features and expression that adults, too, judge to be more attractive (Langlois *et al.* 1990). Computer blends of photographs of young female faces become more attractive to infants and adults as more individuals are added to the blend (Langlois and Roggman 1990). What this preference or sense of personal beauty is based on we do not know. It is usually attributed to some kind of 'averaging' of features to derive a prototype, but it is likely to involve an emotional response and may be related to a harmonious and slightly animated facial expression of feelings that signals an affectionate readiness for gentle play. The serene attractiveness of Leonardo's *Mona Lisa* is just

such a quality of interpersonal relating — like the joy of the smile that she almost gives us.

I believe that communicative skills are so precocious compared to object-using skills because the human species has the kind of brain which must grow with the live company of other human brains and their emotions. I propose that what is being assisted in the infant's brain are the internal consciousness-regulating processes of attention, curiosity, and affective appraisal generated deep in its core (Trevarthen 1989a; 1993a; Trevarthen and Aitken, 1994; Shore 1994).

Neurones in the reticular core, which project throughout other parts of the brain, mediate the range of innate pleasures, preferences, and aversions that are revealed as the emotional and motivational basis for 'art' as well as 'life' (Trevarthen 1986a). The newborn infant does not know how to apply these given states of feeling as evaluations to the specifics of the world; as identified objects, places, etc. — such knowledge has to be learned. I propose that babies learn how to apply the basic motivating and evaluating principles of consciousness and intention to the world, not entirely by private, scientific examination of reality of the kind Jean Piaget demonstrated, but primarily by interacting very intensely with inner brain states and stored experiences of their mothers, other care-takers, and companions. They learn to be part of a culture by empathic transfer of motives (Trevarthen and Logotheti 1987; Trevarthen 1988).

All of the muscles of expression, principally in the face, in the hands, and in the vocal tract, are elaborately connected with the core and limbic structures of the brain, in which motives and emotions are patterned (Trevarthen 1985a, 1989b; Trevarthen and Aitken 1994). In infants and in adults, movements of those muscles externalize states of the regulatory neurones at the same time as they have direct effects on the uptake of sensory information by the special sense organs of the eyes, ears, mouth, and hands. Thus, expressive behaviours link 'self-regulation' of the conscious subject's perceptual experience with 'other-regulation' in intersubjective (person-to-person) encounters (Trevarthen 1993a, b).

Apparently the baby is born with, and the mother still possesses, a *dual organization of mind* that, while not unique to humans, is peculiarly developed in them. Any suitably friendly person who is encountered can be invited to come into correspondence with what Stein Bråten (1988) has described as the *virtual other* in the mind of the person seeking communication. Within the mind of the baby, what the mother is expected to be like (the virtual mother) is joined with what the baby's self is motivated to do and the resultant emotions are communicated to the mother. She reciprocates by reacting to how the real baby corresponds with her anticipated 'virtual baby'. The inner states of the two dyadic self–other systems of mother and

infant become one dynamic emotional process, one protoconversa-tional composition of feelings, which Bråten calls 'dialogic closure'.

Mothers join in conversational play with infants of 6 weeks of age, when the cerebral cortex is very immature — when foveal acuity, feature analysers, and the capacity for binocular stereopsis are just beginning, as Atkinson has explained (Held 1985; Trevarthen 1985*b*). The baby looks with immature vision intently at the mother, with a 'knit brow' (of concentration) and 'jaw drop' (of strongly focused attention) and gets emotionally involved, smiles, and then starts making coos and hand gestures. The baby's lips and tongue become active in 'pre-speech' and one hand, usually the right one, rises up to make a clearly expressive gesture. The infant makes many expressions more strongly or sooner on the right side of the face or with the right hand, and the baby tends to look right when making the utterance, as illustrated in Fig. 8.3. This asymmetry appears to be related to the expressive asymmetry characteristic of adults when they are making a linguistic expression.

Infant communication thus reveals deep 'design features' of human minds that provide the time frame and the code forms for communi-cation between them. Of fundamental importance is the tendency of cerebral activity to be periodic or rhythmic. The earliest communica-

Fig. 8.3. Double-TV communication between a mother and her 8-week-old daughter. They perceive one another entirely by colour television images, with sound. Photographs from the screens show some of their many changing expressions.

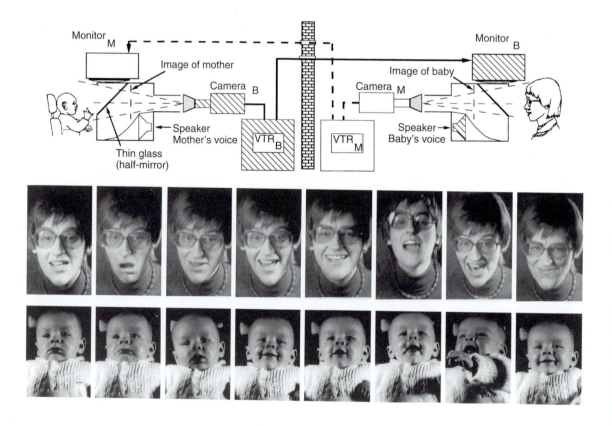

tions have a beat that is close to *adagio* (approximately one beat every 0.8 s) and other regular rhythmic features. This is reflected both in the mother's output (in her 'intuitive motherese' or baby-talk and/or in the rhythms of her gestures) and in the baby's vocal, manual, and facial expressions, which move together in coherent 'utterances' (Trevarthen and Marwick 1986; Trehub *et al.* 1993).

Lynne Murray developed a double TV system for observing the emotions of protoconversation between mother and baby (Murray and Trevarthen 1985; Trevarthen 1985*a*, 1993*a*). The apparatus shown in Fig. 8.3 enables us to photograph the changing expressions of mother and baby through the video images they see of each other while they are looking into one another's eyes and communicating. We record exactly what is seen and heard by the two communicating subjects. It is clear that both of them are expressive and that each is instantly responsive to the other. The communication is held together by a field of emotions mapped out in both their minds and ready to join in an emotional 'composition' closely analogous to a well-preformed musical duet. They are improvising a human mental engagement mediated intuitively by their emotions.

How the infant learns and shares objects of the human-created world aesthetically

After 3 months, as their arms and neck become stronger and their sight sharper, babies become active toward objects and eager to explore things with eyes, hands, and ears together. They make experiments and solve problems and they express the success or difficulty of their efforts in transparent emotion. All carefully observed studies of infants interacting with objects have seen that they have feelings about what they are doing. Take a 3-month-old who is interested in predicting the movement of a mobile connected to her cot by a device that makes it move when she moves a particular way or one that picks up rotations of her head to generate a visual display. Papousek (1967) and Watson (1972) both noticed that the experimenting baby showed pleasure when getting it right and sadness or annoyance when getting it wrong. Piaget described the baby's emotion as 'pleasure in mastery' when the baby is playing with a strong predictive schema, and 'serious intent' when an unsure schema is being tried out. There is a quality of affect expressed in problem-solving. This expression of feelings would seem to be for the benefit of communication with other persons.

The 4-month-old baby who is displaying an awakening interest in an object is using emotions to regulate the brain-generated impulses

of exploration and manipulation. His or her movements project measures of space and time into the experience of the outside world and they are adapted to obtain control over the kinematic constraints of the body (Trevarthen 1990b). Family members play games with the baby's feelings of cognitive mastery of action, drawing the baby into regulated tussles of body displacement, will, and experience that provoke laughter. Babies become 'show-offs', acting out deliberately to impress and amuse people. And mothers all over the world sing action songs to babies after 4 months. At least in Europe, the songs are amazingly uniform (Trevarthen 1988, 1990c). We cannot go into the implications of this for the primitive psychology of poetry and music here, but the research into baby songs can be used to establish a general point (Trehub et al. 1993). Adult and infant appear to be exploiting an innate and universal emotional code, fundamentally carried in the metronomic scale of musical pulse or beat, from urgent *presto* through joyful, energetic *allegro* and relaxed and peaceful *adagio*, to sad or weary *largo*. The timing that carries feeling can be visible or audible or felt in the hand. It must be supplied by deep coordinators of nerve activity in the brain that serve as mental clocks or conductors: Bernstein (1967) called such pacemakers and pattern-generators of movement 'ecphorators' — agents that 'bring forth' or 'express' motor actions).

After 3 months, baby and family companions enjoy increasingly animated and tricky games, and objects become toys in emotionally charged 'plots'. The partners in play laugh and show pleasure in 'metacommunication' (Bateson 1956); that is, they communicate about each other's communicative acts. Gradually the play with a baby brings in objects. All through the first year experience of things is shared in a constant exchange of feelings and then, after 6 months, the infant starts deliberately to ask others about how they value any new object by 'emotional referencing'; the infant taking up emotional evaluations from other known and trusted people to guide learning about the world (Stern 1985).

Donald Winnicott (1971) identified all human creativity with that way of playful escaping from reality that helps the infant bridge the gap between the caring and comforting mother desired and the sometimes absent or unsatisfying or punitive real mother. The gap is bridged or closed by means of imagined or part-imagined 'transitional objects', such as teddy bears or blankets, that bring comfort and satisfy the need for company. Though he had a most rich and sensitive appreciation of the value of play and its importance for cultural mastery of reality and in artistic creativity, Winnicott, in common with other psychodynamic theorists, conceived the infant as primarily taken up with building and defending a separate 'self'. No psychoanalytical student of infancy seems to have perceived the

active way infants direct their play to learn how to cooperate happily in the communicating of meanings with a companion.

Infants are soon studying what they and others can do with hands. As early as 3 months they watch the way hands manipulate things (Trevarthen 1986*b*, 1990*c*). The infant may be manifesting feelings like those adults have when we appreciate the traces of other persons' handwork. Visible works of handcraft carry messages about the movement of creation and about the feelings of seeing an arte- fact being made. Works of art portray scenes, objects, and human bodies in different moods, with different emotive colours, different lines of action, different impacts on one another, and different balance. We have such feelings and seek them in others because it is only by way of such products of our similarly motivated brains that we can enter into one another's consciousness and share cooperative learning and action.

By the end of the first year the baby puts communicating and manipulating together in a new intelligence; a cooperative use of objects for creative purposes that does not exist in apes. We use the fol- lowing simple test (Trevarthen and Hubley 1978; Hubley and Trevarthen 1979). The mother asks the infant to put little wooden dolls in a truck, using speech and gesture to try to capture and lead the infant's interest. Frequently the 1-year-old infant complies willingly and promptly, fully grasping what the mother wants without under- standing language, picking up the prosody and the general pattern of her utterance and gesture. Then, having completed the taught act, the infant gives the mother a satisfied smile and the mother says some- thing emphatic and encouraging like, 'Oh what a clever girl' (Trevarthen and Hubley 1978; OCM; 'Infancy, mind in'). Such a coop- erative performance of a simple arbitrary task set by the mother marks a breakthrough in mental development. At the same time the baby starts to show a growing curiosity about the many things that familiar people use and like: books, clothes, kitchen tools, eating instruments, bags and boxes, pushchairs, cars, pets, supermarkets, and so on *ad infinitum*. Sensitivity to the meaning and usefulness of culturally significant objects in constant daily use prepares the infant for learn- ing the meanings of language and many other kinds of symbols and tools (Trevarthen 1988, 1990*c*; Tomasello *et al.* 1993).

In the second year a baby begins to make an effort to name things of shared interest and soon a variety of 'acts of meaning', combining gesture and vocalization, can be immediately translated into needs and wishes by the parents (Halliday 1975; Trevarthen 1988). The baby is protesting, requesting, refusing, giving, receiving and greet- ing, and also showing and naming particular things.

These communicative acts are immediately and continually sensi- tive to the common interests and intentions of the child's partners.

All this is clearly paving the way to a vocabulary that will, in a year or so, free the child's communication from the 'here and now' and open the door to the whole culture of meanings coded in words (Locke 1993; Trevarthen 1994).

Symbols for meanings and for art

Infants show us that language is rooted in cooperation between conscious subjects and that it is guided by the direct communication of feelings that confirm cooperation. Symbols give labels to agreed identities of things in shared interest (Trevarthen and Logotheti 1987; Trevarthen 1994). The arbitrary form enables a symbol to carry feelings about the act of communication that are independent of the referent object and its properties. Symbols have to be arbitrary both in production and reception because that is how they label the creations and discoveries of a coherent culture that persists generation after generation and holds together a community of minds. I believe art explores and confirms the motivational roots of cultural communication and the need to generate symbols. Any reality it accurately and literally refers to is but part of the message.

Now let me try to connect this argument, about emotions in the development of consciousness and knowledge in the emerging microculture of mother with infant, with the emotions of aesthetic enjoyment in sophisticated adult society.

Human beings everywhere appreciate art to share their intuitive evaluations about life experiences. They create works of art that they hope will move other people strongly. The 2-year-old child can show us a proto-art in his or her first attempts to draw or paint. The earliest art productions of children are not representations; they are active and conversational inventions, dramatic or histrionic icons, full of feelings which seek affirmation and fear disapproval. Toddlers use simple stereotypes to evoke meanings and they distort representations to convey the relative importance or vitality of the things that hold their interest. They are not trying to recreate things as seen, caring little for realistic resemblance. Portrayal of reality, with the aid of graphic conventions, is learned inside the energetic line of an intuitive communicative movement, part of a whole dramatic statement (Willats 1977; Freeman 1980; Bornstein 1984a; OCM: 'Children's Drawings of Human Figures'; Matthews 1988).[5] Toddlers

[5] Analyses of the development of children's art, if they have not been used to discover unconscious emotional messages for clinical or forensic purposes, have been largely concerned with the emergence of cognitive skills for representing reality correctly and for planning a coherent and rational statement about natural objects and their relationships. Often, drawing is discussed as if it were primarily a technical problem-solving occupation for the child — Piaget's theories have had a strong influence (Gardner 1973; Golomb 1974; Goodnow 1977).

enter the world of music with the same enthusiasm, making sounds with form that tell how their feelings are making them move (Bjørkvold 1992).

Making a statement about a real or imaginary world, telling a factual story, may be the conscious target of an artist's creative arrow, but it is the flourish of the movements by which the bow is plucked that has the aesthetic message. The artist's brushwork or pencil line conveys his motivation by means that are added to the facts of execution and to the reality imitated or symbolized. In decorative work and abstract art there may be no facts that refer to anything else in the world in the manipulation of colours, forms, and ideas.

I have described the expressions by which an infant makes contact with other minds and begins to learn about a cultural world using communicated feelings. Now I will attempt to relate aspects of the forms and colours of pictures to the brain mechanisms that direct visual perception and cognition in similar ways in each of us. Beautiful art works are important in human communication because they carry evidence of universal parameters of mind work that are infectious and that must be so for co-operative awareness. These parameters are a currency of significance determined by innate species-specific anatomical characteristics of our brains.[6]

Motives for sight within a partly-divided mind

The 'split-brain' operation of Myers and Sperry (1958) proved a most informative method for exploring the anatomy and function of consciousness and learning in the brains of mammals. The same inter-hemispheric surgery (cerebral commissurotomy) has been used on human patients to stop epilepsy destroying brain functions. Cutting the corpus callosum — the great bridge of fibres that connects the two halves of the cerebral neocortex — generally regarded as the tissue of consciousness, leaves each half separated from the other, but still connected to the rest of the brain — the thalamus the basal ganglia, brainstem, and spinal cord — through which pass all lines of communication linking the neocortex to the body and the outside world (Fig. 8.4). The operation creates a unique condition of divided consciousness, from which we have learned much about how the awareness of the individual holds together many contributory systems of perception and action (Trevarthen 1979a).

A split-brain monkey's visual awareness can be turned on or off in one side of the brain by changing which hand the animal uses to

[6] Frederick Turner (1991) proposes that we perceive beauty in response to an inherent feature of the universe shared in our brains. We have evolved to apprehend and manifest this beauty. Richard Gregory (1986), in an essay entitled 'Designing designers', argues that a shared perception of beautiful form makes it possible for builders, of any kind, to agree when a construction is well done.

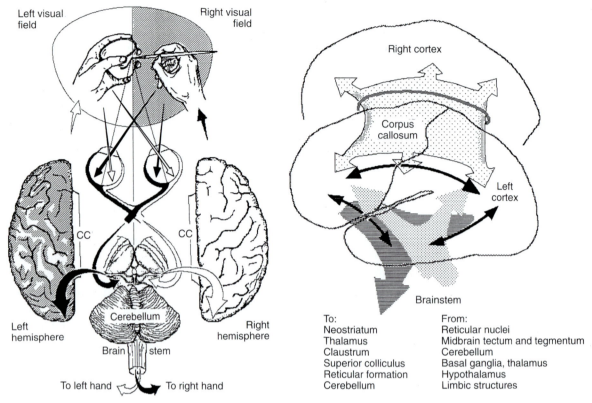

To:
Neostriatum
Thalamus
Claustrum
Superior colliculus
Reticular formation
Cerebellum

From:
Reticular nuclei
Midbrain tectum and tegmentum
Cerebellum
Basal ganglia, thalamus
Hypothalamus
Limbic structures

Fig. 8.4. Anatomy of vision when the hemispheres have been disconnected by commissurotomy (split brain), showing the main tracts linking parts of the cerebral cortices with each other and with centres of the brainstem. (CC = corpus callosum).

manipulate a chosen visual target and thereby gain a peanut reward.

By requiring the monkey to use the right limb, which is controlled by the left hemisphere, one can shut down the vision of the right eye, which, after the surgery, is connected much more strongly to the right hemisphere of the divided brain (Trevarthen 1965; OCM: 'Split brain and the mind'). When using the right hand, the monkey became conscious on the left side of his cerebrum and unable to see with the right cerebral cortex. This caused the monkey to be inattentive to things in the half of his experience that was on the opposite side to the hand he was using and likely to imagine things that did not exist there. The same division of mirror halves of awareness and the same absences and inventions of awareness in the deafferentiated half of the sphere of perception, prevails in a human commissurotomy patient (Sperry 1977; 1982; Trevarthen 1979a, 1990d; Fig. 8.4).

Seeing the immediate surround and scanning for information

Observations of split-brain monkeys additionally helped the discovery of two levels of vision, with different functions in behaviour

(Trevarthen 1968). One level of seeing, which the operation does not divide, provides an automatic or unthinking context or frame-of-reference surrounding the head and body: an awareness of spatial position and distance. In this part-conscious, part-unconscious *ambient vision*, locomotion and looking and reaching out to objects are directed and 'geared' to events in the environment at large. A similar partial level of function that survives loss of the striate cortex has been called 'blindsight' (Weiskrantz 1986). The ambient system is also acting as a motivator and map reader for attention in the second, more refined and more conscious. *focal vision* of shapes, colours, and patterns in detail, which the split-brain operation *does* divide into two.

A commissurotomy patient using ambient vision can orient to both sides of the space round his or her body with either hemisphere, and can make judgements about the 'balance' of experiences on the two sides of the midline of the visual field, while the detailed consciousness of object-identifying focal vision is split into two realms, one on the left seen by the right hemisphere, and one on the right that the left hemisphere sees (Trevarthen and Sperry 1973; Trevarthen 1990*d*).

Each of these systems is important in visual art. The ambient system apprehends the general layout and sculptural form. The focal system provides consciousness with the reality-based detail we pick up when we aim the centre of our visual awareness to a focus of interest and take up excitation from the effects of light in the foveae of our two eyes (Trevarthen 1979*a*). Scanning for detail is done by intermittent fixation of the line of sight, to stabilize on the foveae a nearly stationary image of some interesting locus in the outside world. Our eyes jump from place to place, saccadically, resting a moment each time to capture clear detail with the foveal magnifier, which is connected to a far greater mass of visual cortex than any other equal-sized patch of retina. The impression that we see equally clearly in all directions all the time is a satisfying fabrication, necessary in the planning of future action. In fact, the patch of clear, detailed, full-colour vision is just a degree or two across. This limitation imposes the need for a strategy of successive fixation or serial visual sampling, and one can read the thoughts of a person as they explore a picture by recording which points they fixate and in what order (Yarbus 1967).

Doubtless this two-level model of the visual system is incomplete. There are more than two different ways of assessing visual information in parallel perceptual systems of the brain. But the ambient-focal distinction is a fundamental one. Vision seeks the best available information from light to solve constantly changing ongoing motor problems, both problems of general locomotion and more restricted

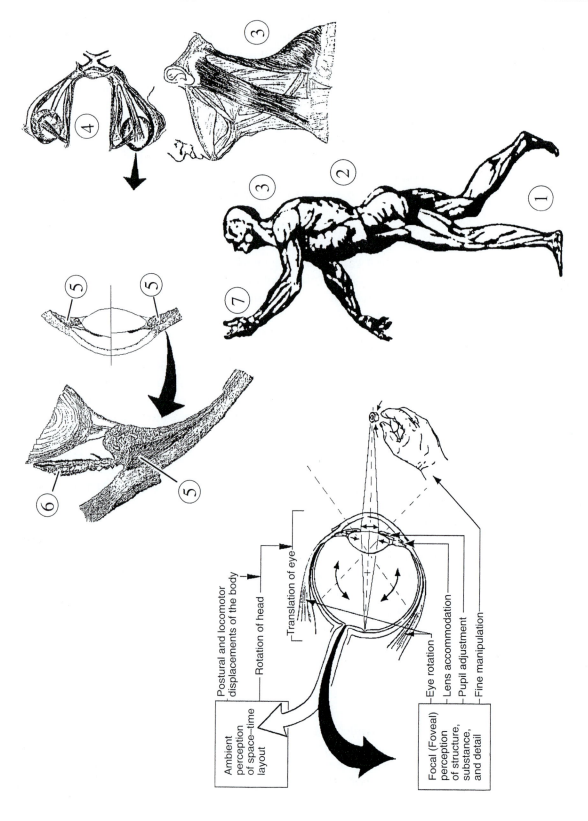

Ambient
perception
of space-time
layout

Postural and locomotor
displacements of the body

Rotation of head

Translation of eye

Focal (Foveal)
perception
of structure,
substance,
and detail

Eye rotation

Lens accommodation

Pupil adjustment

Fine manipulation

and refined problems of looking and manipulating. It is set up extensively in the brain to generate an integrated plan for experience that is fitted to all these forms of action. And the other sensory modalities collaborate in the construction of one perception of the field of possibilities for behaviour, with their ambient and focal levels of function. Thus, the senses of audition, vision, and touch have one common ambient field in which are deployed several 'arms' each carrying 'finger-tip awareness' of very high resolution that can be oriented and projected individually or collectively to 'feel' or 'listen to' the details of local reality according to the strategy already framed by a continuously informed overview of the whole-body-related situation (Trevarthen 1978). The overview of one space at one time and a single 'point of view' is formulated and integrated in an undivided brain system in relation to the initiation of movements of the trunk, head, and arms, and in direct response to the layout and flow of information from the world (Figs. 8.4 and 8.5). Meanwhile the detailed visual picture is being actively made up and tested by the flickering chains of movements of the eyeballs and fingers in two-way communication with the cerebral cortex (Trevarthen 1972, 1979a).

We can better understand the brain's inner visual mechanisms by observing how vision is gated and oriented by movements of body parts. Contracting muscles transform the visual image and visual information uptake in different ways, as they move the eyes or parts of the eyes (the lens) differently (Fig. 8.5). Nearly every muscle in the body can be used to change the stimulation of the eyes and to pick up visual information.

Fig. 8.5. Muscles of vision, and motor transformations of *ambient* and *focal* awareness. Locomotion (1) translates the eyes with the whole body; rotations of hips and trunk (2), and of the head (3) carry the eyes along arcs. These movements transform the whole visual image on the retina, gleaning information from the ambient visual array. The foregoing movements are accompanied by a conscious change in one's position and direction of orientation in relation to surroundings. The extrinsic muscles of the eyes in the orbit (4) rotate the eyes about their centres, displacing the foveae to permit shift of information.. These muscles also permit changes in the vergence of the eyes, allowing them to be directed to points at different depths in visual space. Eye movements in the head, without accompanying head rotation, are sensed not as changes of one's place and orientation, but rather as changes of the place of interest or attention in the world. Intrinsic eye muscles are of two kinds: ciliary muscles (5) flatten the elastic lens, changing the depth of focus of the eye; iris muscles (6) open and close the pupil, changing the aperture of the eye. Pupillary contraction increases the depth of focus. Finally, manipulation (7) can transport or transform objects in the visual field. (Drawings modified from Vesalius, Helmholtz, Gray, and Pirenne; figure at left from Trevarthen 1985b.)

Different regions of the retina send their differently signalled messages to distinct brain networks because the messages have to be processed differently, their information having different significance for the body-moving systems that are looking for guidance. The eyes themselves are, in fact, optical selectors, like a set cameras with different kinds of film in them, that are either directed to select an interesting object, like a searchlight, or opened out wide-angled to receive the whole dynamic picture of possibilities. By their movements, eyes sort out the various streams of retinal evidence from patterns of light about what the body can do in relation to outside reality. Like any tool, and like the hands, the eyes have effects when they are moved in a particular, purposeful, and skilful way. In fact, each eye is a tool-kit of many visual instruments (Trevarthen 1968).

The brain is anatomically adapted to employ the eyes effectively, and a basic principle of the brain's design is the division between the brainstem-based ambient vision system that directs whole-body movements translating the eyes in space and the cortex-dependent focal vision system that rotates the eyes and regulates the focusing of an image on the foveae of the two eyes (Fig. 8.5). Focal vision picks out local information to identify substances and objects, and directs the delicate manipulations of the fingers by which objects are seized, transformed, and combined (Trevarthen 1968, 1972).

Using multiple visual maps and many systems of feature detectors to see one world

As Rose, Livingstone and Hubel, Zeki, and Perrett et al. explain, many maps of the visual world have been found in the brain. The processing that makes it possible for one to be aware of the motion, form, texture, colour, and articulations of objects is divided up between parallel cortical nerve cell populations (Lennie et al. 1990). The combination of all these views of one world and the integration of them with information from the other senses, such as touch and hearing, depends on a mapping of every sensory projection system according to the body's symmetry, which is printed into the brain tissue from its first appearance in the embryo (Trevarthen 1985a; OCM: 'Brain development'). In brain development, all the cortical maps become linked, in a body-scape (somatotopic) code, to similarly mapped core sensory-motor systems below the cortex that can move and orient the whole body. In functional terms, the brain's sensory receiving areas are assembled to focus the 'light of consciousness' together at one point, the centre of a single subject's awareness.

Physiologists studying vision, increasingly influenced by computational theories of machine intelligence, usually conceive the essential first event in the brain for seeing something as the excitation in redundant detail of a pattern of features in the 'primary' visual tissue (the striate cortex) at the back of the head. Elemental or featural visual discriminations (a 'primal sketch') made by the cells there, which receive a fairly direct input from the retina, are assumed to be sifted out later into higher-order categories by a cascade of combinings and rejections of decisions about what information is useful in the visual signal as it rolls forward through the cell matrix of the cortex. On this view the 'conscious image' is assembled as in a factory that has an input of sorted and named components and a rather passive system of assembly belts. But this theory does not clarify where or what shape is the neural representation or control of what is going to be built to identify an object with usefulness and meaning. The effective visual intelligence of young infants, in whom the primary visual cortex is still half-formed, suggests that there is a deeper source of coordinated awareness anticipating the synthesis from striate cortex analysers.[7]

In reality, the process is surely adapted from the start to fitting seeing to action. Cortical 'visual' cells give *and receive* communications to *and from* many visual *and non-visual* parts of the brain. The cull of detailed visual features of texture, colour, form, motion, etc.; is almost certainly admitted at the end of the process of picking up and synthesizing information, to answer questions that have already been given an approximate form and purpose in more central parts, where all sensory modalities converge and where motivations important to the subject are generated. The prospective control (planning ahead) of consciousness must be set up in the brain, far from the analysers of received sensory input. Consciousness must be checked and redirected by experience (see footnote 3).

Paintings as records of visual consciousness on-the-move

The reverse way of looking at visual processing in the brain, as a hunting for detail to fill out a growing purposeful awareness, might

[7] More advanced computational theories confront problems such as how the form of the human body with its several axes of symmetry is perceived, and the perception of spatial layouts and objects in 'virtual worlds' (Marr 1982; Boden 1991). These give the psychophysics of aesthetics and creativity new force, but still leave the processes of motivation and communication largely unexplained (OCM: 'Art and visual abstraction'; Runeson 1980; Stephan 1990).

have use for artists, because it helps explain too how one can have strong and emotionally charged ideas about what one sees in anticipation of the kind of detail that focal vision picks up and checks against categories in memory. Full consciousness is also directed by a synthesis of thinking and 'working things out' as ideas in the head; but this rational awareness grows on an unthought set of motives that are more directly connected with moving and planning to move. In this view (of 'top-down' or, rather, 'centre-to-periphery' processing) a subjective abstraction emerging first and directly in perception is a fundamental basis for enquiries about more objective 'real' details that may require reference to 'declarative' memories and extended rational analysis.

Indeed, the complementary roles of ambient and focal vision in setting up active, information-chasing consciousness seem to be captured, frozen in time, in many beautiful drawings and paintings. Turner, a forerunner of the Impressionists, is a master of the wraith-like context of dramatic experience in which only a few details are clearly delineated and this creates a sense of being swept up, like Horatio Hornblower, in mysterious, partly-comprehended circumstances — evening, daybreak, storms at sea, battles, and the like. Van Gogh exaggerates the aura of seeing in colour and motion, leaving one hunting in a tapestry of highly contrasted colours. Great painters of all times have explored half-conceived stages of creative seeing. They record motivation for seeing, events nearly seen, as well as something seen.[8]

Left and right in the space of consciousness: the hemispheres have different minds.

A majority of us are 'right-handed', preferring to take conscious control in the right hand, especially for communicating by gesture or writing and for carefully directing tools like pencil or paint brushes by eye (Corballis and Beale 1976). A majority of humans have been right-handed for many thousands of years (Coren and Porac 1977) and this has been evident in tools and artworks since Neolithic times (Marshack 1972, 1976). We also tend to move the right side of our mouths more or earlier in speaking, and to look right as we speak 'our mind'.

These biases in acting and attending, though they are elaborated as learned skills, originate in asymmetries implanted in subcortical

[8] The history of art shows that there have been cycles of relative sophistication and naïveté: periods that value consciously refined and stylistic complexities that are largely arbitrary are eventually followed by a deliberate seeking for intuitive abstraction and simplicity of convention (Gombrich 1977; OCM: 'Art as perceptual experience').

systems before birth (Trevarthen 1990*a*). They are linked to the differences in the ways our two cerebral hemispheres function (Sperry 1982; Bradshaw and Nettleton 1983). These differences have been studied in perception, memory, language motor patterning, and, more recently, in terms of cognitive strategies integrating all these processes to take in environmental information or coordinate movements. In an influential review, Bogen (1969) described the right hemisphere as 'appositional' and the left as 'propositional'. Bogen and Bogen (1969) gave the appositional function primary importance in artistic and intellectual creativity. Findings with commissurotomy patients, in whom unity of consciousness is sometimes achieved by 'cross-cueing' of sensory input caused by the subject's movements, have been used to support theories of modular intelligences derived from neuropsychological and cognitive science fields (Gazzaniga and Le Doux 1978; Marr 1982; Fodor 1983; Gardner 1984). These theories do not suggest a purpose or evolutionary explanation for the different kinds of cognitive processing proposed.

It has been clear for more than 100 years that language functions are more strongly represented in the left hemisphere, which is called the 'dominant' hemisphere. There is, however, a complementary superiority in the right hemisphere for perceiving the layout of the world around the body and for directing eye and hand in this larger space, and this hemisphere seems to have a more reality-oriented memory. The phenomenon of left-field visual neglect or one-sided unconsciousness that follows damage to the right parietal cortex, and the absence of a complementary effect after the same degree of left-hemisphere damage, shows that the right hemisphere has a more complete representation of both sides of the space to be explored and searched in around the body. Right-hemisphere lesions selectively impair object and event recognition by sight or hearing and may have a devastating effect on the capacity to recognize who other people are and what their emotions may be. Right posterior lesions can also weaken people's discrimination of their own expressions of feeling and generally lower self-awareness. Finally, there are many classical demonstrations that right parieto-temporal and frontal lesions cause selective losses in skills that require an imagination of object orientations and spatial arrays that serve to guide manipulation of combinations of objects or in pathfinding. It needs to be emphasized that all these cognitive and performance functions of the right half of the brain are important to a person's cultural life in a community, and to the acquisition of many skills that language may find hard to handle (Dissanayake 1992). Moreover, they serve to support the language-mediating functions that are more strongly represented in the left hemisphere.

In recent years, largely because of the interest generated by studies of consciousness in commissurotomy or split-brain patients (Sperry 1977, 1982), but also informed from a century of information on the effects of lesions in different parts of the cerebral cortex, there has been much writing and speculation about how recurring asymmetries in works of art might be related to the anatomy of the brain (Levy 1976, 1988; Gardner 1982*a*, 1984; Rentschler *et al.* 1988; Schweiger 1988; Zaidel and Kasher 1989; Zaidel 1990). If artists are exploring their own imaginings and movements when they are creating and using their hemispheres differently to do so, left–right asymmetries will appear in their work. Indeed, there is a school of art teachers who draw on the findings from split-brain research to guide their pupils to make stronger use of the right hemisphere, claiming that this generates more dynamic, coherent and aesthetically-pleasing forms, and some require their right-handed pupils to sketch unthinkingly with their left hands (Edwards 1979; Cross 1984).

Stephan (1990) has synthesized a psychological theory of aesthetics from anthropology, palaeontology, neuropsychology, and cognitive science, deriving support from observations of perception and verbal report in commissurotomy patients. He argues that visual art is appreciated directly by unconscious assimilation of the visual image to a direct intersensorial (multimodal or amodal) understanding of meaning — an icon. This occurs by virtue of 'non-discursive mental competences' in the right hemisphere, independent of words and rationalizations. Because left and right consciousness are anatomically separate modes of awareness, there is a problem of 'translation'. We have to learn how to talk about what we recognize as beautiful in art, and it is inherently difficult to recall what we say about it. Language offers a special way of introspecting, for planning actions, and for manipulating information in 'phenomenal absence' from its source, but it is limited in representational imagination. It is particularly difficult to translate back from word to picture.

Pictures, Stephan proposes, have 'full existential life' because they visually evoke experience 'traces' rich in information that has been gleaned from other modalities: a recasting of the psychoanalytic explanations by Freud and Jung of art's meaning (see also Dissanayake 1992). Art images become verbalizable because of further transformations, which give rise to aesthetic experience or to the capacity to declare such an experience. The generation of an illusory phenomenal awareness in the right hemisphere from the partial information of the two-dimensional picture gives rise to a tension and, thence, to a 'subtle state of emotional arousal'. Cathectic transference into the image leads it to be perceived as beautiful (to have 'affective import') and this experience is translated to the left hemisphere, which can 'discourse' about it.

Fig. 8.6. The 'glance curve' in the three dimensions of a picture.

Our common brain asymmetry does appear to have been unknowingly exploited by many painters to generate aesthetic effects. I believe that the examples which follow illustrate how the inner sense of the brain at work, rather than a learned or rationally constructed sense of 'real', verified things outside in the world, may give rise to aesthetic emotions of pleasure or satisfaction, directly and immediately.

Spatial biases in artists' vision

Figure 8.6 reproduces a *glance curve*; a trajectory of visual attention from the near lower left to the distant upper right that is supposed to be generated in the mind in perception of picture space (Gaffron 1950; Gordon 1981). This hypothetical curve is based on psychological research into attentional biases in the vision of normal subjects. Analyses of the use of space in pictures by artists point to a pervasive asymmetry which carries interest across the picture space upwards and to the right. In a painting affected by this principle, the theme-setting material is at the lower left and the main topic or point of greatest interest lies toward the top right corner. This bias can, as we shall see, be exploited to create an appealing 'narrative' effect in an abstract painting devoid of reference.

Plate 4 shows examples of paintings by a Canadian artist, Guido Molinari, who has applied psychological theory, including Jean Piaget's structuralism, to an exploration of the creative process. Molinari is, as Campbell (1987) explains in a series of scholarly philosophical essays that analyse the painter's work, highly sensitive to imaginative control of transformations in awareness of form and colour in the body-related space–time of a picture. This investigation gained him an awareness of cerebral asymmetry and its effects in action and awareness. Both these abstracts lead the eye upwards to the right. Molinari used various techniques, including painting while blindfolded, to discover the placing of black–white boundaries that

felt satisfying as a coherent representation of the activity of making a picture. He was led to place the areas and boundaries in this way, from a 'more static left-side — vertical movements at left, then ... towards the top right corner, with a counterbalance mass towards the bottom right corner' (Campbell 1987, p. 14). The artistic message of such deceptively simple abstracts claims to be 'dynamic, holistic, and self-regulated' and independent of any reference or any symbol, representing no identifiable object.

Perceiving the feelings and purposes of animate beings

> Make figures with such action as may be sufficient to show what the figure has in mind; otherwise your art will not be worthy of praise.
>
> Leonardo da Vinci, *Notebooks.*

Vision, in addition to seeking information from points in a field of attentional interests, has to accept the traces of motion, not only those generated by the subject himself transporting his eyes and hands along undulating trajectories, but also and most importantly those due to the independent movements of other animate beings. We have great sensitivity to animate movement and can judge much concerning the effort and emotion behind the movement (Johansson 1973, 1975; Runeson 1980, 1985). The sensitivity of infants for the movements of other people indicates that our brains are born with 'detectors' for dynamic effects of others' actions.

Paul Klee was intensely interested in activity, vitality, and rhythm and he gave systematic instructions to guide his students to strong expression of these elements (Klee 1968). His drawing in Plate 5, called *The Snake Goddess and Her Enemy*, illustrates both the sweep of interest up to the right already discussed, and the use of an undulating line to show body movement. Plate 6 is another Klee which shows the use of lines to represent motion or posture. Its title is *Whose Fault Is It?* Here the top right is empty and the 'animals' are looking away from it. A kind of humiliation is portrayed, because they are looking back and down to the left, away from the natural focus of interest at the top right. In this picture a key element is the line of consciousness or will in the beings represented — the direction of *their* interest. Klee appears to be using the same principle as Molinari, that is, a diagonal interest line that starts at the lower left and leads to the upper right. Vitality and rhythm of motion in matter or in animate movement can be seen directly and immediately in static representations such as these drawings. The innate foundation for awareness of motion and movements gives pleasure when we see it captured well and this can be abstracted into a conscious tech-

nique. Many modern painters, from the post-impressionist Seurat, have explored the relation between the emotional connotation of a body line or curve of movement and facial expressions of emotion. Hogarth, in the eighteenth century, proposed a 'serpentine line of beauty' which he believed to be present in all things felt to be beautiful.[9]

We have seen from the ways infants communicate that this sensitivity has an innate basis, with specified feelings and values. Our minds have an extraordinary sensitivity for the human body (see footnote 7) and especially for the person who looks out with eyes of interest and speaks with a voice of feeling. Infants and adults are, moreover, asymmetric in their expressions to others and appear to have different emotional susceptibilities in their two hemispheres. (Trevarthen 1990a; Tucker 1992). This leads us to seek for evidence of asymmetric use of picture space by an artist who wishes to tell a story.

Giotto and the drift of visual narrative

Research by Dahlia Zaidel indicates that the adult human brain is highly asymmetric in its memory systems and especially in the way it relates consciousness to ordinary everyday reality as contrasted with strange, contrived, bizarre, metaphorical, or surreal representations (Zaidel 1986, 1987, 1988, 1990; Zaidel and Kasher 1989). We might find evidence of this from a study of how picture space is used by artists to tell a realistic but significant or moving story or to make an abstract and artificial commentary of a more original or contrived kind.

Giotto depicted the story of Christ in 34 paintings on the walls of the Capella di Santa Maria della Carità in Padua, built for Enrico degli Scrovegni in 1303–1305. The pictures were made to be a visible Bible for the instruction of the illiterate. These pictures give a stunning demonstration of principles of visual narrative in picture space that, whether conscious and conventionalized or entirely intuitive, strongly confirms the idea that the motives we identify in pictures of human action are governed by consistently asymmetric activities in our brains.

Table 8.1 shows that there is a remarkable consistency in Giotto's use of picture space as the viewer sees it, especially with respect to the consciousness of the protagonists and their movement in the landscape and into and out of the buildings. I do not think these fea-

[9] I am indebted to Anthony Fallone for these points of art history.

Table 8.1c Giotto — Scrovegni Chapel, Padua

(a) Deadly vices and virtues: in the order as seen when entering the chapel.
L and R, Direction in which figure is facing in picture space relative to the viewer's
and Giotto's body.

Left wall			Right wall	
A	Despair	L (Passive)	Hope	R
B	Envy	L	Charity	R
C	Infidelity	L	Faith	C (Standing still)
D	Injustice	L (Seated)	Justice	L (Seated R, looking back)
E	Anger	L	Temperance	R
F	Inconstancy	L	Fortitude	R
G	Foolishness	L	Prudence	R

(b) Directions of action within picture space

		Direction of movement or attention of main actor (s) [of passive person(s)]	Goal or feature in landscape	Orientation or place of buildings {Exit facing} [Entry facing]
1	Joachim driven from the temple	R		{R}
2	Joachim and the shepherds	R	R	
3	Annunciation to Saint Anne	R		R
4	Joachim's sacrifice	R	R	R
5	Dream of Joachim	R [L]	R	
6	Meeting at the Golden Gate	R [L]	R	
7	Nativity of the Virgin	R [L]		R
8	Presentation of the Virgin	R	R	R [L]
9	Consignment of the stems	R [L]		R [L]

10	Prayer for the blooming stems	R		R
11	Marriage of the Virgin	R [L]		R
12	Wedding procession	R		R
13	Nativity	R [L]	R	L {R}
14	Adoration of the Magi	R [L]	R	R
15	Presentation at the temple	R [L]		C [L]
16	Flight from Egypt	R	R	
17	Slaughter of the innocents	R [L]		L {R} & R
18	Jesus among the doctors	R [L]		L [R]
19	Baptism	C/R [L]?	R	
20	Marriage at Cana	R		R [L] {R}
21	Resurrection of Lazarus	R [L]	R	
22	Entry to Jerusalem	R [L]		R
23	Expulsion of merchants	R [L]		{R} & R
24	The last supper	R		L?
25	The washing of feet	R [L]		[L?
26	The capture of Christ	R [L*]		
27	Jesus before Caiaphas	R/L [L*]		R [L]
28	The flagellation	R [L*]		[R {R}
29	The way to Calvary	R/L	R	[R]
30	Crucifixion	R [L] [L*]		
31	The mourning and burial of Christ	R? [L]		
32	The resurrection	R/L	R	{R}
33	The ascension	R [L]		
34	Pentecost	C/L		C/L?

Note: All symbolic hand signs and gestures of expressive communication are made with the right hand.

tures can be explained by the principle that the right hemisphere is more interested in visuo-spatial depictions, or that putting the most interesting details in the right half of the picture serves to balance this bias (Gaffron 1950; Levy 1976, 1988). Giotto's art is immediately capturing more of human interest.

In all but two of the pictures (nos 19 and 34) the main person is looking forward and/or moving to the right (R) of the picture, apparently without regard to the position of the altar. *The Baptism* (no. 19) shows Christ in the centre, looking and gesturing up to John on the right. As in most of the pictures, the active attendants to the main actor are behind him (or her) on the left side of the picture facing right. In the *Pentecost* (no. 34), which is very happy and relaxed, Christ chatting with the disciples is left of centre, gazing upwards to the left (his right).

In many of the paintings the passive or receiving persons are on the right, facing left ([L]). Aggression and violence also come from the right to the left ([L*], nos 26, 27, 28, and 30), except in the *Slaughter of the Innocents* (no. 17) in which the soldiers attack from the left and the weeping mothers are huddled to the right, facing

left. In the burial (no. 31) the dead face of Christ is directed upwards
to the right, Mary and the others leaning over facing to the left. *Jesus
before Caiaphas* (no. 27), on the way to *Calvary* (no. 29), and in the
Resurrection (no. 32) is moving to the right, but looking back to the
left. In the *Crucifixion* (no. 30) the virgin and attendant women are
at left facing right, Christ hangs with head looking down to the left,
and on the right soldiers cast lots for Christ's clothes. Sadness, resig-
nation, and pity look back to the left, as shame does in Klee's *Whose
Fault Is It?* (Plate 6).

In Giotto's scenes the place towards which actors are moving is in
the landscape to the right of the picture, never to the left, and build-
ings similarly are placed or oriented to support the direction of the
main rightward action. The layout of Giotto's visual stories is thus
strongly polarized by the direction in which emotions, purposes, and
interests move for the viewer. Furthermore, all significant gestures of
positive communication and all symbolic hand signs are made with
the right hand, whichever way persons are facing.

We shall come back to the psychological asymmetries of narrative
vision when we look at the strange preference of the left hemisphere
for unusual combinations.

Turn of emotion

Motivation for attending to the world we share with others is associ-
ated with emotions. We search with eagerness, pleasure, fear, anger,
and so forth, projecting our states of feeling on to objects as they
come into consciousness. Can brain science make predictions about
how emotions will enter into the cognitive appreciation of pictures?

Commissurotomy patients, when reporting their experiences in
the *left* ambient visual field, sometimes *speak* in a highly emotional
way. This is an exception to the rule that applies in recognition tests,
because a commissurotomy patient can only talk about and describe
consciousness of what kind of thing they see in the *right* visual field.
The right cerebral hemisphere disconnected from the left is mute and
has no access to detailed information that can serve to identify
objects in that field (Fig. 8.4). However, a number of studies have
confirmed that commissurotomy patients can transmit between the
hemispheres less-specific or less-objective feelings about their con-
scious experiences (Sperry *et al.* 1979; Sperry 1984). This suggests
that these subjective or self-referred feelings are associated with the
subconscious impulses and organizations that form among the
deeper circuits, below the level of the split-brain operation. Emotions
are tied to the intrinsic regulations of the brain's actions.

Other evidence indicates that the emotional regulations are asymmetric — different on the two sides of the brain (Tucker 1992). Recently a rather startling claim has been made by Schiff and Lamon (1989) that appears to confirm that the right and left halves of the brain have different moods or temperaments. If, following instructions, people deliberately keep the muscles of the left side of the mouth screwed up tight for approximately 1 min, apparently activating the right cerebral hemisphere, this tends to create in them a feeling of sadness or depression and perhaps isolation. If they twist up the muscles of the right side of the face, this activation of the left hemisphere gives them an ill-defined sense of well-being and extraverted confidence or boldness. The induced emotional states influence the reading of an ambiguous story, making the reader, who has been giving one-sided activation to his brain, perceive the story as more sad or more optimistic. Asymmetries in the emotions expressed by infants, and their reactions to other persons' feelings, would indicate that this feature of the brain, too, has a prenatal origin (Trevarthen 1990a; 1993a).

To return to the Scrovegni Chapel (Table 8.1): Giotto placed figures to represent the Seven Virtues on the right wall, as one enters and nearly all of these happy states of mind face right, *away* from Christ at the altar. The Seven Deadly Vices are on the left wall and all face left, also away from the altar. Giotto's intuition, or possibly some rule of medieval picture construction, makes the opposite feelings direct the consciousness of the observer in opposite directions, and the directions correspond to the asymmetries of emotion revealed in recent neuropsychological research (Tucker 1992).

Depicting values of space and substance with colour

> Shadows become lost in the far distance because the vast expanse of luminous atmosphere which lies between the eye and the object seen suffuses the shadows of the object with its own colour.

Leonardo da Vinci, *Notebooks*

Colour vision has evolved because it is important ecologically. The basic categories and values of colour are products of brain evolution and brain embryology. Indeed, colour is nowhere else but in brains; the primary categories of colour could not have been learned. Infants perceive colour in a set of categories that are universal and that serve as the foundation for a great variety of ways of using and talking about colour in different cultures (Bornstein 1985a, b). In agreement

with Stephan's theory of the learned transformation required to verbalize about phenomenal visual experience (Stephan 1990), young children are remarkably poor at talking about colour, though, provided they are not colour-blind, they appreciate the colour of the world with excellent discrimination (Bornstein 1984a, b).

The evolution of colour vision is dependent on the fact that the spectral composition of light in different environments can have predictable value to animal life, and evolution has built special detectors of these regularities. One such effect is the complementary composition of sunlight and shadows. Under a yellow sun shadows tend to be blue, as Goethe observed (OCM: 'Goethe, Johann Wolfgang von (1789–1832)' (Plate 7). In the above quotation Leonardo describes how the atmosphere scatters blue light. Plate 8 is a David Hockney painting that presents an object in red, brown, green, and white in front of space and the distant landscape sculptured by blue light.

Split-brain patients have an intriguing colour anomia, attributable to a superior but inarticulate ability to perceive colour in the right hemisphere that is disconnected from the speaking left hemisphere (Levy and Trevarthen 1981). Tests reveal that they also retain an undivided brain stem level of colour vision that appears to have a fundamental ecological significance linked to ambient vision of space and motion. This defines a dichromatic distinction between blue airy space, on the one hand and the reddish-brown solids that make up earth, plants, and animals and people, on the other. My tests showed that commissurotomy patients had a blue–red colour vision in their undivided brainstem awareness which conceived light and the phenomenal world to be structured by a blue versus reddish or non-blue kind of distinction (Trevarthen and Sperry 1973; Levy and Trevarthen 1981). In nature, reflections of the sky on the surface of water, or the shiny surfaces of leaves and so on, are blue. Substance, particularly organic substance, is red, brown, or yellowish, as is illustrated in Plates 7, 8, and 9. If you put before your eyes a purple (blue-red) filter that blocks out rays in the middle of the spectrum, leaving only blue and red bands, you can see this ecologically valuable partitioning of the experience of light. Space, air, sky, and the surface of water or metal is blue — earth, grass, wood, food, people, and the clothes they wear are reddish or brown. It seems plausible that a probably ancient dichromatic visual system in the midbrain unconsciously appreciates the way blue space and reddish substance is distributed in the world before the more discriminating and more conscious cortical full-colour vision makes its contribution to perception of detail, chemical analysis or 'tasting' of matter, detecting the products of the chemistry of life. Every fruit-eating bird or monkey knows how to tell ripe, sugar-laden berries by their colour. Bright reds and yellows signal sweetness to birds and mammals. The same colours are effec-

tive socially in courtship and threat — they, with bold stripes and spots, may also be markers of organic poisons.

The picture in Plate 9 from a French women's magazine, is presented at three levels of focus to demonstrate levels of colour resolution that have different functions in awareness. Ideally, these prints should be viewed one at a time in order of increasing clarity of focus. On the left you can easily see the separation of the human figure from the watery background. You can make out the face quite well too. The features and expression of the face are brought out more clearly in the middle picture, but you cannot read the text. The third picture shows the whole clearly and the title, partly visible in Plate 9 (c), is revealed to be appropriate. It is *Les couleurs se font au soleil*. These are three stages in the genesis of visual awareness, calling for increasing refinement of input from the neocortical visual analysers. All are held together by appreciation of the object in space at the first stage. This, and the awareness of the expressive '*Gestalt*' of the face, may be processed more in the right hemisphere.

The Belgian surrealist painter Réné Magritte intrigues us with moody violations that challenge the principles by which we usually comprehend what we see. The picture which he calls *Souvenir de Voyage III* (Plate 10) portrays a table and chairs on a wooden floor, with a bowl of fruit, a book, and a bottle of wine and a glass on the tablecloth in front of an open window through which one can see a rugged cliff. Everything — furniture, fruit, wine, tablecloth — is as if carved of one piece of the pitted, grey rock of the cliff. The objects are made into rock by the texture, but also by the deadly absence of colour, which would have given them their substantial identity. Colour negatives, in which an orange is blue, a rose is green, and the sky is pink, present an ugliness that arises from their systematic unnaturalness.[10]

Colour preferences, mood, and personality

Johannes Itten, who, like Paul Klee, was a renowned teacher at the Bauhaus in the 1920s, used psychophysical principles to demonstrate the evocative powers of colour in different combinations. He discovered that his students had different colour worlds related to their personalities and preferred occupations (Itten 1961). Assigning

[10] In the cultural use of colour, novel and contrasting meanings can be given to hues and their combinations that override the more intuitive and universal 'ecological' or interpersonal values of colour (cf. Bornstein 1985*a*). Artificial colour is used technically to give definiteness and identity to signs and symbols, as can be seen in modern toys, clothes, and advertisements and in the covers of books. Black, white and red are universally favourite symbolic colours in ceremonies, marking 'specialness' (Turner 1966).

harmonic colour combinations to his class, he found that they would not agree with him about what was harmonious, so he left them free to invent individually their own most satisfactory solutions to his test, interrogating their own inner make-ups. After an hour, he reports: 'Each student had painted several original, closely similar combinations on his sheet. But each student's work was very different from the others' (Itten 1961, p. 24). In his famous book *The art of colour: the subjective experience and objective rationale of colour*, photographs of students are placed beside their subjective tone pictures and their abstract representations of the seasons, with a paragraph describing each as a person with an individuality of emotions. It is noteworthy that while Itten was discovering temperamental differences in his students he also expected to be able to name the feelings with one set of terms, *one scale of emotional values*. He assumed an underlying agreement about emotions.

Colour vision appears to provide one fundamental, directly felt setting or context for more reasoned awareness. To act as such an evaluative prior context, it will be heavily loaded with affect. And it will be organized with biases for detection of ecologically useful things, like ripe fruit, wet or dry situations, things that are solid from things that are vacuous, things that are distant from things that are near, living things and dead flesh, different states of animation and health. All of those judgements would constitute a set of immediate aesthetic judgements which would be born in one and distributed among the things one learns. They would, as Itten concludes, also be important, with a host of other kinds of aesthetic reactions, to the development of one's social personality, skills, and occupation; to how one presents oneself to other persons.

Ellen Dissanayake (1992) draws attention to aesthetic preferences that define what is wholesome and good. It is conceivable that colour values and other values important in aesthetics, such as brightness or sharpness of light, reflectance, texture, and aspects of mass such as balance and weight, have direct relations to the brain chemistry of emotion. There may be, for example, an anatomico-functional connection between the category red and a particular balance of neurotransmitter production in those regulatory brain systems of emotion that modulate attention, consciousness, and remembering.[11]

[11] Colour in paintings satisfies many activities of the mind, and there is evidence for many kinds of innate principle in the evaluation of colour arrays, besides those we have discussed. The Austrian painter Friedrich Hundertwasser makes abstracts with extreme contrasts in hue, brightness, saturation, and lustre betwen adjacent elements, exaggerating and magnifying the way that contours and facets on the surfaces of objects reflect light scattered from the varied spectral sources in ambient illumination. In parallel to an innate basis for colour evaluation of space, substance, and form, there will be an innate metric of graininess in the perception of surfaces of matter. With experience of the dividedness and arrangements of

Complementary hemispheric strategies for consciousness of meaning

My final painting is a horrific one by Réné Magritte called *The Rape* (Plate 11). Dahlia Zaidel has used this picture to demonstrate differences in cognitive strategy of awareness between the left and right hemispheres in commissurotomy patients (Zaidel and Kasher 1989; Zaidel 1990).

Zaidel's tests showed that the right hemisphere accepts the surroundings of hair, chin, and neck and sees a face. The subject who is receiving the picture only in his or her disconnected right brain points to 'eyes', the 'nose', and the 'mouth' as if it were altogether a reasonable representation of a face, locating 'breasts' and the 'pubic region' somewhere below, out of the picture. Using their left hemispheres, however, the same people make no mistake about the separate elements the artist has placed absurdly in this frame of the head, pointing to 'breasts' and 'pubis' as they are individually portrayed and failing to find eyes, nose, and mouth. The confusion of perspectives on this muddle of the human body feels very unpleasant to us. The two cerebral hemispheres of a commissurotomy patient resolve the puzzle in different ways.

Jerre Levy (1988) has suggested that the aesthetic values of experience are related to the brain's strategies for making sense of the world — that they help the brain to value good ideas about reality. Assuming that cognition has mastery over emotion, she proposes that, given the hemispheres are specialized for complementary ways of experiencing, in the intact brain the best aesthetic experiences require a balance of evaluation in the two hemispheres working to support one another. Zaidel (1990) emphasizes the differences in the ways the hemispheres remember natural or unnatural, incongruous, and contrived representations in pictures. Stephan's theory relates the aesthetic experience to the 'tensions' generated between different levels of intuitive or learned 'reality' and the artificial constructions of the artist (Stephan 1990).

substrates and surfaces in the world, neural elements of discrimination will refine themselves by known 'activity-dependent' sorting processes. Singer (1990) has considered a theoretical approach to the emergence of self-organizing processes in the functional development of cortical visual systems, including the assimilation from experience of textures in space and time.

Many of the basic dimensions of visual discrimination of spatial detail are inborn, even though they profit from patterned stimulation to develop full refinement. It seems possible that affirmation of any such foundational dimensions in works of art brings pleasure, if only because it stimulates the essential process by which development of perception occurs. Additional pleasure will be obtained by sharing the discovered 'universals' with other perceivers.

It is concluded from the way that newborn infants scan a photograph of a face or a group of geometrical shapes that they cannot see details inside a large surrounding contour. Perhaps their brains function more like the right hemisphere of an adult looking at the whole array (De Schonen and Mathivet 1989). It is known that their right hemispheres are maturing more rapidly than the left at this age (Thatcher *et al.* 1987; Trevarthen 1990*a*). A newborn baby can certainly see and identify parts of a naturally moving face to detect expressions, as we have described (Fig. 8.2), but the baby appears to be more interested in the communicative messages and may not be looking for parts, as such, at all (Trevarthen 1989*b*).

The connection between human brain growth and the creativity of art

It has been shown that crucial developments taking place in an infant's cortex from 3 to 6 months after birth, which establish a conscious perception of detail (Held 1985), are 'gated' or selected by activity of the same reticular system of the brainstem that has control over the patterning of orienting and expressive behaviours (Singer 1990). This core neuronal system is also the source of the beat around which games and songs of communication with the mother are built. It is not difficult to see that the motives in the brain of a young infant, who has still to build his or her primary cortical mechanisms, will be open to directive influences from any outside source *that can resonate with and support the core regulatory states*. The mother is just such a source. We have little exact information on this interbrain process, though evidence has been obtained that the hormones that control the growth of a premature infant's brain can be affected by the baby's emotional state, which, in turn, depends on how gently the infant is handled (Kraemer 1992).

The limbic system and basal ganglia of the forebrain (older in evolution and earlier developing than the neocortex, and closely coordinated with the hypothalamus and reticular core) have crucial parts to play in postnatal development of higher psychological skills. Mortimer Mishkin (1982) has shown that in the monkey brain the sensory pathways of the neocortex and the limbic inputs collaborate in the formation of visual memories. In his laboratory, Merjanian *et al.* (1986) have shown that removal of limbic tissues from a monkey shortly after birth leads, some months later, to a condition resembling autism. That is, the monkey when 6 months old is abnormal in social behaviours and, possibly as a consequence of this, becomes retarded in psychological growth. Mishkin (1982) does not describe

the limbic inputs to the neocortex of frontal, parietal, and temporal lobes as 'regulatory', but I think it likely that the communicated states of emotions that the limbic system generates have a function in guiding the growth of intracerebral connections for mediation of higher cognitive functions.

Most of the evidence for the above statements comes from animal research, from species closer to humans as we come further in the development of the brain. The developing human brain is unique in the sense that it is far more open to communicated feelings and motivations than is the brain of even a young ape, and that these messages from other human brains elaborately affect what traces experience will leave in memory. Such an interpretation makes sense when one takes the view of an anthropologist who is interested in the neuropsychology of myths and rituals that govern the human community and that hold a culture and its beliefs together (Turner 1974, 1982). We need more evidence, however, on how the sharing of human aesthetic evaluations comes about in the brain (see Turner 1985) for evidence on brain-generated universals in the experience of poetic beauty).

Conclusion

Artists, painters, sculptors, and poets, actors, and musicians explore their private discoveries in consciousness and their deepest feelings, leaving a record of what they find. Their work communicates these lived experiences. When they create in authentic relation to their feelings, they make statements that can profoundly direct us — they can open up our consciousness and change how we value what we experience. They also give us durable images to share and treasure as icons that bear 'truths' about our inner lives. I conclude that works of art are possible because human minds are innately equipped to develop and keep alive their consciousness along parallel and communicating lines, collectively.

Art, being communicative, is expressive of motives in consciousness and exploratory action. It comes from and appeals to vitality in awareness and it is evaluated by innate 'vitality affects' (Stern 1985). It has traces in it of the space and time of all behaviour and the form of the body in action, with all its complementary senses. The body is the primary context and theme for deployment of the sensitive focal parts of our consciousness, which are constantly moving, selecting and rejecting, near and far, on left and right. The human cognitive asymmetry that penetrates the records of artists' work is elaborated out of an asymmetry of motives of a personal and emotive kind that serve in all communication.

The anatomy of attention leaves its effects in art. A reciprocal, rhythmic ebb and flow in motivation couples the focal and the ambient in awareness, in every sense modality and in all directions and locations to which receptors can be oriented. Art, a visible or audible product of this movement, can capture both the body-generated, body-related expressive utterance or gesture and the thematic (syntactic) narrative of the whole plan of action. It can express the asymmetry of statements and the figure–ground, feature–frame tension. Thus body and experience map on to one another. They give their layout and process to an art work, which then communicates to the viewer a representation of something in the world seen, studied, and understood, or a display of line, texture, light, shade, colour, and form abstractly generated from the imagination and in the act of creation itself.

I have attempted to use the infant as the clarifier of basic aesthetic universals that are synthetic in the growing brain, its body, and its behaviour field. I have emphasized the primary developmental role of communication in human psychology. Neonatal imitation is immediate and transmodal, and so, too, is an artistic experience. A whole, multisensorial phenomenal reality is the goal of behaviour from birth.

In pictorial art, visible form gives evidence of palpable, hearable, smellable, and tasteable reality in its emotive aspects, inciting awareness of things of importance, recollected and imagined. Temporal arts, of course, have different expressive concerns, which must be included in any general theory of emotions.

Beauty in art is to be found, not simply in what it portrays, but in the clear expression of the impulse of consciousness and discovery itself. The referent becomes beautiful and interesting *by its expression*, as in a mother's 'affect attunement' when she evaluates an act or an object for her infant, giving it the emotion of meaning (Stern 1985). The mood and personality of the work enables the viewer to enter the position of the artist's consciousness, assimilating his gestures and self-expression from the traces he has composed. Poor art, too objective or too subjective and confused, trivializes or offends this link of the viewer to the maker. Devoid of intimacy and authenticity, its 'voice ' is crass, monotonous, or indistinct, repulsive or boring. In the same way, the science or scholarship of aesthetics, if it is only generating a code or set of schemata for execution of forms defined as beautiful, will be sterile. We are motivated to seek spontaneity and authenticity in the expression of others' motives for perceiving and making.

References

Anderson, F. H. (1948). *The philosophy of Francis Bacon*. University of Chicago Press.

Bateson, G. (1956). The message 'This is play'. In *Group processes* (ed. B. Schaffner), pp. 145–241 Transactions of the Second Conference. Josiah Macy Jr. Foundation, New York.

Bernstein, N. (1967). *Coordination and regulation of movements*. Pergamon, New York.

Bjørkvold, J.-R. (1992). *The muse within: creativity and communication, song and play from childhood through maturity*. Harper Collins, New York.

Boden, M. (1991). *The creative mind*. Weidenfeld and Nicolson, London.

Bogen, J. E. (1969). The other side of the brain. II: An appositional mind. *Bulletin of the Los Angeles Neurological Society*, **34**, 135–62.

Bogen, J. E. and Bogen, G. M. (1969). The other side of the brain. III: The *corpus callosum* and creativity. *Bulletin of the Los Angeles Neurological Society*, **39**, 191–220.

Bornstein, M. H. (1984*a*). Psychology and art. In *Psychology and its allied disciplines: Vol. 1, Psychology and the humanities*, (ed. M. H. Bornstein), pp. 1–73. Erlbaum, Hillsdale, NJ.

Bornstein, M. H. (1984*b*). Developmental psychology and the problem of artistic change. *The Journal of Aesthetics and Art Criticism*, **53**,(2), (Winter 1984), 131–45.

Bornstein, M. H. (1985*a*). Infant into adult: unity to diversity in the development of visual categorization. In *Neonatal cognition: beyond the blooming, buzzing confusion*, (ed. J. Mehler and R. Fox), pp. 115–36. Erlbaum, Hillsdale, NJ.

Bornstein, M. H. (1985*b*). On the development of color naming in young children: data and theory. *Brain and Language*, **26**, 72–93.

Bradshaw, J. L. and Nettleton, N. C. (1983). *Human cerebral asymmetry*. Prentice-Hall, Englewood Cliffs, NJ.

Bråten, S. (1988). Dialogic mind: the infant and adult in protoconversation. In *Nature, cognition and system*, (ed. M. Cavallo), pp. 187–205. Kluwer, Dordrecht.

Campbell, J. D. (1987). *Molinari studies*, 49th Parallel, New York.

Changeux, J. P. (1985). *Neuronal man: the biology of mind*. Pantheon, New York.

Corballis, M. C. and Beale, I. L. (1976). *The psychology of left and right*. Erlbaum, Hillsdale, NJ.

Coren, S. and Porac, C. (1977). Fifty centuries of right handedness: the historical record. *Science*, **198**, 631–2.

Cross, A. (1984). Towards an understanding of the intrinsic values of design education. *Design Studies*, **5**, (1), 31–9.

De Schonen, S. and Mathivet, E. (1989). First come first served: a scenario about the development of hemispheric specialization in face recognition during infancy. *Cahiers de Psychologie Cognitive, European Bulletin of Cognitive Psychology*, **9**, (1), 3–44.

Dissanayake, E. (1988). *What is art for?* University of Washington Press, Seattle.

Dissanayake, E. (1992). *Homo aestheticus: where art comes from and why*. The Free Press, New York.

Eco, U. (1976). *A theory of semantics*. Indiana University Press, Bloomington, Indiana.

Edelman, G. M. (1987). *Neuronal Darwinism: the theory of neuronal group selection*. Basic Books, New York.

Edwards, B. (1979). *Drawing on the right side of the brain*. J.-P. Tarcher, Los Angeles.

Field, T. N., Woodson, R., Greenberg, R. and Cohen, D. (1982). Discrimination and imitation of facial expressions by neonates. *Science*, **218**, 179–81.

Fodor, J. (1983). *The modularity of mind.* Bradford, Montgomery, VT.

Freeman, N. H. (1980). *Strategies of representation in young children: analysis of spatial skills and drawing processes.* Academic Press, London.

Gaffron, M. (1950). Right and left in pictures. *Art Quarterly,* **13**, 312–31.

Gardner, H. (1973). *The arts and human development: a psychological study of the artistic process,* Wiley, New York.

Gardner, H. (1982*a*). *Art, mind and brain.* Basic Books, New York.

Gardner, H. (1982*b*). Artistry following damage to the human brain. In *Normality and pathology in cognitive functions,* (ed. A. W. Ellis. Academic Press, New York.

Gardner, H. (1984). *Frames of mind.* Heinemann, London.

Gazzaniga, M. S. (1970). *The bisected brain.* Appleton Century Crofts, New York.

Gazzaniga, M. and Le Doux, J. (1978). *The integrated mind.* Plenum Press, New York.

Gibson, J. J. (1979). *The ecological approach to visual perception.* Houghton Mifflin, Boston, Mass.

Golomb, C. (1974). *Young children's sculpture and drawing: a study of representational development.* Harvard University Press, Cambridge, Mass.

Gombrich, E. (1977). *Art and illusion* Phaidon, London.

Goodnow, J. (1977). *Children's drawing.* Fontana/Open Books, London.

Gordon, I. (1981). Left and right in art. In *Psychology and the arts,* (ed., D. O'Hare), pp. 211–41. Harvester Press, Brighton.

Gregory, R. L. (1980). Perceptions as hypotheses. *Philosophical Transactions of the Royal Society,* **290**, 181–97.

Gregory, R. L. (1986). Designing desingers. In *Odd perceptions,* pp. 195–7. Methuen, London.

Gregory, R. L. (ed.) (1987). *Oxford companion to the minds.* Oxford University Press.

Gregory, R. L. and Wallace, J. G. (1963). *Recovery from early blindness: a case study,* Experimental Psychological Society Monographs, Number 2. Cambridge Unversity Press.

Halliday, M. A. K. (1975). *Learning how to mean.* Edward Arnold, London.

Held, R. (1985). Binocular vision — behavioural and neuronal development. In *Neonate cognition,* (ed. J. Mehler and R. Fox), pp. 37–44. Erlbaum, Hillsdale, NJ.

Helmholtz, H. L. F. von, (1862). *Helmholtz's treatise on physiological optics* (ed. J. P. C. Southall). Dover, New York.

Hubley, P. and Trevarthen C. (1979). Sharing a task in infancy. In *Social interaction during infancy, new directions for child development,* Vol. 4, (ed. I. Uzgiris), pp. 57–80. Jossey-Bass, San Francisco.

Hume, D. (1963). Of the standard of taste. Essay 23. In *Essays moral political and literary,* pp. 231–55. Oxford University Press.

Innocenti, G. M. (1986). General organization of callosal connections in the cerebral cortex. In *Cerebral cortex,* Vol. 5, (ed. E. G. Jones and A. Peters), pp. 291–353, Plenum, New York.

Itten, J. (1961). *The art of color: the subjective experience and objective rationale of color,* (Trans. Ernst van Haagen). Van Nostrand Reinhold, New York.

Jeannerod, M. (1994). The representing brain: Neural correlates of motor intention and imagery. *Behavioural and Brain Sciences,* **17**, 187–245.

Johansson, G. (1973). Visual perception of biological motion and a model for its analysis. *Perception and Psychophysics,* **14**, 201–11.

Johansson, G. (1975). Visual motion perception. *Scientific American,* **232**, (6); 76–88.

Klee, P. (1968). *Pedogogical sketchbood.* Introduction and translation from German by Sibyl Moholy-Nagy. Faber, London.

Kraemer, G. W. (1992). A psychobiological theory of attachment. *Behavioural and Brain Sciences,* **15**, 493–541.

Kugiumutzakis, G. (1993). Intersubjective vocal imitation in early mother–infant interaction. In *New Perspectives in early communicative development*, (ed. J. Nadel and L. Camaioni), pp. 23–47. Routledge, London.

Langlois, J. H. and Roggman, L. A. (1990). Attractive faces are only average. *Psychological Science* **1**(2), 115–21.

Langlois, J. H., Roggman, L. A., and Rieser-Danner, L. A. (1990). Infant's differential social responses to attractive and unattractive faces. *Development Psychology*, **26**, 153–9.

Lennie, P., Trevarthen, C., Van Essen, D., and Wässle H. (1990). Parallel processing of visual information. In *Visual perception: the neurophysiological foundations*, (ed. L. Spillman and J. S. Werner), pp. 103–128. Academic Press, San Diego, Calif.

Levy, J. (1976). Lateral dominance and aesthetic preference. *Neuropsychologia*, **41**, 431–45.

Levy, J. (1988). Cerebral asymmetry and aesthetic experience. In *Beauty and the brain: biological aspects of aesthetics*, (ed. I. Rentschler, B. Herzberger, and D. Epstein), pp. 219–42. Birkhäuser Verlag, Basel–Boston–Berlin.

Levy, J. and Trevarthen, C. (1976). Metacontrol of hemispheric function in human split-brain patients. *Journal of Experimental Psychology: Human Perception and Performance*, **2**, 299–312.

Levy, J. and Trevarthen, C. (1981). Color-matching, color-naming and color-memory in split brain patients. *Neuropsychologia*, **19**(4), 523–41.

Locke, J. L. (1993). *The child's path to spoken language*. Harvard University Press, Cambridge, Mass., and London.

Maratos, O. (1982). Trends in development of imitation in early infancy. In *Regressions in mental development: basis phenomena and theories* (ed. T. G. Bever), pp. 81–101. Erlbaum, Hillsdale, NJ.

Marr, D. C. (1982). *Vision: a computational investigation into the human representation and processing of information*. W. H. Freeman, Oxford.

Marshack, A. (1972). Cognitive aspects of upper paleolithic engraving. *Current Anthropology*, **13**, 455–77.

Marshack, A. (1976). Some implications of the paleolithic symbol evidence for the origins of language. *Current Anthropology*, **17**, 274–82.

Matthews, J. S. (1988). The young child's early representation and drawing. In *Early childhood education* (ed. G. M. Blenkin and A. V. Kelly), pp. 162–83. Paul Chapman, London.

Meltzoff, A. N. (1985). The roots of social and cognitive development: models of man's original nature. In *Social perception in infants*. (ed. T. M. Field and N. A. Fox), pp. 1–30. Ablex, Norwood, NJ.

Merjanian, P. M., Bachevalier, J., Crawford, H., and Mishkin, M. (1986). Socioemotional disturbances in the developing rhesus monkey following neonatal limbic lesions. *Society of Neurosciences Abstracts*, **12**, 23.

Mishkin, M. (1982). A memory system in the monkey. *Philosophical Transactions of the Royal Society*, Series B, **298**, 85–95.

Murray, L. and Trevarthen, C. (1985). Emotional regulation of interactions between two-month-olds and their mothers. In *Social perception in infants*. (ed. T. Field and N. Fox), pp. 177–97. Ablex, Norwood, NJ.

Myers, R. and Sperry, R. (1958). Interhemispheric communication through the corpus callosum. *Archives of Neurology and Psychiatry*, **80**, 298–303.

Papousek, H. (1967). Experimental studies of appetitional behaviour in human newborns and infants. In *Early behaviour: comparative and developmental approaches*, (ed. H. W. Stevenson, E. H. Hess, and H. L. Rheingold), pp. 249–77. Wiley, New York.

Rentschler, I., Herzberger, B. and Epstein, D. (ed.) 1988. *Beauty and the brain, biological aspects of aesthetics*. Birkhäuser Verlag, Basel–Boston–Berlin.

Runeson, S. (1980). There is more to psychological meaningfulness than computation and representation. *The Behavioral and Brain Sciences*, **3**, 399–400.

Runeson, S. (1985). Perceiving people through their movements. In *Individual differences in movement*, (ed. B. D. Kirkaldy), pp. 43–66. MTP Press, Lancaster.

Schore, A. N. (1994). *Affect regulation and the origin of the self: The neurobiology of emotional development*. Erlbaum, Hillsdale, NJ.

Schiff, B. B. and Lamon, M. (1989). Inducing emotion by unilateral contraction of facial muscles: a new look at hemispheric specialization and the experience of emotion. *Neuropsychologia*, **27**, 923–35.

Schweiger, A. A. (1988). A portrait of an artist as a brain-damaged patient. In *The exceptional mind*, (ed. L. K. Obler and D. Fein). Guildford Press, New York.

Singer, W. (1990). Search for coherence: a basic principle of cortical self-regulation. *Concepts in Neuroscience*, **1** (1), 1–26.

Sperry, R. W. (1952). Neurology and the mind–brain problem. *American Scientist*, **40**, 291–312.

Sperry, R. W. (1977). Forebrain commissurotomy and conscious awareness. *Journal of Medicine and Philosophy*, **2**(2), 101–126.

Sperry, R. W. (1982). Some effects of disconnecting the cerebral commissures. *Science*, **217**, (4566), 1223–6.

Sperry, R. W. (1984). Consciousness, personal identity and the divided brain. *Neuropsychologia*, **22**(6), 661–7.

Sperry, R. W., Zaidel, E., and Zaidel, D. (1979). Self-recognition and social awareness in the disconnected minor hemisphers. *Neuropsychologia*, **17**, 153–66.

Stephan, M. (1990). *A transformational theory of aesthics*. Routledge, London.

Stern, D. N. (1985). *The interpersonal world of the infant: a view from psychoanalysis and development psychology*. Basic Books, New York.

Thatcher, R. W., Walker, R. A. and Giudice, S. (1987). Human cerebral hemispheres develop at different rates and ages. *Science*, **236**, 1110–13.

Trehub, S. E., Trainor, L. J., and Unyk, A. M. (1993). Music and speech processing in the first year of life. *Advances in Child Development & Behaviour*, **24**, 1–35.

Trevarthen, C. (1965). Functional interactions between the cerebral hemispheres of the split-brain monkey. In *Functions of the corpus callosum*, Ciba Foundation Study Group, No. 20. (ed. E. G. Ettlinger), pp. 24–40. Churchill, London.

Trevarthen, C. (1968) Two mechanisms of vision in primates. *Psychologische Forschung*, **31**, 299–337.

Trevarthen, C. (1972). Brain bisymmetry and the role of the corpus callosum in behaviour and conscious experience. In *Cerebral interhemispheric relations*, (Proceedings of an International Colloquium held in Smolenice, June 1969), (ed. J. Cernack and F. Podovinsky), pp. 319–33. Slovak Academy of Sciences, Bratislava.

Trevarthen, C. (1974). Conversations with a two-month-old. *New Scientist*, 2 May, 230–5.

Trevarthen, C. (1978). Modes of perceiving and modes of acting. In *Psychological modes of perceiving and processing information*, (ed. J. H. Pick), pp. 99–136. Erlbaum, Hillsdale, NJ.

Trevarthen, C. (1979a). The tasks of consciousness: how could the brain do them? In *Brain and Mind*, CIBA Foundation Symposium 69 (New Series), pp. 187–217. Excerpta Medica, Amsterdam.

Trevarthen, C. (1979b). Communication and cooperation in early infancy. A description of primary intersubjectivity. *In Before speech: the beginnings of human communication*, (ed. M. Bullowa), pp. 321–47. Cambridge University Press. Cambridge, UK.

Trevarthen, C. (1985a). Facial expressions of emotion in mother–infant interaction. *Human Neurobiology*, **4**, 21–32.

Trevarthen, C. (1985b). Neuroembryology and the development of perceptual mechanisms. In *Human growth*, (2nd edn). (ed. F. Falkner and J. M. Tanner), pp. 301–83. Plenum, New York.

Trevarthen, C. (1986a). Brain science and the human spirit. *Zygon: Journal of Religion and Science*, **21**(2), June 1986, 161–200.

Traverthen, C. (1986b). Form significance and psychological potential of hand gestures of infants. In *The biological foundation of gestures: motor and semiotic aspects*, (ed. J. L. Nespoulous, P. Perron, and A. Roch Lecours), pp. 149–202. Erlbaum, Hillsdale, NJ.

Trevarthen, C. (1988). Sharing makes sense: intersubjectivity and the making of an infant's meaning. In *Language topics: essays in honour of Michael Halliday*, (ed. R. Steele and T. Threadgold), pp. 177–99. Benjamins, Amsterdam–Philadelphia.

Trevarthen, C. (1989a) Development of early social interactions and the effective regulation of brain growth. In *Neurobiology of early infant behaviour*, Wenner-Gren Center International Symposium Series, Vol. 55, (ed. C. von Euler, H. Forssberg, and H. Lagercrantz), pp. 191–216. Stockton Press, Basingstoke; Macmillan, New York.

Trevarthen, C. (1989b). Feelings behind face perception: asymmetry may originate in motivation. [Commentary on 'Face recognition in infancy' by de Schonen and Mathivet.] *Cahiers de Psychologie Cognitive/European Bulletin of Cognitive Psychology*, **9**, (1), 129–34.

Trevarthen, C. (1990a). Growth and education of the hemispheres. In *Brain circuits and functions of the mind: essays in honour of Roger W. Sperry*, (ed. C. Trevarthen) pp. 334–63. Cambridge University Press, New York.

Trevarthen, C. (1990b). Grasping from the inside. In *Vision and action: the control of grasping*, (ed. M. A. Goodale) pp. 181–203. Ablex, Norwood, NJ.

Trevarthen, C. (1990c). Signs before speech. In *The semiotic web*, (ed. T. A. Sebeok and J. Umiker-Sebeok), pp. 689–755. Mouton de Gruyter, Berlin–New York–Amsterdam.

Trevarthen, C. (1990d). Integrative functions of the cerebral commisures. In *Handbook of neuropsychology*, Vol. 4, (ed. F. Boller and J. Grafman), pp. 49–83. Elsevier Science Publishers, Amsterdam.

Trevarthen, C. (1993a). The function of emotions in early infant communication and development. In *New perspectives in early communicative development*, (ed. J. Nadel and L. Camaioni), pp. 48–81. Routledge, London.

Trevarthen, C. (1993b). The self born in intersubjectivity: an infant communicating. In *Ecological and interpersonal knowledge of the self*, (ed. U. Neisser), pp. 121–73. Cambridge University Press, New York.

Trevarthen, C. (1994). Infant semiosis. In *Origins of semiosis*, (ed. W. Nöth), pp. 219–52. Mouton de Gruyter, Berlin. (In press.)

Trevarthen, C. and Aitken, K. J. (1994). Brain development, infant communication, and empathy disorder: Intrinsic factors in child mental health. *Development and Psychopathology*, **6**, 599–635.

Trevarthen, C. and Hubley, P. (1978). Secondary intersubjectivity: confidence confiding and acts of meaning in the first year. In *Action, gesture and symbol: the emergence of language* (ed. A. Lock) pp. 183–229. Academic Press, London.

Trevarthen, C. and Logotheti, K. (1987). First symbols and the nature of human knowledge. In *Symbolisme et connaissance/Symbolism and knowledge*, (ed. J. Montagnero, A. Tryphon, and S. Dionnet). Cahiers de la Fondation Archives Jean Piaget, No. 8, pp. 65–92. Fondation Archives Jean Piaget, Geneva.

Trevarthen, C. and Marwick, H. (1986). Signs of motivation for speech in infants, and the nature of a mother's support for development of language. In *Precursors of early speech*, (ed. B. Lindblom and R. Zetterstrom), pp. 279–308. Macmillan, Basingstoke.

Trevarthen, C. and Sperry, R. W. (1973). Perceptual unity of the ambient visual field in human commissurotomy patients. *Brain*, **96**, 547–70.

Tucker, D. M. (1992). Developing emotions and cortical networks. In *Developmental behavioural neuroscience*, Minnesoto Symposium on Child Psychology, Vol. 24, (ed. M. Gunnar and C. Nelson), pp. 75–128. Erlbaum, Hillsdale, NJ.

Turner, F. (1985). *Natural classicism: essays on literature and science*. Paragon House, New York.

Turner, F. (1991). *Beauty: the value of values*. University Press of Virginia, Charlottesville.

Turner, V. (1966). Colour classification in Ndembu Ritual. In *Anthropological approaches to the study of religion*, (ed. M. Banton), pp. 47–84. Tavistock, London.

Turner, V. (1974). *Dramas, fields and metaphors*. Cornell University Press, Ithaca, NY.

Turner, V. (1982). *From ritual to theatre: the human seriousness of play*, Performing Arts Journal Publications, New York.

Warren, R. M. and Warren, R. P. (1968). *Helmholtz on perception: its physiology and development*. Wiley, New York, London.

Watson, J. S. (1972). Smiling, cooing and the game. *Merrill-Plamer Quarterly*, **18**, 323–39.

Weiskrantz, L. (1986). *Blindsight: a case study and implications*. Clarendon Press, Oxford.

Willats, J. (1977). How children learn to represent three-dimensional space in drawings. In *The child's representation of the world*, (ed. G. Butterworth) pp. 189–202. Plenum, New York.

Winnicott, D. (1971). *Playing and reality*. Tavistock, London.

Yarbus, A. L. (1967). *Eye movements and vision*. Plenum, New York.

Zaidel, D. W. (1986). Memory for scenes in stroke patients: hemispheric processing of semantic organization in pictures. *Brain*, **109**, 541–60.

Zaidel, D. W. (1987). Hemispheric asymmetries in memory for pictorial semantics in normal subjects. *Neuropsychologia*, **25**, 487–95.

Zaidel, D. W. (1988). Hemispheric asymmetries in memory for incongruous scenes. *Cortex*, **24**, 231–44.

Zaidel, D. (1990). Long-term semantic memory in the two cerebral hemispheres. In *Brain circuits and functions of the mind: esssays in honour of Roger W. Sperry*, (ed. C. Trevarthen) pp. 266–80. Cambridge University Press, New York.

Zaidel, D. W. and Kasher, A. (1989). Hemispheric memory for surrealistic versus realistic paintings. *Cortex*, **25**, 617–41.

PART III: *Behind the eyes*

introduced by JOHN HARRIS

Introduction to Part III: Behind the eyes

JOHN HARRIS

Central to our visual perception of the world are the processing of motion, edge, shading, and colour information. The chapters in this section describe studies of normal humans which address the nature of this processing, and how they may bear on representation in art and within the brain.

The first two chapters look at different aspects of the perception of moving objects. Oliver Braddick in 'The many faces of motion perception' assesses the importance of movement information in many kinds of perceptual tasks, for example, in recognizing birds from their flight or people from their gait and in segregating moving objects from their background and perceiving their structure. He discusses how these different types of information are processed in the brain and the devices used by various painters to capture the essence of motion in static images. In contrast, Stuart Anstis and V. S. Ramachandran in 'At the edge of movement' show how the perception of edges is affected when static information about them is removed, so that they are defined purely by motion. Such edges are still perceived and can be used to segregate the image into regions, but the visual system makes errors in locating them. The authors also investigate how the shape of the frame surrounding a moving object influences its perceived direction of motion.

V. S. Ramachandran in '2-D or not 2-D — that is the question' discusses how we perceive the shape of objects from the changes of luminance across their surfaces. Far from being a complex aspect of higher cognition, he argues, this is a low-level process occurring early in human vision. The process makes use of some simple assumptions, such as that objects are illuminated by one light source, usually from above and that 'from above' is estimated with respect to the retina, not with respect to gravity. Once processed, shape from shading may be used to segregate the visual scene into separate regions or objects. This presumably reflects the power of shading to evoke the three dimensions of objects and scenes in flat painting. Vincent Walsh and Janus Kulikowski in 'Seeing colour'

discuss the problem of how we perceive the colour of objects. Since colours in a spectrum are closely related to the wavelength of light, one might suppose that reflected wavelengths govern the colour of an object, yet this is not so. Despite gross changes in the wavelength of the light which illuminates them and so of the light which they reflect, objects maintain their colour. Somehow, the perceiver can take the colour of the illuminant into account in perceiving the colour of surfaces. It is argued that this is done by grouping colours into a number of broad categories, relatively early in the cortical processing of colour, though the exact mechanism by which this is achieved remains to be worked out.

9 The many faces of motion perception

OLIVER BRADDICK

Motion perception and visual art

Motion has an unusual position in relation to the visual arts. It is not like the dimensions of form, colour, texture, and spatial order which are themselves properties of the media used by the artist. For these dimensions, our understanding of how they are processed in perception can be applied directly to the process of looking at a work of art. Motion, in contrast, cannot be directly available from the artist's palette, yet artists have been keen to depict it, especially in the last 100 years. Turner was an impressionist several decades before Impressionism, and in his famous picture of the Great Western Railway (*Rain, Steam, and Speed*, Plate 12) the visual impression he seems to want to capture above all is the impression of movement. But he had to create this perceptual effect indirectly from static ingredients.

It would make a fascinating study to investigate how the purely static means used by Turner and others can give us such a vividly dynamic effect. Presumably pictures must achieve this effect by activating, at least partially, mechanisms involved in the perception of true motion and so such a study ought to be revealing about the nature of those mechanisms. Unfortunately there does not seem to be much evidence from visual psychophysical experiments on the conditions for static induction of a motion impression. Turner is perhaps rather rich fare for the laboratory, but simple devices such as the conventional 'speed lines' of strip cartoons (see Gombrich 1962, p. 192) should repay analysis. One obvious account of these is that they simulate the blurring of a rapidly moving object along its direction of motion. However, the striking thing about this blur is that it is not perceived at the velocities which give a good sense of directional motion (Burr 1980; Burr *et al.* 1986). An alternative theory might be in terms of activating a particular type of motion-sensitive neurone, whose optimal contour orientation is parallel to their optimal motion direction (Albright 1984). But these suggestions are quite speculative.

Another intriguing question is why there has been so little interest in extending the media of visual fine art to allow the direct exploitation of motion, despite the technological possibilities. Some artists have worked with mobiles and 'kinetic art', but, even in the exuberant pluralism of twentieth-century art, these have been very marginal activities. Motion pictures are of course not at all marginal, but they have been firmly assimilated to the traditions of drama and of spectacle and not to that of the visual art object.

The visual functions of image motion

From the standpoint of the visual scientist, there is a prior question to these large and unresolved issues, a question to which we may be able to give more satisfactory answers. That is, why should visual artists be so keen to depict motion and what are they prevented from doing if they work in a medium of static images? What use does our visual system make of image motion? How important is it in the overall process of seeing the world?

The obvious response to these questions is that we live in a world of moving objects, and it is vital for us to perceive how they are moving. For instance, a key element of the effect achieved by Turner in *Rain, Steam, and Speed* is that we see the railway train speeding towards us. It is clearly very important for our active interactions with the world that we appreciate the trajectories of moving vehicles coming towards us or of balls that we have to intercept in active games like tennis or cricket. Beverly and Regan (1973), for example, provide psychophysical evidence for a mechanism in the human visual system which can generate a specific signal for objects moving on a course to strike us between the eyes, using the difference in image motion seen by the two eyes. Performances like hitting a ball or avoiding an oncoming object are astonishingly fast and flexible and require a perception of object trajectories which is intimately linked with the control of action. But I want to argue that this obvious application is by no means the only way in which we use image motion and arguably not even the most important.

To see why motion perception does not begin and end with the perception of trajectory, look at Fig. 9.1. Giacomo Balla was one of the Italian Futurists, who perhaps more than any other artistic movement made the dynamism of depicted motion a central aspect of their art. In fact their cult of dynamism had, at least in rhetoric, an unpleasant association with the contemporary movement of Italian Fascism; machine-gun fusillades, along with racing cars and locomotives at full speed, were hymned as supreme art objects. However Balla's painting, titled *Swifts: Paths of Movement*, is pacific

Fig. 9.1. Giacomo Balla: *Swifts: Paths of Movement and Dynamic Sequences.* Oil on canvas. 96.8 × 120 cm. Reproduced by permission from the Collection, The Museum of Modern Art, New York.

enough. Balla has attempted to represent the trajectory of the bird by a series of images, almost a stroboscopic sequence, across the bottom of the picture. For me at least, this picture is something of a failure as a representation of dynamic properties; the Futurists produced some much more successful works in this vein. But the reason for the failure is informative. The sequence show the bird's successive positions, but what is really characteristic about the flight of the swift is not its trajectory between points A and B, but the rhythm and pattern of the motion as it goes from A to B. Indeed, if you watch swifts or similar birds, the characteristic darting and fluttering actions as they nimbly fly about catching insects are one of the most distinctive things about the bird and are much more likely to be the way you recognize it at a distance than anything about its shape. Balla seems to have attempted to include wing positions in this stroboscopic depiction, but I don't think they convey much sense of the fluttering and darting action of the swift.

What I am arguing from this artistic example is that dynamic properties are characteristic of particular objects or particular events and that this represents one of the key ways in which we use motion information. Just as we use features of static shape to recognize objects, so we also use features of the 'kinetic form' or dynamic pattern, particularly in recognizing biological objects and the events associated with them. The most famous examples of this in percep-

tual psychology come from the work of Gunnar Johansson and his followers. In a sequence of frames such as that shown in Fig. 9.2 (Johansson 1975), individual frames are almost unreadable and even looking at the whole sequence, statically, yields little except a set of clusters that change their form. However, when the sequence is displayed as a movie, it is immediately recognizable as the motions of human beings. This is not limited to recognizing that they are

human; the specific actions can be understood and recognized very immediately, in this sequence as a peasant country dance.

With these so-called point-light displays, Johansson and others have shown an exquisite sensitivity to a number of aspects of kinetic form. For instance, we can recognize our friends by their characteristic gait, even though we can't see their outlines (Cutting and Kozlowski 1977) and we can recognize the sex of an unknown person walking even when size cues such as height or length of stride cannot be used (Barclay *et al.* 1978; Kruse 1986). Subjects, shown a point-light display of somebody bending down and picking up a heavy weight, can estimate the weight accurately within 3–4 kg, purely on this kinetic form information (Runeson and Frykholm 1981).

Performance in these point-light experiments must depend on perceptual sensitivities which are very finely developed for our interpersonal perception. Think, for instance, of the situation where across the street you see somebody who is walking in a funny way. As an indication of psychosis or even milder deviance, I think we can be much more sensitive to this kind of dynamic cue, in somebody seen fleetingly or at a distance, than to anything about his or her static appearance. I suspect this use of dynamic cues has its origins or at least its analogies deep in our behavioural evolution. Consider the ability, for instance, of a predator to select as a target the one prey animal in the herd that is moving with a slight limp and so will fall behind in the chase. This is surely a use of very subtle differences in kinetic form.

The most famous artistic application of the idea of kinetic form is in Marcel Duchamp's *Nude Descending a Staircase* (Fig. 9.3). Here again, a kind of stroboscopic depiction has been used, but the pattern of motions of the limbs and their sequence of stepping dominates over any real depiction of the static form of the human body or the exact relative position of its parts. Yet, as in Johansson's point-light displays, it is instantly apparent what is going on.

This point can be developed further if we consider Fig. 9.4. This is another picture of Balla's, *Dynamism of a Dog on a Leash*. I find that, much more successfully and immediately than in *Swifts: Paths of Movement*, he does convey the rapid oscillation and the whipping of the chain and the rest of the characteristic motion. Unlike the case of the walking figure, here one probably does not have any appreciation or great interest in the exact sequence of motions that occurs. The viewer does not care about the way the chain moves in any particular whip across, but only in its broader, general dynamic properties. There is a potential analogy here to a distinction in static form perception; the difference between actually recognizing shapes and simply deriving an overall impression of surface texture. It is still a rather

Fig. 9.3. Marcel Duchamp: 1912 *Nude Descending a Staircase, No. 2*. Courtesy of The Philadelphia Museum of Art: Louise and Walter Arensberg Collection.

unsettled issue in spatial perception how far texture perception and form perception share common mechanisms. For instance, is the processing of little line segments, when they make up the surface texture of a grassy field, distinct from the kind of processing required for the short line segments that together make up the outline of a figure? Julesz (1981) argued that the visual system uses the same set of basic elements (what he called 'textons') both to distinguish textures and to represent the elementary features of form. But at least it is clear in the static case that texture perception and form perception are distinct visual outcomes, possibly sharing some common mechanisms. I want to argue that we have to bear in mind a similar distinction in the dynamic case, between 'kinetic texture' and 'kinetic form'. If we go back to Plate 12, the dynamism which Turner was attempting to convey was not simply the motion of the train. As his

Fig. 9.4. Giacomo Balla: 1912
Dynamism of a Dog on a Leash.
Courtesy of the Albright-Knox
Art Gallery, Buffalo, New York.
Bequest of A. Conger Goodyear
and George F. Goodyear, 1964.

title *Rain, Steam, and Speed* illustrates, the picture is also full of the
motion of the surrounding storm. But in perceiving that motion, we
are not concerned with how individual raindrops are falling or even
to recognize that they are raindrops, but rather with the overall
dynamic properties of the falling water and blown spray that consti-
tute a rainstorm.

We can illustrate a quite different perceptual use of image motion
from another artistic example. Uccello's picture of a hunt in a forest
(Plate 13) is full of depicted action. The conventions and technique
of the time do not provide a very dynamic sense; the scene appears
almost frozen. However, one feature of this picture is that the
animals running through the forest and the huntsmen stand out
very clearly against the background. I suspect that Uccello is here
exploiting a certain amount of pictorial licence and that in the light-
ing conditions of this very dense forest, there would not be this kind
of bright, high-contrast image even from the colourful costumes of
Renaissance huntsmen. None the less, even without the luminance
and colour contrast of Uccello's picture, there is no doubt that, if we
had been present at that hunt, the moving forms of the animals and
the people would have been very immediately apparent to us. That is
because differential motion is a very effective cue for visual segmen-
tation. The movement of an object against its background is one of
the properties which allow it instantly to be perceptually separated

form that background. It is very appropriate that we can illustrate this point with a picture of a hunt, because the visual relationships between prey and predator, which we have already touched on, revolve very closely around segmentation by motion. Both prey animals and predators have gone through elaborate evolutionary manoeuvres to create camouflage, but that camouflage can be immediately broken if there is any relative movement with respect to the background.

The *Gestalt* psychologists called this phenomenon 'grouping by common fate' and more recently it has been the basis of experiments using segmentation in random dot patterns for studying motion mechanisms (Julesz 1971; Braddick 1974). It can be very readily demonstrated with a pair of overhead transparency sheets. Sketch an object on one sheet and on the other scribble a fairly dense jumble of straight and curved lines. With the two sheets laid on top of each other on the projector glass, the object is completely concealed. Slide the object sheet, however briefly, and the relative motion immediately reveals its form, like something good to eat twitching among the foliage.

Yet another use of motion information, which has been the focus of much recent attention, is the use of image motion to give us an impression of the 3-D structure of objects and scenes. As we move through the world, there is relative motion between the images of objects at different distances from us. This 'motion parallax' has been on the textbook list of 'depth cues' at least since Helmholtz, but we owe to J. J. Gibson (1950) the recognition that the observer's motion creates an entire 'optic flow field' whose pattern contains a great deal of information about the depth, the 3-D layout and forms of objects, and the orientation of surfaces in space. This information often goes nowadays under the name of 'structure from motion'. Fig. 9.5 illustrates a simple example of the kind of optic flow field which one creates by moving forwards over a horizontal surface on which there is a vertical obstacle. Part of the information is in fact coming from the segmentation of different motions, much like the camouflage-breaking discussed above. That is, round the border of the obstacle there is a discontinuity in velocity which corresponds to the discontinuity in depth. There is rather more to this than simply defining an object by motion segmentation, because here we can also gain the sign of the depth relationship, that is, which object is in front. Actually, information on this relationship comes from a more complex set of events at the boundary than simply the velocity discontinuity. Details on the further surface are appearing as the nearer object uncovers them (or disappearing as it covers them) and the occluding contour itself shares the motion of surface detail on the nearer rather than the farther object (Yonas *et al.* 1987). But

Fig. 9.5. The pattern of optic flow generated when an observer travels over a horizontal surface, looking straight ahead, with a vertical obstacle to the right of centre. Each line segment represents the direction and speed of image motion at that point in the field of view.

beyond these boundary events, the optic flow field in Fig. 9.5 also includes a smooth steady gradient of image motion across the surface. This is also revealing about depth relations, namely that this surface is at a particular slant relative to our line of sight. In the general case, when our movement is not necessarily parallel to our line of sight and may also include a component of rotation, the geometry is somewhat more complicated, but the information to decipher all the depth relations in a scene is still available (Longuet-Higgins and Pradzny 1980; Koenderink 1986). So long as we are in motion or, indeed, as the objects around us are moving, then the succession of different views and the dynamic relation between them is very important, as a sensitive and robust indicator of 3-D dimensional relationships (Rogers and Graham 1979; Siegel and Andersen 1988).

Marcel Duchamp (of the *Nude Descending a Staircase*) tried to exploit the vividness of structure from motion in artefacts that he called *Rotoreliefs* (Fig. 9.6). These disks bear patterns of spirals or off-centre circles and are designed to be rotated on a gramophone turntable. When you watch them rotating, depth relations appear within them; they seem to be swivelling tunnels receding into the distance or wobbling cones standing up from the surface. The

Fig. 9.6. Marcel Duchamp 1935 *Rotoreliefs*. Each card was designed to be viewed rotating slowly on a turntable. Courtesy of the Philadelphia Museum of Art: Louise and Walter Arensberg Collection.

reasons why these particular patterns produce depth effects are quite complicated and significant for understanding the visual processing of motion. For a moving contour, it is difficult to pick up the component of the velocity which is parallel to the contour. Consider for instance a long uniform line sliding along its own length. Unless you can see the ends or corners, there is no way you can tell that it is moving. (This is a version of the 'aperture problem', which we shall return to later.) Now when you have a moving object containing contours in more than one orientation, there are mathematical rules for solving the problem which in most cases will generally yield the correct perception for a rigidly rotating flat pattern (Hildreth 1984). But in Duchamp's *Rotoreliefs*, each part of the curved lines is moving almost parallel to itself. This makes it particularly difficult for our perceptual system to find the rigid 2-D solution and, indeed, Hildreth's algorithm makes similar mistakes in assigning local motions with this kind of pattern. However, in seeing the tunnels or cones, we are taking these incorrectly assigned local motions and achieving a perception of rigid motion by interpreting them as a rotating object in three dimensions. Duchamp's creations, then, highlight some important issues in perception: the complexity of the computational problems that our visual systems have to solve to achieve apparently effortless perception and the fact that the processing of a two-dimensional image cannot be understood except in terms of the solution of three-dimensional problems.

Fig. 9.7. Pablo Picasso 1910 *Portrait of Ambroise Vollard.* Courtesy of the Pushkin Museum, Moscow/Bridgeman Art Library, London. © DACS 1994.

As I have remarked, dynamic gadgets like the *Rotoreliefs* have never really been accepted into the mainstream of visual art. However, I believe that structure-from-motion is involved in one of the key movements in twentieth-century art, namely Cubism. In paintings like Picasso's *Portrait of A. Vollard* (Fig. 9.7), critics and historians commonly describe what is being attempted as the destruction of the conventional picture plane, breaking down pictorial space and reassembling the fragments. I think we can argue that the fragments are related to the sequence of multiple viewpoints of an object, which are normally provided by the observer's motion and which give us a sense of the object's 3-D form. It is important to appreciate that, although this extraction of 3-D structure depends on visual processing of image motion, in a sense it is not an example of motion *perception* at all. We are generally quite unaware of the image transformation that is occurring; our conscious perception is of 3-D form, not of anything moving or changing. So Picasso's picture can be seen as an attempt to convey this static sense of space, in a static

Fig. 9.8. The pattern of optic flow generated when driving (a) straight down a road; (b) straight but off course; (c) on course around a bend of uniform radius; (d) off course around the bend (from Lee 1980).

medium, but by tapping a visual process which normally reads dynamic image sequences.

The optic flow field in Fig. 9.5 is a joint product of the 3-D layout of our environment and of our own motion through that environment. In fact, we can use the flow field to gain information of about what we are doing as well as about what surrounds us. This points to yet another visual use of image motion information: to monitor and control our own posture and movement. We owe this insight largely to the work of David Lee in Edinburgh, from which Fig. 9.8 is taken. It shows how the pattern of optic flow that occurs as you steer a vehicle indicates, not only the nature of the surface you are driving over and the depth relationship of any obstacles and objects around you, but also your own course. Figure 9.8 (a) shows the optic flow pattern that comes from driving correctly straight down a road. You can see that if you are driving off course (Fig. 9.8 (b)), then the optic flow vectors are misaligned with respect to your target. There is a similar relationship if you are driving along a curve (Fig. 9.8(c) and 9.8(d)). Now the paths of points through the optic flow field are curved, but correct steering of the vehicle corresponds to keeping these trajectories in the visual field parallel with the borders of the road that you are trying to follow. As in some of the other uses of motion information that I have discussed, visual motion processing is here very intimately associated with the control of action. Perhaps this is one of the tensions that exists between the use of image motion and the visual arts. On the whole, visual art objects are not objects to which we are expected to react in a physical sense or towards which we have to control our actions. Looking at art generally involves a more contemplative visual relationship, one for which several of the uses of image motion are not appropriate.

A final use of image motion, again involving the control of action, is in the control of eye movements. In an evolutionary sense, probably one of the most basic reasons for extracting the motion of the visual image is to guide the motion of our eyes, usually with the object of actually abolishing image motion across the retina, and there are believed to be specially wired neural mechanisms, in both cortex and midbrain, contributing to this goal.

The message, then is that although local motion is a clearly defined property of the image on the retina, it would be a mistake to think of the perceptual system as simply translating this image motion into a single entity of perceived motion. In fact, we are processing image motion for six or seven quite distinct reasons, summarized in Box 9.1. Some of these may be very relevant to what visual artists are trying to achieve, while others are linked to visual behaviour outside the normal realm of art.

Box 9.1. Perceptual uses of image motion
1. Perception of object trajectory
2. Recognition of kinetic forms
 2(a) Recognition of kinetic texture
3. Segmentation of objects from background and from each other
4. Perception of 3-D structure from motion
5. Provision of information on observer's self-motion
6. Control of eye movements.

Mechanisms of visual motion processing

This classification of the visual functions of image motion provokes a further question for the scientist studying the mechanisms of vision. Do these six or seven distinct reasons imply an equivalent number of different psychological or neural mechanisms within visual motion processing?

One instance is 'structure from motion'. Does the perception of the 3-D form of an object make any special requirements, that imply a specific mechanism to analyse image motion? Shimon Ullman (1983) and Hildreth and Koch (1987) have argued that the correct computation of structure from motion needs rather accurate information about the optic flow pattern, of a kind that would require the visual system to monitor image changes over a period that could not be very short. This is a matter of some controversy, both from the point of view of computation and of how human vision actually performs. But more generally, there is a plausible contrast between applications that require a very precise computation of the optic flow field and those that could be based on very crude motion information. As an example of the latter, the segmentation of a moving object from a static or differently moving background could work with a very coarse and imprecise representation of the speed or direction of movement.

Can we actually find any evidence for this view that image motion is analysed by different visual mechanisms for different functions? The visual motion system has been dissected in various ways, both psychophysically and physiologically, and a number of what seem to be important distinctions have been established. We must examine whether these distinctions among mechanisms bear any relation to the classification of functions.

One distinction within the motion system comes from experiments on what sometimes is called 'apparent motion', although 'stroboscopic' or 'sampled' motion are better and more specific names for the impression of motion that can occur when static images are shown in rapid succession, as in a film or television picture. The perceived motion implies that the visual system can take the successive images and extract the spatial and temporal relationship between them, that is, recognize that some part of the image is a shifted version of what has been seen in previous images of the sequence. We can then study the properties of a visual motion system by asking: what are the spatial and temporal limits over which that relation can be extracted?

Plates

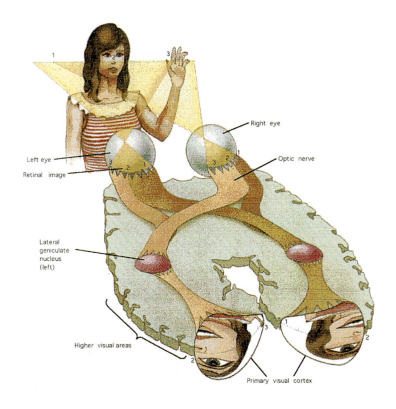

Right eye

Left eye

Retinal image

Optic nerve

Lateral geniculate nucleus (left)

Higher visual areas

Primary visual cortex

Scene

Image on right retina

Primary visual cortex in left hemisphere

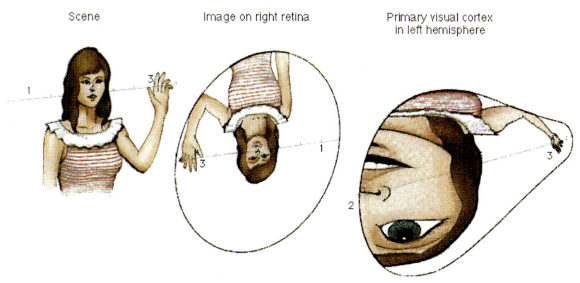

Plate 1. Horizontal slice through the visual system, illustrating the inversion and distortion of the visual scene and its topographic layout in the early visual pathways. The foveal region is analysed in detail by a large region of the primary visual cortex and progressively small areas of cortex are dedicated to more eccentric vision. Modified from Frisby (1979).

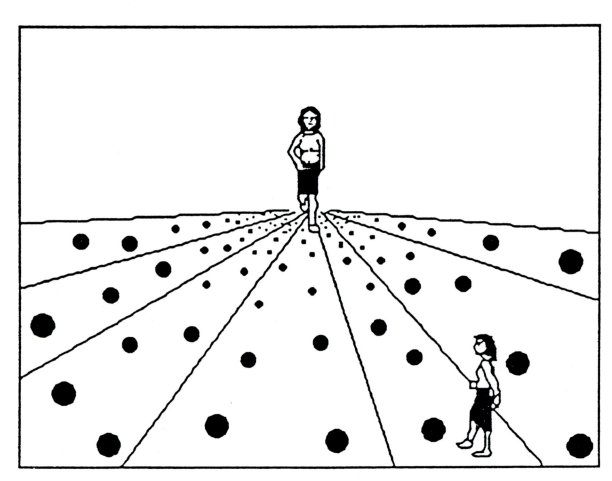

Plate 2. Depth from perspective and illusory size difference due to size scaling. The apparent difference in size between the figures arises because, although they are physically identical, the perspective suggests that the upper one is further away. Since the images are of the same size, the visual system interprets the upper one as being larger. If this image had been rendered in two equiluminant colours instead of black and white, both the appearance of distance and the illusory size difference of the two figures would disappear.

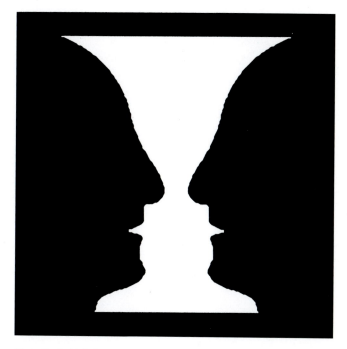

Plate 3. Rubin's figure–ground discrimination problem.

(a) (b)

Plate 4. Guido Molinari: (a) *Tri-Noir*, 1955, (b) *Bi-Noir*, 1956.
© Guido Molinari.

Plate 5. Paul Klee: *The Snake Goddess and Her Enemy*, 1940.
Reproduced with permission from *Paul Klee on Modern art*,
Benteli Werd Verlag. © DACS 1994.

Plate 6. Paul Klee: *Whose Fault Is It?*, 1928.
Reproduced with permission from *Paul Klee on Modern art*,
Benteli Werd Verlag. © DACS 1994.

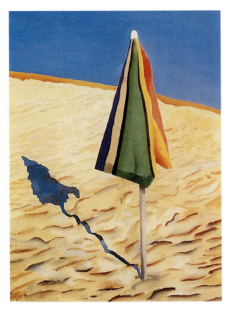

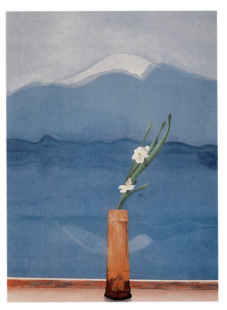

Plate 7. David Hockney: *Beach Umbrella,* 1971. Acrylic on canvas $48 \times 35\frac{3}{4}$ in. © David Hockney. Reproduced with permission.

Plate 8. David Hockney: *Mount Fuji and Flowers,* 1972. Acrylic on canvas 60×48 in. © David Hockney. Reproduced with permission.

(a) (b) (c)

Plate 9. This picture from a French fashion magazine is presented at three levels of focus, to demonstrate levels of colour resolution that have different functions in awareness.

Plate 10. René Magritte: *Souvenir de Voyage III*. © ADAGP, Paris, and DACS, London, 1994. Reproduced with permission.

Plate 11. René Magritte: *Le Viol (The Rape)*, 1934. © ADAGP, Paris, and DACS, London, 1994. Reproduced with permission.

Plate 12. J. M. W. Turner: *Rain, Steam, and Speed — The Great Western Railway*. (1844). Courtesy of the Trustees, The National Gallery, London.

Plate 13. Paolo Uccello: *The Hunt*, 1460. Courtesy of the Ashmoleam Museum, Oxford.

Plate 14. René Magritte: *Discovery*, 1927. © ADAGP, Paris, and DACS, London 1994. Reproduced with permission.

Plate 15. Chromatic borders are ineffective at producing the segmentation that is required for shape-from-shading (compare upper and lower). The 'yellow' background is depicted a lighter grey. See also Plate 14.

Plate 16. Lightness records. (a) Three bands of colour photographed under white light. (b)–(d) The same bands but filmed through either a (b) red, (c) green, or (d) blue filter. Note that under the red filter, the red band is the lightest colour, under the green filter the green band is the lightest colour, and under the blue filter, the blue band is the lightest colour.

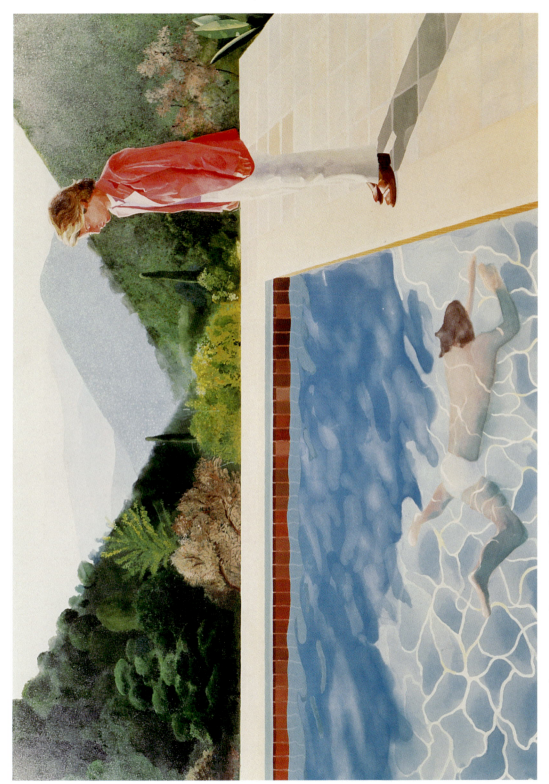

Plate 17. David Hockney: *Portrait of an Artist: Pool with Two Figures*, 1971. Acrylic on canvas 214 × 275 cm. © David Hockney. Reproduced with permission.

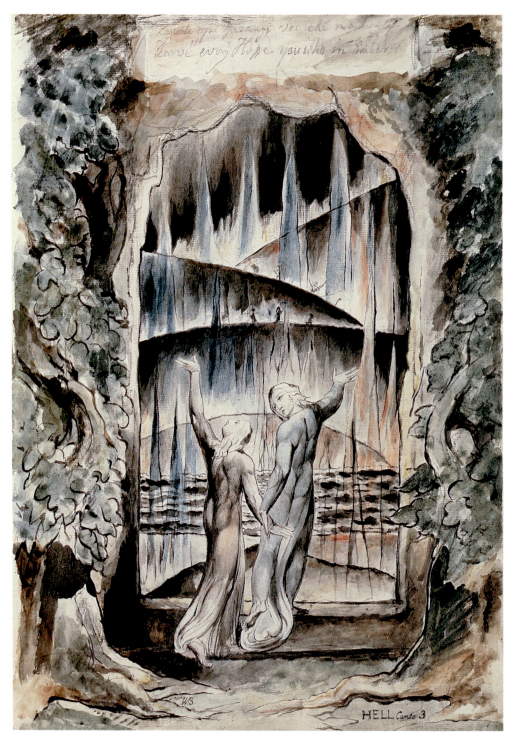

Plate 18. Two streams of pictorial representation: Blake's *The Inscription Over the Gates of Hell* emphasizing *line* and Plate 12 Turner's *Rain, Steam, and Speed*, emphasizing *mass*. Both streams are used in most representational art, though earlier art forms had a greater emphasis on line. Blake's illustration to Dante's Divine Comedy, 1824–7, Courtesy of the Trustees of the Tate Gallery, London.

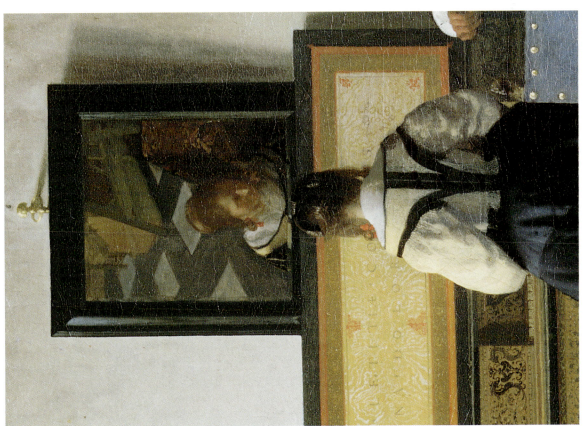

Plate 19. Detail from *The Music Lesson* showing the mirror on the far wall. Vermeer's easel is visible at the top right, the legs of his stool beyond it, and a small part of the back wall of the room at the extreme top left. Courtesy of The Royal Collection. © Her Majesty the Queen.

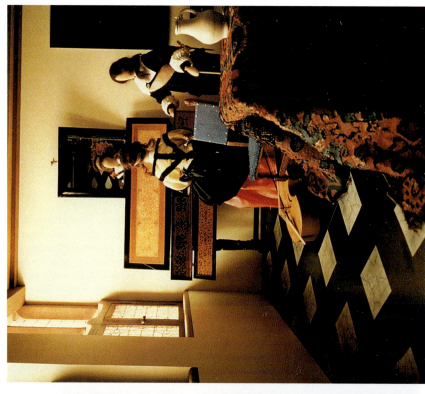

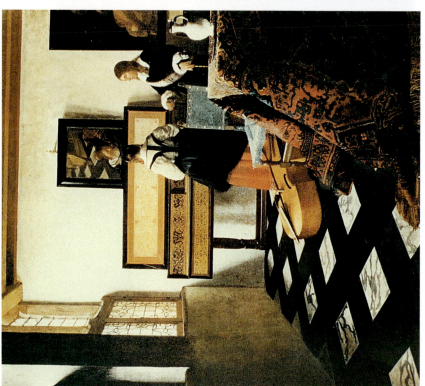

Plate 20. Vermeer: *The Music Lesson* reproduced at one-sixth full size. Courtesy of The Royal Collection. © Her Majesty the Queen.

Plate 21. Photographic recreation of *The Music Lesson* with the one-sixth scale model. This print is reproduced actual size and thus can be compared directly with Plate 20.

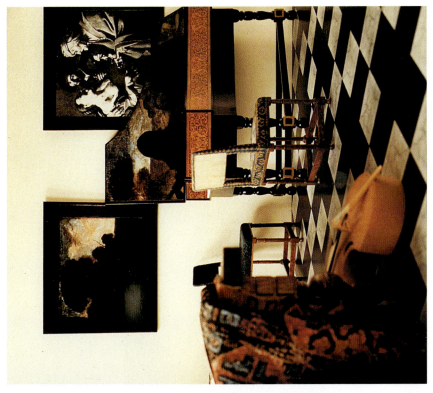

Plate 23. Photographic recreation of *The Concert*. Dirck van Baburen's *The Procuress* (top right) is modelled with a one-sixth scale photograph of the real painting.

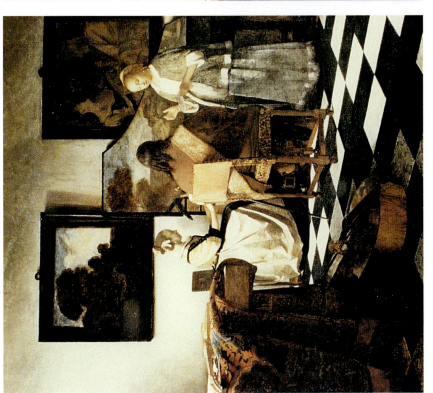

Plate 22. Vermeer: *The Concert* reproduced at one-sixth full size. Courtesy of the Isabella Stewart Gardner Museum, Boston, Mass.

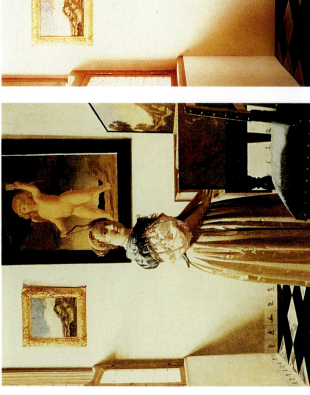

Plate 24. Vermeer: *A Lady Standing at the Virginals* reproduced at one-sixth full size. Courtesy of the Trustees, The National Gallery, London.

Plate 25. Photographic recreation of *A Lady Standing at the Virginals.*

Plate 26. Which is the Constable? (a) Attributed to James Orrock. *Cottage near Bergholt*. Courtesy of Nottingham Castle Museum and Art Gallery. (b) John Constable. *Willy Lott's House*. Courtesy of Ipswich Borough Council Museums and Galleries. (c) Attributed to James Orrock. *Cottage near Bergholt* (detail of sky). Courtesy of Nottingham Castle Museum and Art Gallery. (d) John Constable. *Willy Lott's House* (detail of sky). Courtesy of Ipswich Borough Council Museums and Galleries.

Plate 27. Dame Elisabeth Frink. Copyright © RA Magazine. Reproduced with permission.

Short- and long-range processes

A good way to do this is by using 'random dot kinematograms' (Fig. 9.9). In these displays, stroboscopic motion is the only information available about the presence of a form or its direction of movement. The sequence consists of two or more patterns of random dots. If the patterns are presented singly or in very slow succession, they each appear totally random and unrelated to each other. However, in fact there is a block of dots which has no visible border separating it from the rest of the dots, but is reproduced in displaced positions in successive patterns. The fact that we cannot see the block as distinct when the time interval between patterns is, say, 600 ms indicates that the visual system is insensitive to the spatio-temporal relationship over this interval. If we speed up the sequence so that the interval is only 20 ms, the appearance is very different. Now the central region visibly moves as a rigid block of dots and appears to have a sharp boundary separating it from the background dots (which can be either static or in random motion in different versions of the display). This is a clear example of segmentation by differential motion, which is necessary for the central shape to exist at all as a visual object. The visibility of the moving shape implies that the visual system can pick up the difference in the spatio-temporal relationships between centre and surround. This only works if the time interval between patterns and the size of the jump through which the dots are displaced, are within rather tight limits. Figure 9.10 illustrates results gathered by Curtis Baker and myself, mapping out

Fig. 9.9. A random-dot kinematogram consists of a sequence of dot patterns, with the dots in a certain region shifted as illustrated between successive frames. In the example shown, the surrounding dots are stationary. Although the boundaries of the region are invisible in each individual pattern, it is seen as a clearly separate, moving object when the sequence is shown at a suitable rate.

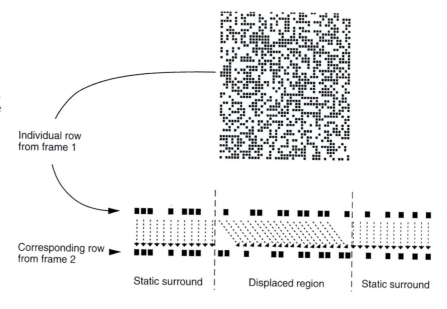

Individual row from frame 1

Corresponding row from frame 2

Static surround | Displaced region | Static surround

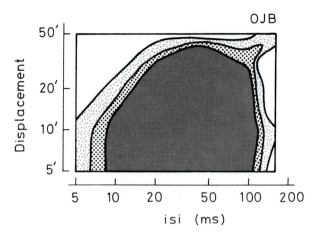

Fig. 9.10. Motion can only be seen in a random-dot kinematogram for certain combinations of time interval (isi, in milliseconds) and spatial displacement (in minutes of arc). The dark-shaded area in this plot shows the combinations for which the observer saw the motion in a two-frame sequence on 95 per cent or more of trials (from Baker and Braddick 1985a).

the range of displacements and temporal intervals which can give such a sense of motion. The narrowness of these limits — up to about 40 min arc and 120 ms under the conditions of this experiment — led to the coinage of the term *short-range process* in motion perception (Braddick 1974, 1980). The point of this term lies in the fact that, with other kinds of display, one can get a clear sense of motion with much larger displacements and much longer time intervals. For instance, the kind of neon advertising sign which shows the same objects (say chorus girls' legs) in three different positions would typically involve much larger space intervals than the short-range limit and yet there is no doubt that the legs appear to move. The important difference seems to be that when successive images contain sufficiently identifiable elements, a 'long-range' motion process can pick up the relationships between these figural elements over much longer intervals of space and time. The random-dot patterns do not contain elements which can be identified in this way, so motion processing is restricted to the 'short-range process'.

It has been argued that the short-range/long-range distinction should be expressed in other terms (Cavanagh and Mather 1989) and it is certainly true that the 'short-range' spatial limit is not fixed. It is larger if the patterns have been strongly blurred, so that their fine spatial detail is lost (cf. for example Cleary and Braddick 1990a,b) or if they are presented in peripheral vision (Baker and Braddick 1985b). None the less, the existence of distinct processes is quite widely accepted (Nakayama 1985; Petersik 1989). We can ask, then, whether this distinction maps on to any of the functional distinctions outlined above.

It has to be said that, so far, efforts in that direction have not been very successful. For instance, Hildreth and Koch (1987) suggest that the solution of 3-D structure from motion requires the system to follow the trajectories of points on the object over relatively long

times and distances. This information might not be expected to be available through the short-range process. But in fact there are a number of more recent demonstrations that have shown good structure from motion under conditions where the short-range process is almost certainly the relevant one. For example, Siegel and Andersen (1988) and others use displays where each moving dot only has a very limited lifetime on the screen, but new dots are continually appearing, so that the optic flow field is well defined. No recognizable features, of the kind that could be used by the long-range process, can persist in these displays for more than a fraction of a second, yet 3-D structures like a rotating cylinder can be clearly depicted. Mather (1989) has shown that 3-D structures can be reliably identified from just two frames, which again argues against the need for extended trajectories of recognizable features; he also shows that this identification depends on the displacement of dots between frames being relatively small, comparable to the short-range limit itself.

Mechanisms for slow and fast motion

A different distinction that one can draw, also based on psychophysical evidence, is between mechanisms subserving perception of slow and of fast motion. There are a number of lines of evidence for such a distinction (see for example Bonnet 1977; Boulton 1987); here I will mention some recent experiments by Robert Snowden in our laboratory. One of these used random dot kinematograms in which individual dots go through two successive steps, as illustrated in Fig. 9.11. Notice that only a proportion of the dots make this movement; the rest appear at unrelated locations in each frame and so act simply as random noise. The proportion of noise dots for which we can still detect the direction of motion correctly provides a sensitive measure of the performance of the motion system. This experiment looked at how performance was affected by the interval between the first and second steps (that is, the duration of frame 2). Snowden and Braddick (1990) found that if this interval is long, then performance with two steps is no better than with a single step. However, for a certain range of intervals, between about 50 and 200 ms, there can be a considerable enhancement of performance. In other words, information from the two steps can be integrated, provided they occur sufficiently close together in time. Nakayama and Silverman (1984) had already reported that this kind of effect could improve the maximum displacement limit for the short-range process. But Snowden and Braddick (1990) showed that the enhancement was only effective for relatively large displacements (7–30 min arc); when

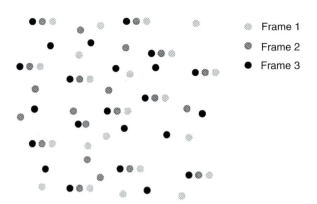

Fig. 9.11. Random-dot display in which moving 'signal' dots (shown with two displacements between frames 1–2 and 2–3) appear among 'noise' dots which are randomly placed in each frame. Performance of the motion detecting system can be measured by the signal-to-noise ratio for which coherent motion can just be detected.

the steps were 1–2 min arc, performance varied very little with the interval. That is, there is no evidence at all of any integration over time for these small displacements. The way that we would speculatively interpret these effects is in terms of cooperative networks of motion detectors (Fig. 9.12), in which detectors responding to particular directions of motion can facilitate each other's responses over a certain range of space and time. These experiments would then indicate the time over which the facilitation can act.

What these results suggest, then, is two different motion systems or at least two very different kinds of behaviour. For the longer steps (or, what amounts to the same thing, higher velocities), these facilitatory interactions have a strong effect. For short steps, or low velocities, they appear to be rather irrelevant. It must be emphasized that this is *not* the short-range/long-range distinction; all the step sizes here are within the short-range limit and the tests use random-dot patterns that do not contain the identifiable shapes required by the long-range process. Within the short-range system, the processing seems to be organized differently for high and low velocities.

Note that the scheme for co-operative interactions (Fig. 9.12) also includes inhibitory connections. That is, we are suggesting that detectors for one direction of motion may tend to suppress the responses of motion detectors in other directions. Snowden (1988, 1989) has done some further experiments on this point, in which the horizontal motion of a set of test dots had to be detected against the background motion of another set of dots moving at right angles, in the vertical direction. He looked at the effects of this kind of interaction both on the largest displacement for correct motion detection (D_{max}, the upper limit of the short-range process) and also on D_{min}, the lower limit or smallest displacement whose direction can be reliably perceived. These effects turned out to be velocity specific. That is, when testing the ability to pick up high-velocity motion, as measured by D_{max}, low background velocities had almost no effect,

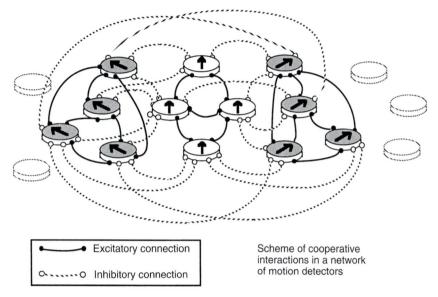

Fig. 9.12. A 'co-operative' scheme of interconnections between the motion detectors responding to a small region of the visual field. Each disk symbolizes a detector, whose preferred direction of motion is indicated by the arrow. Detectors responding to the same direction excite each other, while those responding to different directions inhibit each other's activity.

•————• Excitatory connection

○┄┄┄┄○ Inhibitory connection

Scheme of cooperative interactions in a network of motion detectors

but when the background velocity was increased beyond about 1°/s there was a very abrupt fall in performance. Conversely the ability to perceive very low velocities or small displacements (D_{min}) was markedly impaired by background velocities lower than 1°/s in the right-angles direction, but was largely unaffected by higher velocities. What these results suggest is that the inhibitory interactions shown in the network of Fig. 9.12 act quite separately for low velocities (small displacements) and high velocities (large displacements). We have already suggested that the facilitatory connections in the network are only effective for large displacements. The simplest way to understand this is if in fact there are at least two distinct networks with different properties, processing different velocity ranges.

Cortical bases of motion processing

These proposals about neural networks are derived from psychophysical experiments. Do we have any more direct evidence on how the brain mechanisms are organized? David Rose has already introduced in Chapter 2 the idea that, beyond the primary receiving area for visual information (V1) in the striate cortex, there are a number of extrastriate areas, as shown in the diagram of the brain in Fig. 2.2(a), p. 34, each area with its own specialized mode of processing the visual image. Neurones which respond best to patterns moving in a particular direction ('directionally selective neurones') can be found in a number of these areas, including V1. However, they are particularly numerous in the area which was first described by Zeki

(1974) and named by him V5, although it is now most often referred to as the middle temporal area, or MT for short. The case for a specialized function is better established for V5/MT as a 'motion area' than for any other cortical visual area so far (Maunsell and Newsome 1987). What does this specialized processing consist of, beyond simply a high concentration of neurones that respond strongly to motion?

One indication of a special contribution to motion processing comes from the work of Mikami *et al.* (1986). To stimulate their cells, they used discontinuous sampled motion similar to that of the psychophysical experiments we have just discussed, except that the series of jumps occurred not for dot patterns but for simple single bars. They could measure, for individual cells in the cortex of the macaque monkey, the maximum jump that generated a directionally selective response, a physiological analogy to the psychophysical D_{max}. Each point in Fig. 9.13 represents their D_{max} for a single cell, with triangles for cells in area V1 and circles for cells in area MT. Both these two vary with eccentricity in the visual field, but at any given eccentricity it is immediately apparent that there is very little overlap between them. We know that V1 feeds motion-sensitive signals to MT, but MT must be introducing some further directional selectivity of its own, since cells there are showing directional responses to displacements that are too large (or velocities that are too high) to produce any directionality in the signals from V1. On the same graph, Mikami *et al.* have also plotted as squares some human data, actually drawn from Baker and Braddick (1985*b*). These psychophysical values fall very much within the range of the MT cells, in fact very close to the mean value for these cells, but they are above D_{max} for almost every cell that Mikami *et al.* recorded in V1. There are risks in comparing human and monkey data and also in relating single-cell performance to the perceptual performance of the complete brain. However, we can speculate that the limit on detecting large displacements is set by the properties of the network of cells in MT, while for smaller displacements and, hence, lower velocities, the limiting factors may lie in V1. This anatomical division may underlie the differences in facilitatory and inhibitory interactions that Snowden found in his experiments.

The extended velocity range is by no means the only special property found in MT neurones. Box 9.2 summarizes some of the ways in which, it has been suggested, MT elaborates the motion information that it receives from V1. The proposal that has received most attention (number 2 in the table) is concerned with the processing of the motion in complex patterns, related to the 'aperture problem' that I referred to in explaining the effect of Duchamp's *Rotoreliefs*. Recall that, for a long contour, it is impossible to detect any component of

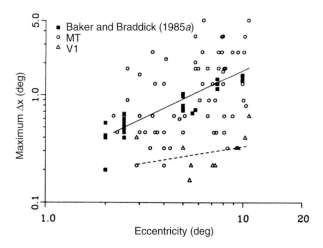

Fig. 9.13. The maximum step size which could elict a directional motion response in cells of areas V1 (triangles) and MT (circles) in the monkey's brain, at different eccentricities in the visual field. The black squares show human psychophysical results with random-dot kinematograms, for comparison (from Mikami *et al.* 1986).

Box 9.2. Proposed elaboration of motion information in cortical area MT

1. D_{max} and velocity range increased from V1 (Mikami *et al.* 1986)

2. Directional selectivity for pattern motion rather than component motion (Movshon *et al.* 1985; Rodman and Albright 1989)

3. Stronger contrast effects and other interactions from surround outside the 'classical receptive field' (Allman *et al.* 1985; Orban *et al.* 1989)

4.· MT required for discriminations based on structure from motion (Andersen 1989)

5. MT required for initiation of smooth pursuit eye movements (Newsome *et al.* 1985)

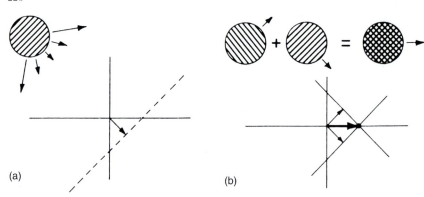

(a) (b)

Fig. 9.14. (a) Moving lines seen through an aperture can only give information about the component of motion at right-angles to the lines; thus the true motion could be in any of the directions shown (any vector to a point lying on the 'constraint line'). (b) When two moving gratings are presented together as a plaid, only one rigid motion is compatible with the components at right-angles to both gratings; it is given by the vector to the point where the two constraint lines meet (from Adelson and Movshon 1982).

motion that lies along the contour. Now consider a plaid pattern made up of two sets of diagonal stripes at right angles (Fig. 9.14). If the pattern moves vertically, any mechanism that picks up information from one set of stripes alone will be able to derive only the oblique component of the motion at right angles to those stripes. The other set of stripes will yield motion in the other oblique direction. When we look at such a pattern, we see the stripes as a coherent plaid moving horizontally, which implies that we are combining information from the two components of the pattern to derive the only direction of motion which is compatible with both of them (Fig. 9.14(b)).

Movshon *et al.* (1985) and Rodman and Albright (1989) have used moving patterns of this kind to stimulate cells in areas V1 and MT of monkey cortex. For V1 cells, they could find the optimal direction for a single stripe pattern; they then predicted the response to the plaid from what would be expected if the cell was detecting the motion of the individual pattern components. For example, the vertically moving pattern in Fig. 9.14 would stimulate best those cells which responded selectively to oblique motion of one or other of the diagonal gratings. Some MT cells behaved the same way. However, there was a substantial subset of cells in MT which behaved differently. These 'pattern motion' cells, if they preferred a vertically moving grating, would also prefer a vertically moving plaid, even though its components are not moving vertically. The 'pattern motion' cells can be seen as performing an integrative function. They behave as if they are taking the signals of 'component motion' cells (either from V1 or MT), and combining these so as to pick out the one direction of pattern motion which is compatible with the whole set of component motions that are being signalled.

There is another way in which MT cells have been described as elaborating the initial motion processing that begins in area V1 of the cortex. Both John Allman in California and more recently Guy Orban in Belgium have investigated 'surround effects' on the direc-

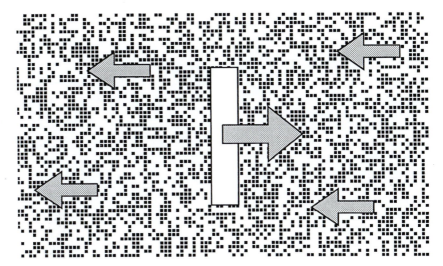

Fig. 9.15. The type of stimulus used to demonstrate surround effects in motion-sensitive cortical cells. The central bar is set to the optimal orientation and direction of motion of the cell; in some cells this respond is enhanced when surrounding texture is added with the opposite motion.

tional responses of individual neurones. The usual test for directionally selective neurones is to move a bar or edge of light in the cell's receptive field and find the direction of motion that elicits the best response. Allman *et al.* (1985) added an extended region of visual texture, outside the receptive field as classically defined and tested how the motion of this texture surround affected the response of the cell. They reported that many cells in area MT show the strongest response when the motion of the texture surround opposed the motion of the test bar, as illustrated in Fig. 9.15. That is, the best stimulus for activating such a cell would be a shearing or contrast of the motion between a central object moving in one direction and the background moving in the opposite direction. These are quite similar conditions to those producing the perceptual separation between a central figure and the surrounding region in a random-dot kinematogram or the natural cases of 'camouflage-breaking' that I discussed earlier.

Orban *et al.* (1989) has been studying these surround interactions in more detail and has found that the preference for opposed motion in centre and surround is just one of a number of different patterns of interaction that can be found in MT cells. He also found that in the monkey (as distinct from the cat, which he has also studied), these interactions are generally weak or absent in area V1, but become much more prominent in areas V2 and in MT. So this appears to represent another progressive elaboration of motion information in the sequence of cortical processing areas: a cell in V1 is concerned only with the motion occurring at a single location in the image, but cells in MT can compare that motion with the motion of surrounding regions. This has obvious importance for a system which needs to identify regions of uniform motion and to locate dis-

(a) Rotating cylinder (b) Orthographic (c) Unstructured
 projection display

Fig. 9.16. A 'structure-from-motion' task that can be used to test both human and monkey observers. Dots on the surface of a transparent rotating cylinder (a) give the distribution of velocities in the image shown in (b). Observers can discriminate this from the same velocities distributed randomly in the field (c) (from Siegel and Andersen 1988).

continuities in motion, functions that are important for image segmentation and inferring 3-D structure from motion.

A different approach to understanding the function of area MT is to look at the consequences of damage to that area. A patient with damage in what is probably the human equivalent of MT does indeed suffer serious impairments in perceiving and using motion information (Zihl *et al.* 1983). To analyse this more closely, it is necessary to go to animal experiments. Siegel and Andersen (1988) could actually train monkeys to recognize different varieties of coherent motion. Figure 9.16 shows one example: the pattern of optic flow that is produced by a rotating transparent cylinder. This pattern contains a mixture of dots moving rightwards and leftwards, with a characteristic distribution of velocity and direction across the field. The task is to discriminate this global organization from the same set of dot velocities randomly jumbled so as not to show the pattern that is created by a rotating cylinder. This pattern of motion is coherent only in a 3-D sense. There are simpler patterns which are coherent in two dimensions, such as uniform motion of the whole surface or the dot pattern uniformly expanding from one point on the surface. Andersen (1989) describes experiments in which a small, known, region of the monkey's MT area could be selectively disabled. This produced a short-term deficit, both in recognizing coherent expansion (a 2-D task) and in recognizing the characteristic flow pattern of a rotating 3-D form. However, the monkeys very rapidly recovered their 2-D performance in a matter of days, whereas the deficit in recognizing the 3-D structure of the motion was much more permanent. One can argue from this that MT represents the only route in the visual system, or at least the limiting route, for structure from motion information, whereas motion information for some other per-

ceptual purposes can be handled by alternative neural pathways. That conclusion is well founded, I believe, but it must be clear that the finding does not demonstrate nor did Andersen and his colleagues want to claim that MT is the site of structure from motion processing. Some experiments by Roy and Wurtz (1990) look at the medial superior temporal area (MST), an area which receives signals from MT, and find cells which appear to combine depth and motion information in just the kind of way needed to make sense of the optic flow generated by the observer moving over the ground. These are elegant findings, but whether the neural processing that goes on in MST could solve the computational problems of Siegel and Andersen's transparent rotating cylinder is as yet unknown.

We are left with a diversity of important and distinct perceptual functions that depend on motion information. Both psychophysical and physiological experiments also reveal a diversity of mechanisms for processing motion: long- and short-range, fast and slow, component and pattern motion, and V1, MT and MST. Matching these mechanisms and new ones yet to be elucidated to the jobs that they do in perception remains an exciting problem for the future.

References

Adelson E. H. and Movshon, J. A. (1982). Phenomenal coherence of moving visual patterns. *Nature*, **300**, 523–5.

Albright, T. D. (1984). Direction and orientation selectivity of neurons in visual area MT of the macaque. *Journal of Neurophysiology*, **52**, 1106–30.

Allman, J., Miezin, F., and McGuinness, E. (1985). Direction- and velocity-specific responses from beyond the classical receptive field in the middle temporal visual area (MT). *Perception*, **14**, 105–26.

Andersen, R. A. (1989). Visual and eye movement functions of posterior parietal cortex. *Annual Review of Neuroscience*, **12**, 377–403.

Baker, C. L. and Braddick, O. J. (1985a). Temporal properties of the short range process in apparent motion. *Perception*, **14**, 181–92.

Baker, C. L. and Braddick, O. J. (1985b). Eccentricity-dependent scaling of the limits for short-range apparent motion perception. *Vision Research*, **25**, 803–12.

Barclay, C. D., Cutting, J. E., and Kozlowski, L. T. (1978). Temporal and spatial factors in gait perception that influence gender recognition. *Perception and Psychophysics*, **23**, 145–52.

Beverly, K. I. and Regan, D. (1973). Evidence for the existence of neural mechanisms selectively sensitive to the direction of motion in space. *Journal of Physiology*, **235**, 17–29.

Bonnet, C. (1977). Visual motion detection models: features and frequency filters. *Perception*, **6**, 491–500.

Boulton, J. C. (1987). Two mechanisms for the detection of slow motion. *Journal of the Optical Society of America*, **A4**, 1634–42.

Braddick, O. J. (1974). A short-range process in apparent motion. *Vision Research*, **14**, 519–27.

Braddick, O. J. (1980). Low-level and high-level processes in apparent motion. In *The psychology of vision*, (ed. H. C. Longuet-Higgins and N. S. Sutherland) pp. 137–51. The Royal Society, London.

Burr, D. C. (1980). Motion smear. *Nature*, **284**, 164–5.

Burr, D. C., Ross, J., and Morrone, M. C. (1986). Seeing objects in motion. *Proceedings of the Royal Society of London*, **B227**, 249–65.

Cavanagh, P. and Mather, G. (1989). Motion: the long and short of it. *Spatial Vision*, **4**, 103–29.

Cleary, R. and Braddick, O. J. (1990*a*). Direction discrimination for band-pass filtered random-dot kinematograms. *Vision Research*, **30**, 303–16.

Cleary, R. and Braddick, O. J. (1990*b*). Masking of low frequency information in short-range apparent motion. *Vision Research*, **30**, 317–27.

Cutting, J. E. and Kozlowski, L. T. (1977). Recognizing friends by their walk: gait perception without familiarity cues. *Bulletin of the Psychonomic Society*, **9**, 353–6.

Gibson, J. J. (1950). *The perception of the visual world*. Houghton Mifflin, Boston, Mass.

Gombrich, E. H. (1962). *Art and illusion*. Phaidon, London.

Hildreth, E. C. (1984). *The measurement of visual motion*. MIT Press, Cambridge, Mass.

Hildreth, E. C. and Koch, C. (1987). The analysis of visual motion: from computational theory to neuronal mechanisms. *Annual Review of Neuroscience*, **10**, 477–533.

Johansson, G. (1975). Visual motion perception. *Scientific American*, **232**, (6), 76–89.

Julesz, B. (1971). *Foundations of cyclopean perception*. University of Chicago Press.

Julesz, B. (1981). Textons, the elements of texture perception, and their interactions. *Nature*, **290**, 91–7.

Koenderink, J. J. (1986). Optic flow. *Vision Research*, **26**, 161–80.

Kruse, P. (1986). Transformational invariants in gait perception. *Perception*, **15**, A8.

Lee, D. N. (1980). The optic flow field: the foundation of vision. In *The psychology of vision*, (ed. H. C. Longuet-Higgins and N. S. Sutherland), pp. 169–78. The Royal Society, London.

Longuet-Higgins, H. C., and Pradzny, K. (1980). The interpretation of moving retinal images. *Proceedings of the Royal Society of London*, **B208**, 385–97.

Mather, G. (1989). Early motion processes and the kinetic depth effect. *Quarterly Journal of Experimental Psychology*, **41**, 183–98.

Maunsell, J. H. R. and Newsome, W. T. (1987). Visual processing in monkey extrastriate cortex. *Annual Review of Neuroscience*, **10**, 363–401.

Mikami, A., Newsome, W. T. and Wurtz, R. H. (1986). Motion selectivity in macaque visual cortex II: Spatiotemporal range of directional interactions in MT and V1. *Journal of Neurophysiology*, **55**, 1328–39.

Movshon J. A., Adelson, E. H., Gizzi, M. S., and Newsome, W. T. (1985). The analysis of moving visual patterns. In *Pattern recognition mechanisms*, (ed. C. Chagas, R. Gattass, and C. G. Gross), Pontificae Academiae Scientiarum Scripta Varia, Vol. 54, pp. 117–51. Pontifica Academia Scientiarum, Vatican City.

Nakayama, K. (1985). Biological image motion processing: a review. *Vision Research*. **25**, 625–60.

Nakayama, K. and Silverman, G. H. (1984). Temporal and spatial characteristics of the upper displacement limit for motion in random dots. *Vision Research*. **24**, 293–9.

Newsome, W. T., Wurtz, R. H., Dursteler, M. R., and Mikami, A. (1985). Deficits in visual motion processing following ibotenic acid lesions of the middle temporal area of the macaque monkey. *Journal of Neuroscience*, **5**, 825–40.

Orban, G. A., Lagae, L., Raiguel, S., Gulyas, B., and Maes, H. (1989). Analysis of complex motion signals in the brain of cats and monkey. In *Models of brain function*, (ed. R. M. J. Cotterill). Cambridge University Press, Cambridge.

Petersik, J. T. (1989). The two-process distinction in apparent motion. *Psychological Bulletin*, **106**, 107–27.

Rodman, H. R. and Albright, T. D. (1989). Single-unit analysis of pattern-motion selective properties in the middle temporal visual area (MT). *Experimental Brain Research*, **75**, 53–64.

Rogers, B. C. J. and Graham, M. (1979). Motion parallax as an independent cue for depth perception. *Perception*, **8**, 125–34.

Roy, J.-P. and Wurtz, R. H. (1990). The role of disparity-sensitive cortical neurons in signalling the direction of self-motion. *Nature*, **348**, 160–2.

Runeson, S. and Frykholm, G. (1981). Visual perception of lifted weight. *Journal of Experimental Psychology: Human Perception and Performance*, **7**, 733–40.

Siegel, R. M. and Andersen R. A. (1988). Perception of three-dimensional structure from motion in monkey and man. *Nature*, **331**, 259–61.

Snowden, R. J. (1988). The integration of motion information in visual processing. Ph.D. thesis, University of Cambridge.

Snowden, R. J. (1989). Motions in orthogonal directions are mutually suppressive. *Journal of the Optical Society of America*, **A6**, 1096–1101.

Snowden, R. J. and Braddick, O. J. (1990). Differences in the processing of short-range apparent motion at small and large displacements. *Vision Research*, **30**, 1211–22.

Ullman, S. (1983). Recent computational studies in the interpretation of structure from motion. In *Human and machine vision*, (ed. J. Beck, B. Hope, and A. Rosenfeld), pp. 459–80. Academic Press, New York.

Yonas, A., Craton, L. G., and Thompson, W. B. (1987). Relative motion: kinetic information for the order of depth at an edge. *Perception and Psychophysics*, **41**, 53–9.

Zeki, S. M. (1974). Functional organization of a visual area in the posterior bank of the superior temporal sulcus of the rhesus monkey. *Journal of Physiology*, **236**, 549–73.

Zihl, J., von Cramon, D., and Mai, N. (1983). Selective disturbance of motion vision after bilateral brain damage. *Brain*, **106**, 313–40.

10 At the edge of movement

STUART ANSTIS AND V. S. RAMACHANDRAN

The edges of objects in the real world are revealed by abrupt changes in retinal images of several kinds: brightness, texture, motion, colour, depth, and so on. The two-dimensional artist cannot depict edges in motion or stereopsis, but plenty of cues are still available to his or her palette. Here we describe what happens when one throws away brightness, colour, and everything else, until only motion is left. Some things get worse — edges cannot be localized accurately, but new and interesting perceptual effects emerge. Now that the computer is becoming an artist's tool, there may be new areas to be opened up using kinetically revealed objects, or objects visible only by colour, or only by depth and so on.

For objects to be visible they must differ from their surround in some way. There is usually a brightness difference, as in the white square in Fig. 10.1(a). But recently there has been much interest in equiluminous objects (Livingstone and Hubel 1987) which differ from their surround along some non-luminous visual dimension, such as stereo depth (Fig. 10.1(d)), or texture (Fig. 10.1(b) and (c)), where the square and the surround have different textures but share the same space-averaged brightness. In particular, motion can make an object stand out from its surround. Figure 10.1(e) shows a motion-defined square on a surround of stationary random dots, like a sheet of sandpaper with a small foreground square of sandpaper moving in front of it. As a result the square is seen as moving. Thus motion itself can reveal the objects, even when there is no difference in brightness. Of course the edges of the square move with the texture, because the whole thing is moving. But one could equally well have a large sheet of stationary sandpaper with a small square hole cut in it, through which is seen part of a large background sheet of moving sandpaper (Fig. 10.1(f)). This gives a stationary window of moving texture.

We have studied these stationary motion-defined windows that contain drifting dots (Ramachandran and Anstis 1987, 1990; Anstis 1989). All stimuli were displayed on a computer-controlled TV

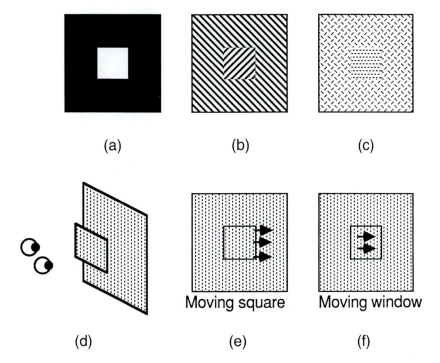

Fig. 10.1. Ways to see a square. (a) brightness. (b,c) texture. (d) stereoscopic depth. (e,f) motion. In (e) the whole square drifted to the right (arrows), including the edges. In (f) the dot texture drifted to the right behind a window with stationary edges. All the stimuli we used were windows like (f).

screen (Anstis 1986; Anstis and Paradiso 1989). We used three types of random-dot textures. The random dots could be stationary, or drifting together (coherently) in one direction or else jumping around incoherently in all directions, rather like the 'snow storm' on a detuned TV receiver (random dynamic noise). If any two of these textures are butted together they produce a clearly visible edge that is revealed only by motion. Notice that the motion edge does not exist in any single snapshot, but only as a correlation between successive frames of a moving picture over time. There is no edge revealed by brightness, because the average brightness of the dots is the same on both sides of the contour. If the dots are made a little darker on one side of the border, we have an edge that is revealed both by motion and by brightness.

We have discovered several illusory effects produced by such windows of drifting texture (Fig. 10.2). First, the position of each window appears *displaced* in the direction of the drifting dots that it contains. This is true only when the textures inside and outside the windows have the same mean brightness, so that the edges are revealed only by motion. When we add the brightness edges the apparent displacement is no longer seen. Second, the window also appears to *move along* with the dots even though it is stationary — an example of motion capture (Ramachandran 1987). Third, if the stationary window is embedded in dynamic visual noise and viewed

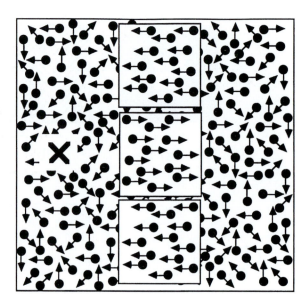

Fig. 10.2. Three stationary windows were filled with random dots that drifted to the right in the central window and to the left in the top and bottom windows. The surround was filled with randomly twinkling dots. Result: the central window appeared subjectively displaced to the right (illusory displacement). Also, if the subject fixated the cross then the windows could disappear within 4–8 s.

peripherally during steady fixation, it rapidly vanishes from sight, becoming invisible within about 5 s and reappearing only when the eyes are moved (Anstis 1989; Ramachandran and Anstis 1990). This rather alarming artificial blindspot or 'galloping glaucoma' is probably caused by the twinkling background rather than by motion within the window, since uniform grey patches embedded in visual noise also fade rapidly when viewed peripherally (Spillman and Kurtenbach 1990; Ramachandran and Gregory 1991). We have noticed that small coloured spots also fade quickly in peripheral vision, even when they have an average brightness different from that of the dynamic noise. Whereas 'Troxler' fading, as described by Pirenne (1967), generally works best for blurred or very stable edges, the twinkling noise in our displays constantly refreshed the edge, yet the perceptual vanishing was very rapid.

In this chapter we extend these studies to stationary windows that contain not drifting dots, but drifting stripes. We shall describe three perceptual phenomena:

(1) illusory offsets;

(2) motion segregation — seeing that objects are different by their different movements;

(3) the aperture problem — the fact that the shape of the frame surrounding movement affects the perceived direction of the movement.

It has long been known that steadily fixated edges perceptually fade (the Troxler effect — see Pirenne 1967). However, this effect has been thought to work best for blurred stationary edges given by luminance change. In our displays, the twinkling noise constantly redefined the edge, yet the perceptual fading was very rapid.

The illusory offsets obtained with the windows filled with drifting stripes are similar to those obtained with random-dot textures. However, rapid disappearance in peripheral vision was not observed with stripe-filled windows and the motion segregation and aperture effects are peculiar to windows filled with stripes.

Illusory offsets

Figure 10.3(a) shows, on a uniform grey surround, a stationary window within which stripes drift to the right. The change of brightness between adjacent black and white stripes was not abrupt but gradual — a graph of brightness against position would produce a sine wave. All windows in this paper were a whole even number of stripes wide, so that at all times a stripe appearing at one edge had the same brightness as the stripe that was disappearing at the other edge. There was almost always a brightness difference between the edge of the window and the grey surround, because at an instant when drifting black (or white) stripes reached the edges of the stationary window these stripes were darker (or lighter) than the grey surround. Only on the way up and on the way down did the grey of the stripes match the grey of the surround, and only at these brief instants was there no brightness-defined edge.

There are three ways to get rid of these brightness edges.

1. The brightness of the uniform surround can be swept up and down smoothly (sinusoidally) over time, in such a way that the surround brightness always matches the stripes at the edges of the window (Fig. 10.3(a)).

2. The mean brightness of the striped pattern can be varied, rather than that of the surround (Fig. 10.3(b)). When the stripes at the edge of the window were light, we lowered their average brightness until these stripes were mid-grey to match the unchanging surround. When the stripes at the edge of the window were dark, we raised their average brightness until these stripes were mid-grey to match the surround. This method is used when many windows, each with stripes in different positions, were viewed against a common surround. Thus, at one instant one window might have

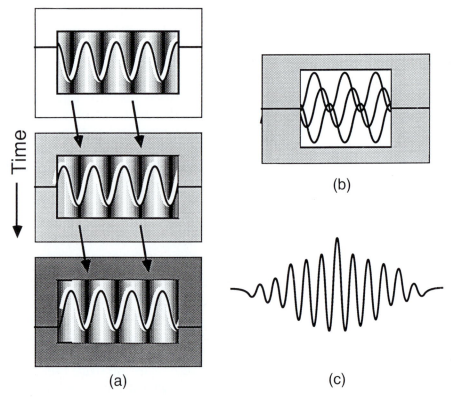

Fig. 10.3. Three methods for removing brightness edges from stationary windows filled with drifting gratings (repetitive patterns of black and white stripes). (a) The brightness of the grey surround was varied smoothly up and down over time in step with the stripes as these reached the sides of the windows. Surround was made white when white parts of the bars were at the edges of the windows (top picture), mid-grey when the grey in the edges of the bars was at the window edges (middle picture), and black when the black troughs of the bars were at the window edges (bottom picture). Brightness profiles of the grating and surround are shown on these examples of the stimuli. (b) The average brightness of the stripes, not of the surround, was varied. Three brightness profiles of the stripes at successive times are shown within the window. In the leftmost, upper profile, dark bars were at the window edges and the mean brightness of the grating was raised to make these dark bars match the mid-grey surround. The middle trace shows the mid-grey of the bar edges at the window edges. In the rightmost, bottom trace, light bars were at the window edges and the average brightness of the bars was lowered to make these light bars match the mid-grey surround. For clarity, the bars themselves are omitted. (c) The contrast of the stripes differs with their position within the window. As stripes enter the window (say from the left) their contrast is zero. Contrast gradually increases until the stripes lie in the middle of the window and then gradually decreases to zero as they reach the right-hand edge of the window (after De Valois and De Valois 1990).

dark stripes at its edges while another had light stripes, but both were matched to the common mid-grey surround.

3. De Valois and De Valois (1990, 1991) have independently discovered the illusory offset phenomenon. The blurry edges of the

windows within which the stripes were displayed effectively removed the brightness edges. The contrast of the stripes was not the same throughout the window, but was high in the middle and tapered off to zero at the edges of the window (Fig. 10.3(c)).

De Valois and De Valois found, as we did, that the apparent position of the window was shifted in the direction of motion of the stripes. This effect became greater as the stripes were moved out of central vision, reaching half a degree at 8° eccentricity.

All three methods produced the same results: with the brightness edges removed, the windows containing stripes showed the same illusory displacement as did the windows containing drifting random-dot textures. In Fig. 10.4(a) three stationary windows containing drifting stripes are lined up one above the other. The stripes in the middle window moved to the right and the stripes in the top and bottom windows moved to the left. If the brightness edges were removed by any of the three methods just described, a strong illusory offset was seen, in which the middle window appeared to be displaced to the right by up to half a degree of visual angle.

In two other conditions in which the brightness edges were not removed (not illustrated) the three windows were seen as being lined up vertically, as indeed they were. In one control condition the surround was simply a steady grey, and in another its brightness changed up and down smoothly, but out of step, not in step, with the varying brightness of the inner edges of the window. This condition kept the brightness edges intact and abolished the illusory offset.

The illusory offsets could produce an impression of stereoscopic depth, just as physical offsets can. If the left eye saw the stimulus while the right eye saw its mirror image (Fig. 10.4(b)), then the binocularly fused central window appeared to lie nearer in depth than the top and bottom windows (Fig. 10.4(c)). This is just what would happen if physical offsets were introduced (as in the right-hand panels of Fig. 10.4(b)).

What is true for position is true for size. In Fig. 10.4(d) the windows of stripes were wrapped around into two disks or bull's-eyes, with expanding concentric rings in one of them and contracting rings in the other. When the brightness edges were removed by our flicker technique, these edges were revealed purely by motion. Result: the expanding rings within one round window made the window itself appear to expand, so that it looked about 10 per cent larger than the window containing the contracting rings.

Why should a stationary window appear to be displaced just because it contains a drifting pattern? A motion-signalled edge must be reported by motion sensors, since no other sensors (for brightness, colour, etc.) are stimulated by it. We conjecture that motion

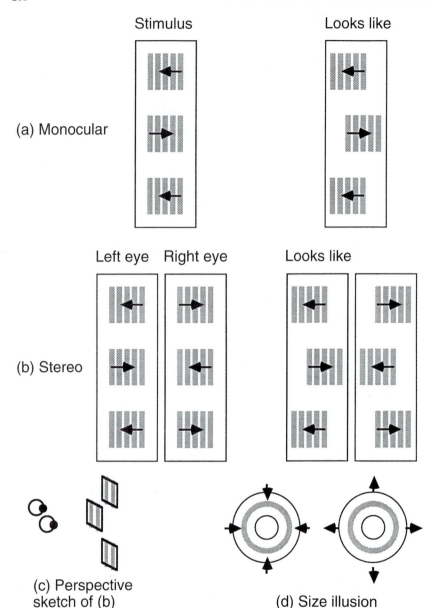

Fig. 10.4. Same as Fig. 10.2., but with gratings instead of random dots. (a) Three stationary windows, aligned vertically, contained drifting stripes. Top and bottom stripes drifted to the left, middle stripes drifted to the right. There were *no* brightness edges, because the surround brightness varied with the window edges (not shown). Result: middle window appeared to be displaced to the right. (b) Left eye saw same as (a), right eye saw its mirror image. Result: in the binocularly-fused image the central window appeared nearer than the others. (c) Perspective sketch of the apparent depth seen in (b). (d) Size illusion in annular windows that contained expanding or contracting circular stripes.

sensors systematically misreport the position of such an edge, assigning to it an offset in the sensor's preferred direction. This offset would help to anticipate the future location of the edge and would compensate for the actual displacement of the object that would occur during the inevitable neural delays of visual processing. Thus, the perceived position is not the position of the stimulus when it actually triggers the sensor, but its *anticipated* position by the time the signal must interact, at some more central neural site, with other sensory or motor processes. This offset played a role in our experi-

ments because signals from directionally selective units are used to localize a kinetic edge and the edge would therefore appear substantially displaced. Patrick Cavanagh (personal communication) and De Valois and De Valois (1990, 1991) have made essentially the same suggestion. When there is also a brightness contrast across the kinetic edge, however, sensors which are stimulated by a stationary luminance change dominate the location of an edge and give accurate information about its position.

In summary, we conjecture that brightness discontinuities give accurate local position information, but motion discontinuities do not. Motion sensors 'aim off' in the direction of the motion to allow for neural processing times, thus leading to illusory displacements. Motion sensors may also respond to rather large areas of the stimulus and so give only crude location information.

Thus, there seem to be two separate but related perceptual effects with kinetic (motion-defined) edges — an apparent offset underlying the perceived offset and also an apparent drift underlying motion segregation of kinetic windows. Both of these phenomena disappear when there is also a brightness contrast across the kinetic edge, because brightness pathways supply signals about position which countermand those of motion to the effect that the edge is stationary and not displaced. Clearly, not all edge cues are created equal. Brightness-edge signals are stronger than motion-edge signals, so they win out when put into competition and they countermand the motion-based illusions. However, colour is probably no stronger than motion, since the illusory offset and drift still occur if the spots or stripes on each side of the kinetic edge are of different colours but of the same brightness. Indeed, a colour border can actually appear to be dragged along by brightness-defined spots (Ramachandran 1987).

Motion segregation

The way in which motion sensors can divide the visual array into regions is readily demonstrated with a field of sparse, coarse spots which move to the right, while a subset of sparse spots arranged in a T move in unison to the left (Fig. 10.5(a)). Subjects can immediately read the T which is revealed by common motion (Fig. 10.5(b)). The segregation fades away as soon as the motion is stopped. We now report that motion segregation can be supported by stationary windows containing drifting gratings — but only if static brightness edges are removed.

Figure 10.5(c) shows an array of striped blobs, in other words stationary windows filled with drifting stripes. Eight of these windows, arranged in a T, contain stripes that drifted to the left, while all the

Fig. 10.5. Motion segregation. (a) Grey dots moved to the right, black dots to the left. Actually all dots were black; some are made grey here for exposition only. Result: the T-shaped region of leftward dots detached itself from the surround (b) in immediate, pre-attentive motion segregation. (c) Stationary windows were filled with stripes that drifted to the left in a T-shaped subset of windows and to the right in the remainder. Result depended on the surround, which is not shown. If surround brightness varied simultaneously with that of the stripes at the window edges, giving no brightness edges, there was strong pre-attentive motion segregation, as in (d). If brightness edges were intact, there was little or no motion segregation.

remaining stripes drifted to the right. Incidentally, it was noticed that if the bars in all the windows had the same spatial relationship, say white bars appearing in all the windows at the same moment, all the windows appeared to pulsate together in brightness. This was felt undesirable, since it might affect the motion segregation for better or for worse, so it was removed by randomizing the spatial positions of the bars across windows (not shown). To accommodate this, the brightness of the windows was flickered by method 2 in order to get rid of brightness edges. When this was done an observer immediately saw the eight windows, revealed by their kinetic edges, 'pop out' in pre-attentive perceptual segregation and move to the left as a unit, spelling out a letter T (Fig. 10.5(d)). However, if the brightness edges were not removed the motion segregation collapsed. An observer could still find the leftward-moving blobs given time, but had to search for them with attentive scrutiny.

Why do the windows segregate when their edges are revealed only by motion, but not when we add brightness edges? Fig. 10.6 shows our conjecture that the stimulus of Fig. 10.5(c) is analysed in paral-

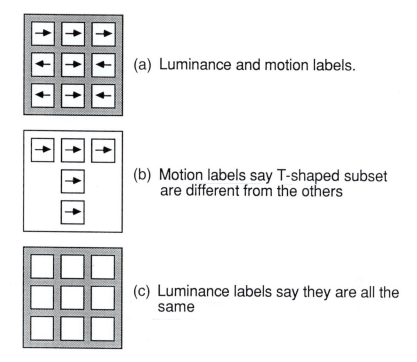

(a) Luminance and motion labels.

(b) Motion labels say T-shaped subset are different from the others

(c) Luminance labels say they are all the same

Fig. 10.6. Results shown in Fig. 10.5. can be explained by competition between brightness and motion signals. See text.

lel (that is, separately) for brightness and motion cues. There are nine little windows, with a T-shaped subset of five windows containing motion to the right. The motion cues signal that all the windows in the T-shaped set are moving to the right as a unit. However, if there are brightness edges around each window, brightness cues signal that all nine windows are 'the same'. When only motion edges are present we see the T-shaped subset. The motion signals identify the T as different, but the brightness signals identify all the windows as the same. This cue conflict is resolved in favour of brightness, which is a stronger cue than motion and motion segregation collapses. It is not clear why the observer seems to throw away the motion information. One might think that once the segregating information was extracted it would be conserved, but in fact it was not.

The aperture problem

Imagine a long vertical line moving sideways behind a circular window, its ends being invisible. If the line were moving down at the same time as it moved sideways, it would still look exactly the same. In fact there is a whole family of possible directions and speeds that would give the same retinal stimulus. The movement of drifting

Fig. 10.7. Aperture problem
with oblique gratings.
(a) Oblique stripes (pale grey)
drifted down to the right (thick
grey arrow). The stripes were
visible only through a vertical
and a horizontal slit, through
which they appeared to drift
vertically and horizontally
respectively (thin arrows). The
oblique stripes shown in pale
grey were actually hidden.
(b) Aspect ratios of slits in (a) are
radically changed, so that now
both slits are oblique, but ends
are cut vertically or horizontally.
Result: the slits, and the gratings
seen through them, appear to
drift vertically or horizontally
respectively (arrows) — but only
if brightness edges are removed.
(c) Brightness edges along sides
are important. Flicker (F) near
long sides keeps the vertical
motion shown in (b), but
(d) flicker near short ends (with
grey (G) along sides) is
ineffective. See text.
(e) Conventional Müller–Lyer
illusion. The line with the
'outgoing' fins appears much
longer than the line with the
'ingoing' fins. (f) Dynamic
Müller–Lyer illusion. Ends appear
to drift outwards on left-hand
slit, inwards on right-hand slit.
Result: left-hand slit looks longer.

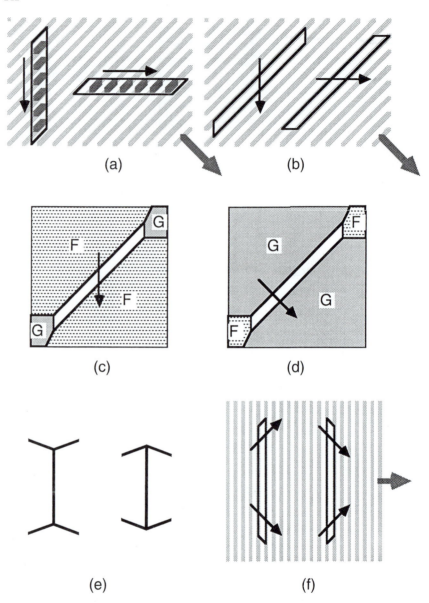

stripes is ambiguous (Adelson and Movshon 1982), because only the
motion component at right angles to the stripes produces any visible
change. In Fig. 10.7 oblique stripes drifting down to the right (thick
grey arrows) were actually visible only through a vertical slit and a
horizontal slit, through which they appeared to be drifting vertically
or horizontally respectively (thin arrows in Fig. 10.7(a)). These per-
ceived motions are consistent with the intersections that move along
the edges of the slits (see Nakayama and Silverman 1988).

If you view drifting vertical stripes through a long thin vertical
window, then not surprisingly you see the stripes moving horizon-

Time ⟶

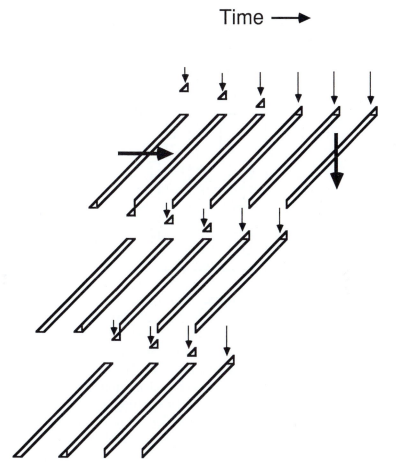

Fig. 10.8. A display of many parallel, oblique stationary slits, behind which oblique stripes (not shown) drift down to the right. Initially the short ends of the slits are cut horizontally, as shown on the left, so that the slits appear to drift horizontally (long horizontal arrow). Then a tiny triangular piece migrates slowly from the bottom of each slit to the top of the slit below. When they arrive they make the slit ends vertical, so that now the slits appear to drift vertically (long vertical arrow).

tally. But if you now make the top and bottom edges of the window slope obliquely, the stripes instantly appear to move obliquely up or down according to the slope of the tiny ends of the window. They appear to be dragged up or down by the tips. This effect is seen only if the brightness differences at the long edges of the window are eliminated. Furthermore, as in the case of the dot pattern, if the average brightness of the stripes is the same as the surround, the entire window appears to drift with the stripes. On the other hand if the brightness difference is introduced the window appears stationary. This phenomenon was demonstrated dramatically by filling the entire screen with oblique slit-shaped windows, all with the same orientation (Fig. 10.8).

The flicker in the surround was manipulated so that it bordered only the sides or only the ends of the slits. Result: it was the sides that were important. When the flicker was confined to the long sides of the slits, removing the luminous edges (Fig. 10.7(c)), the vertically cut slit still appeared to drift vertically and the horizontally cut slit

Fig. 10.9. Motion 'pop-out'. (a) Vertical stripes (not shown) move behind stationary vertical slits. Stripes drift to the left behind the 'target' ('odd person out'), but to the right behind the 'distractors' (all the other similar stimuli). Not surprisingly, the target pops out in motion segregation. (b) Oblique stripes (not shown) drift down to the right behind stationary oblique slits. Although motion is in the same direction behind all the slits, the short ends of the slits make the motion appear horizontal behind the distractors but vertical behind the target, which pops out.

still appeared to drift horizontally. When the flicker was confined to the cut ends (Fig. 10.7(d)), so that there were now brightness edges along the sides of the slits, the effects disappeared and the stripes were seen as moving in a direction at right-angles to the long axis of the slit. We attribute this new aperture effect in Fig. 10.7(b) and (c) to brightness-based motion signals from the ends of the stripes as they drift across the tiny ends of the slits. These signals propagate along the whole length of the slit and determine the perceived direction of drift — unless these are countermanded by brightness signals from the long sides of the slits, which would strongly indicate that the stripes are moving parallel to the slits. Thus, signals from the intersections of the stripes with the ends of the slits compete against signals from the whole length of the sides of the slits. If the latter are not removed by the flicker technique they win the competition and the stripes appear to move at right-angles to the axis of the slits. If the brightness edges from the sides are removed, then the signals from the tiny ends win the day and the whole slit appears to drift in a direction parallel to the tiny ends of the slits.

This new form of the aperture effect was enough to give motion segregation. In Fig. 10.9(a) it is not surprising that the leftward-moving target pops out from the rightward-moving distractors. But in Fig. 10.9(b) all the oblique windows contained stripes drifting in the *same* direction, down to the right. The only difference is that the distractors had their ends cut horizontally, so that they appeared to drift horizontally. The target had its ends cut vertically, so that it appeared to drift vertically downwards. The vertical tiny ends on the target slit were enough to make this slit 'pop out' perceptually from the distractor slits. If the brightness edges were not removed,

however, this motion segregation collapsed. Note that this segregation is based on perceived motion, not perceived position — that is, upon the apparent dynamic drift of the target window, not on any apparent static displacement of the target, which would not even be noticed, since the windows are positioned randomly.

The new aperture effect could alter perceived size in a kind of dynamic Müller–Lyer illusion. In a conventional Müller–Lyer illusion (Fig. 10.7(e)) the apparent length of a line depends on the orientation of the shorter oblique lines ('fins') at the line ends. When these point out, the vertical line appears longer than when they point in. To generate an analogous dynamic illusion, two slit-shaped windows of the same length had their tops and bottoms cut with opposite bevels (Fig. 10.7(f)). When there were brightness differences at the vertical edges the windows were correctly seen as of the same length, but when the brightnesses were the same, the vertical edges being seen only from movement, the top and bottom of the left-hand window appeared to drift outwards and the top and bottom of the right-hand window appeared to drift inwards, so that overall the left-hand window looked longer than the right-hand window. This is not simply another version of Fig. 10.4 (d). In Fig. 10.4 (d) the expanding or contracting rings altered the apparent size of the circular windows. Here it is not the moving stripes themselves, but rather their intersections with the obliquely cut top and bottom of the windows, that determine the perceived size.

Finally, two directions of motion were combined. This shows that what we found in one dimension is also true in two dimensions. Adelson and Movshon (1982) showed that if two striped patterns are superimposed, moving at right-angles, the result is a plaid or tartan that appears to move diagonally. Imagine a 'negative' window —

Fig. 10.10. Behind a grid of stationary slits, horizontal stripes drift down behind the horizontal slits and vertical bars drift to the right behind the vertical slits (short arrows). Result: in peripheral vision, the whole display appears to drift down to the right (long arrow). In the right half of the picture, the same oblique drift is perceived even though the grid intersections are occluded.

with panes of opaque glass and transparent horizontal and vertical bars (Fig. 10.10). Behind this negative window there are vertical stripes drifting to the right superimposed on horizontal stripes drifting downwards. When there are brightness differences there is no net impression of diagonal motion, but if a flickering surround is used to remove the brightness edges, the whole field appears to drift down obliquely, especially in peripheral vision. The oblique motion of Adelson and Movshon's plaid has sometimes been attributed to the intersections of the two sets of stripes, which do move obliquely as moiré fringes. However, if the intersections of the stationary window grid are covered up there is still a reasonable impression of a plaid drifting obliquely, again especially in peripheral vision.

Conclusion

A visible edge can be revealed by a discontinuity in almost any visual characteristic — brightness, texture, depth, colour, motion, and so on. Although a single characteristic can represent an edge, as shown in Fig. 10.1, most edges in real life are visible not by brightness alone but by conjunctions of many characteristics. For instance, if a dark-grey textured rock hides part of a distant light-green grassy meadow, the edge is revealed by brightness, colour, texture, and depth. Why does the visual system use multiple sources of information instead of simply relying on the most common one — brightness differences? The reason is probably that it helps to defeat camouflage and increase reliability. Motion edges are particularly useful for breaking camouflage, as prey and predators both know. Colour vision would be of little use to a lion, since the antelopes on which it preys are the same colour as their average surroundings. But prey must move to escape, so lions and other predators are keenly sensitive to motion. The zebra that stands out clamantly in a zoo blends into the background in the wild and a spotted cat is hard to pick out against foliage — until it moves, when motion-defined edges immediately give away its position. This is why the study of kinetic edges is important. The new illusions that we have described may tell us about the neural mechanisms used in extracting these edges.

Consider recognizing objects in the following sequence of pictures: a black and white photocopy, a tone-graded grey photograph, a colour photograph, a black and white cinema film with a fixed camera, and then a similar cinema film with the camera in motion, so giving the relative motion of objects at different distances. Now we can introduce colour, and indeed stereoscopic depth, using two cameras with polaroid glasses. It is remarkable how well artists can

convey information with pictures of the most basic kind — black lines on white paper. But it is interesting that the visual system has developed these extremely subtle further processes in visual perception, which evidently must have survival value in the real world. Perhaps the other ways in which edges are delineated and objects are recognized are seldom essential; but — fortunately for the richness of our experience and the possibilities given to artists — they are useful enough to occupy large parts of our brain as a result of the evolutionary pressures that operated on our ancestors.

Acknowledgements

Supported by the Defence and Civil Institute of Environmental Medicine through Contract W7711-9-708880/01-XSE from Supply & Services Canada, Grant A0260 from NSERC, and startup funding from UCSD to SMA, and Grant 89-0414 from the U.S. Air Force Office of Scientific Research to VSR. We thank Richard Gregory and John Harris for comments on the manuscript, and Louise Batsch, Dorrie-Ann Cutajar, Patricia Hutahajan, Suneeti Kaushal, and Donna Pickering for their help with the experiments.

References

Adelson, E. H. and Movshon, J. A. (1982). Phenomenal coherence of moving visual patterns. *Nature*, **300**, 523–5.

Anstis, S. M. (1986). Visual stimuli on the Commodore Amiga: a tutorial. *Behaviour Research Methods, Instruments and Computers*, **18**, 535–41.

Anstis, S. M. (1989). Kinetic edges become displaced, segregated or invisible. In *Neural mechanisms of visual perception*. Proceedings of the Second Retina Research Foundation Conference, (ed. D. M.-K. Lam and C. D. Gilbert), pp. 247–60. Portfolio Press, Texas.

Anstis, S. M. and Paradiso, M. (1989). Programs for visual psychophysics on the Amiga: a tutorial. *Behaviour Research Methods, Instruments and Computers*, **21**, 548–63.

De Valois, R. L. and De Valois, K. K. (1990). Stationary moving Gabor plaids. *Investigative Ophthalmology and Visual Science* (Suppl.), **31**, 171.

De Valois, R. L. and De Valois, K. K. (1991). Vernier acuity with stationary moving Gabors. *Vision Research*, **31**(9), pp. 1619–31.

Livingstone, M. S. and Hubel, D. H. (1987). Psychophysical evidence for separate channels for colour, motion and depth. *Journal of Neuroscience*, **7**, 3416–68.

Nakayama, K. and Silverman, G. H. (1988). The aperture problem: I: Perception of nonrigidity and motion direction in translating sinusoidal lines. *Vision Research*, **28**, 747–53.

Pirenne, M. (1967). *Vision and the eye*, (2nd edn). Chapman and Hall, London.

Ramachandran, V. S. (1987). Interaction between colour and motion in human vision. *Nature*, **128**, 645–47.

Ramachandran, V. S. and Anstis, S. M. (1987). Motion capture causes positional displacement of kinetic edges. Paper presented at the 11th European Conference on Visual Perception, Cambridge, U.K.

Ramachandran, V. S. and Anstis, S. M. (1990). Illusory displacement of equiluminous kinetic edges. *Perception*, **19**, 611–16.

Ramachandran, V. S. and Gregory, R. L. (1991). Perceptual filling-in of artificially induced scotomas in human vision. *Nature*, **350**, 699–702.

Spillmann, L. and Kurtenbach, A. (1990). Enhanced contrast fading on dynamic noise backgrounds. *Perception*, **19**, 343. (Abstract).

11 2-D or not 2-D — that is the question

V. S. RAMACHANDRAN

Shape from shading is a topic that is directly relevant to the main theme of this book, but is a problem that has been very much neglected by both physiologists and psychologists. In fact the only person to have thought about it seriously was Leonardo da Vinci. Since then, rather surprisingly, there seem to have been only two or three psychophysical experiments on shape from shading. This is probably because shading has been thought of as something that is used to enhance the aesthetic appeal of pictures, not as a topic for serious study, or something that is handled by the early visual system. Contrary to this view, some new experiments suggest that shading is extracted very early in the visual system.

Of the numerous mechanisms used by the visual system to recover the third dimension, the ability to use shading is probably the most primitive. One reason for believing this is that in the natural world animals have often evolved the principle of countershading to conceal their shapes from predators; they have pale bellies that serve to neutralize the effects of the sun shining from above. The wide-spread prevalence of countershading in a variety of animal species (including many fish and caterpillars) suggests that under usual circumstances shading must potentially be a very important source of information about three-dimensional shapes.

The starting-point of our own investigations in this field was to create a set of simple computer-generated displays. The impression of depth perceived in these displays is based exclusively on subtle variations in shading and we made sure that they were devoid of any complex objects and patterns. The purpose of using such displays, of course, is that they allow us to isolate the brain mechanisms that process shading information from higher-level mechanisms that may also contribute to depth perception in real-life visual processing.

Figure 11.1 shows the simple display used. Most readers should see what appears to be a set of eggs illuminated from the left. But this display is ambiguous, because it could equally depict a set of holes or cavities, which may be perceptible, with some effort of will,

Fig. 11.1

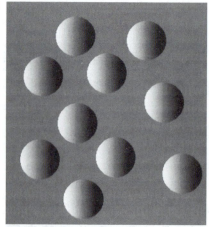

Fig. 11.2

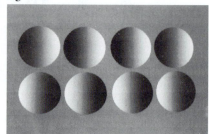

Fig. 11.1. Ambiguous objects that can be seen as either eggs or as cavities. Depth perception in this picture can be improved by squinting one's eyes to blur the image slightly.

Fig. 11.2. Demonstration of the 'single light source' constraint. When one horizontal row is seen as convex the other row is always seen as concave. It is very difficult to see all objects as being simultaneously convex or simultaneously concave. This simple display shows that the brain will accept only one light source at a time for the entire visual image (or a large portion of it).

illuminated from the right. The interesting aspect of the display is that either they are all seen as eggs or all seen as cavities. It is not possible simultaneously to see one as an egg and another as a cavity. One explanation suggested by the *Gestalt* psychologists is that there is a Law of Common Fate, that all objects in the visual field tend to do the same thing.[1] But is it the Law of Common Fate or is it because the visual system has a built-in assumption that light usually shines only from one direction: that there is only one light source illuminating the whole visual image? Figure 11.2 shows an obvious experiment in which we used two rows which are mirror images of each other. Initially one sees them all as eggs, but with prolonged viewing one row is perceived as eggs and the other row as cavities. What this suggests is that the effect is produced not by a common depth assumption but an assumption there is only one light source illuminating the entire visual image or at least that portion of it. This has been called the single light source constraint (Ramachandran 1988), which is a reasonable assumption because we live on a planet that has only one sun.

Notice that in Fig. 11.2 either row can be seen as convex *or* concave if the other row is excluded. When both rows are viewed simultaneously, however, seeing one row as convex actually forces the other row to be perceived as concave. Some powerful inhibitory mechanisms must be involved in generating these effects.

The single light source assumption is implicit in many artificial intelligence models of 'shape from shading', but Fig. 11.2 appears to be the first clear-cut demonstration that such a rule exists in human vision. Another manifestation of the rule is shown in Fig. 11.3,

[1] As Peter Medawar might have phrased it, explanations of this kind are 'mere analgesics; they dull the ache of incomprehension without removing the cause'.

Fig. 11.3. This convoluted form suggest a white tube or 'worm' lit from the right. The two disks on it seem to conform to the lighting scheme; the top disk is seen as a bump and the bottom one as a cavity.

which depicts a convoluted white tube lit from the right. The tube is nearly always seen as convex, perhaps because of subtle clues such as the 'occlusion' of one part of the tube by the other (and partly because of a general tendency to see *any* object as convex). This allows the visual system to infer that the light source is on the right. Interestingly, the depth seen in the two disks on the tube is no longer ambiguous — the one below is usually seen as a cavity and the one above as a 'bump' or sphere. This result implies that cues intrinsic to an object can inform the brain about the direction of illumination and depth seen in other parts of the object is then made to 'conform' to this light source.

In addition to the single light source constraint described above there appears to be also a built-in assumption that the light is shining from above — a principle that is well known to artists. This would explain why, in Fig. 11.4, objects in the top panel are always seen as convex, whereas those in the bottom panel are often perceived as 'holes' or 'cavities'. The sign of relative depth can be readily reversed by simply turning the page (or one's head) upside-down. The effect is a weak one, however, since either panel can in fact be seen as convex *or* concave with some effort of will (especially if the other panel is excluded from view to eliminate the single-light source constraint). On the other hand, if a mixture of such objects is presented it is almost impossible to reverse any of them perceptually, because of the combined effect of two constraints — the single light source constraint and the 'top' light source constraint (Fig. 11.5 (a)).

These observations suggest that the visual system assumes that the sun is shining from above. But how does the visual system know 'above' from 'below'? Is it the object's orientation *in relation to the retina* that matters, or its orientation with respect to gravity? This question was originally raised by Yonas *et al.* (1979), who tested both 3-year-old and 7-year-old children using ambiguous stimuli. (They used photographs of real objects rather than computer-generated images.) They found that the response of the 3-year-olds depended almost exclusively on retinal orientation, whereas 7-year-olds showed roughly equal dependence on both retinal and gravitational frames of reference. They suggested that as children grow older they progressively shift their responses towards more abstract frames of reference. Curiously, Yonas *et al.* did not test adults, but their results imply that if the same trend continues then adults should show an even higher dependence on gravitational (rather than retinal) 'upright' than 7-year-olds.

To test this prediction, stimuli like those in Figs. 11.2 and 11.6 were presented to adult subjects who were asked to rotate their heads by 90°. Instantly, all the objects which were 'top' *in relation to the retina* were seen as convex and the others were seen as cavities.

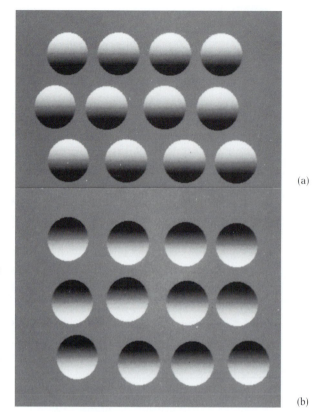

(a)

(b)

Fig. 11.4 The brain assumes that the light comes from above. The objects in group (a) therefore appear convex, whereas those in group (b) appear concave. If you turn the page upside down, the objects will reverse in depth. By turning your head upside down and looking at the page, you can prove that it is the orientation of the pattern on the retina that matters.

The effect was a striking one; even a head tilt of as little as 15–20° was sufficient to generate the unambiguous percept of eggs and cavities (Ramachandran 1988). When the head was tilted by 15° in the opposite direction the eggs and the cavities reversed depth instantly. When a slide of this display was shown to a lay audience of several thousand spectators (Ramachandran 1989) all of them, without exception, reported the perceptual switch by raising their hands. We may conclude from this that the interception of shape from shading depends primarily, if not exclusively, on retinal rather than gravitational cues. The implication is that shape from shading is probably extracted fairly early in visual processing, since it must occur before signals from the vestibular system about head tilt combine with actual signals about position.

One of the exciting things about studying perception is that one can begin with a set of almost 'axiomatic' first principles and arrive at interesting generalizations. One can demonstrate striking spatial interactions in the extraction of shape from shading by the visual system. These interactions bear a tantalizing resemblance to the classic 'centre–surround' effects that have been reported for other stimulus attributes such as luminance, colour (Land 1983), and

Fig. 11.5. (a) A random mixture of eggs and cavities. Notice that the depth effects are enhanced and also that you can mentally group and segregate all the eggs from all the cavities. The effect is reduced considerably if you rotate the page by 90°. If you turn the page upside-down, on the other hand, all the eggs become cavities and the cavities become eggs. Surprisingly, the grouping effect can be obtained even if different eggs and cavities are in different (random) stereoscopic planes, suggesting that it is based directly on shading rather than on depth that is conveyed by the shading. (b) Is a 'control' stimulus — identical to (a) in every respect except that we have a step-change in luminance instead of continuous gradients. No grouping is observed here, suggesting that the grouping seen in (a) must be due to differences in shading; not just differences in luminance polarity.

(a) (b)

motion (Nakayama and Loomis 1974), in which the characteristics of one region of the display can affect how a nearby region is perceived. They reveal, once again, the importance of the single light source constraint.

One question about the interpretation of shape from shading arises when the visual system receives conflicting information about light source location. The display in Fig. 11.7 was shown to an audience of 48 students, who were asked to examine the two panels ((a) and (b)) carefully and to compare the two central disks. Their task was to judge which of the two central figures ((a) and (b)) appeared more convex. The experiment was then repeated with the position of the two panels ((a) and (b)) interchanged.

The results were clear-cut; the central disk in panel (b) almost always appeared more convex than that in panel (a) (72 out of 96 trials). In fact many subjects spontaneously reported that the disk in panel (a) almost appeared flat.

These results suggest that the magnitude of depth perceived from shading is enhanced considerably if objects in the surround have the opposite polarity; a spatial contrast effect that is vaguely reminiscent of the centre–surround responses that have been reported to other stimulus dimensions such as motion and colour. Another way of saying this would be, that the perception of shape from shading is

Fig. 11.6. Is similar to Fig. 11.5 (a) except that we have left–right differences in shading instead of top–bottom differences. Grouping is difficult to obtain, suggesting, again, that the grouping observed in Fig. 11.5 (a) and (Fig. 11.6(b)) cannot be due to differences in luminance polarity.

(a) (b)

enhanced considerably if the information in the scene is compatible with a single light source. When the information from the majority of objects (for example, panel (a)) suggests that the light source is on the left (or right) the shading on the central object is perceived as a variation in reflectance rather than in depth.

Another example can be seen in Fig. 11.8. In this display subjects usually saw the central disk in panel (a) as being more convex than that in panel (b) (44 out of 48 trials). The reason for this, again, may be an interplay between three constraints or 'rules' — the rule that the light is probably shining from above, the rule that there is probably a single light source, and, finally, a tendency to assume that objects are usually convex. In panel (b) the objects in the surround are seen as unambiguously convex because of the built-in assumption that the light is shining from above. This, in turn, makes the central disk look relatively flat. In panel (a), on the other hand, there is no conflicting information, since all the disks can be assumed to be illuminated from the left. Consequently they are all seen as convex without violating the single light source assumption. The reason they are seen as convex rather than concave may be that there is also a tendency to assume that objects are more likely to be convex. This is not surprising, given the 'cohesiveness' of matter. Object boundaries and surfaces in the world are more often convex than concave.

Fig. 11.7. Demonstrates 'centre–surround' interactions in the perception of shape from shading. The central disk in panel (a) is usually seen as less convex than the one in panel (b). These effects are usually much more pronounced on the CRT than in the printed versions shown here.

(a) (b)

Fig. 11.8. The central disk in (a) is seen as more convex than the one in (b). The latter is usually seen as concave or flat.

(a) (b)

Fig. 11.9. (a) The central disk is usually seen as more convex in (b) than in (a).

(a) (b)

To demonstrate the 'convexity' assumption more clearly the display shown in Fig. 11.9 was devised. In this display the central disk in panel (b) is usually seen as more convex than the one in panel (a) (43 out of 48 responses), perhaps for the following reasons:

There are two conflicting cues in panel (b) — the top light source assumption, which would tend to make the disk look concave vs the convexity assumption, which tends to make them look like eggs.

(a) (b)

Fig. 11.10. (b) The central disk is usually seen as more convex in (a) than in (b).

Interestingly, the convexity assumption 'wins', and subjects usually report seeing 'eggs lit from below'. (Notice, however, that one doesn't have to violate the single-light-source rule to obtain this percept.) In panel (a), on the other hand, the discs in the surround are unambiguously convex, since they are assumed to be lit from above. This in turn forces the central disk to be seen as concave or relatively flat, since the system will accept only one light source. Clearly, the single light source rule is strong enough to override the convexity assumption in this situation.

The next demonstration (Fig. 11.10) reveals a new rule that is not evident in any of our earlier demonstrations. Most of the 24 naïve subjects reported that the central disk (a) was more convex than that in (b) (45 out of 48 trials).

Since both displays violate the single-light-source rule it is unclear why the central disk in (a) is seen as slightly more convex than that in (b). Perhaps this is an example of a 'depth contrast' effect that would be analogous to motion contrast (that is, induced motion) — although this is merely a description, not an explanation. Notice that the disks in the surround are obviously more convex in (b) than in (a). This might make the central disk appear less convex in (b) than in (a); a spatial 'depth contrast' effect that cannot be directly deduced from any of the earlier rules about light sources.

Does the assumption of convexity play a role in the perception of more complex 3-D objects? The fact that hollow masks can be perceptually reversed to resemble a normal (convex) face has been known for a long time, and has been pointed out by both Helmholtz (1963) and Gregory (1970). Not surprisingly such a reversal is easier to produce if the mask is illuminated from below and viewed with one eye shut to eliminate disparity cues.

What would happen if one were to illuminate the mask from above rather than from below? According to the assumption that the light source is at the top, the mask should look hollow and it should

be difficult to reverse it perceptually. The importance of this assumption is evident from Fig. 11.5 (2), in which there was a mixture of concave and convex objects. It is virtually impossible to produce a depth reversal in this figure, that is, one cannot 'imagine' that the light is shining from below in order to generate a reversal of depth. The convex and concave objects always retain their shapes, suggesting that the rule about illumination from the top is a very powerful one that cannot be overridden by imagery. Yet this principle appears not to be true for hollow masks (Fig. 11.11). When this mask was illuminated from above it did appear hollow initially, yet it was very easy to reverse it perceptually to produce a normal-looking face, and parts of the mask that were originally convex now looked concave. Why is 'imagery' effective in producing a reversal in Fig. 11.11 but not in Fig. 11.5(a)? Does this have something to do with the fact that faces are familiar objects? Oddly enough, when viewing the hollow mask, the face alone could sometimes be reversed, with portions of the beard continuing to look hollow for a short period before they finally 'caught up' with the rest of the face.

It is often assumed that effects such as these arise from our past experience of and familiarity with faces. However, similar depth reversals can even be obtained with complex 'nonsense' shapes such as abstract sculptures or convoluted lumps of clay that have several bumps and protrusions on them (Deutsch and Ramachandran 1990). If such objects are illuminated from below and photographed,

Fig. 11.11. This is the inside of a hollow Halloween mask of Santa Claus illuminated from above. Yet it looks like a normal face lit from below.

Fig. 11.12. Hollow-mask interiors lit from above produce an eerie impression of protruding faces lit from below. In interpreting shaded images the brain usually assumes light shining from above, but here it rejects the assumption in order to interpret the images as normal convex objects. Notice the two disks near the chin still appear as though lit from above; the right disk seems convex and the left one concave. When the disks are pasted on the cheek (left) their depth becomes ambiguous. When blended into the cheek (right) the disks are seen as being illuminated from below, like the rest of the face.

the pictures are usually seen as convex rather than concave. We may conclude, therefore, that the reluctance to see hollow objects derives from a general assumption that complex objects are usually convex rather than from specific 'top-down' influence from high-level semantic knowledge of faces (or other familiar objects).

Another example is shown in Fig. 11.12. These are actually photographs of two Halloween masks illuminated from above, so that they should really look hollow rather than convex. But, as in Fig. 11.11, the visual system regards hollow objects as a highly unlikely occurrence and prefers to interpret the image as convex objects lit from below. Notice the two small circular disks between the chins and the two faces. Interestingly, even though the light is now 'assumed' to come from below, the disk on the right is seen as convex and the one on the left as concave — as though they were both being lit from above. Even when the disks are directly pasted on the cheek (left mask) the one on the right is sometimes seen as a bump and the one on the left as a dimple. Perhaps the sharp outlines that delineate these from the face allow the visual system to segment them from the rest of the face, so that they are regarded as separate objects illuminated from a different direction. Indeed, when the disks are 'blended' into the face by blurring their outlines (right mask) the one on the right is almost always seen as a dimple and the one on the left as a tumour, as though they were illuminated from below like the rest of the face. Thus, the visual system will sometimes give

up its assumption of a single light source, but only if there are separate objects in the image. For different *parts* of a single object it is reluctant to accept more than one light source.

An experiment done in collaboration with Graeme Mitchison provides a striking demonstration of some of these ideas. A hollow Halloween mask of Richard Nixon was illuminated from above. Its video image on a television screen appeared like a normal (convex) face illuminated from below — as in Figs. 11.11 and 11.12. Two ping-pong balls were glued inside the eye-sockets and small black 'pupils' were painted on them, so that they resembled eyeballs. Even though the face looked convex — as though illuminated from below — the eyeballs also appeared convex, as though they were separately illuminated from above. This result is similar to that observed in Fig. 11.12 (left-hand panel) except that the disks are superimposed on the eye-sockets rather than on the cheek. The mask was then rotated around its vertical axis so that it made short arc-like excursions. On the video screen the face appeared perceptually reversed and therefore, appeared to rotate in a direction *opposite* to that of its actual rotation. The ping-pong balls, on the other hand, were not perceptually reversed and, consequently, they appeared to rotate in the direction corresponding to the true direction of rotation of the mask (and opposite to the direction of apparent rotation of the face). The net result was a striking and somewhat comical impression of the eyeballs rotating within their sockets — as though Nixon were alternately gazing leftward and rightward. Mitchison (personal communication) has noticed a similar effect using a mask of Margaret Thatcher.

The next study concerned the role of outlines and of gradient of luminance in the perception of shape from shading (Fig. 11.13). A spherical object such as a ping-pong ball, illuminated from one direction, say from the top, varies in luminance as a cosine function as one moves from the pole towards the equator.[2]

An illusory circle, generated with a technique described by Gaetano Kanizsa (1955), was superimposed on a one-dimensional luminance ramp. Initially this appears flat, but on longer inspection one perceives an illusory sphere, even though there is no luminance boundary at the edge of the sphere. So the mere presence of an illusory outline implied by occlusion is sufficient to define a boundary that the visual system can use for shape from shading. It turns out that such illusory edges are more effective in this situation than luminance edges (compare Fig. 11.14(b) with 11.14(a)), since the illusory sphere effect is stronger with the illusory edge. At first sight,

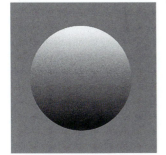

Fig. 11.13. A ping-pong ball illuminated from above. The luminance varies as a cosine function as one moves from the 'pole' to the equator.

[2] Dorothy Kleffner and I have begun to compare the appearance of cosine variations in luminance with (say) linear changes. The perceived shape does depend, to some extent, on the actual luminance profile.

Fig. 11.14. (a) An illusory
circle was superimposed on a
simple one-dimensional
luminance ramp. This creates
the impression of an illusory
sphere even though there is no
change in shading across the
border of the sphere
(Ramachandran 1988).
(b) If the illusory circle is
replaced by a 'real' circle, the
sphere is no longer seen. This is
because illusory contours are
more reliable indicators of true
object boundaries than 'real'
luminance-based edges.

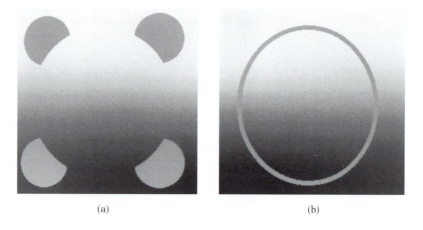

(a) (b)

it may seem paradoxical that an illusory edge defined by occlusion is
more 'real' to the visual system than a 'real' contour defined by
luminance. This may be because luminance edges can arise else-
where than at object boundaries, for example at the borders of
shadows or between the elements of a texture. However, an illusory
contour defined by occlusion must always occur at an object bound-
ary. In Fig. 11.15, for example, the luminance edges of the 100 stripes
on the zebra are not perceived as 100 objects, because the visual
system knows that luminance edges are a less reliable indicator of an
object boundary than an illusory edge defined by occlusion.

For real objects in the world different types of edge usually co-
incide — luminance edges, occlusion edges, texture borders. But one
can put them in conflict, as done by some artists, especially Magritte,
the great Belgian surrealist (Plate 14). This creates a very disturbing
visual effect, because you don't know whether the breast is really
made of wood or not. Similarly, in Plate 10. Everything appears to be
made of cork, but the luminance edges suggest that there is a table
there and this generates a visual paradox.

So the dissociation of normally correlated ways of signalling edges
can lead to some strange visual effects, in science as well as in art.

Another visual property which usually changes at edges, along
with luminance, texture, and so on, is colour. Can chromatic con-
tours provide the segmentation of the image needed for shape from
shading?

In Plate 15, colour changes smoothly within the circle, which is
set in a grey background. However, the luminance is the same any-
where in the display, though the circle is easily perceived because of
the colour difference. Interestingly, however, the circle doesn't look
like a sphere, unlike the display in Fig. 11.3, but rather like a grey
cylinder with a circle painted on it. There must be a mechanism
which can detect the circle, but that mechanism cannot be used by

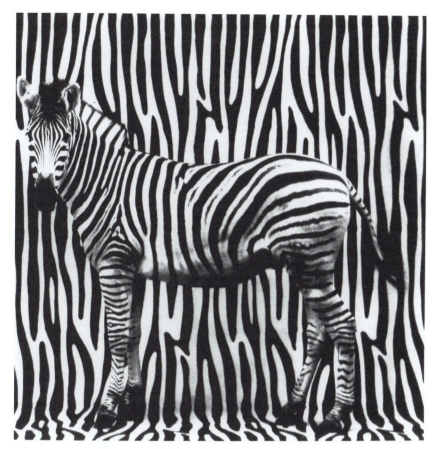

Fig. 11.15. This photograph illustrates that for extracting object boundaries the visual system relies on multiple mechanisms (for example, this case, illusory contours created by occlusion) rather than just luminance edges. If it relied exclusively on luminance edges, you would see a hundred objects here instead of one!

the shape-from-shading system. It is true that some impression of depth remains, but it is much reduced, suggesting that illusions like the sphere are handled by a phylogenetically primitive system, which processes luminance differences rather than colour differences.

Once shape from shading is extracted by the visual system, what can the brain do with this information? Some features in the environment, such as oriented lines, lead instantly to perceptual grouping: for example, one can usually group oblique lines and segregate them from vertical lines in other parts of a display. But one cannot segregate the mixture of smiling and frowning faces in an audience, even though perceptually smiles and frowns are just as salient as differences of orientation. It seems to me that it is not a coincidence that visual features which can be segregated are the very same features that the physiologists have discovered in the early stages of visual processing.

So it appears that one can use perceptual grouping and segregation as a criterion for deciding whether something is an early visual feature or not. Can this criterion be applied to shape from shading?

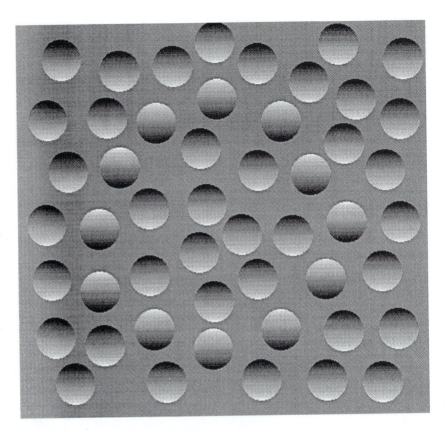

Fig. 11.16. Normally, this photograph should simply look like a random jumble of shaded circular disks. But if you rotate your head by 90° you will soon see a large 'circle' emerging from the background — a circle that is defined exclusively by shading. Would a shape-sensitive cell in visual areas IT or DL respond to shapes such as these that are defined by shape-from-shading?

The left-hand panel (a) of Fig. 11.5 shows a set of shaded objects. An earlier section suggested that the visual system assumes that there is only one light source which is illuminating the whole image: the single light source constraint. Also there appears to be a built-in assumption that the light is coming from above. This assumption is reasonable, since statistically the sun *is* usually shining from above. Figure 11.5(a) is a striking demonstration of this principle: it is a set of cavities and a set of eggs, 'sunny side up' (as the Americans say). One can clearly see the eggs, and, more interestingly, one can *group* and *segregate* the eggs from the cavities. Of course it is important to be sure that the grouping is due to the shape from shading and not just to the luminance polarity. An appropriate 'control' condition is shown in Fig. 11.5(b). Even though one can pick out individual display elements they do not group in panel (b), whereas in panel (a) grouping is immediate and compelling. This suggests that shape from shading can lead to perceptual segregation and grouping and therefore is perhaps an elementary feature of vision.

The segregation observed in Fig. 11.5(a) is clearly due to top-down differences of shading — some are cavities (sunny side down) and some eggs (sunny side up). Another way of showing that group-

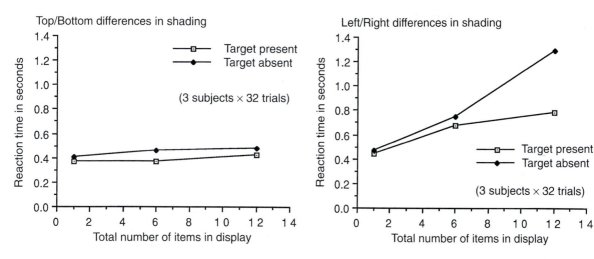

Fig. 11.17. Depicts reaction time for detecting a single egg against a background of distractors. Notice that the reaction time does not increase as you increase the number of distractors. Each datum point represents the mean of 96 trials (32 trials × 3 subjects). This experiment was done in collaboration with Dorothy Kleffner. Naïve subjects often show much longer reaction times.

Fig. 11.18. Visual search is effortful and laborious when left–right differences in shading are used instead of top–bottom differences. Notice that reaction time increases as you increase the number of distractors.

ing is not just due to luminance polarity, but rather to the depth seen from shading, is to demonstrate that left–right differences in shading do not produce grouping and segregation, whereas top–bottom differences do (Fig. 11.16). One sees no coherent structure in this figure, but rather a set of objects, but by rotating the head by 90° one can perceive a large circle slowly emerging. The assumption that the light is shining from above is in relation to the retina (not world-centred coordinates but retinal coordinates), suggesting again that it is an early visual rather than a cognitive process.

Figure 11.17 depicts the results of a more formal experiment which shows that the processing of pop-out or top–bottom differences in shading is parallel in a visual search task: that is, the time to detect that an array of 'cavities' contains an 'egg' (or not) is independent of the number of 'cavities', suggesting that all the items can be processed simultaneously. On the other hand, the processing is 'serial' if you use left–right differences in illumination (Fig. 11.18): that is, search time rises with the number of cavities. These results were obtained in experienced subjects who had considerable previous experience viewing eggs and cavities, but similar effects can also be seen in naïve subjects. We may conclude, therefore, that relatively complex 'scene-based' image characteristics — such as assumed location of light sources — can also influence perceptual grouping and visual search (Ramachandran 1988, 1990).

The conclusion that more complex 'whole image' characteristics can influence perceptual grouping also receives support from another recent experiment on motion perception. The stimuli were two sparse patterns ((a) and (b)) of small randomly arranged squares that were optically superimposed on each other and viewed monocularly. One of the patterns (a) was then arranged to approach the

observer by making the squares move radially outward from the centre, while, at the same time, (b) was made to shrink inward (that is, to 'recede' from the observer). The sizes of the squares were randomized and the whole display was viewed through a window, so that the outer margins of (a) and (b) were invisible. Subjects had no difficulty in segregating (a) from (b), so that what they perceived was a receding plane of little squares *through* a 'transparent' plane of approaching squares. Notice that in each plane ((a) or (b)) there were elements that were actually moving in *opposite* directions in the frontoparallel plane — corresponding to either expansion or contraction, yet the visual system had no difficulty in grouping these together. We suggest, therefore, that although *segregation* is usually based on local feature differences, grouping can take advantage of more 'global' rules that reflect higher-order invariances. Cells in extrastriate 'motion' areas of visual cortex which are sensitive to expansion or contraction may be involved in mediating these effects. Similar effects were observed when two superimposed random-dot patterns rotated in opposite directions (for example, clockwise versus counter-clockwise).

The last point in this chapter also concerns motion. Shape from shading can lead to perceptual grouping and segregation, an observation that already suggests that it occurs early in visual processing. Another surprising result is that shape from shading can provide an input to motion perception. This was demonstrated with a moving picture in which each frame was a little cluster of eggs in a background of cavities. In successive frames the cluster of eggs was displaced horizontally, though the exact positions of eggs and cavities were randomly chosen for each frame. This was done so that any perceived motion could not have been due to the visual system's matching identical patches of luminance in successive frames. Nevertheless, the film produced a vivid impression of horizontally moving eggs (Fig. 11.19). However, rotation of the head by exactly 90° markedly reduces the impression of motion. If the continuous luminance gradients forming the eggs are replaced by black/white edges (similar to those in Fig. 11.5(b)) in the film, then all one sees is random movements of the elements. Experiments are under way in collaboration with Tom Albright in which the responses of cells in the middle temporal area (MT) are recorded, to see whether they respond to motion of a bar defined by shape from shading rather than by luminance.

These findings raise an interesting question. Clearly the motion system, probably the long-range motion system (see Chapter 9 by Braddick) can use shape from shading as an input. Previous work has shown that it can use colour (Ramachandran and Gregory 1978) and also texture borders (Ramachandran *et al.* 1973). But if

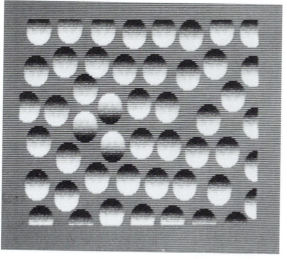
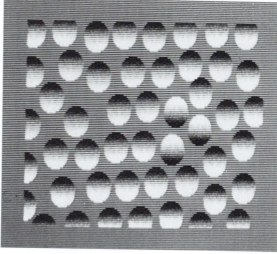

(a) (b)

Fig. 11.19. Two frames of a moving picture film. Frame (b) is shown next to frame (a) for clarity, but in the original experiment they were optically superimposed and flashed in succession. The positions of the objects are uncorrelated in the two frames, but the central cluster of eggs as a whole is displaced horizontally. Vivid apparent motion of the central cluster could be seen when the two frames were alternated.

an object moves in the real world there is ordinarily a luminance edge associated with it. So why bother using shape from shading, colour, texture, or stereo as an input? The answer probably is that by using multiple strategies each can be relatively crude and easy to implement in real neural hardware and noisy visual images of the kind encountered in the real world can be tolerated.

There is more to visual perception than this. Everything in this chapter so far deals only with the one aspect of vision called 'spatial vision' — a collection of processes whose goal is rapidly to compute a 3-D representation of the world that the organism can use for navigation and for manipulating objects. The more difficult problem of object recognition has not even been touched on — the visual system's ability to extract relationships between certain salient features of an object in order to determine what it is. And, as any artist will tell you, our visual system can do this with uncanny accuracy even when confronted with mere fragments (Fig. 11.20). Notice that it takes a long time — sometimes several minutes — to recognize these objects. But were the same pictures to be presented an hour or even a week from now you would see the objects instantly — a remarkable example of one-trial learning. Of course, we have no idea how this learning occurs or what parts of the brain are involved. When these pictures were shown to a patient with *anterograde amnesia* (Korsakoff's syndrome) surprisingly he showed no evidence of perceptual learning. His latency for recognizing them the first time was relatively normal, but there was no reduction in latency when he was shown the same pictures a second or even a third time! Medial temporal lobe structures are often damaged in Korsakoff's amnesia and these structures may also mediate the kind of one-trial

Fig. 11.20. Fragmented figures gleaned from various sources. Can you guess what they are? It may take you several minutes to recognize each object. But if you look at the same fragments again a week from now you will recognize the objects instantly. Would single cells in IT display this kind of one-trial learning? What about patients with anterograde amnesia? (See text.)

learning seen in Fig. 11.20. If so, one wonders whether a 'face detecting' cell (see Chapter 5 by Perrett *et al.*) in the temporal lobes would also display this kind of one-trial learning. Would the cell fail to respond to fragments initially, but do so once the face has been recognized by the monkey? Also, would such a cell respond even better to a caricature of a face — with grossly exaggerated features — than to the original face that it was 'trained' with? Trying to answer questions such as these will keep us busy for a long time to come.

Acknowledgements

I thank the Airforce Office of Scientific Research (grant no. 89-0414) for funding this research, and F. H. C. Crick, T. Sejnowski, H. Pashler, T. Albright, D. Rogers-Ramachandran, D. Plummer, and A. Yonas for stimulating discussions. The experiment with fragmented figures was done in collaboration with J. A. Deutsch.

References

Deutsch, J. A. and Ramachandran, V. S. (1990). Binoculas depth reversals despite familiarity cues: an artifact? *Science*, **249**, 565.

Gregory, R. L. (1970). *The intelligent eye*. Weidenfeld and Nicolson, London.

Helmholtz, H. (1963). *Handbook of physiological optics*. Dover Reprint, New York.

Kanizsa, G. (1955). Margini quasi-percettivi in campi con stimolazione omogenea. *Rivista di Psicologia*, **49**, 7–30.

Land, E. H. (1983). Recent advances in Retinex theory and some implications for cortical computations: color vision and the natural image. *Proceedings of the National Academy of Sciences, USA*, **80**, 5163–9.

Nakayama, K. and Loomis, J. M. (1974). Optical velocity patterns; velocity sensitive neuron and space perception: a hypothesis. *Perception*, **3**, 63–80.

Ramachandran, V. S. (1988). Perception of depth from shading. *Scientific American*, **269**, 76–83.

Ramachandran, V. S. (1989). Visual perception in people and machines. Presidential special lecture given at the annual meeting of the Society for Neuroscience, Phoenix, Arizona.

Ramachandran, V. S. (1990).Visual perception in people and machines. In *AI and the eye*. (ed. A. Blake and T. Troscianko). Wiley, Chichester.

Ramachandran, V. S. and Gregory, R. L. (1978). Does colour provide an input to human motion perception? *Nature*, **275**, 55–6.

Ramachandran, V. S., Rao, V. M. and Vidyasagar, R. R. (1973). Apparent motion with subjective contours. *Vision Research*, **13**, 1399–1401.

Yonas, A., Kuskowski, M. and Sternfels, S. (1979). The role of frames of reference in the development of responsiveness to shading. *Child Development*, **50**, 495–500.

12 Seeing colour

VINCENT WALSH AND JANUS KULIKOWSKI

Introduction

When looking at the colour of an object one is usually confident that the colour is, in some sense, a fixed property of the object being viewed. For example, grass is green, London buses are red, and daffodils are yellow. Following Newton's statement that 'Every Body reflects the rays of its own Colour more copiously than the rest ...' one might conclude that grass reflects more green light than light of other wavelengths, London buses reflect mostly red light, and daffodils reflect more yellow light than that of any other wavelengths. However, as was demonstrated by Land (1977) and is illustrated in Fig. 12.1, this notion does not explain why we see colour. Fig. 12.1 represents a multicoloured 'Mondrian' surface illuminated by three projectors. One of the projectors illuminates the Mondrian with long-wavelength (reddish) light, another with middle-wavelength (greenish) light, and the third with short-wavelength (bluish) light. Now if the intensities of the three projectors are changed, it is possible to make any surface in the Mondrian reflect the same physical quantities of long-, medium-, and short-wavelength light as any other surface in the array. When this is done the observer perceives that each patch maintains (more or less) its own colour: the red is still red, the violet still violet, etc. Similarly, at different times of day, when the wavelength content of daylight varies, familiar objects like grass, buses, and flowers may reflect varying amounts of different wavelengths. Again, the objects will be perceived to retain their 'correct' colours. It is this characteristic of colour vision — somehow ignoring changes in the illuminant — which is called **colour constancy**. More precisely, since surfaces maintain their quality of redness, blueness, greenness, etc. rather than an exact colour, under different illumination conditions, one should speak of **effective colour constancy**.

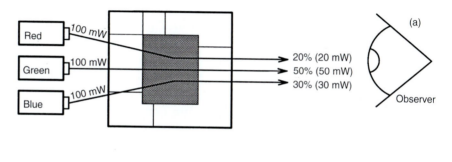

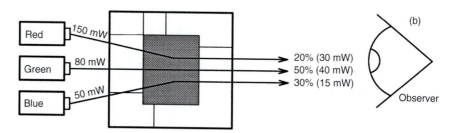

Fig. 12.1. Schematic diagram of a Mondrian display illuminated by three projectors. In (a) the shaded patch is illuminated by 100 mW each of long-wavelength (red) light, middle-wavelength (green) light, and short-wavelength (blue) light. The patch reflects 20 per cent of the long-wavelength light, 50 per cent of the middle-wavelength light, and 30 per cent of the short-wavelength light. In (b) the same display is illuminated with 150, 80, and 50 mW of long-, middle-, and short-wavelength light, respectively. The patch reflects the same percentages of each available illuminant (20, 50, and 30 per cent). Consequently the patch in (b) reflects more red, less green, and less blue than the patch in (a). To calculate colour constancy the visual system deals with the reflectance ratios that remain constant, rather than the total amount of light of a given wavelength, which fluctuates markedly. (After Zeki 1990.)

Why do we have colour constancy?

There are many types of perceptual constancies which must be explained as an attempt by the brain to extract permanence from an ever-changing world. For example, a football 1 metre away casts a retinal image ten times larger than that of the same football 10 metres away. Owing to the mechanism of **size constancy** the ball is not seen to increase in actual size and so can be caught. Similarly, the mechanisms underlying **shape constancy** mean that a piece of sculpture can be recognized as the same piece even when viewed from different angles, despite the fact that every new view presents the retina with a unique set of signals (Newell and Findlay 1992). Of course, size constancy did not evolve for catching footballs, nor shape constancy for art appreciation and colour constancy did not evolve to help commuters catch the right bus. Rather, these mechanisms are vital for the evolutionary success of many species, and the consequences of losing perceptual constancies are not difficult to imagine: an animal that did not have colour constancy would be unable to assess the ripeness of fruit at different times of day. It is not surprising, therefore, that colour constancy has been observed in other species, such as monkeys, goldfish, and bees (Ingle 1985; Wild *et al.* 1985; Werner *et al.* 1988; Walsh *et al.* 1993).

Theories of colour constancy

The attempts to understand colour constancy have emphasized different aspects of visual processing. Helmholtz (1924) suggested that the brain calculates how a coloured object would appear under 'normal' lighting conditions, and then makes corrections for differences in wavelength reflectancies caused by changes in illumination conditions, such that 'we learn to judge how such an object would look in white light, and since our interest lies entirely in the object colour, we become unconscious of the sensations on which the judgements rest'. It remains to be seen how the brain would determine what constitutes the 'normal' conditions against which new presentations are compared.

An alternative view suggested by Hering (1920, trans. 1964) attempts to explain colour constancy in terms of colour memory. In this scheme coloured objects would be seen under different illumination conditions and, eventually, 'the colour in which we have most consistently seen an external object is impressed indelibly on our memory and becomes a fixed property of the memory image'. Thus one remembers implicitly that grass is green, buses are red, and daffodils should be yellow. This theory cannot account for the fact that we can identify the colour of novel objects and that familiarity with objects does not improve our perception of their colour.

Hering also emphasized the importance of changes in pupil size and adaptation of the wavelength-sensitive cones. It is true that the photoreceptors adapt to changing illumination conditions and there is no doubt that this has a role to play in some aspects of constancy. However, adaptation is not sufficient as an explanation of constancy, since we can identify the colour of an object in a scene even when the scene is flashed on to a screen for a fraction of a second — too fast for retinal adaptation to compensate.

Recent attempts to understand colour constancy have been dominated by the **retinex** theory of colour vision developed by Edwin Land (the inventor of the Polaroid camera). According to Land, a coloured scene is analysed into three **lightness records** (Plate 16). These records give a measure of how much of the available red, green, and blue light a surface reflects and can be thought of as equivalent to viewing the scene through a monochromatic (single-coloured) filter. Thus, when a scene is viewed through, say, a red filter, one sees an array of reds ranging from very light to very dark (the lightest areas of a scene viewed through the red filter reflect a lot of long-wavelength light and the darker areas reflect little of the available long-wavelength light). The same is true of the green- and blue-filtered images and the information about particular colours is

obtained by comparing these lightnesses. The lightest part of the scene will be white, since white reflects more of any wavelength than coloured surfaces and the next lightest will be the most red, green, or blue depending on the lightness record in question. Zeki (1990) summarizes the importance of this process of comparing lightness levels as follows: 'Since colour depends on lightness and lightness depends on reflectance and since reflectance is independent of intensities, it follows that colour itself is independent of actual intensities reflected from single surfaces ...'; that is, regardless of how much red light (or green or blue) is contained in an illuminant the lightness values can always be compared and calculated to be in the same relation to each other.

The importance for colour vision of making such comparisons between areas can be illustrated by viewing coloured surfaces in isolation, or **void mode**, in which perception is governed only by the light reflected from the isolated patch. Adding a surround of as little as one-sixtieth of the area of the void patch will result in the **natural colour** of the patch being perceived. Thus, colour depends on the wavelengths reflected from the whole visual scene, not just the wavelengths reflected from a particular part of the scene. Indeed, some colours (known as dark or contrast colours) cannot be represented in void mode. Brown, for example, exists only when the wavelengths reflected from a yellow surface are darker than their surround; maroon and olive are other examples of this class of colours.

Is there a colour area in the brain?

Hubel and Livingstone's chapter outlines the functional segregation of the analysis of colour, motion, and shape in the visual system. If, as we have shown, colour perception is not determined by wavelength information alone, we can ask: where in the visual system do neurones begin to transform wavelength information into the colours we perceive? In other words, when does the brain cease to be Newtonian?

Consider the experiment shown in Fig. 12.1, in which the wavelengths reflected from a part of the Mondrian have little effect on the colours perceived. If this Mondrian display is presented to a macaque monkey while recording the activity of individual brain cells, the activity of cells in area V1 (see Fig. 12.3) may be described accurately as a function of the wavelength reflected 'more copiously than the rest'. That is, neurones in this visual area appear to respond to the wavelengths reflected from local regions of the display. However, in area V4, a cortical area which receives input from V1 and so handles later stages of perceptual processing, neurones behave as if they are respond-

ing to colours as seen by human observers. Several experiments (for example, Wild *et al.* 1985; Walsh *et al.* 1993) have shown that monkeys who have had visual area V4 removed have difficulty in identifying colours when the illumination conditions are changed, despite the fact that they are able to detect very small differences in wavelength. Even if only some of area V4 has been removed (Carden *et al.* 1992), the monkeys cannot carry out a colour constancy task — perhaps because they cannot make enough comparisons of lightness levels with the remaining V4 neurones. The neurones in areas V1 and V2, however, continue to respond to chromatic information (Kulikowski and Walsh 1993; Kulikowski *et al.* 1994) and it is this activity which accounts for the spared ability to discriminate simple differences in wavelength.

Further support for the idea that there is a region of the brain specialized for colour perception comes from positron emission tomography (PET) scanning experiments with human subjects and also a wealth of historical data which has been ignored for many years (see Zeki 1993).

It appears, then, that area V4 is necessary for normal colour constancy, but as the next two sections discuss, other visual areas make significant contributions to the analysis of chromatic information.

Categorizing, remembering, and imagining colours.

One of the major tasks of the brain is to organize the vast amounts of incoming sensory information into manageable units. For example, all possible taste sensations can be grouped into only five taste categories (sweet, sour, bitter, salt, and a category discovered more recently called umami — see Yamaguchi 1991); the range of detectable sound pressure levels are grouped into speech sounds and non-speech sounds and objects can be categorized as inanimate/ animate, indoor/outdoor, edible/inedible. The case of colour vision is similar. The number of colours that humans can discriminate runs to several thousand, yet the brain organizes the perception of these colours into as few as eight fundamental chromatic categories — red, green, blue, yellow, violet, orange, pink, and brown — and three achromatic categories — black, white, and grey. An identical system has been observed in chimpanzees and categorization schemes have been observed in macaque monkeys, tamarins, bees, goldfish, and pigeons (see Walsh *et al.* 1992, for a review and references). There are several important features about categorical colour perception that are informative about neural processes underlying colour vision.

Fig. 12.2. Categorical discrimination of colours at thresholds of detection. The figure shows the ability of subjects to distinguish between lights of different wavelengths when the lights themselves are just detectable. A score of 1 indicates that subjects can discriminate wavelengths as well as they can detect them. A score of 0 indicates that the discrimination of the two wavelengths in question is at chance. A score of 0.5 marks the transition from one colour category, as defined by naming, to another category. In each panel the square represents a fixed wavelength against which the others (circles) were compared. So, the subject at the left of panel (b) could discriminate 475 nm (square) from 410 nm (left-most circle). The subject shows a sharp decrease in her ability to discriminate at around 455 nm. She was unable to discriminate between any two wavelengths longer than 610 nm. Data are taken from subject K.T.M., after Mullen and Kulikowski (1990).

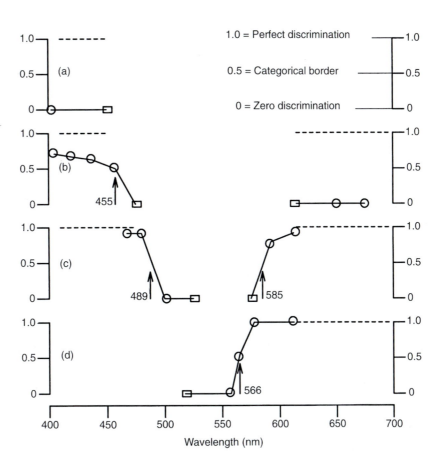

First, the ability to detect differences in wavelength information is much better at categorical borders than at the centre of categories. This is demonstrated in Fig. 12.2, which shows the sharp changes in discriminative ability that occur in four regions of the spectrum: in the transitions from yellow to red (575–595 nm), green to yellow (555–575 nm), green to blue (500–480 nm), and blue to violet (475–430 nm). Further details are given in Kulikowski and Walsh (1991).

The effects of categorization are different when colour naming and memory are considered. Following the work of Berlin and Kay (1969), who found that basic colour terms were universal, Boynton and his colleagues (for example Boynton and Olson 1990) have shown that colour naming is more reliable for the names pertaining to only the eight basic chromatic categories than for other colour names. People decide more quickly and more consistently agree on what is, say, red (a basic colour term) than on what is vermilion and more people agree on what is green or blue than on aquamarine or

jade. Colour memory is more accurate for colours that are good examples of their category. Thus highly saturated, bright reds are remembered better than orangey-reds and deep, bright blues are remembered more accurately than greeny-blues. Memories also converge on to the centres of colour categories when we attempt to recall the colours of common objects — buses are remembered as redder than they really are, grass as greener, ... and the bloom of youth as more pink than it really was? (Bartleson 1960).

Mental images also seem to be influenced by colour categorization. In an informal experiment we asked subjects to imagine a simple scene — a man wearing a blue shirt, opening a red door, for example. We then asked the subjects to select the imagined colour of the shirt and the door from a set of Munsell colour standards. Subjects showed a strong tendency to select **centroid colours**. Analogous results have been found in object imagery. When asked to generate a mental image of a familiar item, people tend to report that the image is of a typical or **canonical view**, which usually means a three-quarter view of the object rather than a head-on or a profile view.

Categories and constancies

Where in the visual system are colour categories constructed? Figure 12.3 shows a representation of the side view of the brain of the macaque monkey. The brain of the macaque has many of the features of the human brain and macaques have colour vision almost identical with normal human colour vision. Until recently it was believed that area IT was the site at which colours were categorized, but our experiments (Walsh *et al.* 1992) have shown that removal of area V4, which provides the largest anatomical input and so is the major source of information to IT (Model and Bullier 1990), does not affect categorical colour perception. Logically, therefore, the organization of the fundamental perceptual categories must occur at a stage of processing earlier than V4 or IT. On the basis of electrophysiological recordings we have argued (Kulikowski and Walsh 1993) that the colour categories are generated in areas V1 and V2. Support for this comes from Yoshioka *et al.* (1988; T. Yoshioka personal communication), who have discovered cells in visual cortical areas V1 and V2 that are responsive not only to the five basic hues, but also to pink, orange, and dark colours such as brown, maroon, and olive. This work is strong evidence that perceptual categorization is accomplished before the information reaches V4 or IT.

The main implication of these new findings is that one would

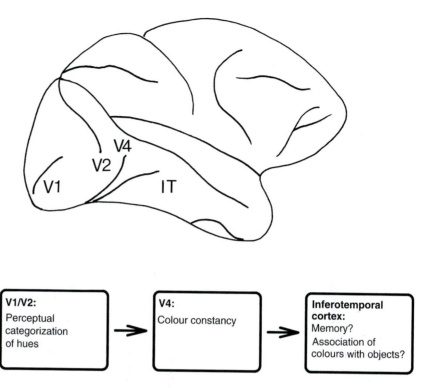

Fig. 12.3. Lateral view of macaque brain showing the main areas of the cortex involved in analysing colour. The boxes below show the direction of the anatomical connections and stages of processing discussed in the text. Areas V1 and V2 are the first cortical areas to receive information about chromatic stimuli. These areas construct the major perceptual colour categories. The next link in the chain is cortical area V4, the best candidate for the site of colour constancy. Area V4 sends projections to the inferotemporal cortex. The role of this region is unclear, but it may be involved in some aspects of colour memory and/or the association of objects with colours.

expect colour constancy, like colour discrimination, naming, memory, and imagery, to be organized categorically. To return to the demonstration in Fig. 12.1 and the notion of approximate colour constancy: it is true that reds remain red, blues blue, etc., in different lighting conditions, but it is also true that there is a slight perceived change in the colour and the overriding impression is that a colour retains its membership of a colour category. From the new evidence that colour categorization precedes colour constancy we can predict that colour constancy, like memory and imagery, will be better for centroid colours than for border colours. Experiments to test this prediction have not been performed, but evidence is beginning to emerge that colour categorization is a useful concept to employ in the study of colour constancy (Troost and de Weert 1991).

The sequence of categorization followed by constancy is also observed in the way we see objects. For example, if one is shown a picture of a thrush, it will be recognized as a member of the category 'bird' before being identified as a specific member of that category. Of course there are exceptions to this rule; an ostrich would be identified as an ostrich before it is called a bird; so too would a penguin. But ostriches and penguins are atypical examples of the 'bird' category, and it is difficult to think of similar anomalies in the colour domain.

Conclusions

We have seen that colour perception cannot be explained entirely by the physics of colour, nor by adaptation, nor in terms of memory. We have also shown that information about colours is analysed in many different areas of the brain rather than in just one central colour area. The main organizing principle of colour vision is the way in which physical stimuli — lights of different wavelengths — are arranged into a small number of broad stimulus categories. These categories determine the way we discriminate, recognize, identify, remember, and even imagine colours. The phenomenon of colour constancy depends, to some extent, on the way we categorize colours and it is one of the outstanding problems in colour vision to understand how these categories are recovered and maintained from the changing wavelength information contained in a coloured surface.

References

Bartleson, C. J. (1960). Memory colours of familiar objects. *Journal of the Optical Society of America*, **50**, 73–7.

Berlin, B. and Kay, P. (1969). *Basic colour terms: their universality and evolution*. University of California Press, Berkeley.

Boynton, R. M. and Olson, C. X. (1990). Salience of chromatic basic colour terms confirmed by three measures. *Vision Research*, **30**, 1311–17.

Carden, D., Hilken, H., Butler, S. R., and Kulikowski, J. J. (1992). Lesions of primate visual area V4 produce long-lasting deficits of colour constancy. *Irish Journal of Psychology*, **13**, 455–72.

Helmholtz, H. von (1924). *Treatise on physiological optics*, (translated by J. P. C. Southall). Dover Publications. New York.

Hering, E. (1920). *Outlines of a theory of the light sense*, (trans. L. M. Hurvich, and D. Jameson, (1964). Harvard University Press, Cambridge, Mass.

Ingle, D. (1985). The goldfish as a retinex animal. *Science*, **227**, 651–4.

Kulikowski, J. J. (1992). Contrast and contrast constancy: sustained and transient components. *Irish Journal of Psychology*, **13**, 473–93.

Kulikowski, J. J. and Walsh, V. (1991). On the limits of colour detection and discrimination. In *Limits of vision*, Vision and visual dysfunction, Vol. 5, (ed. J. J. Kulikowski, V. Walsh, and I. J. Murray), pp. 202–20. Macmillan Press, London.

Kulikowski, J. J. and Walsh, V. (1993). Colour vision: isolating mechanisms in overlapping streams. *Progress in Brain Research*, **95**, 417–26.

Kulikowski, J. J., Walsh, V., McKeefry, D. M., Butler, S. R., and Carden, D. (1994). The electrophysiological basis of colour processing in macaques with V4 lesions. *Behavioural Brain Research*, **60**, 73–8.

Land, E. H. (1977). The retinex theory of color vision. *Scientific American*, **237**, 108–28.

Morel, A. and Bullier, J. (1990). Anatomical segregation of two cortical visual pathways in the macaque monkey. *Visual Neuroscience*, **4**, 555–78.

Mullen, K. T. and Kuliskowski, J. J. (1990). Wavelength discrimination at detection threshold. *Journal of the Optical Society of America*, **A7**, 733–42.

Newell, F. and Findlay, J. M. (1992). Viewpoint invariance in object recognition. *Irish Journal of Psychology*, **13**, 494–507.

Troost J. M. and de Weert, C. M. M. (1991). Naming versus matching in color constancy. *Perception and Psychophysics*, **50**, 591–602.

Walsh, V., Kulikowski, J. J., Butler, S. R., and Carden, D. (1992). The effects of V4 lesions on the visual abilities of macaques: colour categorization. *Behavioural Brain Research*, **52**, 81–9.

Walsh, V., Butler, S. R., Carden, D., and Kulikowski, J. J. (1993). The effects of V4 lesions on the visual abilities of macaques: hue discrimination and colour constancy. *Behavioural Brain Research*, **53**, 51–62.

Werner, A., Menzel, R., and Wehrhahn, C. (1988). Color constancy in the honeybee. *Journal of Neuroscience*, **8**, 156–9.

Wild, H. M., Butler, S. R., Carden, D., and Kulikowski, J. J. (1985). Primate cortical area V4 important for colour constancy but not wavelength discrimination. *Nature*, **313**, 133–5.

Yamaguchi, S. (1991). Basic properties of umami and effects on human. *Physiology and Behaviour*, **49**, 833–41.

Yoshioka, T., Dow, B. M., and Vautin, R. G. (1988). Close correlation of color, orientation and luminance processing in V1, V2 and V4 of the behaving macaque monkey. *Society for Neuroscience, Abstracts*, **14**, 457. (Abstract 187.3)

Zeki, S. M. (1990). *Colour vision and functional specialization in the visual cortex*, Discussions in Neuroscience, Vol. 6. Elsevier, Amsterdam.

Zeki, S. (1993). *A vision of the brain*. Blackwell Scientific Publications, Oxford.

Glossary terms

Canonical view: The best or most typical view of an object. This is often a three-quarters view (cf. **centroid colours**).

Centroid colours: Also called focal colours. These are colours which are considered to be the best or most typical example of a particular colour category, for example the reddest red, the greenest green (cf. **canonical view**).

Colour constancy: The ability to see an object or surface as having the same colour when the object reflects different ratios of wavelengths under different illumination conditions. Because colour constancy is an approximate, rather than precise function, a better term is **effective colour constancy**.

Lightness: In the **retinex** theory of colour constancy lightness correlates with the amount of a given wavelength reflected from a surface relative to the amounts of that wavelength reflected from other surfaces.

Natural colour: The colour of a surface when it is perceived in the context of other coloured surfaces, i.e. when not viewed in **void mode**.

PET: Positron Emission Tomography. A method for measuring metabolic rate in the brain. Patients are given a radiolabelled metabolic marker, and the density of the marker in different brain regions gives a measure of activity. When used in conjunction with specific tasks, for example looking at coloured displays, black-and-white displays, or moving displays, the technique can be used to locate the brain areas involved in processing certain types of information.

Retinex: A theory of colour constancy based on the comparison of the **lightness** readings of surfaces.

Size constancy: The ability to perceive the size of objects despite changes in viewing distance and retinal image size.

Void mode: A way of looking at a coloured surface through an aperture, such that everything but a small portion of the surface is excluded from the field of view.

Acknowledgements

This work was partly supported by Wellcome Trust, Nuffield Foundation and Academic Development Resource Committee (UMIST).

PART IV: *Physic*

introduced by J O H N H A R R I S

Introduction to Part IV: Physic

JOHN HARRIS

The power of drugs to change visual perception is enshrined in our culture as the double vision of the drunkard and the pink elephants of *delirium tremens*. More selective drugs than alcohol have by turns inspired the mystical, as in Aldous Huxley's *Doors of perception*, and terrified the respectable. Drugs must act by interfering with the complex electrochemical machinery of the brain. Psychotropic chemicals give a rich range of phenomena to be explained, and a new set of instruments with which to dissect the brain mechanisms which produce them.

Janus Kulikowski and Ian Murray in 'Chemical dreams' explore the idea that drugs may affect perception through their different effects on the main visual processing streams (which originate in the magno- and parvocellular pathways of the retina and lateral geniculate nucleus), first by identifying visual stimuli which selectively stimulate these pathways and then by showing that particular drugs, given systemically, can change the electrical responses of the visual system to these stimuli. These responses can be the records of the isolated activity of single nerve cells, or of the simultaneous, cumulative, activity of large numbers of nerve cells. Both kinds of evidence support the idea that some drugs produce their dramatic effects on human perception by disturbing the normal cooperative activity between different visual processing streams,

Adam Sillito in 'Chemical soup' looks at the fine chemical details of the transmission of visual information from a fibre in the optic nerve to a cell in the lateral geniculate nucleus. It turns out that only approximately 20 per cent of the inputs to the LGN come from the retina. Approximately 60 per cent come from fibres descending from the cortex (to which the LGN transmits visual information), and the remainder from centres in the brainstem believed to be involved in the control of attention and arousal. Sillito dissects out the role of various chemical messengers and their receptors in the complex information transfer at this single visual nerve cell junction. He shows that while some chemicals appear to have straightforward

functions of information transmission, others modulate or regulate transmission in more complicated ways. In the visual cortex, the inhibitory transmitter GABA (gamma-aminobutyric acid) appears to be involved in the precision with which neurones respond to features of the retinal image: for example, their preference for particular directions of motion or orientations of edges. Interference with the activity of GABA can reduce or abolish these preferences.

Chemicals which affect natural neurotransmitters at any level of the visual system can change visual perception. These chapters report progress in unravelling the complicated chemical interactions which underlie vision, and relating them to normal and drug-disordered visual experience.

13 Chemical dreams

JANUS KULIKOWSKI AND IAN MURRAY

Introduction

Artists throughout the ages have often been inspired by the visions
induced by hallucinogenic drugs or by psychiatric conditions that in
turn may reflect disturbances in the chemistry of the brain. Styles of
artists as diverse as those of van Gogh, Modigliani, Munch, the sur-
realists, and modern op, pop, and psychedelia show evidence of
chemical dreams (Critchley 1987; Arnold 1992). One painter
(Witkacy) specified the amount and kind of alcohol and drugs that
he ingested when painting.

Yet attempts to explain the neurophysiological bases of hallucina-
tions have so far proved unsuccessful. Most hallucinogenic drugs
have widespread actions in the brain and it is difficult to pinpoint the
crucial locus at which visual distortions occur. For example, LSD
merely either attenuates or augments the responses of cells in the
visual pathways, without major effect on their response properties,
(see for example, Rose and Horn 1977).

Recent decades have continued to bring disturbing reports of the
abuse of hallucinogenic drugs. One example, Angel Dust, is related to
the veterinary anaesthetic, ketamine. In this chapter we describe
some work with monkeys which allows us to interpret the hallucino-
genic percepts associated with ketamine and its derivatives and sug-
gests a general explanation for visual hallucinations and illusions.

The most extensive description of the experimentally induced
effects of ketamine was given by Gregory (1986). The subject,
Richard Gregory himself, was conscious during the experiment and
was able to report his observations and respond to various stimuli.
The most affected aspect of vision was image stability. According to
Gregory at 3 min after infusion of the drug '... when I moved my
eyes the wall appeared to move with them, especially at the begin-
ning of the eye movements' and 'the entire world jazzed about most
disconcertingly'. Colour vision and visual acuity (vision of fine detail)
did not seem to be disturbed. Patients having larger, anaesthetic,

doses of ketamine report such illusory effects as changes in colour percepts, instability of vision, and wooden-like faces (Corsen and Domino 1966; Knox *et al.* 1970). Gregory had a sub-anaesthetic dose and it is therefore possible that he was not subject to the full force of the hallucinogenic effects of the drug experienced by patients.

In our experiments full anaesthetic doses of ketamine were administered to reveal the possible neurophysiological basis of its effect.

Dual pathways in vision

In neurophysiological terms the evoked activity of cells of any sensory modality can be described as transient and/or sustained. A transient response is a brief, vigorous, burst of neuronal impulses occurring when a stimulus is turned on or off or is simply changing in any way. Cells with such properties respond to rapid alterations in the environment, for example a flickering light. A sustained response, on the other hand, persists for as long as the stimulus is present and can signal the presence of stable objects and colours in the environment.

This division of labour into transient versus sustained cells has been extensively investigated in the primate visual system (Gouras 1968; Kaplan and Shapley 1982; Livingstone and Hubel 1984, 1987; Tootell *et al.* 1988; Lee *et al.* 1989; Kulikowski 1991). There are two main types of neurones, which approximately fit this division, called magno- and parvocellular, after the layers in the lateral geniculate nucleus (LGN) to which the retinal cells project. The LGN is the main relay station between the retina and the visual cortex (see Chapter 2 in this volume). Many studies have demonstrated that, very broadly speaking, non-coloured (achromatic), coarse grating patterns (low spatial frequencies) can be detected with high sensitivity by magno cells; whilst coloured, coarse patterns (for example blurred red and green stripes) are best detected with the parvo cells. However, such selective activation occurs only at low contrasts (Tootell *et al.* 1988). Less coarse patterns (medium spatial frequencies) at contrasts higher than threshold, whether chromatic or achromatic, activate both magno and parvo cells.

Thus only at *low* spatial frequencies and *low* contrasts is the division of labour clear-cut: magno cells respond transiently to achromatic, dark-and-light patterns (but little or not at all to coloured patterns), whereas parvo cells with sustained responses are activated only by chromatic stimuli.

In the visual cortex, it is evident that substantial reorganization of

signal processing occurs (Ts'o and Gilbert 1988). Colour-specific cells do not respond to fine detail (Kulikowski and Vidyasagar 1986) or to fast motion or fast flicker. So, for example, fine chromatic striped patterns of red and green bars fail to activate colour-sensitive neurones in visual cortex unless the bars are at least three times wider than the finest bars that achromatic cells can resolve (Kulikowski 1991). For non-coloured patterns there is a much less clear-cut division of cellular specialization: achromatic cells respond to a broad range of spatial and temporal frequencies. Individual cells are specialized in either fine, medium, or coarse patterns and fast- or slow-moving stimuli. In one extreme group there are cells which respond best to coarse, fast-moving patterns and which have predominantly transient properties; they are virtually insensitive to stationary stimuli. In the other extreme group, cells respond to finer, slow-moving pattern and have sustained properties (Kulikowski and Walsh 1993).

As a general rule, achromatic coarse gratings of low contrasts are detected by cortical cells whose response properties are transient, whereas fine gratings are detected by sustained cells. At high contrast, other neurones of lower sensitivity are also activated. In both the colour and non-coloured domains, the final percept results from the balance of these group activities, as is evident from the data on multiunit recordings and visually evoked electrical potentials (Kulikowski 1991). This system of cells is capable of signalling both the shapes and the mobility of objects, thus reconstructing the visual scene.

Several visual illusions have been reported when this balance is upset (Kulikowski and Tolhurst 1973; Kulikowski 1992). Most importantly, low-contrast blurred stationary stripes are not seen unless the subject's eyes move or the stripes are abruptly presented on and off; in the latter case, however, the stationary stripes seem to move — an observation which somewhat resembles Gregory's experience under ketamine.

Hypothesis of drug-induced hallucinations

It seems likely that under normal conditions, when observers view a scene with various contrasts, colours, and spatial details, both the sustained and the transient systems are activated; then stable visual perception depends on the *relative balance* between the two systems. *If anaesthesia selectively affects neural mechanisms which process information about stationary patterns and colours in our environment, then the resulting imbalance may form the physiological basis for certain types of perceptual distortions, illusions, and, possibly, hallucinations.*

Many different anaesthetic compounds are used in veterinary practice as well as in electrophysiological experiments on the visual systems of animals (which for the reasons discussed below are not recommended in human patients). There are accounts indicating that sustained mechanisms are particularly susceptible to some of them (Ikeda *et al.* 1989). The anaesthetic ketamine and the compound MK801 (a prospective anti-epileptic drug), are both likely to have this property of inhibiting sustained mechanisms. Thus both are antagonists of NMDA, a substance that maintains neuronal excitation, which is particularly important in sustained responses (see the discussion below, and Chapter 14 by Sillito in this volume).

Methods

To investigate the basis of the perceptual effects of ketamine and MK801, a visual evoked potential (VEP) technique has been used on rhesus monkeys. VEPs are the electrical potentials generated within the brain by visual stimuli and detectable at the surface of the scalp through electrodes stuck to the skin. VEPs are advantageous in that they can be measured non-invasively — that is, without penetrating the skin and thus without anaesthesia — and give an overall indication of drug effects on the whole visual system. The same technique can be used to monitor drug effects in human patients (Parry *et al.* 1988, 1989). Moreover, by choosing appropriate stimuli, which physiological experiments suggest can strongly activate either sustained or transient mechanisms, we can investigate those mechanisms' characteristics separately (Kulikowski *et al.* 1989*b*). As outlined above, the mechanisms processing information about colour cannot resolve fine detail (see also Mullen 1985) or fast motion, so a chromatic red–green pattern composed of broad stripes is the most appropriate stimulus. A similarly coarse grating but without any colour variations (that is, monochromatic — which will be referred to as an achromatic grating) is most appropriate to reveal purely transient responses (Kulikowski and Tolhurst 1973).

For comparison, in other experiments we recorded three types of neuronal responses simultaneously: single units (the activity of individual nerve cells), multi units (the activity of groups of cells), and slow field potentials (electrical potentials oscillating between 1 and 30 Hz within the cortex, which reflect the summed activity of very large numbers of neurones). Full details are given in Kulikowski and Walsh (1993) and in Kulikowski *et al.* (1989*a*, pp. 85–100 and 586–90). This link between the different ranges of electrophysiological measurements is important, because single units represent the basic building-blocks on which the origins of perception are built.

Results

It turns out that when cells of a given processing stream (for example, magno or parvo) are anatomically grouped and operate in concert, their collective response characteristics are similar to the corresponding single-unit characteristics. Examples of VEPs are shown in Fig. 13.1. It is evident that either ketamine or MK801 administration reduces chromatic VEPs more than achromatic VEPs. The same effect can be seen while recording single or multi units (see Kulikowski and Walsh 1993).

Is it sustained or chromatic responses that are selectively attenuated?

For simplicity we have used coarse chromatic and achromatic gratings to monitor the effects of ketamine. However, in other experiments we have shown that ketamine attenuates the VEP generated by fine achromatic gratings (Kulikowski and Murray 1988). Since fine-pattern analysis relies on sustained responses (Kulikowski and

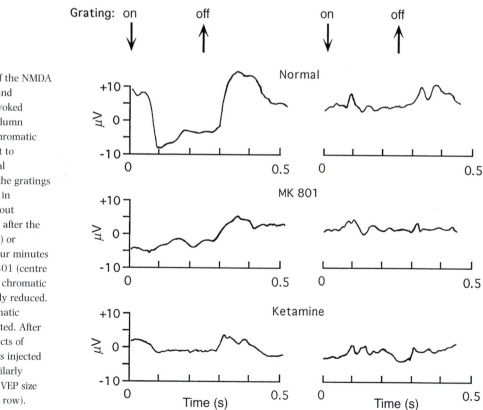

Fig. 13.1. Effects of the NMDA antagonists MK801 and ketamine on visual evoked potentials. The left column shows responses to chromatic gratings and the right to achromatic. In normal conditions (top row) the gratings evoked clear changes in electrical potential about one-tenth of a second after the grating appeared (ON) or disappeared (OFF). Four minutes after injection of MK801 (centre row) the responses to chromatic stimuli were drastically reduced, while those to achromatic stimuli were less affected. After recovery from the effects of MK801, ketamine was injected and 4 min later a similarly selective reduction in VEP size was obtained (bottom row).

Tolhurst 1973) the activity of ketamine is not confined to chromatic channels, but will suppress any processes which rely on the activity of sustained neurones.

It should be recognized that this selectivity holds only for small/moderate doses. Larger doses abolish both achromatic and chromatic VEPs.

Benzodiazepines and other drugs

It should be mentioned that MK801 was originally expected to be an anti-epileptic drug, reducing the maintained activity which causes epileptic fits. Several compounds have been developed in the pursuit of anti-epileptic drugs. By reducing sustained excitation, these drugs do certainly have an anti-epileptic action.

Benzodiazepines are drugs widely used as anticonvulsants, sleeping pills, and anxiolytics. These drugs broadly speaking potentiate the action of the inhibitory transmitter gamma-aminobutyric acid (GABA; see Chapter 14 by Sillito). At first sight an action which augments inhibition seems equivalent to one which inhibits excitation. However, the important difference is that inhibition is less selective than excitation. Consequently, we may expect less selective effects from benzodiazephines than those from NMDA antagonists.

Our human experiments with benzodiazepines (Parry *et al.* 1988) and control experiments on monkeys using both benzodiazepines and the new compounds, beta-carbolines (which also interact with the sites of action of benzodiazepines — experiments of Kulikowski and Kranda), revealed only a slight preference in the attenuation of chromatic versus achromatic VEPs. In other words, the effects were much less selective than with ketamine. Consistent with this, observations by human observers indicate that benzodiazepines do not elicit any hallucinations or distortions; nor do barbiturates, which also augment GABA inhibition (J. Kulikowski, personal observations).

Under a mild anaesthetic, nitrous oxide (also known as laughing gas), some attenuation of the VEPs elicited by the sudden appearance of a grating was also noticed, mainly related to the sustained component. Human observers reported that vision became more transient and eye movements were needed to prevent image fading (Kulikowski and Leisman 1973); however, the effects were weaker than under ketamine (Gregory 1986).

These observations are thus consistent with the hypothesis that drug-induced hallucinations arise from an imbalance between sustained and transient channel activity.

Discussion

Possible sites and action of NMDA antagonists

There are several identifiable receptors of excitatory amino acids, examples of which are quisqualate, kainate, and N-methyl D-aspartate (NMDA): see Chapter 14 by Sillito in this volume. NMDA receptors appear to maintain, rather than initiate, the excitation of neurones. Our results, which indicate that the drugs described as NMDA antagonists preferentially reduce sustained responses in the striate cortex, are generally consistent with the background neurophysiology. However, our data show greater selectivity than those obtained when drugs are applied directly to cells (see Chapter 14 by Sillito), presumably because our experiments compare the simultaneous activity of two neuronal populations, rather than responses of individual neurones examined successively. A major caveat is, however, that the site of ketamine action is uncertain. The use of intravenous administration in our experiments means that retinal and LGN neurones could also be affected. In monkey LGN, Schiller (1984) reported that both parvo- and magnocellular cells were susceptible to the drug, the preferential attenuation being evident only for ON-centre cells and possibly for sustained responses.

General perceptual implications of imbalance between channels

The presence of parallel processing mechanisms in the visual pathway implies that the final percept depends on integrated inputs from several channels (Zeki and Shipp 1988; Zeki 1993). *If some channels are preferentially attenuated this may give rise to misleading or contradictory signals and subsequently to illusions or hallucinations.*

One strategy to investigate the visual system is to use selective *adaptation*. This purely psychophysical technique may be regarded as a means of temporary disconnection of one among several parallel channels. Moreover, each parallel channel has several processing stages, from the retinal photoreceptors to the visual cortex. It is assumed that the adaptation site determines the kind of illusion: the higher the site of disconnection the more complex are the associated perceptual distortions, as the following examples illustrate.

Imbalance of retinal origin

Chromatic adaptation may be used to desensitize two of the three cone types in order to reveal the characteristic of the remaining type. For example, looking at an intense yellow light for several seconds

renders the visual system less sensitive to red or green. In addition, the immediately obtained percept is distorted. Thus adaptation to yellow gives the world a bluish tint. Another case of induced imbalance occurs when blue cones are damaged (because of over-exposure to light). Immediately afterwards observers report seeing white as yellow.

Parvocellular neurones in the LGN and their retinal equivalents are colour opponent; that is, they respond most strongly when their receptive field centres are illuminated with, say, red light and the surrounds with green. These cells are particularly prone to damage from neurological disease or injury. Patients with optic atrophy gradually lose optic nerve cells subserving colour vision. They describe their vision as 'not colourful' (desaturated), but do not experience obvious visual distortions, presumably because the atrophy is relatively slow and some 'compensation' may occur. However, careful examination of their perception reveals conditions which cannot be compensated: for example, apart from colour deficiencies these patients tend to experience perceptual fading (the gradual disappearance of boundaries during steady fixation), which is a characteristic of transient vision. Another consequence of such transient, short-persistence vision is that such patients do not see after-images, which a normal observer sees after looking at a strong source of light.

Imbalance between channels signalling stationary objects and motion under ketamine

It seems that visual information about stationary objects is prone to distortion. One effect of intoxication is on our sense of balance: we are more likely to become disoriented when drunk. One explanation for this is that the organs concerned with balance are affected directly. Here, we suggest another possibility: disorientation may arise through purely visual changes. It is the sustained neurones, which signal the presence of stationary objects to the brain, that are most susceptible to drug effects or damage. If these are impaired, the balance between their activity and that of transient neurones signalling motion changes, so that the world is more likely to be seen (wrongly) as moving, and, hence, the drug-affected person becomes disorientated. This hypothetical imbalance is strongly supported by our experiments with ketamine.

Whatever the specific mechanisms and their sites, substantial changes occur in sustained responses as a result of ketamine absorption. In the context of the present experiments this means that the chromatic channel is affected, but in general sustained channels which subserve fine pattern and slow-movement detection can also

be suppressed. Gregory (1986) vividly described the instability of the visual world induced by ketamine (the scene appearing to move with the eyes and its disconcerting 'jazzing about' — see the Introduction to the chapter). Our experimental work suggests that this instability arises because the drug (together with related compounds) suppresses the sustained activity of the visual nerve cells which signal that objects are stationary. It is interesting to contrast these perceptual effects resulting from selective suppression of excitation of one system with the generally attenuating effects of drugs that augment inhibition.

Though the subject is beyond the scope of this chapter, it is possible that an account of the perceptual effects of other drugs could be couched in related terms.

Conclusions

The present results allow us to hypothesize that at least two effects contribute to hallucinations:

1. Specific imbalance in the relative activity levels of the parallel channels or sub-systems, especially of the sustained versus transient channels, leads to unstable perceptual distortions. This can occur even with very small doses of NMDA antagonists (see also Gregory 1986).

2. In addition to producing distorted input to the higher visual mechanisms which interpret images, ketamine might affect those higher centres directly. It might also influence those higher centres indirectly, by acting first on the brain's general arousal or attention systems that provide input to those higher visual centres.

Acknowledgements

We thank Dr N. R. A. Parry for developing the software for stimulus generation, David Carden and John Simpson for designing the hardware, and Robert Morrisey and Keith Street for assistance. Some of the experiments reported were conducted with Dr T. R. Vidyasagar and Dr K. Kranda (with benzodiazepines and beta-carbolines). The compounds were supplied by Schering AG (Berlin) and Merck, Sharp, & Dohme Research Laboratory (MK801) and partly from a Wellcome Trust grant.

References

Arnold, W. N. (1992). *Vincent van Gogh: chemicals, crises, and creativity*. Birkhäuser, Boston, Mass.

Corsen, G. and Domino, E. F. (1966). Dissociative anesthesia: further pharmacologic studies. *Anesthesia and Analgesia*, **45**, 29–39.

Critchley, E. M. R. (1987). *Hallucinations and their impact on art*. Carnegie Press, Cadley.

Gouras, P. (1968). Identification of cone mechanisms in monkey ganglion cells. *Journal of Physiology*, **199**, 533–47.

Gregory, R. L. (1986). *Odd perceptions* (Chapter 30). Routledge, London.

Ikeda, H., Robbins, J., and Kay, C. (1989). Excitatory amino acid receptors on feline retinal ganglion cells. In *Neurobiology of the inner retina*, (ed. R. Weiler and N. N. Osborne), pp. 323–34. Springer Verlag, Munich.

Kaplan, E. and Shapley, R. (1982). X and Y cells in the lateral geniculate nucleus of macaque monkeys. *Journal of Physiology*, **330**, 125–43.

Knox, J. W. D., Bovill, J. D., Clarke, R. S. J., and Dundee, J. W. (1970). Clinical studies of induction agents, XXXVI: Ketamine. *British Journal of Anaesthesia*, **42**, 875–85.

Kulikowski, J. J., (1975). Apparent fineness of briefly presented gratings: balance between movement and pattern channels. *Vision Research*, **15**, 673–80.

Kulikowski, J. J. (1991). On the nature of visual evoked potentials, unit responses and psychophysics. In *From pigments to perception*, (ed. A. Valberg and B. B. Lee), pp. 197–209. Plenum, New York.

Kulikowski, J. J. (1992). Contrast and contrast constancy: sustained and transient components. *Irish Journal of Psychology*, **13**, 473–93.

Kulikowski, J. J. and Leisman, G. (1973). The effect of nitrous oxide on the relation between the evoked potential and contrast threshold. *Vision Research*, **13**, 2079–86.

Kulikowski, J. J. and Murray, I. J. (1988). Occipital potentials evoked by chromatic and achromatic gratings in sedated macaques. *Journal of Physiology*, **399**, 87P.

Kulikowski, J. J. and Tolhurst, D. J. (1973). Psychophysical evidence for sustained and transient detectors in human vision. *Journal of Physiology*, **232**, 149–52.

Kulikowski, J. J. and Vidyasagar, T. R. (1986). Space and spatial frequency: analysis and representation in the macaque striate cortex. *Experimental Brain Research*, **63**, 5–18.

Kulikowski, J. J. and Walsh, V. (1993). Colour vision: isolating mechanisms in overlapping streams. *Progress in Brain Research*, **95**, 417–26.

Kulikowski, J. J., Dickinson, C. M., and Murray, I. J. (eds.)(1989a). *Seeing contour and colour*. pp. 85–100 and 586–590. Pergamon, Oxford.

Kulikowski, J. J., Murray, I. J., and Parry, N. R. A. (1989b). Electrophysiological correlates of chromatic-opponent and achromatic stimulation in man. In *Colour vision deficiencies*, Vol. 9, (ed. G. Verriest and B. Drum), pp. 145–53. Kluwer Academic, Amsterdam.

Lee, B. B., Martin, P. R., and Valberg, A. (1989). Sensitivity of macaque retinal ganglion cells to chromatic and luminance flicker. *Journal of Physiology*, **414**, 223–44.

Livingstone, M. S. and Hubel, D. H. (1984). Anatomy and physiology of a color system in the primate visual cortex. *Journal of Neuroscience*, **4**, 309–56.

Livingstone, M. S. and Hubel, D. H. (1987). Psychophysical evidence for separate channels for the perception of form, color, movement and depth. *Journal of Neuroscience*, **7**, 3416–68.

Mullen, K. T. (1985). The contrast sensitivity of human colour vision to red–green and blue–yellow chromatic gratings. *Journal of Physiology*, **359**, 381–400.

Parry, N. R. A. Kulikowski, J. J., Murray, I. I., Kranda, K. and Ott, H. (1988). Visual evoked potentials and reaction times to chromatic and achromatic stimulation: psychopharmocological applications. In *Psychopharmacology and reaction time*, (ed. I. Hindmarch, B. Aufdembrinke, and H. Ott), pp. 155–76. Wiley, Chichester.

Parry, N. R. A., Kulikowski, J. J., and Kranda, K. (1989). Chromatic and achromatic visual evoked potentials and reaction times in the investigation of drug action. In *Seeing contour and colour*, (ed. J. J. Kulikowski, C. M. Dickinson, and I. J. Murray), pp. 578–85. Pergamon, Oxford.

Rose, D. and Horn, G. (1977). Effects of LSD on the responses of single units in cat casual cortex. *Experimental, Brain Research*, **27**, 71–80.

Schiller, P. (1984). The connections of the retinal ON and OFF pathways to the Lateral Geniculate Nucleus of the monkey. *Vision Research*, **24**, 923–32.

Tootell, R. B. H., Hamilton, S. L., and Switkes, E. (1988). Functional anatomy of macaque striate cortex. IV: Contrast and magno–parvo streams. *Journal of Neuroscience*, **8**, 1594–1609.

Ts'o, D. Y. and Gilbert, C. D. (1988). The organization of chromatic and spatial interactions in the primate striate cortex. *Journal Neuroscience*, **8**, 1712–27.

Zeki, S. (1993). *A vision of the brain*. Blackwell, Oxford.

Zeki, S. and Shipp, S. (1988). The functional logic of cortical connections. *Nature*, **335**, 311–17.

14 Chemical soup: where and how drugs may influence visual perception

ADAM SILLITO

In Chapter 1 Gregory described three levels for investigating brain function. In this chapter we will enter the second and third levels, to peer inside the black box. We will look at the physiological, circuit diagram description of the visual pathway from eye to brain and the chemical constituents of which it is composed.

It is not only at the hardware level that we can ask how drugs might come to affect visual perception. We find that visual perception must not be considered as resulting from a set of hard-wired computer-like circuits, where the electrical impulses in one nerve cell interact with those from others in the circuit via junctions where the events transfer as if at a soldered joint on a circuit board. Instead, the transfer from one nerve cell to the next in a brain circuit is mediated by a chemical substance, released from the terminal of the input nerve fibre and which diffuses to special receptor molecules on the surface membrane of the receiving cell (see Fig. 14.1). It turns out that in such synaptic junctions between nerve cells a wide range of chemical agents, the so-called neurotransmitters and neuromodulators, influence groups of specialized chemical receptors in an interactive way and the transmission of information depends on all these. The interactions at the junctions between nerve cells can be very complicated, even at the earliest stages in the visual system, let alone those involving cortical circuitry. Suddenly, it seems that visual perception comes from a process that swims along in a 'chemical soup' rather than from the digital dash of the computer.

To chase the logic of the chemical 'soup' we need to look at individual steps in the visual system with the techniques of the neurobiologist. We will focus on how the information from the retina is conveyed across the first neural junction in the lateral geniculate nucleus (LGN), before it goes up to the visual cortex and then consider some of the chemical processes that are occurring in the visual cortex and how these might influence perception (Fig. 14.2).

Figure 14.2(b) summarizes some of the connections seen in the retina of the eye. A point to note is that the transmission of signals

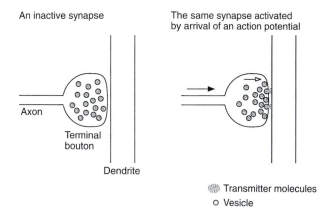

Fig. 14.1. Diagram of a synaptic junction between two nerve cells. The neurotransmitter is stored in spherical vesicles within the swollen terminal bouton of the nerve axon that provides the input to the synapse. When nerve impulses (action potentials) arrive they induce the vesicles to release their transmitter contents into the gap between the terminal bouton and the dendrite, the part of the receiving cell which is sensitive to the presence of transmitter molecules. These molecules interact with special receptor molecules embedded in the cell membrane of the dendrite. As a result, special channels open through the membrane and charged ions in the fluid surrounding the membrane are able to pass through. Their passage alters the electrical balance across the membrane. At excitatory synapses, positively charged sodium ions pass into the cell, making the inside (which is normally more negative) less negative; that is, they depolarize the cell. This increases the probability that the receiving cell will fire an action potential along its axon. However, at inhibitory synapses other ions (for example, potassium or chloride) flow through, which may make the dendrite even more negative inside and, hence, reduce the likelihood that the cell will fire.

from one cell to the next, in the sequence originating at an individual photoreceptor, is influenced by connections that are driven from adjacent groups of photoreceptors. This type of lateral (or sideways) control of the transmission of information is seen at all levels in the visual system. Figure 14.2(c) summarizes some of the connections seen in the circuit carrying the retinal input to the visual cortex; the pattern of connections shows further complexities. The retinal input goes to relay cells in the LGN and these send their axons to the visual cortex. However, it is not a simple matter of the retinal cells' releasing a chemical which jumps across to the LGN cells, to excite them and so to cause the signal to go on up to the visual cortex. The activity of the LGN relay cell is influenced by lots of other synapses, especially top-down from the visual cortex, which sends axons back down to the LGN and so to some extent controls the transfer of visual information it receives from the retina. This is not a trivial process, since the majority of excitatory terminals in the LGN come from the cortex (60 per cent or more), with a relatively small component (10–20 per cent) from the retina. Here is a paradoxical situation: the LGN can virtually be regarded as part of the cortical

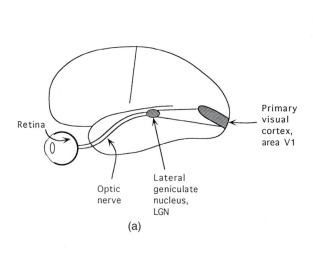

(a)

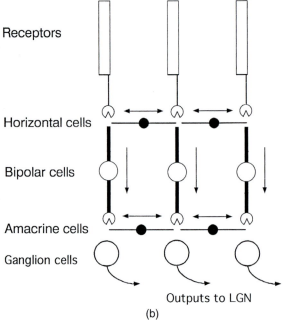

Receptors

Horizontal cells

Bipolar cells

Amacrine cells

Ganglion cells

Outputs to LGN

(b)

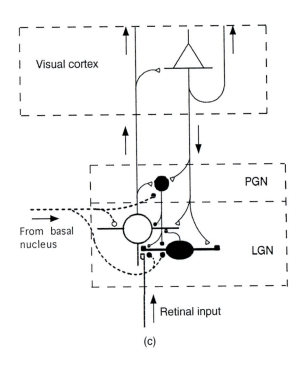

Visual cortex

PGN

From basal nucleus

LGN

Retinal input

(c)

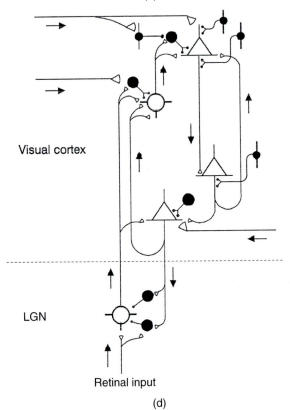

Visual cortex

LGN

Retinal input

(d)

circuitry and any transfer of information will be subject to influences that reflect cortical operations.

Aside from the cortical and retinal inputs there are other major influences acting within the LGN. Two groups of inhibitory cells, one lying just above the LGN (in a structure called the perigeniculate nucleus) and the other within the LGN, release an inhibitory transmitter chemical called GABA, and exert a strong control over the transfer of information to the cells that 'relay' information to the cortex. In addition there are at least three sets of non-visual inputs arising from brainstem regions, all with their own transmitter substances, that play an important role in determining behavioural state (for example, how alert an animal is) and the shift from sleep to wakefulness. As the animal changes from drowsy to awake, the ways in which it needs to process visual stimuli also change and the ascending inputs from the brainstem adjust the circuitry of the LGN to account for this, using at the most conservative estimate five neurotransmitters.

The LGN

I would like to take the circuitry discussed above as an example with which to explore the 'chemical soup' through which the visual process must swim. In the first instance I shall focus on the events that transfer the excitatory input from a nerve fibre carrying information from a retinal ganglion cell in the eye to an LGN cell in the

Fig. 14.2. Elements of the synaptic circuitry in the central visual system. Cell bodies are shown by large circles or triangles, and the dendrites (receiving input) and axons (carrying the cell's output) are shown as lines. Arrows alongside the axons show the direction of information flow. Small circles or triangles at the ends of the axons represent the synaptic boutons. The cell bodies and the synaptic boutons of excitatory cells are left white; those of inhibitory cells and synapses are black. (a) Lateral view of the brain showing the locations of the retina, LGN, and visual cortex. (b) Connections within the retina, showing receptors, bipolar cells, and retinal ganglion cells. Horizontal cells and amacrine cells make lateral connections that allow adjacent photoreceptors to influence information flow from any given receptor. At each cell junction there are several cells interacting, both bottom-up and sideways. (c) Connections in the lateral geniculate nucleus (LGN) and its feedback from the perigeniculate nucleus (PGN) and the visual cortex. Bottom-up cells from the retina release glutamate as transmitter, sideways cells from the basal nucleus whose axons are shown as dashed lines release ACh as transmitter substance, and the inhibitory cells in the perigeniculate nucleus and in the LGN itself release GABA. Top-down cells from the cortex influence the inhibitory cells as well as the LGN cells projecting to the cortex. (d) Pattern of connectivity seen in the visual cortex and its interaction with the LGN. Long-distance horizontal excitatory connections from other cells within the cortex are shown with large white synaptic terminals. Note the presence of contacts between inhibitory interneurones and the circuit linking all layers of the cortex and the LGN.

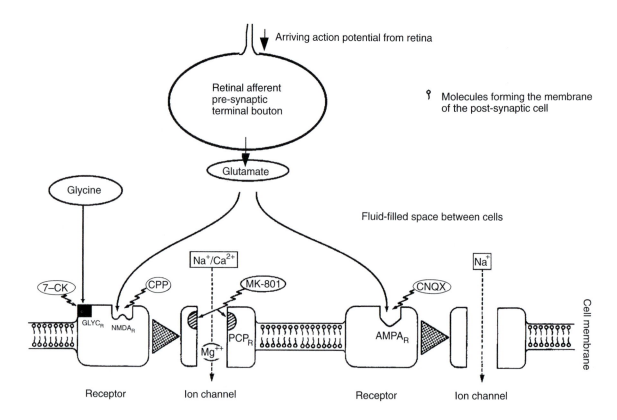

Fig. 14.3. Schematic summary of the post-synaptic membrane of an LGN cell. The pre-synaptic bouton from the retina is not shown in detail and is at a smaller scale than the post-synaptic cell membrane. Structures within the cell membrane are shown diagramatically to illustrate the findings regarding excitatory amino acid receptors and the transfer of visual information.

brain. For simplicity here, I would like to reduce the anatomical complexity of this stage to a single synapse or junction — that from an axon from the retina on to an LGN relay cell. At the same time, I would like to increase the chemical–pharmacological complexity, as shown in Fig. 14.3. This synapse, like many other excitatory synapses in the central nervous system, uses an amino acid (glutamate) as the neurotransmitter released from the terminal boutons of the axon coming up from the retina. Excitatory amino acids interact with two classes of receptor on the recipient cell (the post-synaptic LGN cell). These types are each named after the artificial chemical compound that most effectively binds to each receptor. (Binding is the process of a chemical's sticking to the receptor; in the cases of neurotransmitters and these particular compounds the act of binding activates the receptor and these chemicals are therefore known as 'agonists'.) The two types of receptor are called the NMDA (N-methyl-D-aspartate) receptor, and the AMPA (commonly called the non-NMDA) receptor.

It seems that molecules of the natural neurotransmitter (glutamate) released by the pre-synaptic terminal diffuse across the

synapse and interact with both classes of receptor. The central significance of this dichotomy into two types of receptors is that the non-NMDA receptors seem to function to mediate normal excitatory neurotransmission (evoking a rapid depolarization of the LGN cell by allowing sodium ions to enter and tending to generate a nerve impulse). It is these non-NMDA receptors which initiate the transfer of visual information arriving in the optic nerve fibre to the LGN relay cell. Meanwhile, the NMDA receptors have a more subtle effect, one that varies with the degree of membrane depolarization. Initiation of a nerve impulse via the NMDA receptor requires that the cell must be already partially excited by some other input. The NMDA receptor's ion channel is normally blocked by magnesium, but when the cell is depolarized, the magnesium ions are (somehow) removed. As the post-synaptic relay cell becomes progressively more depolarized, the normal level of blockade of the channels by magnesium ions is diminished. Both sodium and calcium ions can then enter through the NMDA receptor's ion channel. Thus activation of the NMDA receptor by glutamate only affects the cell when the cell is already in an excited state, causing it to become more excited. This particular channel is called 'voltage-dependent', because as the cell slowly gets more excited this receptor becomes effective. But it is becoming clear that NMDA receptors are also involved in the dynamics of excitatory processing in the central nervous system. Where they are so involved this makes the excitatory transfer of information particularly vulnerable to a range of other influences that affect membrane polarization. In other words, drugs that affect the NMDA receptor may powerfully affect the neural processing of visual information.

One can explore the contribution of each of these groups of receptors to the transfer of the visual input by carrying out a localized pharmacological experiment in the vicinity of the synapse. We do this by implanting a special electrode to record the electrical activity of cells; this electrode has glass tubes around it that contain drug solution that can be released under control into the vicinity of the cell. So we can record from a cell to see how it responds to a visual stimulus (via the nerve fibre driving it from the retina) and at the same time we can apply minute amounts of drug which may influence the responses of the cell. Two sorts of experiment are possible. One can examine the effect of the agonists for each type of receptor on the firing of the cell or one can use antagonists (drugs that selectively block access of the agonist or the neurotransmitter, to one of the receptors). We then check for any effect on the responses of the cell to its input from the retina. In particular, using antagonists selective for NMDA receptors (for example, CPP) or for non-NMDA receptors (for example, CNQX blocks the AMPA receptor), it is possible to attempt to dissect out the contribution of the two cat-

egories of receptor to the visual responses of the LGN cells (Sillito *et al*, 1988, 1990*a,b*).

The data obtained from this approach are clear; selective blockade of either NMDA (Kemp and Sillito 1982; Sillito *et al*. 1990*b*) or non-NMDA (Sillito *et al*. 1990*a*) receptors by local application of the appropriate antagonist can reduce or eliminate the visual response of LGN cells. Thus, for example, CPP blocks a cell's responses to NMDA, but not to a non-NMDA agonist, and the visual responses cease. Conversely, CNQX blocks non-NMDA, but not NMDA, but the visual responses again cease. Thus, only when both receptors are active can visual signals be transmitted. The conclusion from experiments of this type is that the full transfer of the visual input in the LGN involves the natural transmitters activating both NMDA and non-NMDA receptors. A loss of either activity makes the transfer ineffective.

In monkey and human, there are two major processing streams reaching the LGN from the retina: the magnocellular system, which responds best to coarse moving objects and the parvocellular system, which responds well to colour differences and to finer stationary patterns. The cat, the animal in which these pharmocological experiments were done, lacks colour vision, so one would not expect to find a colour-tuned subsystem in it. However, there are two subsystems in the cat which share some of the characteristics of the primate magnocellular and parvocellular systems. One seems to respond best to fine stationary patterns, the other to coarse moving patterns. Despite these functional differences, both systems seem to have the same pharmacological mechanism for transfer of visual information from optic nerve fibre to LGN relay cell.

The effectiveness of transfer of visual information via the NMDA receptor is subject to several influences. Inspection of the detail in Fig. 14.3 shows the presence of a receptor site within the ion channel, called the phencylidene receptor. The drugs MK-801 and ketamine act on this receptor to block the ion channel (see below and Chapter 13 by Kulikowski and Murray for the effects of MK-801 on vision). Another receptor, also linked to the NMDA receptor, is activated by glycine and blocked by the drug 7-CK. (Glycine is another amino acid that acts as an inhibitory neurotransmitter at several other locations in the nervous system.) Activation of this receptor facilitates the effectiveness of the NMDA receptor (Johnson and Ascher 1987) and, in the absence of this facilitation, effects mediated via the NMDA receptor are greatly reduced. How does blockade of this glycine receptor influence visual transmission in the LGN? Empirical studies show that application of the drug 7-CK, which blocks the glycine receptor, almost eliminates both the response to NMDA and the visual response.

There may in fact be two components to the modulation by glycine, one relating to the initiation of NMDA receptor activation and the other preventing its desensitization in the face of repeated and prolonged activation (Johnson and Ascher 1987; Mayer *et al.* 1989; Thompson *et al.* 1989). The high firing rate of retinal ganglion cells in the quiescent state (even with no visual input) and the rapid and repeated changes in their firing frequency elicited by the ever-shifting retinal image underline the potential significance of the glycine effects on desensitization of the NMDA receptor.

Despite certain complexities in interpretation, the present findings lead to a fairly clear overview of factors that seem to influence excitatory transmission from retinal afferents to LGN cells (Fig. 14.3). The retinal ganglion cell neurotransmitter (glutamate) acts on both non-NMDA and NMDA receptors. In the initial, quiescent state, the NMDA receptors are ineffective because they are blocked by magnesium ions. However, activation of the non-NMDA receptors can depolarize the post-synaptic cells. As the level of membrane depolarization increases, the contribution from the NMDA receptors comes into play. This, in turn, is dependent on activation of the glycine site in the NMDA receptor complex. However, we have yet to arrive at an understanding of the natural factors that modulate the activation of the glycine receptor — a part of the recipe in this particular 'soup' that remains obscure.

The greater part of the visual response thus appears to be mediated at the level where both NMDA and non-NMDA receptors are contributing to the depolarization of the LGN relay cells. The background discharge levels of retinal ganglion cells, together with the influences of the modulatory systems from the brainstem, are contributing factors to the kinetics of the transmission (Sillito *et al.* 1988).

Visual circuits

The pattern of events described above also applies to the transfer of excitation between bipolar cells and retinal ganglion cells in the retina (Fig. 14.2(b)) and to the many excitatory interactions occurring in the complex circuitry of the visual cortex (see Fig. 14.2(d) for a summary of cortical circuitry). The system only works because of the interaction of many contingent factors in the micro chemical world of each synapse. We are, as yet, far from understanding the detailed functional significance of all the steps, but we can conjecture about some, as was discussed above. Another fact that is important in relation to the NMDA receptor's role in visual perception is that the brief depolarization it elicits lasts for significantly longer than that generated by the AMPA receptor. This allows a longer

time-period for the excitatory input elicited by one event to interact with another. This point is probably best illustrated by considering the role of the feedback circuit from the visual cortex to the LGN. The long duration of the NMDA receptor-mediated excitation means that the influence from the cortex can return whilst the retinally mediated excitation is still present, allowing for an interaction between the retinally elicited excitation and the cortical response to the onset of that excitation. Higher visual cortical areas (for example V4) provide feedback to the earlier stages (V1 and V2) and similar principles may apply. Thus, the NMDA receptor produces changes that could be linked generally to brain growth, learning, and memory or could be the sort of effect that would produce a long-lasting visual after-image.

All this suggests that any drug influencing the effectiveness of the NMDA receptor might have a profound effect on visual perception. We are very fortunate to have an account of the influence of such a drug from a very eminent psychophysicist with a life-long interest in visual perception (Gregory 1986). This involves the anaesthetic ketamine, which acts on the phencyclidene receptor in the NMDA receptor ion channel and diminishes effects mediated via the NMDA receptor. Volunteering for this experiment, Richard Gregory reported what he saw as the drug effect built up. I quote:

During the infusion of ketamine, stereopsis for the random dot picture was still present, although it seemed impossible. Colour vision remained normal. Acuity did not seem to be reduced from normal though the visual world was highly unstable. Visual recognition of pictures was not severely impaired, at eleven minutes after the infusion (the drug was given intravenously) I could immediately recognize a picture of the Queen, at twenty five minutes I accurately described a scene of Mohammed Ali with children, but failed to recognize Ali. Distortions and changes in pattern vision did occur. These were one of the most striking effects of ketamine. Six minutes after the infusion, I said of the Zollner illusion that it was very odd and moved about. It was jazzing about so violently that I could not say that the normal illusory distortion was present. The stability of the visual world was impaired. At three minutes after the infusion, I said that when I moved my eyes the wall appeared to move with them, especially at the beginning of eye movements.

There is no doubt that ketamine had some remarkable effects on the visual mechanism (see also Chapter 13 by Kulikowski and Murray). However, taking note of my comments indicating that the transfer of the retinal input to the brain depends on NMDA receptors, the reader might well ask why Richard Gregory was not rendered blind by the drug. The answer to this is that the dose of ketamine used was sufficiently low to ensure that the action of NMDA receptors was not completely blocked, just slightly reduced. Had it been higher he would have been unconscious and unable to tell us anything. Thus, these observations tell us the perceptual effect of a subtle downgrading of the effectiveness of NMDA receptor action in the visual system. This under-

lines the importance in a functional sense of those natural processes that modulate the effectiveness of the NMDA receptor.

The two groups of inhibitory interneurones influencing the transfer of information in the LGN (see Fig. 14.2(c)) both utilize the neurotransmitter GABA. The inhibitory cells that sit just outside the LGN (in the perigeniculate nucleus: Fig. 14.2(c)) provide a local feedback circuit. Those within the LGN are unusual, because their dendrites both receive input from the incoming retinal axon and form synapses on to the LGN relay cell. This is an unusual arrangement, in that the dendrite actually releases neurotransmitter, thus having also a role as a pre-synaptic structure. This is a feed-forward inhibitory process: the retinal transmitter both excites the relay cell and the dendrite of the inhibitory cell, which in turn inhibits the relay cell. As yet we do not understand the significance of this, but it could be some type of gain (that is amplification) control mechanism. Our visual system has to cope with a wide range of variations in the contrast and intensity of the retinal image. In this synaptic arrangement, a reduction in the level of excitation will lead to a reduction in the amount of inhibition and vice versa, thus tending to offset the impact of the change in input. The logic cannot be phrased this simply, of course. As Fig. 14.2(c) shows, the system of nerve fibres from the cortex, which is the major input to the LGN, contacts both groups of inhibitory interneurones as well as the relay cells. Thus, the balance of the effectiveness of the inhibitory and excitatory mechanisms will be strongly influenced by events that activate the feedback from the cortex.

Additionally, a modulatory input from the brainstem, using acetylcholine (ACh) as its neurotransmitter (referred to as a cholinergic projection), influences both relay cells and inhibitory interneurones. Different receptors for ACh are involved at these locations, and ACh exerts different effects: the relay cells are facilitated and the inhibitory interneurones are inhibited by ACh (Sillito *et al.* 1983). Thus, the cholinergic input will tend to increase inhibitory effects and enhance the responsiveness of relay cells. Other modulatory inputs to the LGN utilize noradrenaline and serotonin as neurotransmitters. There is not space to discuss their effects here. The point at issue is that it is clear we should expect drugs interfering with the action of any of these neurotransmitter 'systems' to have, potentially, very significant effects on the transfer of visual information.

The visual cortex

The visual cortex provides dramatic examples of the capacity of drugs to influence visual responses. A simplified version of elements

of the circuitry is given in Fig. 14.2(d). The GABA-releasing inhibitory interneurones play a major role in restricting the development of excitatory responses in the cortical network.

As one moves to the visual cortex, there is transition in the features of the image that each cell responds to. Receptive field properties in the retina and LGN are characterized by a circular concentric centre–surround pattern, whereas elongated 'orientation-tuned' receptive fields characterize responses in the cortex. Thus, cortical cells seem to be most strongly activated by an elongated stimulus, such as an edge or a bar of light, moving over their receptive field, but any given cell is highly selective to the orientation of that edge and will respond to only one or a restricted range of orientations. For many cells in the cortex, this property may be altered by applying the GABA antagonist N-methyl bicuculline in the vicinity of the cell, so reducing the effectiveness of inhibitory interneurones. The blockade of inhibitory mechanisms in this section of the visual network allows a totally new pattern of excitatory response to develop (Sillito 1977, 1979, 1984; Sillito et al. 1980). The cell is then no longer responsive to only one orientation and, indeed, the responses to other orientations may exceed that to the original optimal orientation — so the cell has lost its previous selectivity. The development of sensitivity to the orientation and direction of motion of visual stimuli seems to be a crucial first step in the cortical stage of visual processing. The integrity of this and other aspects of visual processing depends on the complex interplay of excitatory and inhibitory mechanisms in the circuitry. Blocking the action of GABA undermines the whole network function.

The main point from this is that cortical processes utilizing the inhibitory transmitter GABA contribute to response properties of visual cortical cells which we can link to visual perception. Thus, drugs such as benzodiazepines (for example, Valium), which influence the sensitivity and effectiveness of the GABA receptor, are interfacing with key processes in the visual system. We may expect these drugs to produce subtle modulations of elements of visual perception reflecting the operation of these processes. As an example, Gelbtuch et al. (1986) found that lorazepam, a widely used benzodiazepine, enhances the tilt illusion, a visual effect in which the angle between two lines of similar orientation is apparently expanded. This enhancement could result from an increase in the strength of inhibitory processes acting between orientation-selective cells in the human visual cortex.

As in the LGN, there are extensive inputs from the brainstem neuromodulatory systems to the visual cortex and these involve noradrenaline, acetylcholine, and serotonin as neurotransmitters. In the case of the cortex, the cholinergic projection originates from a

nucleus of cells in the basal forebrain. Deficits in this system are linked to Alzheimer's disease. The effects of the cholinergic system in the visual cortex can be marked. Application of ACh locally to a cell may produce a major increase in the magnitude of responses to a bar of light moving over the receptive field; further, the responses can be very selective for the direction of bar motion. We know that ACh facilitates excitatory interneurones in the visual cortex and directly excites inhibitory interneurones. The net effect seems to be a strong enhancement of both the responsiveness and selectivity of the cortical network, seemingly increasing the 'contrast' in the representation of significant events (Sillito and Kemp 1983; Murphy and Sillito 1990). The cholinergic system, in combination with the other neuromodulatory inputs, determines the change in brain mechanisms linked to the behavioural state, for example between the response of a sleeping and waking cortex. Quite clearly, if the cholinergic input to the cortex is damaged, one could expect highly impaired cortical function.

ACh is, though, only one of the wide range of chemicals that convey the subtle messages underlying visual perception. The language of the interaction is far from digital; it is one of an ever-shifting chemical context in each synaptic microcosm in the network. If these contexts are changed by drugs our perceptual mechanisms, whether in vision, audition, or somaesthesia, are vulnerable at every level. The nature of the change will be complex, because the effects will involve different levels of the visual system and the brain simultaneously. Thus, in the visual system, a drug administered via the bloodstream that influences for example excitatory amino acid receptors or GABA receptors may have effects on retinal, LGN, and cortical circuits. It may be difficult, on the basis of present knowledge, to generate sensible predictions of the effects — save that we would expect changes and the changes may help us to understand the mechanisms a little more.

References

Gelbtuch, M. H., Harris, J. P., and Phillipson, O. T. (1986). Modification of visual orientation illusions by drugs which influence dopamine and GABA neurons: differential effects on simultaneous and successive illusions. *Psychopharmacology*, **90**, 379–83.

Gregory, R. L. (1986). *Odd perceptions*. Routledge, London.

Johnson, J. W. and Ascher, P. (1987). Glycine potentiates the NMDA response in cultured mouse brain neurons. *Nature*, **325**, 529–31.

Kemp, J. A. and Sillito, A. M. (1982). The nature of the excitatory transmitter mediating X and Y cell inputs to the cat dorsal lateral geniculate nucleus. *Journal of Physiology*, **323**, 377–91.

Mayer, M. L., Vyclicky, L., and Clements, J. (1989). Regulation of NMDA receptor desensitization in mouse hippocampal neurons by glycine. *Nature*, **338**, 425–7.

Murphy, P. C. and Sillito, A. M. (1990). Cholinergic enhancement of direction selectivity in the visual cortex of the cat. *Neuroscience*, **40**, 13–20.

Sillito, A. M. (1977). Inhibitory processes underlying the directional specificity of simple, complex and hypercomplex cells in the cat's visual cortex. *Journal of Physiology*, **271**, 699–720.

Sillito, A. M. (1979). Inhibitory mechanisms influencing complex cell orientation selectivity and their modification at high resting discharge levels. *Journal of Physiology*, **289**, 33–53.

Sillito, A. M. (1984). Functional considerations of the operation of GABAergic inhibitory processes in the visual cortex. In *The cerebral cortex*, Vol. 2A, (ed. A. Peters and E. G. Jones), pp. 91–172. Plenum Press, New York.

Sillito, A. M. and Kemp, J. A. (1983). The influence of GABAergic inhibitory processes on the receptive field structure of X and Y cells in the cat dorsal lateral geniculate nucleus (LGN). *Brain Research*, **277**, 63–77.

Sillito, A. M., Kemp, J. A., Milson, J. A., and Berardi, N. (1980). A re-evaluation of the mechanisms underlying simple cell orientation selectivity. *Brain Research*, **194**, 517–20.

Sillito, A. M., Kemp J. A., and Berardi, N. (1983). The cholinergic influence on the function of the cat dorsal lateral geniculate nucleus (LGN). *Brain Research*, **280**, 299–307.

Sillito, A. M., Murphy, P. C., and Moody, I. (1988). The modulation of the retinal relay to the cortex in the dorsal lateral geniculate nucleus. *Eye, Supplement*, **2**, S221–32.

Sillito, A. M., Murphy, P. C., and Salt, T. E., (1990a). The contribution of the non-N-methyl-D-aspartate group of excitatory amino acid receptors to retinogeniculate transmission in the cat. *Neuroscience*, **34**, 273–80.

Sillito, A. M., Murphy, P. C., Salt, T. E. and Moody, C. I. (1990b). Dependence of retinogeniculate transmission in cat on NMDA receptors. *Journal of Neurophysiology*, **63**, 347–55.

Thompson, A. M., Walker, V. E., and Flyn, D. M. (1989). Glycine enhances NMDA receptor mediated synaptic potentials in neocortical slices. *Nature*, **338**, 422–4.

PART V: *Physics*

introduced by PRISCILLA HEARD

Introduction to Part V: Physics

PRISCILLA HEARD

Many natural phenomena of optics — rainbows, cusps, caustics, and twinkles — have great beauty. The scientist has an added dimension of appreciation — that of understanding. Michael Berry gives us insight into the physicist's mind as he describes and explains phenomena of the natural focusing of rays of light, using the language of mathematics, expressed as geometric landscapes with maxima and minima that form catastrophe patterns. But what is catastrophe theory? We learn that it is about rainbows. We also learn that dim rays of light show phenomena of quantum mechanics, as we may observe interference fringes build up, point by point, by the random arrival of photons.

Roger Penrose gives mathematical insights to the study of perception by taking us on trains of thought, in part inspired by M. C. Escher's repeated tessellations, such as the woodcut *Fish and Scales*. We are transported through patterns that fail to repeat, quasicrystals with symmetries that might reflect underlying atomic structures, and decagons that suddenly appear, through different impossible structures. The journey ends in what he calls invisible impossible figures, which we see although they are not there.

15 Natural focusing

MICHAEL BERRY

I will discuss the geometry of light. In a sense every contribution to this book is concerned with the same subject: eyes are of no use without light, and visual perception inevitably involves geometry. But I am not going to be speaking about light as perceived, as a tool for seeing, but rather concentrating on the physics of light itself. There are several reasons for injecting physics into a book such as this. One is that the patterns I am going to be describing can be seen with the naked eye, unlike much of science nowadays, so it is now 'eyes on', if not 'hands on', physics. Second, the patterns I am describing are appealing ones, although I am not under any delusion that this is either a necessary or a sufficient condition for them to be regarded as art. And third, consistently with this being a section concerned with art and mathematics, the branch of optics I am going to be describing was developed under the stimulus of an advance in mathematics, namely the celebrated and notorious catastrophe theory created several decades ago by René Thom and Vladimir Arnold. What I will describe is the *focusing of light in nature*.

Figure 15.1 shows the sparkling of sunlight on the water in Bristol docks. I am going to use it to sidle into the mathematics. Each of the bright points is an image of the Sun in the water. It corresponds to a place where the water surface has the right slope to direct light from the Sun into the eye. Figure 15.2 shows the sun and the eye in a situation where three rays reach it. If you were to look down you would see three bright points (labelled 1, 2, and 3). What distinguishes these three from all the other points? Of course, you know from elementary optics that rays correspond to points where the ingoing and outgoing rays make equal angles with the reflecting surface. The point P, for example, does not correspond to a ray and has different angles in and out.

But there is another feature which distinguishes the brilliant points. If you ask 'What is the travel time of light between the Sun and the eye via the water, for these different paths?' and draw a graph of it, then you get Fig. 15.3, a landscape curve with maxima

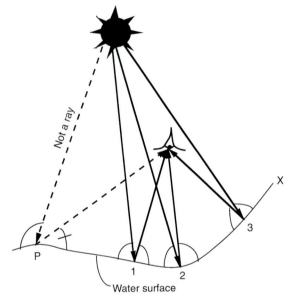

Fig. 15.1. Reflections of the
Sun in wavy water.

Fig. 15.2. Three reflected
images of the Sun.

and minima. The maxima and minima — places where the land-
scape is flat, the so-called critical points — are the points on the
surface which correspond to rays (this is Fermat's principle of geo-
metrical optics) and so P is not a ray because it is not one of the
flats: it lies on a hillside. So there is a relation between optics and the
geometry of landscapes. Now, catastrophe theory is about geometric
landscapes, so we are in the right mathematical world, at least. But
we are not there yet.

To come closer, consider what happens as time passes: the water
surface changes and the brilliant points move about. They can
collide with each other and disappear or they can be born sponta-
neously in pairs. These events are called twinkles and they usually
happen too fast to be perceived individually. Their rapid succession is
what gives illuminated water its sparkling appearance. Now, each
twinkle corresponds to something more than the water surface
having the right slope. It corresponds to the water surface also being
curved just right, so as to *focus* the light into the eye as well as
directing it there.

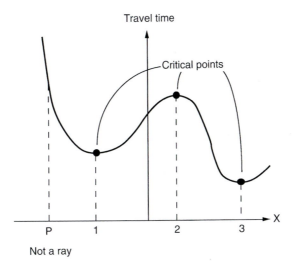

Fig. 15.3. Travel time 'landscape'; rays correspond to critical points (minima or maxima).

To illustrate this, Fig. 15.4 shows a different view of the geometry, with the sun far away. Rays emerge in different directions. Their envelope is a focal curve (in three dimensions it would be a surface), called a *caustic* from the Greek work for burning, because curves like this are commonly seen in light focused by burning glasses. The caustic distinguishes places like A, where only one reflected ray exists (one brilliant sun image) from places like B, where there are three. Figure 15.5 is a water surface seen from a place like B. This has local interest, because it shows the tidal bore on the River Severn near Bristol, together with a TV helicopter and its three reflections (the third is very faint). Across the caustic there is a discontinuous change in the number of rays. Commonly the caustic is more complicated and one sees many images. So the existence of caustic surfaces in space lies at the heart of the births and deaths of the brilliant points.

We shall concentrate on this kind of focusing. Let us look more closely at one of the caustic curves (Fig. 15.6) and see what happens near it. The caustic is the envelope of the family of rays. Across it, the number of rays changes by two. The caustic is very bright, because the energy that is concentrated between any pair of rays shrinks down to be infinitely concentrated there. Therefore, caustics dominate optical patterns, as we will see. They are places of discontinuity and, moreover, of exactly the same discontinuities that the mathematics of catastrophe theory describes, namely discontinuities in mathematical landscapes as they are altered to make maxima and minima coincide.

Therefore the mathematical theory of catastrophes describes the physics of focusing. What does it tell us? It gives us a classification of the geometric shapes that caustics can take. There is one refinement

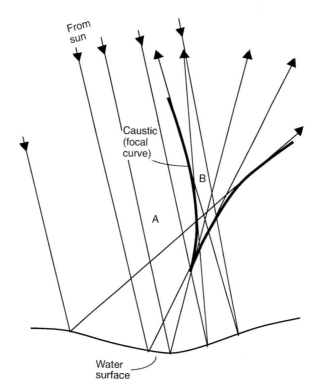

Fig. 15.4. Caustic curve of focused reflected sunlight.

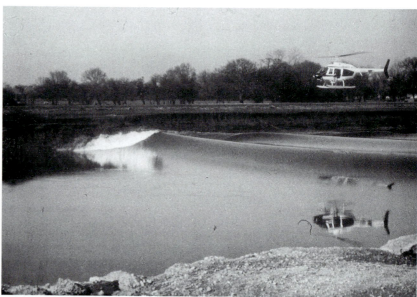

Fig. 15.5. Reflections in the Severn Bore.

which is actually crucially important. Instead of classifying all focal surfaces, it classifies those which have a mathematical property called 'structural stability'. It is often easy to understand something by knowing what it is not. Figure 15.7 shows an *unstable* focus, the

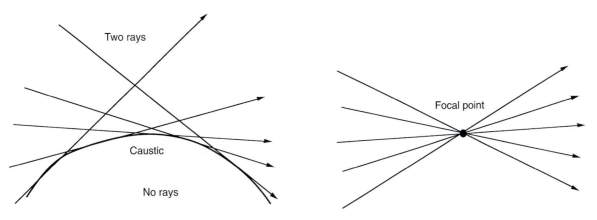

Fig. 15.6. Across a caustic, the number of rays jumps by two.

Fig. 15.7. Unstable point focus.

one we learned about in school optics, where all the light rays pass through a single point. That is highly improbable in a focusing situation; a large part of the lensmaker's art is devoted to making it happen. Structural instability means that the slightest disturbance of the conditions that gave rise to it caused this point to explode into complicated shapes, which are what the theory classifies. So we expect that the shapes that the mathematics classifies are those caustic curves and surfaces to be found in nature, where there are often no special symmetries.

Let us start to go through the catalogue. You might expect the mathematical caustics to be organized in terms of the number of dimensions they occupy. That is not quite how it works. They are organized by something called *codimension*. The codimension is the number of dimensions you must typically explore to find something. For example, a line in space has codimension two, because in order to cut it you typically need a surface, which has two dimensions. Obviously the simplest case is codimension one. The corresponding catastrophe (Fig. 15.8) has a name: the *fold*. A point on a line has codimension one. You find it as you go along a line in one dimension. A line in a plane has codimension one. You find it by exploring the plane. Similarly, a surface in space has codimension one. This is not very exciting geometry; there seems nothing particularly interesting about it. In focusing, however, it corresponds to something very familiar, namely the *rainbow*. If anybody asks you what catastrophe theory is, you can say it is about rainbows. I will explain why that is, before going on to more substantial applications.

The rainbow is formed by sunshine on a dripping cloud. Sunlight hits a raindrop at various latitudes and comes out in various directions. If you make a graph of the out direction against the in latitude then you find a curve with a fold (minimum) in it. Near the fold a bundle of rays going in gets concentrated into a very narrow bundle going out. This is focusing in angle. The angle is a single variable

Fig. 15.8. Fold catastrophe: co-dimension one.

Fig. 15.9. Cusp catastrophe: codimension two.

that you change in order to see the caustic, which is at 138° to the forward direction, that is away from the sun. The raindrop reflects a bright cone of rays at 42° to the backward direction, and you, on the ground, see, brightly lit, all the raindrops on whose cones your eyes lie.

Now let us go on to codimension two. This is important because screens, retinas, and photographic plates are two-dimensional. Here the catastrophe is called the *cusp* (Fig. 15.9). In the plane, a cusp is a point where two fold caustic curves meet; they kiss, with a common tangent. In three dimensions this codimension-two object is a cusped line, a crease where two focal surfaces join. Here the mathematics gains substance, because it declares that this cusp is the only stable structure: other structures are not stable. For example, a smooth curve coming to an end (like the crock of gold at the rainbow's end) is not stable, nor is an isolated point, nor is a finite-angled corner; these cannot exist unless there is some special condition operating. It is quite easy to see cusps. You can see them as bum-shaped curves in teacups (Fig. 15.10), diffusely reflected from the milk in the tea or coffee. You can also see them if you wear glasses and walk in the rain at night and look through the distorted droplets on your glasses (which were not as clean as you thought, so that — because of non-uniform wetting — the drops are not circular). Look at a distant light through such water-droplet lenses and you will see patterns like Fig. 15.11 with many cusps. In Fellini's film $8\frac{1}{2}$, there is a beautiful sequence at night where

Fig. 15.10. Caustic in a teacup.

Fig. 15.11. Cusps from an irregular water-drop 'lens'.

the camera in the rain is looking at circus lights; cusps abound. Clearly visible in Fig. 15.11 are delicate interference bands. These will be more prominent in later pictures and I will describe them later. At the moment, however, I am drawing attention to the cusps, as examples of typical focusing. You can create cusps easily with a laser beam shining through a water-droplet lens hanging on a dusty glass plate (that is how Fig. 15.11 was made).

Let us proceed to three dimensions. There are three different co-dimension-three catastrophes; that is, three different types of singular point on caustic surfaces in space. One is the *swallowtail*, so named by the blind mathematician Bernard Morin. In the swallowtail (Fig. 15.12) two cusped edges meet at the catastrophe point. It is hard to show caustics in three dimensions. It is possible to see them with smoke in the region of the focus, but much more commonly we observe sections and the telltale section of the swallowtail is a self-crossing of caustic curves. Again, it is possible to make swallowtails with water droplets; Fig. 15.13 shows two.

The second codimension-three catastrophe is the *elliptic umbilic* (Fig. 15.14), a waisted spire shape, whose telltale sections are three-cusped triangles. There is a special section which is just a point. Previously I stated that a point focus is unstable and now we can see the instability in action: with any other section, the point explodes into the three-cusped triangle, which is stable because it consists

Fig. 15.12. Swallowtail catastrophe: codimension three.

Fig. 15.13. Swallowtails from an irregular water-drop 'lens'.

Fig. 15.14. Elliptic umbilic catastrophe: codimension three.

Fig. 15.15. Elliptic and hyperbolic umbilics from bathroom-window glass.

Fig. 15.16. Hyperbolic umbilic catastrophe: codimension three.

only of folds and cusps Figure 15.15 shows an elliptic umbilic section, produced by shining light through smoothly irregular bathroom-window glass. The three-cusped triangle is obvious, as is much interference decoration.

Figure 15.15 also serves to illustrate the third and last co-dimension-three catastrophe, namely the *hyperbolic umbilic* (Fig. 15.16), which consists of two interpenetrating sheets, the inner of which is cusped. So the telltale section here is a smooth outer curve and a cusped inner one. There is also a special (unstable) section with a finite-angled corner, where the two curves coincide. Figure 15.15 shows three hyperbolic umbilics, in various degrees of unfolding from their special section, sprouting from the elliptic umbilic triangle.

This kind of physics has a botanical flavour: the mathematics guarantees that certain shapes are stable and one does experiments with no special symmetry operating and seeks specimens of them. Different 'specimens' of the same catastrophe, for example the three hyperbolic umbilics in Fig. 15.15, are the same in the sense that flowers of a particular type are the same, and not in the sense that Ford cars or crystals are the same. What the catastrophes share is a topological identity with a precise mathematical meaning (basically, any 'specimen' can be obtained by smoothly deforming any other specimen of the same catastrophe).

It is not at all far-fetched and indeed quite helpful to think of the catastrophes as *atoms of form*. Consider real atoms. They occupy a sort of mesoscale, separating larger (macro) scales, on which atoms link together into molecules, liquids, solids, etc., from smaller (micro) scales, with subatomic detail such as electrons, nuclei, quarks, etc. Likewise in optics the catastrophes occupy a mesoscale. As we will see later, many catastrophes can be linked together into larger structures. Figure 15.15 shows a rudimentary example, in the form of a 'molecule' consisting of one elliptic and three hyperbolic umbilics. It is also possible to descend to finer scales, and this we now do.

Until now, although the mathematics I have been describing is today's, the physics has been that of the seventeenth century, namely the ray theory of light. Now we move on to the physics of 1800, when Thomas Young, in experiments at the Royal Institution, just off Piccadilly, proved that light is better described as a wave motion, with a wavelength of about one two-millionth of a metre. Of course we have already seen these waves as fine-scale decorations of the caustic patterns in Figs. 15.11, 15.13, and 15.15. One of the pleasant surprises from catastrophe theory is that the mathematics gives not only a classification of the caustics, but also a description of the wave interference that decorates them on fine scales: each caustic has its characteristic interference pattern.

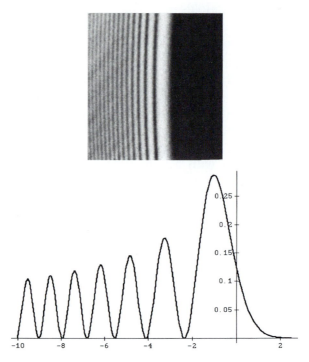

Fig. 15.17. Interference fringes near a fold catastrophe and graph of light intensity.

Figure 15.17 shows the pattern that decorates the fold catastrophe. If ray theory were true, the intensity would rise smoothly to the bright line, where geometric focusing would occur, but in reality there are interference fringes on the side where there are two rays. In the case of the cusp (Fig. 15.18(a)), the pattern is much more complicated. Magnification (Fig. 15.18(b)) and comparison with a computer simulation generated by the mathematics (Fig. 15.18(c)) shows that the smallest details, even the little pairs of dark spots, which are only a few wavelengths apart, can be accurately reproduced. One is here reminded of Maxwell's observation: 'the dimmed outlines of phenomenal things all merge into one another unless we put on the focusing glass of theory and screw it up, sometimes to one pitch of definition and sometimes to another, so as to see down into different depths through the great millstone of the world'.

In codimension three, the interference catastrophe patterns are incredibly complicated architectural arrays of brights and darks in space. We can only look at sections. Figure 15.9 shows part of the elliptic umbilic pattern, alongside a computer simulation. The whole three-dimensional pattern has been studied in great detail, as have its counterparts for the hyperbolic umbilic and the swallowtail.

Although this will mean digressing from our main theme of focusing, I cannot resist bringing in the physics that we have learned since 1800. We now know from quantum mechanics that light is

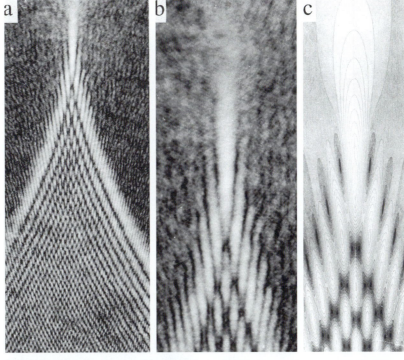

Fig. 15.18. Interference pattern near a cusp catastrophe.

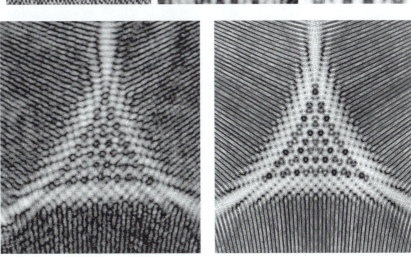

Fig. 15.19. Section through the interference pattern near an elliptic umbilic catastrophe (left); computer simulation (right).

actually a stream of photons. Why can these not be seen in the fine-scale interference patterns? The reason is that the light is too bright. In the laser beam that produced Fig. 15.17, about 10 000 million million photons strike each square millimetre of the screen every second, so we see only their collective effect. To detect individual photons, it is necessary to dim the light by a comparable factor. Then the interference fringes would be built up point by point. Photons

Fig. 15.20. Interference fringes built up by random impacts of photons.

arrive at random, but after some time it becomes apparent (Fig. 15.20) that the probability of arriving near a bright line is much greater than that of hitting a dark line. So the pattern you see is actually built up out of a multitude of individually random events.

To finish, let us climb to the macroscale and look briefly at the intricate networks of caustics produced on bottoms of swimming pools on sunny days. The sunlight refracted by the water surface makes complicated caustic surfaces in the space in the water below and what we see is where those patterns cut the bottom of the pool, which acts as a screen. Rather than show a real caustic network, it is instructive to begin with David Hockney's painting of one (Plate 17), because this illustrates an important point.

As expected, no interference detail is visible on such a large scale. What was not expected, however, is that the patterns as observed cannot be immediately interpreted as stable caustics. Consider, for example, the many places in Plate 17 where caustic lines appear to meet in threes. Such meetings are not described by catastrophe theory (the only stable singularities in the plane are cusps). This looks like a paradox. Its resolution is that we usually see swimming-pool caustics under conditions of poor resolution, which obscure their fine structure. The blurring is caused by the rapid motion of the patterns and the half-degree width of the Sun's disk.

More detailed laboratory investigation of this caustic junction, supported by mathematics, reveals that each of the lines is really double, so six of them meet where uneducated observation suggests three. At each meeting-point there is an elliptic umbilic triangle (Fig. 15.21). There are other sorts of junction, and complicated ways in which they can be assembled into networks. In every case, the

Unresolved

Resolved

Fig. 15.21. Caustic 'triple' junction, with elliptic umbilic at its centre.

large-scale networks are organized by the forms in the small library of catastrophes, acting as structural elements enabling us to understand what would otherwise be collections of lines without meaning.

Further reading

Arnold, V. I. (1986). *Catastrophe theory* (2nd edn). Springer, Berlin.

Berry, M. V. (1976). Waves and Thom's theorem. *Advances in Physics*, **25**, 1–26.

Berry, M. V. and Nye, J. F. (1977). Fine structure in caustic junctions, *Nature*, **267**, 34–6.

Berry, M. V. and Nye, J. F., and Wright, F. J. (1979). The elliptic umbilic diffraction catastrophe. *Philosophical Transactions of the Royal Society of London*, **A291**, 453–84.

Berry, M. V. and Upstill, C. (1980). Catastrophe optics: morphologies of caustics and their diffraction patterns. *Progress in Optics*, **18**, 257–346.

Nye, J. F. (1978). Optical caustics in the near field from liquid drops. *Proceedings of the Royal Society of London*, **A361**, 24–41.

Nye, J. F. (1986). The catastrophe optics of liquid drop lenses. *Proceedings of the Royal Society of London*, **A403**, 1–26.

Poston, T. and Stewart, I. (1978). *Catastrophe theory and its applications*. Pitman, London.

Walker, J. (1983). Caustics: mathematical curves generated by light shined through rippled plastic. *Scientific American*, **249**, 146–53.

Walker, J. (1988). Shadows cast on the bottom of a pool are not like other shadows. Why? *Scientific American*, **259**, 86–9.

Walker, J. (1989). A drop of water becomes a gateway into the world of catastrophe optics. *Scientific American*, **261**, 120D–3.

Upstill, C. (1979). Light caustics from rippling water. *Proceedings of the Royal Society of London*, **A365**, 95–104.

Wright, F. J. (1988). Spectacles in the rain: catastrophe optics. *Physics Bulletin*, **39**, 313–16.

16 Mathematics of the impossible

ROGER PENROSE

Using various devices in his remarkable graphic work, the Dutch artist M. C. Escher could frequently confound the viewer into puzzling and sometimes paradoxical perceptual interpretations. He often used repeating tessellations by interlocking creatures, or globally inconsistent designs, to achieve startling effects. In Fig. 16.1 (his 1959 woodcut '*fish and scales*'), both of these features are exhibited in the same print. The basic tessellation, upon which it is partly based, consists of an endlessly repeating pattern of two kinds of interlocking fish, one black and one white, swimming in opposite directions. However, an additional paradox is presented. The pattern of fish itself emerges from the arrangement of scales on a single fish — take the large one on the left — and the fish that are its scales get larger and larger as we proceed to the right. The largest of these has its own scales, which are seen to become similar patterns of interlocking fish, but as we proceed back again to the left we find that these fish increase in size until the largest of *these* fish becomes the one on the left that we started with. Thus, the original fish is itself a scale of a fish that is actually one of its own scales! In this article, I shall present some elaborations of both these themes: tessellations and globally inconsistent configurations. I believe that these matters are of some interest for the study of perception.

Quasiperiodic tilings

Let me first show you a tessellation that bears some resemblance to those of Escher (and gained some inspiration from his marvellous work), but in which the pattern never actually quite repeats itself. This is illustrated in Fig. 16.2 and it is made up entirely of two interlocking birds, one large and one small. The design of these pieces is based on the two shapes known as a 'kite' and a 'dart', as shown in Fig. 16.3, whereas the actual kite and dart are shown in Fig. 16.4. With the notches and thorn embellishments as shown, these two

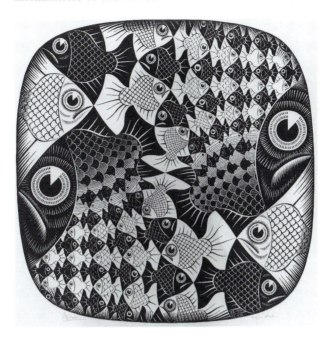

Fig. 16.1. M. C. Escher's 1959 woodcut *Fish and Scales*. Courtesy of the collection Haags Gemeente Museum, The Hague. © 1994 M. C. Escher/Cordon Art, Baarn, The Netherlands. All rights reserved.

shapes will tile the entire Euclidean plane, but not in any way that is periodic (that is, endlessly repeating in two independent directions). Thus, the resulting configuration differs in an essential way from any of the periodic (that is, 'crystalline') tessellations considered by Escher. A large assembled array of kites and darts is provided in Fig. 16.5, where the darts are coloured grey and the kites white. The fact that these patterns are very close to repeating, but always necessarily just fail to do so, creates many intriguing perceptual effects, as does the 5-fold symmetry that the pattern continually strives to achieve. In Fig. 16.6, I have indicated a closely related pattern made from four shapes: a regular pentagon, a five-pointed star ('pentacle'), a 36° rhombus, and a three-pointed incomplete star ('jester's cap'). If we adorn these shapes with appropriate notches and protuberances, as shown in Fig. 16.7, we get a set of six polygonal tiles that can only be assembled according to such a non-periodic arrangement. (For further information, see Grünbaum and Shephard 1987; Gardner 1989.)

It is a remarkable fact that, as has been known for about 10 years now, actual crystal-like materials (called *quasicrystals*; see Schechtman *et al.* 1984; Steinhardt and Ostlund 1987) exist which have axes of 5-fold symmetry — which is not allowed for a classical (periodic) crystal. It is believed that tiling patterns like those of Figs. 16.5 and 16.6 may well underlie their atomic structures. Quasicrystals are also known which have axes of 8-fold and 12-fold symmetry and corresponding tiling patterns (due to Ammann and Socolar, respectively; cf. Grünbaum and Shephard 1987; Socolar

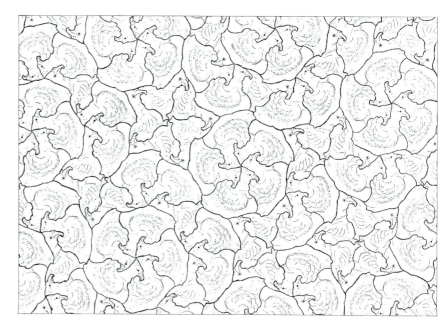

Fig. 16.2. This pattern of two bird shapes can be continued to cover the entire plane, but only quasiperiodically.

Fig. 16.3. The bird shapes of Fig. 16.2 are modified 'kites' and 'darts'. Reproduced with permission from *M. C. Escher: Art and Science* (1986), Elsevier Science Publishers, Amsterdam.

Fig. 16.4. The kite and the dart, with embellishments that enforce a quasiperiodic tiling. Reproduced with permission of Springer-Verlag from 'Pentaplexity: a class of non-periodic tilings of the plane', *Mathematical Intelligencer*, **2**, 32-7 (1979)

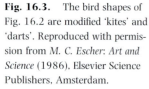

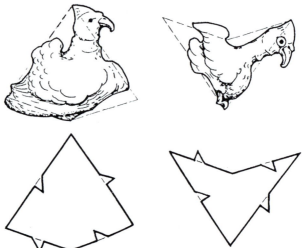

1990). In Fig. 16.8, I give an appealing modification due to Nissen 1991 of Socolar's remarkable 12-fold quasisymmetric tiling taken from a talk by Nissen on quasicrystals given at Bielefeld in 1991.

If we stare at large arrangements of this kind we often find that there are features that jump out from the pattern, especially after one instance of the feature has been pointed out. For example, in Fig. 16.5, we find that the darts (in grey) join together in chains — or else five of them form a little star, which is a degenerate case of a chain. Whenever such a chain closes (and in an infinite pattern vir-

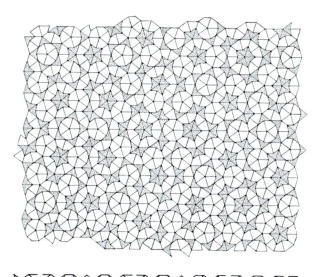

Fig. 16.5. A region of the plane tiled with kites and darts.

Fig. 16.6. A pentagonally quasisymmetric tiling of the plane by regular pentagons and three other shapes. Reproduced with permission from *The Emperor's New Mind: Concerning Computers, Minds, and the laws of physics.* Oxford University Press (1989).

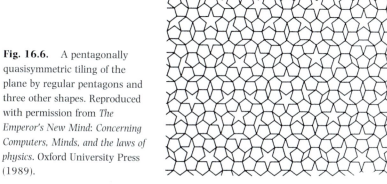

Fig. 16.7. Six tiles that will tile the plane only quasiperiodically, according to Fig. 16.6.

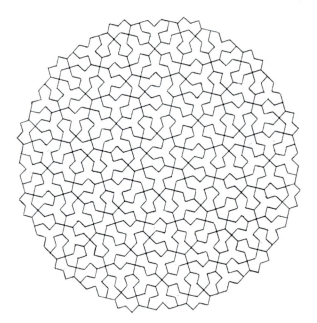

Fig. 16.8. H.-U. Nissen's
modification of J. E. S. Socolar's
12-fold quasisymmetric tiling.

tually all of them would eventually close) it forms a pattern with exact 5-fold symmetry. As one stares at the pattern, with this expectation, such 5-fold-symmetric rings of darts begin to jump out of the page. The bird patterns of Fig. 16.2 have similar features and they acquire a somewhat floral character. In the pattern of Fig. 16.6, there are many instances of regular decagons (ten-sided figures), these always being made up of precisely three pentagons, two rhombuses, and one jester's cap. Sometimes two such decagons will overlap. Once one has caught sight of one of the decagons, others are seen to spring up all over the place. Moreover, every one of these decagons is surrounded by a ring of ten pentagons, irrespective of whether or not the decagon overlaps with another. At many places, also, there can be found a ring of ten rhombuses, alternating with ten pentagons. Each such ring is always centred on one of the aforementioned decagons. In Fig. 16.8, we find many equally surprising and attractive features, but now with a 12-fold aspect. The spotting of such patterns presents many interesting perceptual exercises.

Impossible figures with perspective

Now, let us turn to the globally impossible structures. Perhaps the most direct of such structures is the so-called *tribar*. This is frequently depicted without any perspective, although in the article that I originally wrote with my father (Penrose and Penrose 1958*a*) we did use some perspective. To illustrate what I mean by this, I have

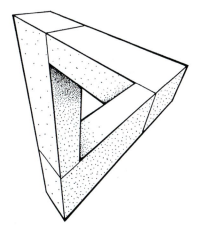

Fig. 16.9. The tribar, drawn with (excessive) perspective. Reproduced with permission from *M. C. Escher: Art and Science* (1986), Elsevier Science Publishers, Amsterdam.

drawn it out again, with exaggerated perspective (Fig. 16.9). Impossible figures of this kind, in which perspective features, also implicitly contain an additional paradox. One could imagine some ants crawling all around the tribar, always locally drawn accurately to scale with each other, so that the ants that are nearby to any one ant would be depicted in such a way that when allowances are made for the relative distances that they are judged to be from the eye, then they appear to be the same size as each other. However, as we follow the ants all around the tribar, we find that this criterion is impossible to maintain. At some point the sizes jump discontinuously, and an ant finds herself next to one of her sisters differing greatly in size. In a collection of Christmas puzzles that my father and I subsequently published (Penrose and Penrose 1958*b*), we tried to illustrate this point in what was (deliberately!) the most incomprehensible of the puzzles in the collection. In Fig. 16.10, this effect is illustrated, perhaps with a little exaggeration, in terms of some (toy?) people getting off a train, walking to the base of a ladder, and then climbing to the top, where they find that the very train from which they alighted a short while before is but a toy train and the people alighting from it indeed appear to be tiny model people (originally from Penrose 1986).

The arrangement of Fig. 16.10 gains its effect from a global geometrical inconsistency like that of a tribar with perspective. The ladder and upper and lower walkways constitute the actual tribar. An impossible staircase with perspective would do just as well, in relation to this kind of size inconsistency. This is in evidence in the photograph given in Fig. 16.11, which depicts an object constructed by my father. Here we have some (model) dogs distributed around a track whose shape is basically an impossible staircase (cf. Penrose and Penrose 1958*a*). Each dog appears to be the same size as its immediate neighbours except just at one place. This place is mani-

Fig. 16.10. An impossible picture, based on the tribar with perspective, illustrating the size inconsistency illusion. Reproduced with permission from *M. C. Escher: Art and Science* (1986), Elsevier Science Publishers, Amsterdam.

Fig. 16.11. An actual photograph illustrating, with model dogs, the size illusion arising from an impossible staircase (made by L. S. Penrose).

festly *not* a point at which the track is actually 'broken' though viewed from a carefully chosen vantage point so as to appear intact. In fact there is such a break, but it occurs at a point at which the dogs themselves appear *not* to jump in size, so one is thrown off the scent. The effect is achieved by having model dogs of two different sizes, so at the point where the break does occur there is a jump in

the actual size of the dogs precisely compensating the jump in distance from the viewer.

Impossible figures from Necker-cube-type ambiguities

The well-known Necker cube illusion, according to which a picture of a cubic structure may have an ambiguous interpretation, can be used to curious effect in impossible figures. One such effect is achieved in Escher's remarkable 1955 lithograph *Convex and Concave*, cf. Fig. 16.12. Here there is a central portion of the picture which is genuinely ambiguous in its interpretation, but as we move to the left we find that only one of these interpretations is consistent, whereas moving to the right we find that it is only the other that is consistent. Thus, there is no consistent interpretation of the picture in its entirety.

In Figs. 16.13 and 16.14 I have illustrated another type of global inconsistency (originally presented in Penrose 1986). There is an ambiguity of interpretation, *locally*, throughout the entire figure, but this ambiguity cannot be resolved simultaneously for the figure as a whole. The effect is quite a subtle one, and a casual glance does not reveal the

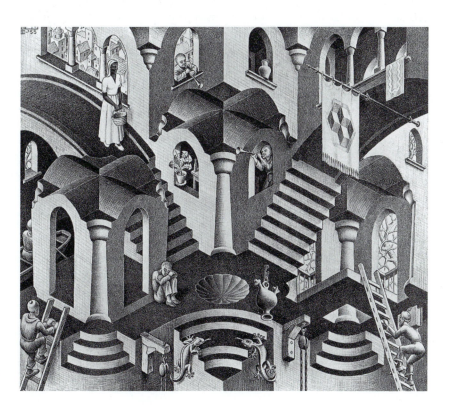

Fig. 16.12. Escher's 1955 lithograph *Convex and Concave*. Courtesy of the Collection Haags Gemeente Museum, The Hague. © 1994 M. C. Escher/Cordon Art, Baarn, The Netherlands. All rights reserved.

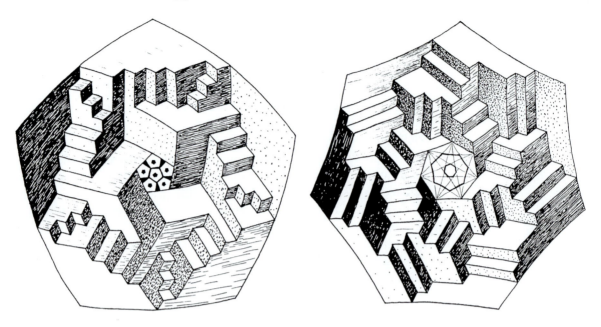

Fig. 16.13 and 14. Two impossible figures illustrating a kind of non-localizable impossibility based on the Necker-cube illusion. The figures look three-dimensional, but the solid shapes that are suggested cannot be consistently constructed. Reproduced with permission from *M. C. Escher: Art and Science* Publishers, Amsterdam.

impossibility at all. The figures appear, at first sight, to be things that could perfectly well be carved out of wood, for example. But more careful examination reveals that this is not so. Any way that one started, the carving would ultimately be confounded as one tried to complete it, there being no consistent three-dimensional interpretation of either figure. (This type of impossibility, as well as that of the tribar and impossible staircase, illustrates the mathematical concept of *cohomology*; see Penrose 1991 for an explanation.)

An invisible impossible figure

Another illusion, well known to students of perception, is illustrated in Fig. 16.15. Here one sees an 'invisible' white triangle, whose presence is perceptually inferred from the fact that it seems to be obscuring the background figures — assumed to be three black spots and a triangular design. As an additional feature, I have added a ring, which seems to be pinning the invisible white triangle to the background triangular design (although its presence does make the white triangle a little harder to see).

I had wondered whether such effects might be used in order to suggest the presence of a similarly 'invisible' tribar. Here the inferred object has to be a *three*-dimensional impossible structure, which means that its spatial extent in various directions must be appropriately suggested by the way that it obscures certain three-dimensional structures — all of which must be depicted on the plane, of course.

Fig. 16.15. A well-known illusion in which a white 'invisible' triangle can be perceived, here pinned to the background triangular design by a ring.

Fig. 16.16. As in Fig. 15.5, an 'invisible' figure is suggested, but here it is an impossible tribar!

My best efforts are illustrated in Fig. 16.16, a version of which I presented for the first time at the symposium which led to this book. The tribar that is presented is, I suppose, technically of a featureless white, rather than being truly 'invisible'. One might also envisage depicting a tribar, say, which *is* truly invisible in that it does not obscure what lies behind it nor does it cast any shadows. A modification of Fig. 16.16 along these lines can certainly be provided, but I am not sure how effective it is.

References

Gardner, M. (1989). *Penrose tiles to trapdoor ciphers.* W. H. Freeman, New York.

Grünbaum, B. and Shephard, G. C. (1987). *Tilings and patterns.* W. H. Freeman, New York.

Penrose, R. (1986). Escher and the visual representation of mathematical ideas. In *M. C. Escher: Art and science* (ed. H. S. M. Coxeter, M. Emmer, R. Penrose, and M. L. Teuber), pp. 143–57. Elsevier Science Publishers, Amsterdam.

Penrose, R. (1991). On the cohomology of impossible figures. *Structural Topology,* **17**, 11–16.

Penrose, L. S. and Penrose, R. (1958a). Impossible objects: a special type of visual illusion. *British Journal of Psychology,* **49**, 31.

Penrose, L. S. and Penrose, R. (1958b). Puzzles for Christmas. *New Scientist,* (December 25).

Schechtman, D., Blech, I., Gratias, D. and Cahn, J. W. (1984). Metallic phase with long-range orientational order and no translational symmetry. *Physical Review Letters,* **53**, 1951.

Socolar, J. E. S. (1990). Weak matching rules for quasicrystals. *Communications in Mathematical Physics,* **129**, 599–619.

Steinhardt, P. J. and Ostlund, S. (1987). *The physics of quasicrystals.* World Scientific, Singapore.

PART VI: *Artistry*

introduced by RICHARD GREGORY

Introduction to Part VI: Artistry

RICHARD GREGORY

Both art and science gain inspiration from regularities and surprises. The highly distinguished historian of art, Sir Ernst Gombrich, writes at length and with wisdom on the *need for regularity* (as Sir Karl Popper puts it[1]) in his Wrightsman Lectures, delivered at the Institute of Fine Arts of New York University, *The sense of order*.[2] Gombrich writes (p. 5):

So deeply ingrained is our tendency to regard order as the mark of an ordering mind that we instinctively react with wonder whenever we perceive regularity in the natural world.

He continues:

Sometimes, in walking through a wood, our eyes may be arrested by mushrooms arranged in a perfect circle. Folklore calls them fairy rings, because it seems impossible to imagine that such regularity has come about by accident. Nor has it — though the explanation of the phenomenon is far from simple.

Ernst Gombrich goes on to ask why we are so startled, though there is much order in nature — from the motions of the stars downwards to the structures of crystals. His 'brief answer' is that order occurs in nature only where the laws of physics operate simply, without much interaction. But Gombrich's main and very important point is that we use perception of order to survive by the simplest kind of prediction — induction from instances — and from deviations from order that startle us into awareness as they signal need for extra mental resources, since we cannot simply rely on what usually happens. We may well believe that surprise is related both to information and to consciousness.

The extreme example of repeated symmetry is patterns in a kaleidoscope. Gombrich makes the interesting point that as the pattern of the symmetry dominates so the meaning of the individual components, or objects, is lost. Thus, kaleidoscope patterns soon lose their

[1] Popper, K. R. (1972). *Objective knowledge*. Oxford University Press.
[2] Gombrich, E. H. (1979). *The sense of order: a study in the psychology of decorative art*. Phaidon, London.

interest. It is, indeed, this interplay of symmetry and breaks from symmetry that links art and science.

Of illusion: we might say that art thrives on illusions — while science does its best to avoid illusions. This is not to say that illusions are beyond explanation. Indeed there is what we might call the unnatural science of illusion, where we study examples with the tools of physics, physiology, and the cognitive sciences to explain and control illusion. For illusions can be dangerous and also useful, and highly suggestive for understanding the artful eye. They can cause sometimes fatal accidents and they make technologies such as cinema and television possible. The fact that we accept pictures as surrogates of very different realities, is the key to visual art. It is not obvious why marks on a cave wall are accepted as animals — they are very different! And whether we should call this tolerance to such departure from obvious fact 'illusion', is a decision linking definition to chiaroscuro. Art needs both tolerance and discipline, and so does science. So do we all. The problem is to know what tolerance and what discipline is needed. No doubt this is wisdom.

Anthony Hayes tells us how a computer can produce line drawings from photographs. This introduces, in a new way, the fundamental perceptual issue of how much 'top-down' effects of knowledge are necessary for presenting the world with pictures. More prosaically, perhaps, they show how economics of coding can be used to transmit pictures.

Philip Steadman describes a truly wonderful experiment involving Sherlock Holmes detection to suggest a hypothesis from subtle clues. The hypothesis is that Vermeer used a camera obscura for many of his best-known interiors. Philip Steadman created a Vermeer room. So he reversed the usual illusion from reality — to create the reality that produced Vermeer's illusion!

David Philips takes us into the criminal world of forgery. Students are taught by copying the Masters; yet copying can lead to prison. There are fine lines to be drawn here, in the world of art.

The late Dame Elizabeth Frink is rightly renowned for her larger-than-life heads and for her essence-of-life animals. They give her immortality.

The psychologist–artist Nick Wade presents portraits of artists and scientists. Wouldn't it be great if they communicated more effectively! Perhaps this book will help, just a little.

17 Lines of sight

ANTHONY HAYES AND JOHN ROSS

The knowledge of the outline is of most consequence, and yet may be acquired to great certainty by dint of study; as the outlines of the human figure, particularly those which do not bend, are invariably the same. But the knowledge of the situation, quality and quantity of shadows, being infinite, requires most extensive study.

Leonardo da Vinci: *Treatise on painting.*

A likeness of a visual scene may be achieved with a drawing constructed simply of lines. Such drawings have been used to depict the visual world from the earliest of times in human history, as is exemplified by the line drawings of Australian aboriginal cave artists of possibly 40 000 years ago and by the well-known drawings of Magdalenian artists, an example of which we present in Fig. 17.1.

The ubiquitous use of line drawings to stand in for scenes occurs despite the very different patterns of brightness and darkness — the very different distributions of image intensity values — of each. In this

Fig. 17.1. Magdalenian line drawing of a bison. The artist, who lived in France probably some 10 000 to 15 000 years ago, has used a sharp implement to draw the animal on limestone.

(b)

(a)

Fig. 17.2. A photograph of a small bakery in North Adelaide (a) and a line drawing by Scott Hartshorne of the same building (b) drawn about 10 years before the photograph was taken by the first author (note the transposed electricity pole!). The three-dimensional graphs beneath each drawing represent the brightness values (grey levels) at different points in the images. Imagine that the images have been placed horizontally and that the graphs have been placed on top of them. The graphs look like sketches of a landscape. The higher the hillocks, the darker the image at that point and the deeper the valleys, the brighter the image. Although the two images clearly depict the same scene, the graphs show the lack of correspondence between their distributions of brightness.

respect line drawings are quite unlike photographs or even most representational paintings in this. Bright regions in a photograph or painting correspond to bright regions in the scene and dim regions, and so forth, also correspond; there is no such correspondence for line drawings, yet line drawings readily convey scenes, as is confirmed by the drawing and photograph we show in Fig. 17.2. Beneath each we also show their intensity profiles — how brightness varies across the picture. The lack of correspondence of intensity values is readily apparent.

An observation about line drawings, which has often been noted in the vision literature, is that they can accurately depict objects and scenes with great economy, and under some circumstances everyday objects are identified as quickly and as accurately from simple line drawings as from colour photographs. These perceptually useful properties of line drawings have led to a number of techniques which reduce the amount of space taken up on a computer disk by digitized images (that is, when the brightness of each point is represented by a number) by means of extracting a line-drawing-like representation from a full-tone image. The purpose of such techniques is to produce useful images that can be more readily or more economically stored or transmitted, for example images to be sent by ordinary telephone cable. In Fig. 17.3 we present the output of one such technique applied to the photograph in Fig. 17.2.

The question of interest arising from the observation that the brightness distribution of a line drawing differs markedly from that of the scene itself is this: why is it that line drawings are able to convey, often with great efficiency, that which they represent? Precisely what it is that the lines of drawings are related to in an original scene is not immediately obvious, and a number of authors

Fig. 17.3. 'Feature map' of the photograph in Fig. 17.2 (a). The feature-map was generated by applying a sequence of operations to a digitized version of the original photograph. First the coarse, medium, and fine detail in restricted regions of the image are separately measured by separate sensors; then lines are drawn at the points in the image where there is the greatest correspondence of activity across the sensors (see Burr and Morrone 1990). Some people working in vision research speculate that the human visual system applies sensors of this kind to the retinal image at an early stage of visual processing. Whether this speculation is well founded or not, the similarity between this image and the simple line drawing of Fig. 17.2 (b) is quite remarkable.

have contributed suggestions. Some, such as Kepes (1951) and Goodman (1969) have proposed that drawings (and other forms of pictorial representation) follow a set of conventions which are learned rather as the conventions of written text are learned. However, this view would imply that essentially identical conventions developed independently at different times and places, and is rejected by authors who hold that a drawing has a natural correspondence to the original scene. Gibson (1954) suggested that lines of a line drawing have a point-to-point correspondence to the original scene, and faithfully depict edges and corners of the world. Attneave (1954) advanced the more sophisticated conjecture that lines in a drawing indicate points where information — in the sense of places where change occurs — is maximal, as where contours bend. Ratcliff (1972) suggested that lines represent scene contours which occur where there is a local change in brightness or colour between adjacent areas, and several authors have from time to time made the suggestion that the lines occur at points where a transition in a scene from a bright region to a dark region (or vice versa) is steepest. Finding such transitions turns out to be a mathematically reasonable way of locating the position of an edge in a scene, especially if the edge is not perfectly abrupt.

But, looking at the problem in reverse, successful line drawings do not seem to be easily derived from scenes by means of the simple transformations implied by these ideas. For example, as we show in the edge map of a two-tone image presented in Fig. 17.4, even some two-tone 'lithographic' images are not well depicted by their edges alone, and attempts to produce intelligible line drawings of natural images by marking as lines the points at which brightness changes most abruptly generally fail. In Fig. 17.5 we present an example of a 'line drawing' derived from such changes. This image fails because, among other reasons, all visually important features do not necessarily coincide with abrupt changes of brightness.

Fig. 17.4. Edges of a two-tone image of a face. This produces an image very similar to a two-tone lithograph. To find these edges, all the image points lighter than mid-grey are made white and all those darker than mid-grey are made black. The lines are drawn where the black–white boundaries fall. The edge map shown here contains much the same amount of 'information' (in a strict and simple sense of information content) as a two-tone image, yet it is almost impossible to recognize the face. The addition of only two brightness levels to this edge map results in the face being quite recognizable, as can be seen by turning to Fig. 17.12.

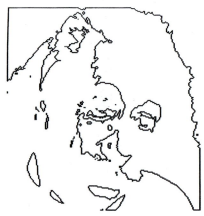

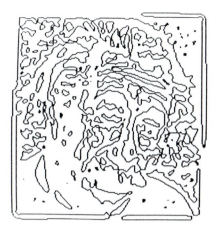

Fig. 17.5. The lines indicate the position of abrupt brightness changes in the fine detail of the image and are the basis for Marr's (1982) 'primal sketch', a representation in the brain of the edges of features of an object. Although Marr himself did not suggest such representations should be in themselves interpretable as 'line-drawings', it is a notion that has been proposed from time to time.

Retreating from his earlier position that drawings have congruent forms with the scenes they represent, Gibson (1971) realized that there is 'no point-to-point correspondence of the brightness or colour between the optic array from a line drawing and the optic array from the object represented' (p. 28; see also Fig. 17.2). He claimed that differences between those who argue for drawings as symbolic representation and those who argue for an identity of optical projections cannot be resolved and suggested that there is some sort of higher-order correspondence in which the artist captures 'invariant relations' (information) in the original scene and it is these invariants that are represented in the line drawing.

Marr's (1976) suggestion that an artist's local symbols — lines — are in correspondence with natural symbols computed by the brain out of the image during the normal course of its interpretation, it would seem, *does* resolve the conflict: lines of line drawings have neither point-to-point correspondence with the original scene, nor are they arbitrary symbols — they correspond to a description calculated by the visual system itself. While the idea that visual processing should commence with the extraction of a more or less elaborate line drawing is not entirely new, it has gained currency as a result of Marr's work (see Marr 1982). Marr, whose ideas about early vision were themselves inspired by the ability of line drawings to represent the visual world with power and economy, proposed a model for edge specification by the human visual system. His model was based on some quantitative studies from psychophysics which indicated the type of operations that the visual system may first apply to a retinal image. He pointed out that regions of a natural image where intensity undergoes significant change occur at different spatial scales — from changes at fine scales, such as the structure of leaves on a tree, to coarse scales, such as the clumping of groups of trees. These changes can be found by two operations. First the image is

'smoothed' or, in effect, blurred. The amount of blurring determines the fineness of the detail in the image. For example, a small amount of blur will turn the leaves on a tree into a homogeneous green area, but the tree will still be distinguishable from the neighbouring trees of the clump. More severe blurring will amalgamate the trees in the clump, but still leave the clump distinguishable from other nearby clumps. By blurring the image by varied amounts brightness changes at several spatial scales can be revealed.

Secondly, the locations of these changes can be found by finding where brightness changes most abruptly, for each chosen degree of blurring. For reasons which need not concern us here, the locations of image positions at which brightness changes most abruptly are known as 'zero-crossings'.

Marr proposed that some nerve cells in the visual system could perform these operations: the 'zero-crossings' in the outputs of neurones which looked at a small region of the image would locate positions of most abrupt brightness changes at a fine scale, whereas neurones which processed a larger region of the image would locate such changes at a coarser scale. He further proposed that these regions of change in intensity may be combined over a number of spatial scales to construct lines ('zero-crossing segments') which identify places in the image where significant features occur. He suggested that the visual system combines zero-crossing segments that align at a number of scales, and the result is a description he called the 'raw primal sketch'. It is uncertain how far Marr's suggestion would work, but it is accepted by many authors that a function of early vision is to form a more or less elaborate line-drawing-like description of the retinal image.

An interesting logical consequence of the notion that the visual system may compute a line-drawing-like description is that this computation would need to be 'idempotent' when subjected to an actual line drawing. That is, the line-drawing-description that the visual system calculates from an actual line drawing imaged on the retina would need to be very similar to the line drawing itself if the line drawing is to be readily interpreted by the visual system. Marr's model loosely fulfils this requirement, as is illustrated in Fig. 17.6, though other models (for example, Burr and Morrone 1990) behave better.

Line drawings are interesting because not only are the lines dense in information — sketches of lines and objects using only lines are often sufficient for good representation even when the lines are very sparse — but the lines themselves provide no indication of the direction of the intensity changes that they mark and this property of line drawings does not seem to render them useless for human vision. There are two implications arising from this lack of sign of lines in

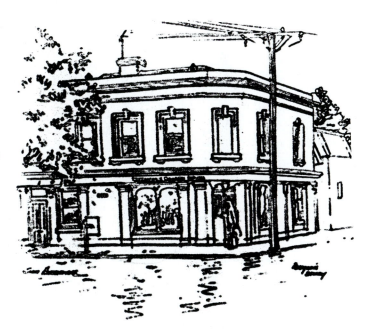

Fig. 17.6. 'Zero-crossings' of the line drawing shown in Fig. 17.2 (b). This image loosely fulfils the 'idempotency' requirement (see text). If one assumes that the visual system is so good at interpreting ordinary line drawings because it itself computes a line-drawing-like representation, then any process intended to mimic that computation should not significantly alter a line drawing that is passed through it. The 'local-phase congruence' algorithm (see Fig. 17.3) fulfils this requirement.

line drawings. Firstly, a black on white simple line drawing should be interpreted as readily as a white on black line drawing. As can be observed from the drawings shown in Fig. 17.7 and confirmed by the experimental results presented beneath the drawings, this is indeed true: not surprisingly, simple line drawings are usually as easily 'read' in both positive and negative form. However, it is only true providing that positioning of lines to represent different brightnesses has not been employed by the artist. This type of drawing, illustrated in Fig. 17.8, while constructed of lines, is not in the sense in which we are speaking simply a line drawing, since the artist has capitalized on the property of the visual system to average over local regions of space and has thereby introduced simulated shading.

The second implication arising from the lack of sign of lines is that since simple line drawings are not multi-stable, flipping from positive to negative appearance, rather as a Necker cube flips from one depth solution to the other (Fig. 17.9), the visual system must solve this potential problem.

One way a solution may be achieved is by means of top-down processing — stored knowledge of the probable direction of lightness distribution is used in the interpretation of the drawing. However, a more parsimonious explanation is that the lines of line drawings are processed by the human visual system as unsigned tokens, that is, as representing, for example, a black–white border without implying which side of the border is black and which white. Since it is unlikely that the visual system has developed separate processes for the inter-

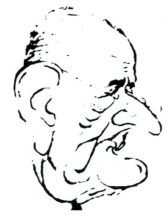
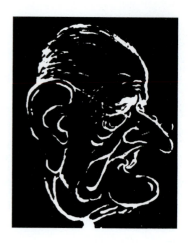

Fig. 17.7. Positive (black-on-white) and negative (white-on-black) simple line drawing. Simple drawings, like this one, are as readily interpreted in positive or negative form. The graph below the images shows the result of an identification task in which observers were briefly presented with a line drawing and were then required to point to a photograph — one among an array of photographs — of the face of the person that they decided the drawing was of. As can be seen, no significant difference was found between performance in the two conditions of this task (the bars indicate one standard error — a measure of the variation in the judgements — above and below the average results of ten subjects).

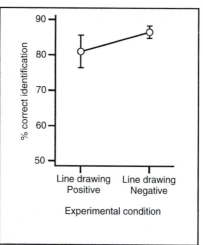

pretation of line drawings, that the unsigned nature of lines in line drawings presents no problem for vision suggests that at some early stage of analysis the visual system produces a description which is itself unsigned.

However, that line drawings that contain an element of shading or blocking (often called mass), even if the amount is small, *are* less easy to interpret in negative than in positive form is shown by the drawings, and results of an experiment beneath the drawings, in Fig. 17.10. This type of drawing, unlike simple line drawings, also looks 'negative' when reversed. It is as if a small element of mass is sufficient to impart a sign to the rest of the drawing. We (Hayes *et al.* 1986) have shown that it is the coarse-scale components of photographs of faces in negative which present difficulties for vision, but not the fine-scale components. Simple line drawings carry little or no useful information at coarse scales, though some information is probably available about image structure (shape-from-shading) at

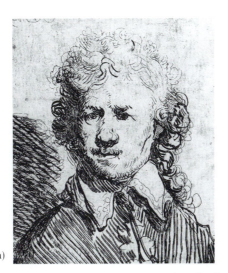
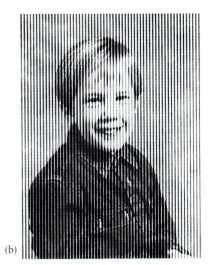

(a) (b)

Fig. 17.8. (a) Self-portrait by Rembrandt. The artist has used 'hatching' to simulate shading. The effect of the hatching is similar to the effect of varying line thickness to produce apparent intensity changes in the newspaper graphic shown in (b). Both of these images are interesting because even when viewed from a close distance, close enough for the individual lines to be clearly resolved, there is a strong sense of shading — that is multiple levels of grey. This effect is unlike that of a magazine monochrome photograph, which is made up of every fine dots of different sizes that, at normal viewing distances, are smeared together in order to result in a range of apparent tones. A degree of 'tonality' is achieved with the two images shown here even when the elements are not so small that they are smeared by the optics of the eye. Panel (a) Copyright British Museum.

Fig. 17.9. The Necker cube. This famous illusion shows spontaneous alternation of apparent depth, so that sometimes the upper and sometimes the lower square face appears nearer. Even though line drawings are ambiguous (in the sense that they do not convey which side of the border is darker) they do not show alternation between apparent dark on the light and light on dark, perhaps because the visual system itself extracts a representation of the scene which is independent of the direction of image contrast.

coarse scales for a line drawing which contains elements of mass — see Ramachandran's Chapter 11. A demonstration is shown in Fig. 17.11, which presents two drawings, one a simple line drawing (a), the other containing blocking (b), and their respective coarse-scale components. Speed (1923), in his classic text on the practice of drawing, differentiated between 'mass' and 'line' as parallel streams of pictorial representation, and pointed to the emphasis that individual artists may give to each; for example the emphasis that William Blake (see, for example, Plate 18) and Edward Lear give to line and J. M. W. Turner (see, for example Plate 12) and Claude Monet give to mass. This idea is also alluded to by Leonardo da Vinci in his Treatise on painting 'notes for the painter' (see epigraph) and is suggestive of the idea that the visual system itself selects out elements of mass and line for separate processing.

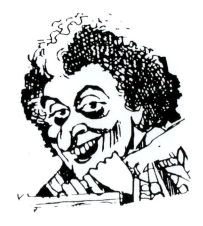

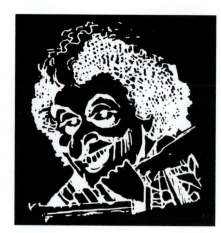

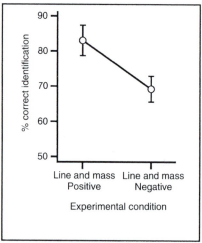

Fig. 17.10. Positive (black-on-white), and negative (white-on-black) line drawing containing an element of 'mass'. These drawings, even where the element of mass is small, are not as readily interpreted in negative as in positive form. The graph below the images shows the result of an identification task similar to that described in the caption to Fig. 17.7. As can be seen, negative images are significantly more difficult to identify than positive images.

The results of some of our recent work (Hayes *et al.* 1986; Burr *et al.* 1986) have provided support for this notion, indicating the existence of two separate processes: one operating at coarse scales and the other operating at fine scales. The coarse-scale process (mass), which may be thought of as engendering shape from shading, is sensitive to sign and the fine-scale process (line) is insensitive to sign and may be thought of as engendering contour structure. It seems that even for images changed to two intensity levels, shape-from-shading derived from coarse scales still plays a role in image perception. Figure 17.12 shows a full-tone photograph (a) and a two-tone 'lithographic' image (b) of Albert Einstein. Beneath each image the coarse-scale components of each are shown ((c) and (d)). As can be readily observed, there is little difference between the two coarse-scale images, implying that the structural properties of the usually smooth changes associated with shape-from-shading are preserved in the two-tone image (which may account for the

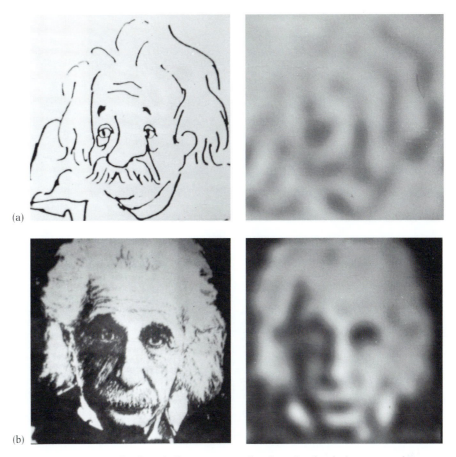

Fig. 17.11. Two sketches of Albert Einstein and to the right of each the coarse-scale components. The coarse-scale components of the line drawing (a) contains little information useful for recognition of the face; however, there is useful information in the coarse-scale components of the image in (b), which has been drawn using a 'blocking' or 'fill' technique (emphasizing mass rather than line). © 1974 Sidney Harris. Reproduced with permission.

remarkable power of two-tone images such as lithographs and medieval woodcuts: see Hayes 1988).

The arguments and demonstrations presented in this chapter support the idea, implied by Leonardo, of the existence of two systems which process visual input, one activated by edges and lines, the other by mass. The first results in a symbolic description that specifies contours; the second is intensity-driven and is used in extracting shape-from-shading. The lines of line drawings correspond to edges and bars and possible other features observed in the original scene. The lines are unsigned and this presents no problem for vision because the visual system itself constructs an unsigned description which signals feature position alone. Mass in a chiaroscuro drawing — a sketch in light and shade — corresponds to shading in the orig-

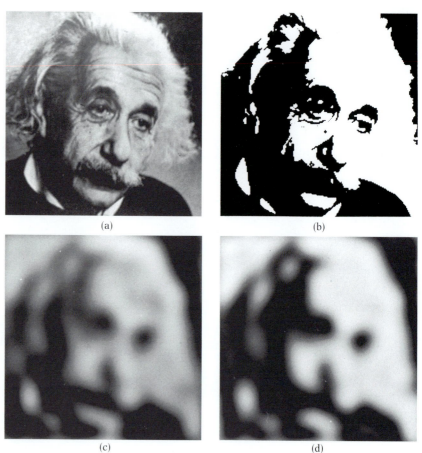

Fig. 17.12. (a) Full-tone and (b) two-tone images of Albert Einstein. The two-tone image was made by changing the full-tone image to two values (black and white). The threshold for change was chosen so that approximately 50 per cent of the image is forced to black and 50 per cent to white. The two images below the full-tone and two-tone pictures, (c) and (d), are smoothed versions of each. The fine-scale components have been removed, leaving only the coarse-scale components. The coarse-scale components of each image are very similar, indicating that there is little loss of these components in the thresholded image. The smooth changes associated with 'shape-from-shading' are contained in the coarse scales and are preserved in the two-tone image.

inal scene and shading is inherently signed and tends to operate at coarse scales.

The implication here is that shape-from-shading is derived from the interaction of the coarse-scale brightness gradients in the image and the feature boundaries signalled by the first process. This idea has some support from recent results of Ramachandran (1988 and this volume, Chapter 11), who demonstrated that the perception of three-dimensional shape results from the interaction of luminance gradients and occluding edges that delineate shape from its background. This strong influence of local boundaries on global shape

Fig. 17.13. Spatially coarse-quantized (blocked) image. Each square is set to the average brightness of the original image in that region. The image becomes recognizable when viewed from afar. For this image, a distance of approximately 70 times the height is about optimal. At this distance a face will be perceived that may be recognizable to some southern-hemisphere readers, but even those who do not recognize the face will be able to perceive details such as approximate age and sex, etc. Spatially coarse-quantized images pose a problem for vision scientists because the effect of viewing from a distance is to remove information — the fine-scale components are eliminated and the coarse-scale components remain. While the fine-scale components contain no information about the face (they carry the edges of the blocking structure), it is odd that their removal, by increasing viewing distance, should allow the face to be revealed, since the coarse-scale components are present both when viewed from close up and when viewed from afar. It is as if, when the image is viewed from close up, the fine-scale structure perceptually masks the coarse-scale structure. For discussion of this issue see Harmon and Julesz (1973) and Marr (1982, p. 74).

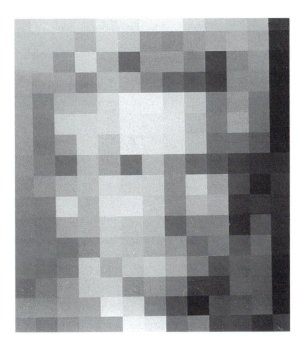

perception (also shown by Burr *et al.* 1986) is probably an important factor in the inability of observers to recognize faces in 'blocked' portraits (unless they are blurred or, better, viewed from a distance), such as the one shown in Fig. 17.13

References

Attneave, F. (1954). Some informational aspects of visual perception. *Psychological Review*, **61**, 183–93.

Burr, D. C. and Morrone, M. C. (1990). Feature detection in biological and artificial visual systems. In *Vision: coding and efficiency* (ed. C. Blakemore). Cambridge University Press, Cambridge, UK.

Burr, D. C. Morrone, M. C. and Ross, J. (1986). Local and global visual processing. *Vision Research*, **26**, 749–57.

Gibson, J. J. (1954). A theory of pictorial perception. *Audio Visual Communications Review*, **1**, 11–23.

Gibson, J. J. (1971). The information available in pictures. *Leonardo*, **4**, 27–35.

Goodman, N. (1969). *Languages of art: an approach to the theory of symbols.* Oxford University Press.

Harmon, L. D. and Julesz, B. (1973). Masking in visual noise: effects of two-dimensional filtered noise. *Science*, **180**, 1194–7.

Hayes, A. (1988). Identification of two-tone images: some implications for high and low spatial frequency processes in human vision. *Perception*, **17**, 429–436.

Hayes, A. Morrone, M. C., and Burr, D. C. (1986). Recognition of positive and negative bandpass-filtered images. *Perception*, **15**, 595–602.

Kepes, G. (1951). *Language of vision* (8th edn). Paul Theobald, Chicago.

Marr, D. (1976). Early processing of visual information. *Philosophical Transactions of The Royal Society of London, Series B*, **275**, 483–524.

Marr, D. (1982). *Vision*. Freeman, San Francisco.

Ramachandran, V. S. (1988). Perception of shape from shading. *Nature*, **331**, 163–6.

Ratliff, F. (1972). Contour and contrast. *Scientific American*, **226**(6), 90–101.

Speed, H. (1923). *The practice of drawing*. Seeley, Service, and Cooper, London.

18 In the studio of Vermeer

PHILIP STEADMAN, WITH PHOTOGRAPHS BY
TREVOR YORKE AND RICHARD HEARNE

It has become almost universally accepted among Vermeer scholars
that the artist used the camera obscura as an aid in setting up his
compositions. The first person to suggest this was Joseph Pennell
(1891), the American etcher and lithographer, in an article in the
Journal of the Camera Club. Since then the idea has been taken up
again and again — by Lawrence Gowing (1952) in his great mono-
graph and more recently by Arthur Wheelock (1977), Svetlana
Alpers (1983) and a number of others (Hyatt Mayor 1946; Seymour
1964; Schwartz 1966; Fink 1971; Blankert 1978). This belief does
not however rest on any documentary evidence. What little is
known about Vermeer's life is drawn almost exclusively from civil
and legal records (Montias 1989) and these throw no light whatso-
ever on his methods of working. No drawing by his hand is known.
Some historians have imagined connections between Vermeer and
those of his contemporaries who are known to have been interested
in optics and perspective illusion, such as Fabritius or van
Hoogstraten; but these links are entirely hypothetical.

The belief rests rather on certain properties of the paintings them-
selves. The first is what Pennell called the 'photographic perspective'
of such pictures as the *Officer and Laughing Girl*, in which the figure
of the soldier is so disproportionately large. We are familiar with
such effects today from snapshots — the perspective is quite correct
for the 'close up' viewpoint — but for a seventeenth-century paint-
ing the disparity in size of figures that are placed so near together is
most unusual.

Second is the extraordinary fidelity, the minute accuracy, with
which Vermeer reproduces the *maps* seen hanging on the walls in a
number of his interiors. The historian of cartography James Welu
has discovered surviving examples of all the printed maps and globes
which appear in the pictures and has shown how precisely Vermeer
copies the originals (Welu 1975). It is a map of Holland designed by
Berckenrode which features for example both in the *Officer and
Laughing Girl* and in the *Woman in Blue Reading a Letter*. The camera

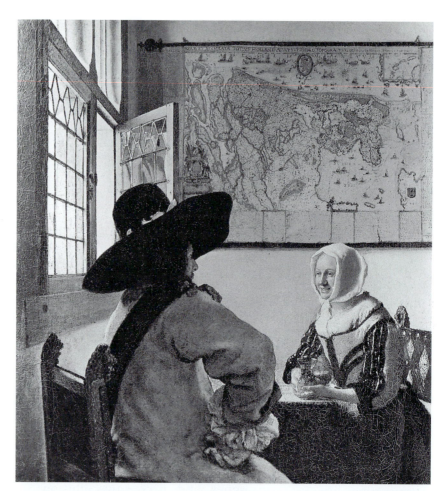

Fig. 18.1. *Officer and Laughing Girl.* Copyright The Frick Collection, New York, 50 × 46 cm.

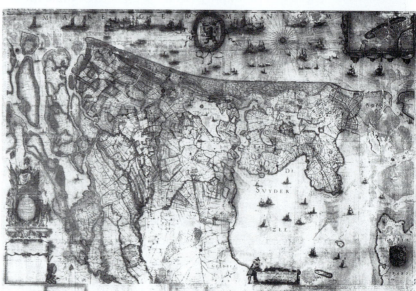

Fig. 18.2. Actual copy of printed map of Holland designed by Balthasar van Berckenrode in 1620 (compare Fig. 18.1). Courtesy of the Westfries Museum, Hoorn, Holland.

obscura was used in the eighteenth and nineteenth centuries for copying existing pictures and prints. (Of course this fact proves nothing definite in the case of Vermeer, who could well have made such accurate copies by other means.)

The third piece of evidence for Vermeer's supposed use of the camera obscura is his treatment of *highlights* on reflective surfaces such as metal, ceramics, or polished wood. These often take the form of small circles of white or yellow pigment. They occur for example on jugs, wooden furniture, and upholstery nails. It has been suggested that these reproduce artefacts of slightly unfocused optical images, in which points of light are spread into small circles of confusion — something which would not of course be seen by the unaided eye. Hyatt Mayor (1946) wrote of these highlights that they 'break up into dots like globules of halation swimming on a ground glass'.

There are two examples where Vermeer's 'soft focus' rendering of polished metal seems especially 'photographic': the pair of tiny portraits in the National Gallery in Washington, *The Girl with a Red Hat* and *The Young Girl with a Flute*. The lions' head finials on the chairs are painted here in a particularly loose and schematic style, which nevertheless seems to catch very realistically the reflections of light off the sculptured brass. In the early 1960s the critic Charles Seymour and the photographer Henry Beville made some experiments to try to simulate these effects (Seymour 1964). They used a nineteenth-century viewing camera to obtain out-of-focus images of a similar lion's head and velvet drape. The results were quite convincingly close to Vermeer's painted treatment.

Finally, Lawrence Gowing (1952) has pointed to some more general qualities of Vermeer's style which might be attributed to a study of optical images. In many passages Vermeer seems to transcribe just the pattern of lights and darks in his subject with little of the underlying modelling or drawing by which other artists would build up a representation. As Gowing puts it:

> The description is always exactly adequate, always completely and effortlessly in terms of light. Vermeer seems almost not to care, or even to know, what it is that he is painting. What do men call this wedge of light? A nose? A finger? What do we know of its shape? To Vermeer none of this matters, the conceptual world of names and knowledge is forgotten, nothing concerns him but what is visible, the tone, the wedge of light.

The portrait of *The Girl with a Pearl Earring* was X-rayed at the time of the van Meegeren forgeries. This X-ray shows some striking features which Gowing suggests may provide further clues to the use of the camera. The first stage of painting seems to consist of a 'sharply contrasted pattern of light and dark', without evidence of line or design. 'No other artist's method', says Gowing, 'reveals this

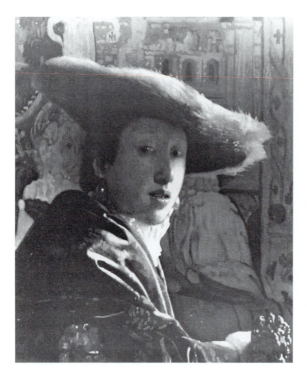

Fig. 18.3. *The Girl with a Red Hat*. Courtesy of the National Gallery of Art, Washington DC, 23 × 18 cm.

Fig. 18.4. Photograph taken by Henry Beville of the image in a camera obscura, to simulate details in *The Girl with a Red Hat* (compare Fig. 18.3). Reproduced with permission from Seymour (1964).

immediate and perfect objectivity: the radiography of painting has indeed never shown a form in itself as wonderful as this strange, impersonal shape. We are in the presence of the real world of light, recording, as it seems, its own objective print.'

This then is the background to the hypothesis of Vermeer's use of the camera obscura. There is no doubt that the apparatus and the necessary knowledge of lenses *could* in principle have been available to him. Holland was of course a centre for the manufacture of high-quality optical instruments in the seventeenth century. The camera obscura was used by several astronomers in the early 1600s, including Kepler (1604, 1611) and the Jesuit Christopher Scheiner (1630), who made detailed studies of sunspots. Constantijn Huygens, father of the physicist Christiaan, recorded in his memoirs how he bought a camera obscura in London in the 1620s from the mysterious Dutch inventor and alchemist Cornelis Drebbel. Huygens took the instrument back to Holland and gave a demonstration at which the painter Torrentius — another shadowy figure on the edges of alchemy — was present. Although Torrentius was secretive about his techniques, Huygens got the strong impression that he already knew all about the camera, and attributed the remarkably detailed realism of Torrentius's still lifes — of which only one is known today — to his use of the instrument (Huygens 1946).

Books describing the camera obscura and its possible use in paint-

Fig. 18.5. Detail (left) from *The Girl with a Pearl Earring*, and radiograph (right) of the same detail, showing sharply contrasting areas of light and dark. Left hand panel © Mauritshuis, The Hague. 46 × 40 cm. Reproduced with permission.

ing would have circulated in Holland, notably della Porta's *Magia naturalis* (1558), which went into many editions, and Athanasius Kircher's *Ars magna lucis et umbrae* (1646). So the camera obscura was known in Holland and seemingly known to artists during Vermeer's lifetime (1632–1675), although, again, there is no firm evidence that Vermeer himself was familiar with the device.

I have approached this old question from a new direction: through the *perspective geometry* of Vermeer's paintings. Anyone who looks even casually at these pictures is struck by the fact that several of Vermeer's interiors — perhaps as many as a dozen — seem to show the same room. One of the best views of this room is *The Music Lesson* from the Queen's collection at Buckingham Palace. Certainly many similar architectural features recur: a very characteristic pattern of leaded panes in the casement windows, on the floor, black and white marble tiles (arranged in several distinct patterns, whose size, mottling, and colour are however always similar), and where the ceiling is visible, the same size and spacing of ceiling joists. We might suppose that this is an actual room in Vermeer's house 'Mechelen', on the market square in Delft, which he perhaps used as

a studio. (The site of the house is known, and it appears in an eighteenth century engraving; but unfortunately it was demolished in the nineteenth century.) Always in these dozen pictures the far, blank wall is viewed frontally and the window wall is to the painter's and viewer's left.

My first step was to try to reconstruct the architecture of this room in three dimensions, to determine whether the proportions and dimensions matched in all cases. There are several recognizable pieces of furniture — the lion's head chairs, a table with bulbous legs — which also recur from one painting to another and whose sizes could also be compared. It is possible to make this reconstruction with some accuracy, because of the fact that the floor is tiled and so provides a reference grid. The technique (first described by Leonardo) is essentially that for setting out a frontal or one-point perspective, but carried out in reverse.

The straight lines of the architecture receding away from the viewer all converge together in the picture to the central 'vanishing-point'. This establishes the level of the horizon line, which passes through the vanishing-point. The diagonals of the pattern of floor tiles also converge together and meet at two more points on the horizon line, the so-called 'distance points'. The distance from vanishing-point to either distance point must be equal to the distance of the theoretical *viewpoint* of the picture from the picture plane, along a perpendicular passing through the vanishing point. (Because two distance points can be plotted, there is a double check on this dimension.) From the height of the vanishing-point in the picture it is possible to compute the height of the viewpoint above the floor of the room. From all this information it is possible to work out more-or-less complete plan and side views of the room and its furniture.

(There are in principle many — indeed infinitely many — three-dimensional forms which can correspond to any single two-dimensional perspective projection. It is necessary in this kind of reconstruction to make some supplementary assumptions: that the architecture depicted is rectangular, that the tiles are square, that chairs and tables are the familiar shapes we know them to be, and do not have pathological Ames-type deformities — all of which seem reasonable.)

Figure 18.6 (a)–(d) show plans made in this way for four of the paintings: *The Music Lesson, The Concert, A Lady Writing a Letter with her Maid,* and *A Lady Standing at the Virginals.* Figures 18.6 (e) and 18.6 (f) show plans for two more pictures, *A Woman and Two Men* and *The Glass of Wine,* which seem to show a room with similar windows, but different floor tiles. These are small red and black clay tiles, not the black and white marble. I will come back to this point.

This geometrical procedure can be used to find the *relative* sizes of

the various features of the room, but not the absolute scale. Speaking strictly geometrically, the pictures might just as well show dolls in a doll's house as real people in normal-size rooms. It is possible to make some fair guesses, of course, as to the heights of human figures, the typical heights of chair seats and table tops, and so on. However, there is a more exact way of finding the true scale and that is from the printed maps, whose actual dimensions are known (assuming Vermeer painted them at their real sizes). Vermeer also shows in two of the interiors a real painting which belonged to his family: Dirck van Baburen's *The Procuress*. This picture belongs today to the Museum of Fine Arts in Boston and provides another measuring scale. Several paintings show musical instruments such as the viola da gamba. The virginals in *The Music Lesson* are recognizable as the work of the famous firm of Ruckers. These instruments were made to standard sizes and provide yet another cross-check on dimensions.

I tried to relate the versions of the room in the different paintings together, by taking a common unit for the size of the marble floor tile. As the assumed dimension of the tile is varied, so all other features of the architecture are scaled up or down accordingly. By means of a great deal of experiment I was able to find a size of tile which brought all the furniture and human figures to plausible sizes and the maps and van Baburen's *Procuress* precisely to their known sizes. It emerges that, with certain minor inconsistencies, the dimensions of the room and of the recognizable pieces of furniture *are* the same from painting to painting. In the case of the two pictures with the ceramic tiled floors, the sizes all work out consistently if it is assumed that these tiles are exactly *half* the dimension of the marble tiles.

Vermeer's house was presumably built of brick, like all houses of the period in Delft, and indeed it transpires that the dimensions of such features as window embrasures and the spacing of joists are exactly consistent with brick construction.

There are some parts of the room which we never see directly, in particular of course the part behind us, behind Vermeer as he painted. There are, however, two paintings in which we glimpse this area indirectly. In *The Music Lesson*, on the far wall above the virginals, hangs a *mirror* (Plate 19). (I will come to the second case later.) The precise alignment of this mirror can be worked out from the known positions of the furniture and floor tiles reflected in it. Just visible are Vermeer's easel and stool. The stool turns out to stand, as it ought to, precisely below the theoretical viewpoint of the picture. (Vermeer himself, elusive as ever, is nowhere to be seen.) And at the very top left-hand corner of the mirror, it is just possible to see a fragment of the back wall of the room.

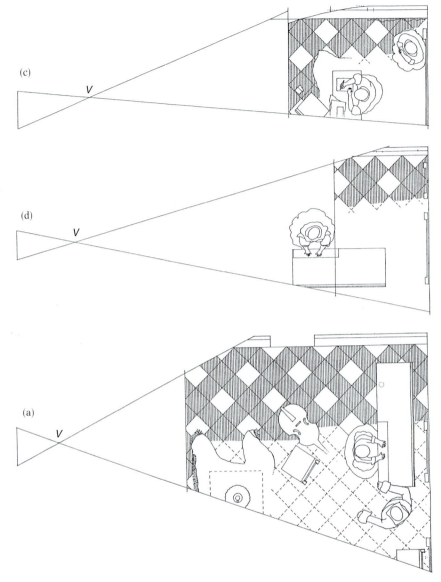

Fig. 18.6. Reconstructed floor plans of the parts of Vermeer's room visible in six paintings, drawn to a common scale. *V* marks the theoretical viewpoint in each case. For paintings **(a)** to **(d)** the marble floor tiles are assumed to be the same size throughout. In paintings **(e)** and **(f)** the ceramic tiles are assumed to be half the size of the marble tiles.
(a) *The Music Lesson* (Queen's Collection, Buckingham Palace, London, 73 × 64 cm). (b) *The Concert* (Gardner Museum, Boston, 72 × 65 cm). (c) *Lady Writing a Letter with her Maid* (Beit Collection, Blessington, Ireland, 71 × 58 cm). (d) *A Lady Standing at the Virginals* (National Gallery, London, 52 × 45 cm). (e) *A Woman and Two Men* (Herzog Anton Ulrich-Museum, Brunswick, 78 × 67 cm). (f) *The Glass of Wine* (Gemäldegalerie, Berlin-Dahlem, 65 × 77 cm).

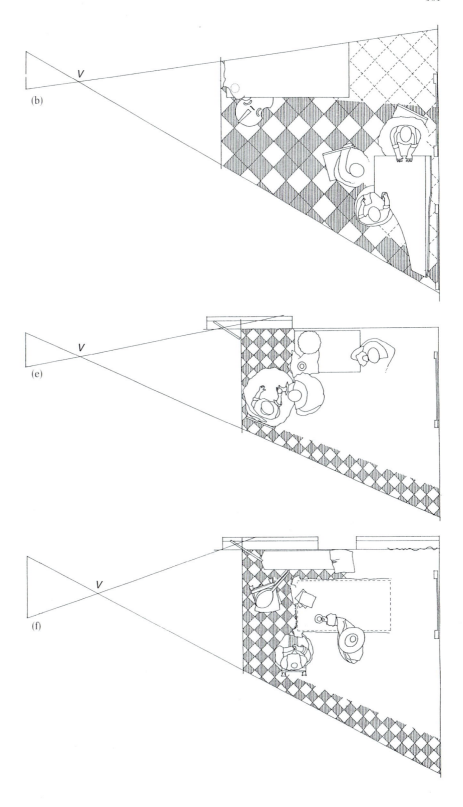

(b)

(e)

(f)

This gives us the length of the room overall. It turns out that the dimension corresponds nicely to an exact number of repeats of the tile pattern on the floor. It also allows for three equal-sized and equally-spaced windows, of which only two are generally visible. So on this hypothesis the whole conjectural plan of the room is symmetrical.

Figure 18.7 shows the viewpoints and angles of view of the six reconstructed pictures, all superimposed on this plan. The viewpoints are not all the same: Vermeer moves back and forward 50 cm or so and moves laterally over a larger distance. But he is always in this same general area, opposite the centre of the [hypothetical] backmost window.

It was at this point that I made what I believe is the significant discovery in relation to Vermeer's technique. If the angle of view of each picture, both in plan and in side view, is carried back through the viewpoint to meet the back wall, it defines in effect a rectangle on that wall. In all the six cases illustrated, *this rectangle is the exact size of the corresponding painting.*

This fact, I suggest, is very strong evidence that Vermeer used an optical arrangement in which a lens was placed at the viewpoint of the picture and an image was projected on to the back wall. Vermeer would then have traced this image. He would have needed to view such an image in relative darkness. We can imagine that he screened

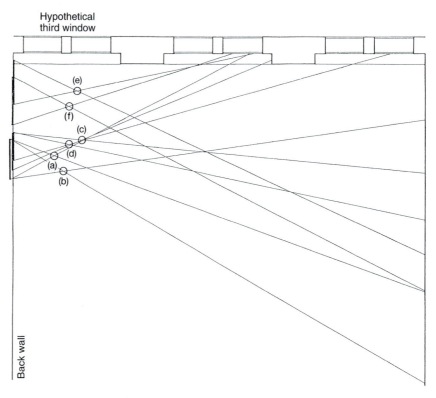

Fig. 18.7. Reconstructed floor plan of Vermeer's room. The letters mark the viewpoints of six paintings (see Fig. 18.6). The angles of view are carried back to meet the back wall. The hypothetical third window is at top left.

off a small cubicle and placed the lens in a hole in this screen. This is a camera obscura, a darkened room, in the literal sense, inside which Vermeer would have worked. Figure 18.8 gives an idea of what this arrangement might have looked like. It would have been necessary to shift the lens to the viewpoints of the different pictures. Perhaps it could have been set in a movable screen whose edges were then curtained with drapes? If there *was* a window at this position in the room, it would have been very convenient. The external shutter could have been closed to black the cubicle out, and opened again when light was needed.

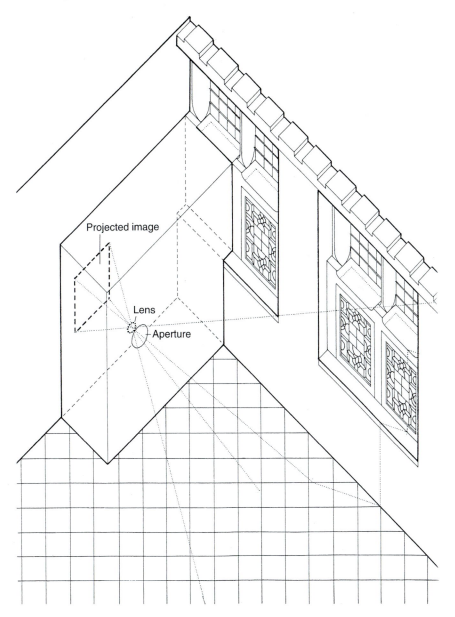

Fig. 18.8. Suggested arrangement of Vermeer's camera obscura. Note that the cubicle coincides with one casement of the (hypothesized) back window, whose external shutter could be closed to black it out, or opened to give light.

The projected image, as seen from inside the camera, would have been reversed top to bottom and left to right. The fact of its being upside-down would have been inconvenient, but nothing worse. The lateral reversal is however more problematic. If Vermeer had placed a sheet of paper or canvas on the wall to receive the projected light directly and then traced, he would have ended up with a mirrored image.

One possibility can be dismissed: that Vermeer's studio was not in reality as we see it in the paintings, but was itself mirrored, like the room Alice stepped into through the looking-glass. This attractive idea is spoiled by the fact that the people in the pictures hold glasses, play stringed instruments and write letters with their right hands, and, more conclusive, the maps and the written inscriptions on the virginals are evidently *not* reversed.

There are, however, two quite straightforward ways in which Vermeer might himself have effected the necessary reversal. *Either* he could have traced the images on the back wall directly on to paper and then reversed them laterally in the process of transferring them to canvas. It was standard studio practice to transfer a drawing by pricking through the design with a pin, laying the paper over the canvas, and sprinkling it with 'pounce' (powdered charcoal), which sifted through the holes. The technique was used widely in the Delft pottery industry. If the paper was laid drawing-side down, the image on the canvas would thus be mirrored.

Or else it is conceivable that the relevant part of the back wall might have coincided with an *opening* into the next room. This might either have been a door or an internal window (such windows are characteristic of houses of the type and period), in which Vermeer could have placed a sheet of semi-transparent material — perhaps cloth or oiled paper — and traced from the opposite side. This would have given him an image which was not then laterally reversed and which could have been transferred to canvas by pricking through (but *not* turning the sheet over) as before. A cubicle-type camera obscura on precisely this arrangement is illustrated by Kircher in *Ars magna lucis et umbrae*. Kircher's diagram is somewhat eccentric, but the principle is perfectly sound.

It would not have been possible for Vermeer to *paint* — or at least to paint in colour — inside the cubicle while studying the projected image, because of the lack of light. We must imagine that his main use for the camera was to obtain an outline drawing of his composition. Perhaps he was even able to achieve his singular method of underpainting in the 'sharply contrasted pattern of light and dark' to which Gowing refers, by setting his canvas directly alongside the projected image or taking it inside the camera at intervals for comparison? We can imagine that at the later stages of painting Vermeer

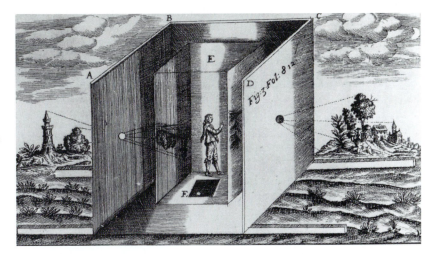

Fig. 18.9. Cubicle-type camera obscura from Athanasius Kircher, *Ars magna lucis et umbrae* (1646). The artist draws on the back side of a translucent screen. (It is a double camera, with a pair of lenses and screens facing in opposite directions.)

would have worked in the full light, but might have stepped into the camera every so often to study tonal and colour values.

Is it possible that in this hypothesized tracing technique we might find an explanation for the odd fact that, although the room shown in the six paintings has exactly the same size and design in all cases, the patterns of floor tiles shown by Vermeer are always changing? There are the two types of tile, ceramic and marble; but even the placing of black and white marble tiles varies, as mentioned, from one picture to another. Nevertheless, the reconstructions show that the lines of tiles in all these patterns fall precisely on the same underlying grid — even the smaller ceramic tiles, since these are half the dimension of the marble. The paintings showing the ceramic tiled floors are generally thought to be earlier works. It is of course conceivable that Vermeer had his room re-tiled. But is another possibility that Vermeer painted the ceramic tiles in front of him a couple of times, but later decided to ring the changes by filling in the same traced grid with some alternative patterns?

There is another instance where the same outline seems to have been filled in differently in detail. The instruments in the *Lady Standing ...* and the *Lady Seated at the Virginals* are identical in size and design, with the exception of the two landscapes painted on the insides of the lids. When these 'paintings within paintings' are reconstructed front-on, instead of being seen at steep angles as Vermeer shows them, they turned out to be anamorphic or stretched perspectives. These appear quite normal when seen obliquely, but would seem grossly distorted if seen frontally. This fact suggests strongly that neither landscape appeared on the actual instrument, but that they were composed by Vermeer within the trapezoidal per-

spective outlines of the lids, to suit the respective moods of his two pictures.

What about the six remaining pictures, out of the dozen which show the room in question? Do they fit the theory? For three of these the matter cannot be decided, since they do not show sufficient areas of floor to make reconstructions possible. Two more pictures, the *Art of Painting* and the *Allegory of the Faith*, do *not* have projected images at the correct sizes on the back wall. These are, however, unusual among Vermeer's interiors in being very much larger paintings than all others — about 120 cm in height, where the remainder are all approximately 60 cm. Perhaps the compositions for these pictures were worked out in the same way as the others, and were then enlarged up somehow to their final sizes? The last picture in the group is the *Lady Seated at the Virginals*. This too does not project at its true size on the back wall, despite the fact that its companion piece or 'pendant', the *Lady Standing at the Virginals*, *does* fit the theory. This anomaly is quite perplexing.

In order to test the hypothesis more fully, I have had a model built of the room at one-sixth full size. I have also had furniture, 'props' and, for *The Music Lesson*, appropriately-dressed male and female figurines made to the same scale. At the back of the model room a photographic plate camera can be placed, with the lens at the positions of the various viewpoints and its plate in line with the back wall. This camera plays the role of Vermeer's camera obscura. With the furniture, figures, and camera in the correct positions, each composition can be recreated photographically. The model allows for light and shadow effects to be studied that the purely geometrical analysis on paper could not address.

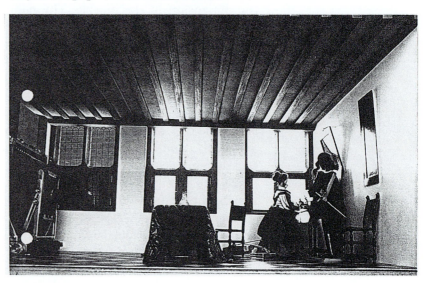

Fig. 18.10. Model room at 1 : 6 scale, showing furniture for reconstruction of *The Music Lesson* and plate camera in position.

Plates 20 and 21 show the photographic simulation of *The Music Lesson*, set against the original painting for comparison. It is clear that the geometrical match is very close, although there are some small discrepancies, such as that the model virginals have been made slightly too short and the jug at the right is too large. The model is lit by lamps with large diffusers outside the windows to simulate north light. Much of the lighting of the original is closely reproduced, as, for example, the shadows under the virginals, the bright patch on the far left-hand wall below the sill, where light is reflected off the polished end of the virginals case, and the double shadows cast by the virginals and mirror, which result from light arriving from the two nearest windows. (Vermeer paints shadows for the mirror, however, which are not consistent with the angle at which it must hang to have the reflection he shows in it.)

Plates 22 and 23 show *The Concert*, but without figurines in the reconstruction. Van Baburen's *The Procuress* is modelled with a one-sixth scale photographic reproduction (in black-and-white) of the real work. Plates 24 and 25 show *A Lady Standing at the Virginals* (without the lady). The main geometrical discrepancy here is in the window, which differs somewhat in the details of the leading and the mouldings of the frame, from the windows shown in other paintings. The colours of the anamorphic landscape on the virginals lid are rather bleached in the model by comparison with Vermeer's original.

Photographic reconstructions of this kind were made for all six relevant paintings and fully confirmed the geometrical findings of the original drawings. In every case the same model and the same pieces of furniture (where appropriate) were used, with the camera plate always exactly in the line of the back wall. Although the *Allegory of the Faith* is not one of the pictures which fits the hypothesis, a photographic experiment was made for this painting too, since this is the second case where Vermeer shows a mirror reflecting the back of the room. This mirror is spherical and hangs by a ribbon from the ceiling. Vermeer includes it for its allegorical significance, to symbolize 'the ability of the human mind to contain the vastness of the belief in God' (Wheelock 1981). For the present discussion, it has however a more practical interest: it reflects, though dimly, a wide vista of the room, including the whole of the window wall. Although the windows are partly shuttered and curtained, it is plain that there are *three* of them, with the third window, never otherwise seen, in the position next to the back wall which we have hypothesized.

A small mirrored ball of the correct diameter was set in the model room and photographed. The pattern of light reflected from the windows in Vermeer's rendering was quite accurately reproduced (Fig. 18.11). Whether Vermeer's actual cubicle can be made out in

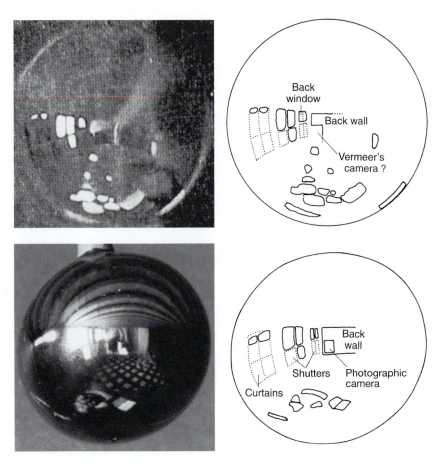

Fig. 18.11. Detail (above) from *Allegory of the Faith* (Metropolitan Museum of Art, New York, 114 × 89 cm) showing the spherical mirror reflecting the back of Vermeer's room and (below) a photographic recreation of the same detail using a mirrored ball in the model room. Three windows are visible in each case: one on the left in the reflection, heavily curtained, one in the centre with one of its lower casements shuttered, and one on the right (at the back of the room) with both its lower casements shuttered.

his painted reflection is more dubious. There is a clearly defined patch of light tone corresponding to the upper part of the back wall, above where the camera should be; but what is in the darkness below it is difficult to say.

In 1989 BBC Television built a set of the room at full size, furnished as for *The Music Lesson*, for an edition of their popular science programme *Take Nobody's Word for It* devoted to this work on Vermeer. A simple biconvex lens of 10 cm aperture was used for the camera obscura. An image of the room was cast on to a translucent screen in an opening in the back wall (as in Kircher's arrangement), so that it could be filmed from outside the room. The result was a clear sharp image at the actual size of the painting, quite bright enough to film. Some writers on Vermeer and optics have questioned whether a camera obscura used indoors would not give an image so dim as to be useless. They cannot have made the experiment for themselves. The windows of Vermeer's studio occupy a large fraction of the wall in question and the room would have been very well lit. In the BBC studio set, the lighting, although it came entirely

through the windows, was of course artificial and powerful. On the other hand the human eye is much more sensitive than the television camera.

In this paper I have presented what I believe to be conclusive proof of something that has been long suspected: that Vermeer did make extensive use — indeed much more extensive than previously thought — of the camera obscura. I have offered much supplementary speculation about his precise techniques. But if readers are sceptical about any of the details, I would ask them to acknowledge at a minimum the central geometrical findings: the coincidence of the 'projected images' of the six paintings on the back wall of Vermeer's room. This is too much to be coincidence in the second sense of the word and demands explanation. Note that the basic geometrical conclusions do not even depend on finding the position of the back wall from the mirror reflection in *The Music Lesson*. Even if this piece of evidence did not exist, it would still be the case that a single plane could be found — at this same position — on which the projected images of the six paintings would all assume their correct sizes.

Are there other techniques or methods of composition, besides the camera, which could account for these geometrical facts? Some authors, such as Wilenski (1945), have suggested that Vermeer traced over or measured images in a *mirror*. But this would mean that the mirror would have had to be placed in a new position — nowhere near the back wall — for each painting. Others, chief among them Swillens (1929/30, 1950), have argued that Vermeer constructed his perspectives geometrically. (Swillens made plans and side views of the room — or rooms, as he thought — in which Vermeer painted, similar to those described here, although his measurements seem to have been rather imprecise. He was adamant that Vermeer used no optical aids.) But it is *not* the case that Vermeer used for example some uniform perspective construction with fixed patterns of vanishing-point, horizon line, or standardized image of the grid of floor tiles. On the contrary, these differ appreciably from one painting to another, because of the differing viewpoints.

Both these suggested methods — the use of mirrors, and the use of standard perspective layouts — are perfectly plausible and feasible in themselves. The point is that neither can explain the peculiar geometry which I have demonstrated and that this geometry *is* consistent with the simple camera obscura arrangement proposed.

Coda

There is one more twist to this detective story. I have no new information to add here to what others have already suggested, but the

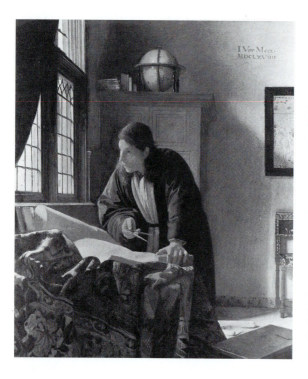

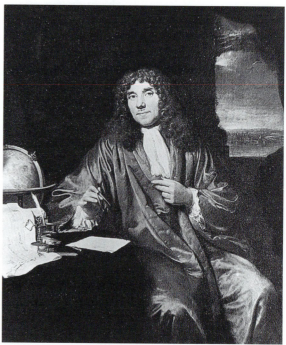

Fig. 18.12. *The Geographer* Courtesy of the Städelsches Kunstinstitut, Frankfurt, 53 × 47 cm.

Fig. 18.13. Portrait painting of *Antony van Leeuwenhoek* (1686) by Johannes Verkolje Courtesy of the Rijksmuseum, Amsterdam. (Verkolje also made a mezzotint version of this portrait in which the figure is reversed and holds a microscope instead of the dividers.)

picture is not quite complete without this one last tantalizing, if inconclusive, clue. Who might have taught Vermeer about optics and lenses? The question is completely open — there is again no firm evidence, but an intriguing possibility is that it might have been the pioneer of microscopy, Antony van Leeuwenhoek.

Leeuwenhoek was born in Delft in the same year as Vermeer — their names appear on the same page of the register of births. And when Vermeer died, Leeuwenhoek acted as his executor. It is possible that he performed this service as part of the duties of his part-time civic office of chamberlain — Vermeer died bankrupt, but it is also possible that he did it as a family friend.

It has even been suggested by Lucas (1922) that it is Leeuwenhoek who is portrayed in the two matching pictures by Vermeer now known as *The Geographer* and *The Astronomer*. *The Geographer* is dated 1669. This is the year in which Leeuwenhoek qualified as a surveyor. The picture gets its title only from the surveying instruments and maps which the scholarly figure has laid out around him. Leeuwenhoek's appearance is known more certainly from a portrait painting and mezzotint by Johannes Verkolje, made when he was 54. If it *is* Leeuwenhoek in *The Geographer* he would then have been 37. There are strange resemblances between the two paintings: the loose flowing gown and cravat, matching globes from the publisher Hondius, the fact that both men carry dividers in the

right hand. Are they one and the same man — the same fleshy features, the same prominent long nose? It is a pleasant thought to imagine a congenial friendship between Vermeer and Leeuwenhoek, these two great masters of minute, patient observation of the effects of light.

Acknowledgements

This work would not have been possible without the contributions of the many craftsmen and women who helped so enthusiastically to recreate and photograph Vermeer's studio in miniature and at full size. George Beale of Bassett-Lowke built the model room and he and Cyril Hughes made the furniture. Sue Reed made the costumes and Deborah Hopson the pots. Trevor Yorke and Richard Hearne took the photographs. The full-size room for *Take Nobody's Word for It* was built by John Bone, and the programme was produced and directed by George Auckland and Hendrik Ball.

References

Alpers, S. (1983). *The art of describing: Dutch art in the seventeenth century.* John Murray, London.

Blankert, A. (1978). *Vermeer of Delft.* Phaidon, Oxford.

Fink, D. A. (1971). Vermeer's use of the camera obscura — a comparative study. *Art Bulletin,* **53**, 493–505.

Gowing, L. (1952). *Vermeer.* Faber, London.

Huygens, C. (1946). *De Jeugd van Constantijn Huygens door Hemzelf Beschreven* (ed. A. H. Kan). Donker, Rotterdam and Antwerp.

Hyatt Mayor, A. (1946). The photographic eye. *Bulletin of the Metropolitan Museum of Art,* **1946**, 15–26.

Kepler, J. (1604). *Ad Vitellionem paralipomena.* Frankfurt.

Kepler, J. (1611). *Dioptrice.* Augsburg.

Kircher, A. (1646). *Ars magna lucis et umbrae.* Rome.

Lucas, E. V. (1922). *Vermeer of Delft.* Methuen, London.

Montias, J. M. (1989). *Vermeer and his milieu: a web of social history.* Princeton University Press.

Pennell, J. (1891). Photography as hindrance and a help to art. *Journal of the Camera Club,* London, **V**, 75.

Porta, G. B. della (1558). *Magia naturalis.* Naples.

Scheiner, C. (1630). *Rosa ursina sive sol.* Rome.

Schwartz, H. (1966). Vermeer and the *camera obscura. Pantheon,* **24**, 170–80.

Seymour, C. (1964). Dark chamber and light-filled room: Vermeer and the camera obscura. *The Art Bulletin,* **46** 323–31.

Swillens, P. T. A. (1929–30). Een Perspectivische Studie over de Schilderijen van Jan Vermeer van Delft. *Oude Kunst* **VII** 129 ff.

Swillens, P. T. A. (1950). *Johannes Vermeer, painter of Delft 1632–1675.* Spectrum,

Utrecht–Brussels.

Welu, J. A. (1975). Vermeer: his cartographic sources. *The Art Bulletin*, **57**, 529–47.

Wheelock, A. K. (1977). *Perspective, optics and Delft artists around 1650*. Garland, New York.

Wheelock, A. K. (1981). *Jan Vermeer*. Thames and Hudson, London.

Wilenski, R. H. (1945). *Dutch painting*. Faber, London.

19 How do forgers deceive art critics?

DAVID PHILLIPS

We begin with an aesthetic roller-coaster. The watercolour shown in Fig. 19.1 was, for many decades, a prized possession of Manchester University's Whitworth Art Gallery, a Gauguin of 1889 called *En Bretagne*. Then one day in 1980 a letter arrived in the post from the celebrated critic and collector Douglas Cooper, who was working on a catalogue raisonnée of the work of Gauguin. He was courteously forewarning the gallery that he would not be including *En Bretagne*, since it was clearly a grotesque forgery. He pointed out various shortcomings, notably the unusual use of gold paint and a strange signature. After surprisingly little discussion, a consensus developed that he was probably right. Over the next few years, the picture even travelled around the country in an exhibition of forgeries. Then one day in 1987 the morning post brought a letter from the National Gallery of Art in Washington. They were organizing a definitive Gauguin show and sought the loan of *En Bretagne*. It was, the letter suggested, one of the artist's finest drawings and without it the exhibition could not claim to be definitive. Some of Washington's enthusiasm for the picture can be put down to the truly Byzantine courtesies and exaggerations which are the small change of correspondence between exhibition organizers and the owners from whom they hope to coax loans. All the same, off to Washington the picture went, once again with the dignity of an autograph work. No wonder that the Washington catalogue entry begins: 'This watercolour poses certain problems ...' (Brettell *et al.* 1988).

What on earth is going on? Surely this is either a fully elaborated study by a great artist, an object endowed with those rare properties which alone can induce in the viewer a special mental state of aesthetic rapture, or else it is a pitiful travesty, by which no experienced viewer of pictures could be deceived for a moment? The question arises whenever a major deception in the art world unravels, and it is hardly surprising if it contributes to the common suspicion that the whole business of art is a fraud. As the boatman who took some of the delegates to the meeting out of which this book developed for

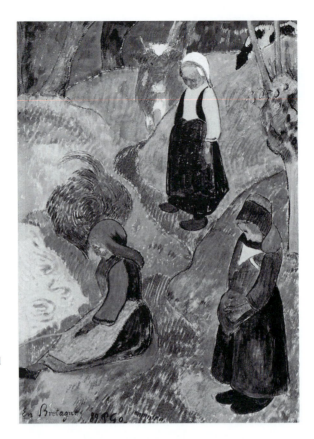

Fig. 19.1. Gauguin or not Gauguin? *En Bretagne*, attributed to Paul Gauguin, Courtesy of Whitworth Art Gallery, University of Manchester.

a trip round Bristol's Docks remarked of the renowned and pioneering Arnolfini contemporary art centre, 'Don't tell them, but that's what we call the Arnolphoney Gallery.' Many art historians now would also take the view that 'connoisseurs' are so readily deceived because the whole notion of connoisseurship is simply a self-deceiving vehicle for expressing social power. The absence, in English, of a word for the business of artistic judgement less loaded with social pretension than 'connoisseurship' speaks volumes by itself. There is no question but that all kinds of messages about social power are indeed encoded both in what pictures show and in how we look at them. Anyone who wants to retain in the process as well a role for aesthetic experience as special state of mind, attained through the perception of mysterious but physical qualities, which only gifted makers can realize in artefacts, has a difficult case to defend. Coming to terms with the puzzle of the deceptive powers of forgeries is an inescapable first step.

Perhaps the deception of the connoisseurs is only puzzling if we suppose that we should be able to switch on aesthetic rapture, rather as one might switch on a light, just by propping up a connoisseur in front of a work of quality. That might be true if aesthetics were a

simple matter of stimulus and response but it would also allow aesthetics only a lowly status amongst other conscious perceptions, along with spontaneous reactions like the involuntary glance with which we respond to a movement glimpsed in the periphery of vision. Fully conscious perception, most specialists assure us, is an active, searching process, in which knowledge and expectation contribute largely to whatever is perceived. Allow that they also contribute to aesthetic perception and much of the surprise of the deceptions of forgery vanishes. To make a physical replica or imitation of an object hundreds of years old is hardly credible, but to manipulate expectations and attention is commonplace. Forgeries are like conjuring tricks: they play the role in aesthetics that optical illusions play in everyday vision. Far from being mysterious, their success is only to be expected.

The history of forgery offers a good deal of anecdote consistent with this idea. We will concentrate on forgeries of Western pictures. These, as we shall see, can be laughably unlike their originals. The secret of their success often lies not in craftsman-like fabrication of an object physically indistinguishable from its model, but in conman-like skill in presenting it so as to encourage in the viewer the wish and expectation that it should turn out to be genuine. To assess a work of art, the expert relies on evidence of three kinds: old-fashioned connoisseurship, scientific examination, and historical information. Again and again, the very evidence on which the experts rely is turned against them, as in a novel by John le Carré. Let us look at each kind of evidence in turn, seeing first how it can help the expert and then how it can be deceptively manipulated.

First, the evidence of connoisseurship. Such judgements are notoriously hard to put into words without recourse to vague atmospherics. I hope, though, to show that, at least in a number of instances of forgery, it is not hard to discriminate between model and imitation on the basis of quite down-to-earth criteria.

Figures 19.2 (a,b, and c), for instance, all show images of the *Madonna and Child* associated with Botticelli. Two are generally accepted attributions, in the Uffizi in Florence. The third was bought by Lord Lee for £30 000 in 1929, much reproduced as a masterpiece in the next decade and then quietly exposed as a recent forgery when Lord Lee's collection came to the Courtauld Institute after the Second World War. In this case, a judgement can be made on what one might call dramatic rather than abstract formal criteria. Two of the images present us with Madonnas with notably abstracted expressions on their faces. That perhaps seems right for Botticelli, when we call to mind the dreamy face of the famous Venus, being blown to shore on her shell. In fact it is unusual. Botticelli was a marvellous observer of human mood and expression and his pictures

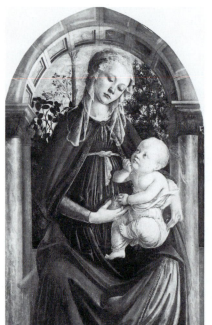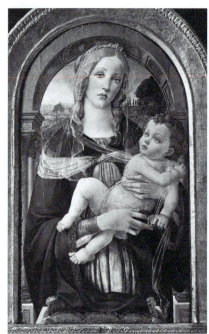

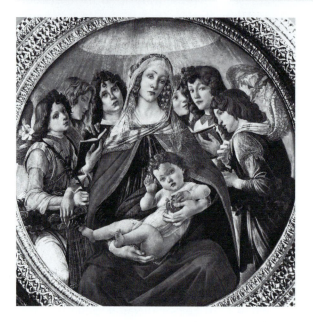

Fig. 19.2. Which picture is not by Botticelli? (a) Sandro Botticelli, *The Madonna of the Rosebush*, Uffizi, Florence. Photo Copyright Archivi Alinari S.p.A. (b) Imitator of Botticelli, *The Madonna of the Veil*, Courtesy of University of London, Courtauld Institute, Department of Conservation and Technology. (c) Sandro Botticelli, *The Madonna of the Pomegranate*, Uffizi, Florence. Photo copyright Archivi Alinari S.p.A.

are characterized by the intense awareness shown by his figures of themselves, one another, and the viewer. In one of the autograph works here, mother and child are, as is usual with Botticelli, intensely focused on one another. In the second, the Madonna is moodily self-absorbed, but as a result the temporarily neglected child is restless and fractious. In the forgery the Madonna looks like a

teenager admitting, not for the first time, that she has forgotten her bus fare. Her infant looks stoned. There are plenty of Botticelli-style pictures with Madonnas and children looking just as vacant as this, but none now thought, on other grounds, to be autograph, except perhaps the Racsinsky Tondo in Berlin. Here again, the Madonna and child are surrounded by animated figures.

Whoever made Lord Lee's forgery may not have had the imagination to invent and develop an idiom, as Botticelli did, but he or she was no mean performer. It is, one might say by musical analogy, in many ways an impressive performance of Botticelli. Many forgeries, by contrast, are technically incompetent. Compare one of Samuel Palmer's landscapes with an imitation by Tom Keating, in Figs. 19.3(a) and 19.3(b). Samuel Palmer was an artist whose rather escapist romanticism disguises an absolute passion for acute observation of the three-dimensional shape of things. He understood how characteristic patterns in nature, whether in the landforms of a view or in the branching of a tree, depend on natural processes. If we compare one of his drawings with a detail from an imitation by Tom Keating, we can see that Keating conjures up a certain mood, but misses the acute observation of shape and space. Look at the foliage on the tree to the left in each picture. In one it is firmly massed around the branches of the tree and the branching looks as if it might have grown that way. In the other picture, the top of the tree suddenly sprouts feeble branches, not unlike a bunch of bananas, which disappear into a foam of leaves. The hillside to the right of the same picture suddenly takes an improbable upward turn towards its summit; a similar profile in Palmer's picture makes sense as an outcrop of rock. We could take a stab at a map of Palmer's scene, marking in distances and contours in the landscape. We would be hard put to do the same for Keating's. Just what happens at the foot of the hill?

The same criteria serve to sort out a sketch by Constable from an imitation, as shown in Plate 26. The imitation, as Charles Rhyne pointed out (Rhyne 1981, pp. 403–7), is from the collection, but probably not the busy hand, of James Orrock. Orrock had a notoriously relaxed, but generous, attitude to the work of his predecessors; he felt he understood it so well that he was entitled to paint more pictures on their behalf. Once again, ask yourself how easy it would be to make a map from each picture. One picture represents a sequence of spaces leading on one to another. The other is a sequence of profiles, each mercifully occluding the uncertainties beyond. Does the barge which we see in one of the pictures seem to be in proportion to the bridge it has just passed under?

Judgements of competence often suffice to rule out poor forgeries. They are less help with the work of a critic's own time which pre-

(a) (b)

Fig. 19.3. Which is the
Samuel Palmer? (a) Samuel
Palmer, *The Flock and the Star*,
Courtesy of the Ashmolean
Museum, Oxford. (b) Tom
Keating, *Shepherd and his Flock in
a Hilly Landscape with Shoreham
Church (detail)* Courtesy of Mrs
Geraldine Norman.

sents novel aesthetic conventions. The shortcomings of Orrock's imi-
tation Constables would still have been hard for even a late nine-
teenth-century eye to detect. We are still particularly vulnerable to
forgers of such painters as Matisse and Picasso. Nor do judgements
of competence help with forgeries by more competent forgers. We
can get nearer to more specific qualities by thinking of the picture
surface just as a two-dimensional pattern and then seeing how
pattern properties have been used to represent space and things,
rather as words are combined with music in singing. We can try and
see how forgers miss the bus at two different scales of size. First we
will look at the way in which whatever is represented can be orga-
nized into patterns which work across large sections of the surface.
Then we will look at patterning, such as brushstroke marks, more
locally characteristic of the graphic process used for the picture.

Samuel Palmer had a passion not only for the structure of things,
but especially for three-dimensional shapes which made for strong
patterning in pictures. As the eye travels up the picture by him in
Fig. 19.3 there are two broad masses of light and shade. The flock of
sheep, seen as a whole, becomes lighter with distance, until it pre-
sents a bright profile against the dark base of the hill. Dark gives way
to light as the eye moves up the hill, which in turn appears light
against the sky. The shading is not smooth. The backs of the sheep
make up a roughly periodic pattern of bright patches in the flock, in
which the area of brightness tends to increase from what one might
call cell to cell of the pattern. The trees in a wood on the hillside do
the same for part of the hill. Furthermore, the straight line of what
one might call the horizon of the flock of sheep resembles the

straight backs of the individual sheep, whilst the rounded shape of the hill is echoed on a smaller scale in the rounded trees, and again in the rounded clumps of foliage just visibly composing them. Why it should be that combining patterning like this with representation has an effect like combining words with music is mysterious, but Palmer's work is full of examples. Nothing like this is happening in Keating's imitation.

At a smaller scale in the image we can look at patterns characteristic of the graphic process used for the picture, such as brushstrokes. At this level there is an effervescent spottiness about Tom Keating's imitations of Palmer which is not unconvincing. For a clearer example of failure we can turn to the two pictures associated with John Constable in Plate 26. In the details seen in Plate 26, the bright paint of Orrock's clouds has been pastily churned about in the manner which French painters call *la cuisine*. The darker, blue patches worked into the dough still look nearer to us than the clouds. Constable's clouds are effective illusionistically, intensely bright on top against the distant blue sky, but with convincingly vaporous bodies. The paint which represents them was rapidly applied, then left undisturbed. It is vivid as an evocation of a familiar visual experience, but remains beautiful as a pattern, like marbling.

Maybe advances in image processing will one day help us to characterize two-dimensional properties of the work of different painters considered just in the abstract, as patterns of light and dark. The pattern qualities I have chosen to describe in Samuel Palmer's picture are suggestive. The idea of an overall gradation from dark to light made up of periodic smaller gradations sounds a bit like an analysis of an image into spatial frequency components. The idea of similar shapes, like the profile of the hill, repeating on smaller and smaller scales, sounds a bit fractal. Fortunately for this author, we need not pursue in any detail what these mathematical terms mean. Though powerful procedures in image analysis, they offer, as yet, no scope in characterizing paintings.

Critics do though seem to use intuitive judgements about properties of this kind in pictures as aids to recognition. The Italian critic Morelli, at the end of the last century, tried to put connoisseurship on a scientific basis in a somewhat analogous way, by providing tables of the characteristic shapes of ears, hands, and drapery folds in the work of different painters. His idea seems to have been that by looking at parts of a picture which an artist might form as unconsciously as we form the shapes of letters in handwriting, the critic can concentrate on cues which suffice for recognition, whilst avoiding the subjectivity of more frankly aesthetic quality judgements. Just how rigorously Morelli intended his procedure to be applied is debated and a particularly psychological approach is taken in a

recent discussion by Maginnis (1990) that covers a number of the issues raised here. Morelli seems to have been concentrating on somewhat handwriting-like outlines of parts of the picture surface that would have been drawn with movements of the hand rather than of the whole arm. As we have seen, pictures offer a much richer menu of pattern properties, on many scales. Consciously or not, connoisseurs doubtless take advantage of them.

But then the whole house of cards collapses, because one of the pictures which Morelli studied and dismissed (as a studio work, not a forgery), is precisely the Botticelli Madonna and Child alone which I have used in Fig. 19.2 (relying on the near-universal consensus of all other scholars), as an example of a genuine Botticelli. That is not to dismiss connoisseurship as a method. It has proved very effective as an aid to the rather taxonomic study of pictures in schools and periods which preoccupied art historians for most of the century. It has provided the evidence on which alarm bells were set ringing in many forgery scandals. For instance David Gould, the Palmer special-ist, publicly dismissed one of Keating's imitations long before others spoke up, just on the basis of a newspaper photograph (Norman 1977, p. 211). But connoisseurship of this kind has a poor record, by itself, in gaining consensus.

Enter the forger. All the forger has to do, it seems, is to, as it were, hang a big enough label on his work, saying 'Botticelli' or 'Constable' very obviously and there is a fair chance that someone will accept the forgery. Shortcomings like those described are over-looked, except by a handful of keen observers, who often keep quiet for legal reasons. At its simplest, as with Orrock's Constables, the label simply consists of picking the same subjects as Constable and painting in a sketchy manner. More sophisticated forgeries are often either direct copies, with small variants or else are compositions made up of elements from genuine works. Lord Lee's Botticelli was put together like this. The Madonna is quite like the lady in Botticelli's *Madonna of the Pomegranate*, but in fact she and her infant even more closely resemble their counterparts in another picture in the Uffizi, the *Saint Barnabas Altarpiece*. The coffered arch, the pillars, and even their capitals, beneath which Lord Lee's Madonna sits, are also borrowed. Notice how they closely resemble those in the other Botticelli shown. Keating often used this trick as well. Similar suck-ling lambs appear at lower right in both his picture and Samuel Palmer's in Fig. 19.3. It is a clever procedure, because artists fol-lowed it in their own work as well.

Some of the resulting forgeries only succeed in fooling people who are not knowledgeable; others deceive extremely acute critics. For one viewer the knowledge may just be a familiarity with the kind of subject-matter and landscape preferred by Constable. Another may

recognize the reassuringly familiar details in facial and architectural detail in a Botticelli. Whether the knowledge of the viewer is great or small, what matters is that it can be turned so as to favour a mistaken judgement. The trick works because every critic, collector, curator, or dealer presented, often very secretly, with a Botticelli, Palmer, or Constable, terribly wants it to be genuine thus offering the chance of a marvellously enviable discovery or acquisition or a prodigious financial killing. Once the carefully sown seeds of attribution have taken root, the victim jumps to an aesthetic conclusion. Curiously, from then on, counter signs are just ignored.

Even experienced critics seem to jump to aesthetic conclusions, and on the most varied of criteria. In this respect the anecdotal evidence seems to fit in well with experimental findings reported some years ago by David Perkins (1979). He reported a number of experiments, his own and others, in pursuit of common criteria on which aesthetic judgements of quality were based. In the end the complexity of artworks and of the perceptual process obliged him to reserve judgement on the existence or otherwise of objective criteria of quality, but a number of interesting findings emerged from the spectacular lack of consensus displayed by his critical subjects. In particular, his critics tended to jump to aesthetic conclusions about the quality of pictures on the basis of detailed discussions of only very limited parts and aspects of the works they discussed. Such a tendency plays into the hands of the forger. The judgements of detail on which global judgements of quality in paintings are based are sometimes partial in the sense of being spatially local. In the case of Lord Lee's Botticelli, it does indeed seem that overall shortcomings were overlooked in the face of a mass of convincing detail. In other instances, as with Orrock's Constable, it is particularly at the level of detail that the forgery falls down. In the cases we are next going to discuss, the most powerful signals in favour of authenticity were often not visual at all, so much as scientific or historical.

No wonder connoisseurs turn to science in the hope that its instruments have a better reputation for objectivity (justified or otherwise) than the mind alone. They are generally in search of an opinion as to whether the materials and procedures employed in making a work of art seem compatible with its supposed date. This is often decisive. In the case of Lord Lee's Madonna, once doubts were raised the people in white coats made short work of pointing out all manner of failings. For instance, the X-ray in Fig. 19.4 shows that a modern, wire-drawn nail was driven into the side of one of the three planks of which the panel is composed, a little below the infant's lower hand, *before* the planks were assembled and painted over. But the whole point is that Lord Lee's painting was never given the scientific treatment in his lifetime. X-rays were available; just around

Fig. 19.4. X-ray of a detail from Imitator of Botticelli, *The Madonna of the Veil*, (Fig. 19.2 (b)), showing a modern nail embedded in the structure of the panel, in the area just below the hands of Madonna and child. Courtesy of University of London, Courtauld Institute, Department of Conservation and Technology.

the time he made his purchase, they were first used to expose peculiarities in the technique of the collection of Van Gogh's with which Otto Wacker amazed Berlin (Arnau 1961). But scientific tests seem to have been considered unnecessary by Lord Lee's advisers. The surface of the picture seemed, from a technical point of view, so convincingly bumpy, crackled, damaged, and repaired (Jones 1990). The fact that the venerable-looking trio of rather miscellaneous planks on which it was painted bore little resemblance to the exquisitely carpentered panels of fifteenth-century workshop practice escaped any commentator who left a record.

The most cunning contriver of scientific evidence in this way was the notorious van Meegeren, forger of Vermeer, for his most spectacular effort, the *Disciples at Emmaus*. Like the forger of the Lee *Madonna*, he anticipated all the obvious technical criteria assessable by a simple visual inspection. For instance he used a genuine piece of old canvas, from which he had scraped a seventeenth-century painting. He even avoided scraping away the old, cracked preparation on the canvas, because he had found a way of using the age-cracking in it as a foundation for inducing convincing cracking in the new paint layer of his forgery. More crucially, he also anticipated one more

technical scientific test. Faced with an apparently old oil painting, restorers used often to try the effect of a little mild solvent, such as white spirit, on some inconspicuous part of the surface. This is less alarming than it sounds, since genuinely old paint is extraordinarily hard and resistant, but it poses a problem for the forger. The test rapidly softens more recent paint. Van Meegeren hit on a painting medium using a synthetic resin, Bakelite, which could be mixed with oil and brushed on fluid, but dried to a hard, enamel-like surface, impervious to the restorers' mild solvents and remarkably convincing as an imitation of Vermeer's paint surface. It rapidly ceased to be convincing when subjected to more careful analysis as van Meegeren's career unravelled, but the point was that until rather late in the day it was never a candidate for such analysis, because it seemed to offer just the reassuring signals appropriate for the real thing (Werness 1983).

Just the same dangers lurk in the third line of defence, the evidence of history. First, it should be said there is one kind of historical evidence which is rarely of much help, even though it is argued over with passion in controversies about old paintings. The specialist seeking to discredit an attribution will often point out that something represented in the picture is historically inaccurate. Surely the inclusion of ocelot fur makes a mockery of the attribution of the *Adoration* to Mantegna? Could that acute observer Georges de La Tour ever have painted the laughably impractical detailing of the buff jerkin of the young man in *The Fortune Teller* in the Metropolitan Museum (Wright and de Marly 1980)? But always in these cases another specialist pops up, to say that the fur is not ocelot but genet, just what you would expect (Norman 1985), or that the detailing of the brown jerkin is right once we recognize it as a working-class *casaque* and so forth. The doubters could well be right in some of these cases, but we will probably never be sure of it. We just do not know enough about these arcane details of the past for a consensus to form.

More purely art-historical evidence, such as the existence of related works, is also very valuable, but we have already seen how dangerous it is in cases of forgery. Much more useful is the record of ownership and exhibition of works of art. Most works carry clues to this history, in the form of labels, stamps, and seals on their backs, recording saleroom appearances, exhibition loans, and customs inspections. These are valuable precisely because the same history can be reconstructed, even for a work currently lost, from documentary sources such as wills, inventories, and catalogues of sales and exhibitions. The leading scholars in this kind of expertise tend to know, for instance, that in the library of a small convent in Barcelona there just happens to be a catalogue of an auction in

Lyons in which, treasure of treasures, someone passed the time by noting down the names of the buyer of each lot. Evidence of this kind constitutes the acres of small text, under the heading 'provenance', to be found in definitive catalogues.

But of course this evidence too is vulnerable. There is, for instance, a standard process called lining in the conservation of oil paintings, which involves fixing to the back of a canvas a new, reinforcing canvas. The process has been employed for centuries, so that what can be seen on the reverse of a seventeenth-century painting will commonly be, say, an early nineteenth-century lining canvas. The lining canvas will have accumulated labels and inscriptions. In modern conservation practice, such later canvases are almost invariably removed before a new lining is added. The conservator is then left with a genuinely old bit of canvas, covered in perfectly genuine labels and inscriptions. Not everyone resists the temptation to paint a suitable forgery on the front of this canvas.

Alternatively, labels, seals, and inscriptions can also be forged. An imaginative set of inscriptions seemed to establish, at the end of the twenties, that a collection of no less than 2414 drawings which turned up in Soho were Corot's own collection, of all his most cherished and private sketches (Huyghe 1936). The inscriptions added up to a sort of diary, revealing that behind his notably blameless public persona the artist was prone to pinching cooks, lascivious fantasies about country girls, and temper tantrums when, by accident, he used his handkerchief as a paint rag. All this remarkable nonsense and more helped persuade the distinguished Keeper of Prints and Drawings at the British Museum amongst others that some, at least, of the drawings might be genuine. Again, many of us who recall admiring the spectacular group of Tom Keating's Palmers in a Bond Street show in 1972 overcame our surprise at the discovery of so many of them because of their provenance. Just fancy, they had been in a cupboard in Ceylon! We willingly overlooked the fact that only one or two brief inscriptions connected the pictures with the family who were supposed to have owned them (Norman 1977, p. 217). The family were genuine — the ancestors of Keating's girlfriend. Otto Wacker's Van Gogh's came from the oldest chestnut of all, a noble East European family whose identity had to be concealed to protect them from the wicked Communists.

Enough may have been said to confirm how feeble forgeries often are and how often they pass muster thanks to inspired conmanship. It is still mysterious that knowledgeable specialists in these cases perceive beauty in the works and it is hard to tell what is going on, since not many distinguished victims of forgery want to dwell on the experience. Fortunately, such valuable subjects, though rare, can be found at less distinguished levels of the business. Figure 19.5

(a) (b)

Fig. 19.5. Which is the Henry Pickering? (a) Henry Pickering, *Mrs Rowe*, Courtesy of York City Art Gallery. (b) Imitator of Henry Pickering, *Lady Dixie*, Courtesy of Nottingham Castle Museum and Art Gallery. (c) Imitator of Henry Pickering, *Lady Dixie* (detail). Courtesy of Nottingham Castle Museum and Art Gallery.

(c)

includes the first painting bought on my recommendation for a public museum. It came from an impeccable source, a venerable landed family from whom, years earlier, the museum had acquired a companion picture, of the lady's husband. They offered the wife in good faith. Both paintings bore the signature of the minor eighteenth-century painter, Henry Pickering, known to have worked extensively for the family. The husband's portrait is a rather grand, full-length affair; the wife's, in a thrifty convention of the times which is sexist without even being gallant, only three-quarter-length, in a standard format. There seemed little scope for complications.

It was only some time later that cleaning of the proud acquisition revealed that it was a nineteenth-century pastiche, probably painted as a decorative companion piece. It cannot have been a straightforward copy, since the artist turned out to have attempted an ambitiously elaborate costume and coiffure and then painted over it with something simpler. The painting technique was quite inappropriate

for a portrait of this type. Painters like Pickering tended to build up their paint surface in separate layers. You, I, or Van Gogh, wanting to end up with a pink colour, would most probably just mix some red and white on our palette, stir it about vigorously to get the colour even, and brush it on. That kind of direct, thick use of paint only became general in the nineteenth century. Earlier painters would commonly have got their pink by letting a layer of pale paint dry, not necessarily even a pink layer, and would then have added over it just a thin layer or glaze of red paint, rather like a tinting wash of water-colour. Techniques like this take advantage of the real physical behaviour of light within the translucent layers of oil paint to mimic subtle effects of light in nature due to the optical properties of such subject-matter as human flesh. The detail in Fig. 19.5(c) hints at how far from this kind of thing our new acquisition was. The high-light on her forehead is just a thick, pasty bit of solid impasto.

At the time, I did not know any of this and also had to make a judgement on a very discoloured painting. I recall, all alone in the basement of the museum, congratulating myself on the acquisition and admiring certain qualities of the dress and face, which I was sure would emerge even more vividly after cleaning. This kind of quite conscious projection of qualities into pictures is something that artists and art historians must do routinely. In the first place pictures are transformed by ageing and the conservation treatments they receive. The revelation of changes by cleaning is sometimes as dis-turbing as a veil of discolouring dirt. Quite often, for instance, a seventeenth-century painting which has been cleaned will seem very dark, with intense islands of the most glowing red and blue drapery, which seem to hang in space nearer the viewer than the rest of the figures they clothe. This is because the tonal range of the unsatu-rated dark colours has been lost in irretrievable darkening and with it the tonal gradations on which coherent spatial effects depended. The result is rather beautiful, but probably quite unintentional.

Before the opportunities for travel and for public access to collec-tions in the twentieth century, painters often had to form a view of the work of others largely on the basis of the even more remote and variable evidence of engravings by copyists. Now all too often we do the same through the dark glass of reproduction technologies. The illustrations in this article are many times removed from their orig-inals. Except in cases of forgery or mistaken identification, we remain, of course, quite conscious of the differences between damaged works, reproductions, and imitations and the originals from which they diverge. At the same time, in some strange way, we learn to see characteristics of individual schools and artists which are preserved in all these changeable manifestations and to see in them at least some aesthetic qualities.

How firm is the border between conscious and unconscious projection of previous experience into our aesthetic perception of pictures? Recognizing anything at all, after all, involves similar processes. As Maginnis (1990, p. 109) points out in the context of his discussion of connoisseurship, we recognize a familiar face in spite of the ever-changing appearances it offers with ageing, movement, changes of expression, and lighting. Recognition must require some comparison of each new presentation with a representation in memory from previous experiences. The nature of the constants peculiar to each face, which we extract for future reference and presumably update with each new experience, are notoriously mysterious. So are the processes of reference to them. Perhaps similar processes of reference to mental representations are involved not only in the recognition of works of art, but also in experiencing the recognition as beautiful. Art-lovers do seem to guard their expectations about art of different kinds as jealously as museums and collectors guard the actual works of art. Nothing in the world of art arouses greater passions than the two occasions which enforce sudden, radical changes in aesthetic expectation: the dramatic trans-

Fig. 19.6. Amedeo Zuccarini levitating in Milan, 1907.

formation of old favourites (such as currently Michelangelo's Sistine Chapel ceiling) by cleaning and the appearance of novel conventions in art. All this would seem to imply that we have to learn to see works of art as beautiful, which seems to be the case, but also that the individual work of art is less important in the business than the collective memory of many works. It is not so odd if some forgeries act as illusory stimuli.

Such an account of the mystery of the ready deception of connoisseurs leaves the door open to the possibility that there is something special about the effect on our awareness of 'great' works of art and about the talents which go into making them. It is no kind of proof, though. On the contrary, it is all just as compatible with the idea that the expectations of connoisseurs involve no kind of special state of mind at all, just old-fashioned status games. We are left, intent but puzzled, like the Italian physicists of 1907, whom we see in Fig. 19.6 trying to understand whatever is going on during a levitation séance in which they are also participants.

References

Arnau, F. (1961). *Three thousand years of deception*, pp. 226–41. Cape, London.

Brettell, R., Cachin, F., Freches-Thory, C., Stuckey, C., and Zegers, P. (1988). *The Art of Paul Gauguin*, catalogue no. 102, p. 181. National Gallery of Art, Washington.

Huyghe, R. (1936). Simple histoire de 2414 faux Corots. *L'Amour de L'Art*, **2**, 73–6.

Jones, M. (ed.) (1990). *Fake? The art of deception*, catalogue no. 7, p. 34. British Museum, London.

Maginnis, H. B. J. (1990). The role of perceptual learning in connoisseurship: Morelli, Berenson, and beyond. *Art History*, **13**, 1, 104–17.

Norman, G. (1977). Art trading and art faking. In *The Fake's progress* (T. Keating) pp. 200–72. Hutchinson, London.

Norman, G. (1985). Mantegna's 'Magi'; Fine art or forgery? *The Times*, 4 December p. 12.

Perkins, D. N. (1979). Are matters of value matters of fact? In *Perception and pictorial representation* (ed. C. Nodine and D. Fisher), pp. 301–14. Praeger, New York.

Rhyne, C. (1981). Constable drawings and watercolours in the collection of Mr and Mrs Paul Mellon and the Yale Centre for British Art. Part II, Re-attributed works. *Master Drawings*, **19**, pp. 391–425.

Werness, H. B. (1983). Hans van Meegeren *fecit*. In *The forger's art* (ed. D. Dutton), pp. 1–87. University of California, Berkeley.

Wright, C. and de Marly, D. (1980). Fake?. *Connoisseur*, **205**, 823, pp. 22–5.

20 My life and work

ELISABETH FRINK

RLG: Your art gives us a powerful sense of significance. I find this especially so with your famous Heads. They completely dominate a whole gallery. I would love to know just why they are so powerful. Your animals, also, really are wonderful. Almost more than living!

We want to feel that there is something significant beyond our own lives, but at the same time we want to feel that our own lives are highly significant in our relationship to our children, our love affairs, and our marriages and so on. How does one reconcile all this? You are very interested in religion. What worries me about religion is that it seems to be antipathetical to humanism, that is to family and individual aims, because it is looking at the next world in a highly metaphysical way, which is perhaps nothing to do with human life at all. I personally find that very scary.

Dame Elisabeth: Well, I think that one of the main worries about religion is looking to the next world and not being very caring for the present one. I think definitely that this is wrong. I think religion will have to change quite a lot. I don't know that it is changing enough and we all have to change it. There is no doubt that people find it very helpful to think of an afterlife, that when you go it isn't the end of everything; but it isn't in any case, because you leave something of yourself on this earth.

RLG: Well, you do because you are an artist, but what about the ordinary person who doesn't contribute anything very obvious, apart perhaps from producing children?

Dame Elisabeth: I don't feel that it is of all-consuming importance to me that my work will be here after I go. I don't think of it like that when I am working. If I didn't have my work I would hope that something of one's spirit would survive or that one would leave

Fig. 20.1. War horse.

something behind in the atmosphere. That sounds very fanciful —
it's a collective thing really. We exist for some reason, we are not
here for nothing. Even if you don't do very much with your life, in
some way you contribute something. There are diabolical people who
contribute nothing but destruction, of course — a negative contribu-
tion.

But I feel very strongly that the Church has to change its attitude
— the militant parts of religion that we are seeing now are appalling
— because it's very antihuman. I don't mean to be disrespectful to
Islamic religion, but I find the Koran a very tough book to read —
it's full of retribution, which I find threatening; so is the Old
Testament. It's the way the Catholic Church leans on poor people,
telling them that they will gain a place in heaven — if they worship
well, take the Sacraments, and believe in the Catholic religion, then
the hereafter will be beautiful. They are encouraged by the Church
in poor countries — i.e. South America/Mexico — to have large fam-
ilies, but they are starving and their children are suffering from mal-
nutrition — the Pope on his last visit saw all that, but nothing has
changed with the Catholic Church's attitude. I think that is very seri-
ously wrong and really dangerous and destructive. I don't know,

Fig. 20.2. Riace I, 1986,

though, whether it is possible to really change religion. But then you have Communism: that is frightful. The idea was wonderful, but it didn't work. People were deprived of religion in the Communist countries — and now look at it. They obviously wanted and needed their religion and weren't allowed it. People do need something to pin their faith and hopes on.

RLG: Because their lives are not sufficiently significant. If one got science really going, with more understanding of science in general, do you think this would be a substitute which would work? In other words, set up people's curiosity about the universe as it can be investigated rather than intuitively through metaphysics.

Dame Elisabeth: Well, I am sure science should help people to understand more. People are going around now living their lives without knowing what is going on half the time. They are missing out on so much.

RLG: I think most people see the universe as a sort of conjuring trick. If science were more generally understood, would one need religion, and then where would art be?

Fig. 20.3. Desert quartet, 1989.

Dame Elisabeth: I don't think one could live just by science — or any one thing alone. I don't know whether it's because our ancestors believed in magic and the earth and their roots and the elements far more than we do now, but this has come through to us and now — with the Green Movement, etc — there is a resurgence of this and people want to be part of their surroundings, and I think they should be. This is a part of the living thing that we have lost recently. People want to believe in a higher spirit or a God, they do need that. They regard science, I think, as something they don't quite understand. Something their minds can't aspire to. Ordinary people are not scientifically minded. At the same time, I would have thought that more people understand science now than they ever did before, because we get scientific programmes on the radio and television, which help us to understand. In medical science, life-saving operations and discoveries have been quite revolutionary, so in that sense it is essential that people become more scientifically minded and appreciative, and I think they will. This is not enough alone, though. I don't think anything is enough on its own — the human mind is far too complicated. It is better to believe in something passionately than to believe in nothing.

RLG: I sometimes think that we get fobbed off by religion. There are limits to human knowledge, and because it is not adequate we get fobbed off by a lot of fairy tales.

Fig. 20.4. Large lying down horse.

Dame Elisabeth: We can live with question marks.

RLG: I think religion stretches out the question marks until they look like exclamation marks — turning them into exaggerated statements of apparent truth.

Dame Elisabeth: Well, the dogma — being dogmatic about whether Christ rose again from the dead — may be rather ridiculous — but people want to believe it. I don't think that it is possible to wipe out religion. Communism certainly didn't achieve this. People are happy to be allowed to go to Church again. In its best sense this is very good, in its worst sense it is terrible.

RLG: Because it's obfuscating. What a good word!

Dame Elisabeth: Opaqueness and all that. I think people need religion and they need science and they need art. This is civilizing — going back even to the cup and saucer and things one has in one's house.

RLG: It also provides symbols one can latch on to which make one's mind resonate, so to speak.

Fig. 20.5.

Dame Elisabeth: It makes you think. Any piece of art or sculpture which makes people stop and think, meditate, has done its job. Even in the slightest sense — it doesn't have to be very deep.

RLG: Yes, this is very important.

Dame Elisabeth: People travel more and see the ancient splendours. But now tourism is wearing the world down. Have you heard that one? The Pennine Way is having to be repaved — the Parthenon is just disappearing! But on the good side, it is marvellous that people, who never would have done so before, are now seeing the wonders of the world, and that has got to be good. So people's comprehension will increase about science, art, and religion.

Fig. 20.6.

RLG: When you are thinking about one of your works, do you decide what its purpose is beforehand, or does it evolve as you are making it?

Dame Elisabeth: I have an idea, but then, I think, it evolves.

RLG: Can you describe this creative process?

Dame Elisabeth: It is always interesting because — if you take the Heads, for example, the early Heads with goggles — I wanted them to be very sinister and unpleasant and the later heads are much more meditative, contemplative things and therefore I think they are rather medieval. I love the medieval heads in old cathedrals because they are so thoughtful and very serene and serenity is a very nice thing to look at. If you are making a statement about man's inhumanity to man, then a very beautiful head is quite a good statement, because of the human side of the human face — there are so many sides. I have a fascination with the human head. You never know which way the mouth is going to go — accidents can happen, textures change, and the end-result is sometimes a surprise to oneself. But you don't create a work of art to impress people. I am trying to get an idea through. I am now trying to recreate for the public and for myself the image of the Green Man.

RLG: How far is a new work a statement of what they feel and think? I mean how far is it set up for other people to find their own meaning in it?

Fig. 20.7.

Dame Elisabeth: This is difficult to answer, because I don't think anyone can be expected to look at your work and have the same feeling as you do. Some might arrive at the same conclusion as I had in making it. A lot of people will look at it and read something else into it.

RLG: You don't mind that?

Dame Elisabeth: I don't think so because there may be some aspect of it that appeals to somebody else. As long as it appeals in some way, there is some reaction.

RLG: Does this make it different from writing? I write books on science, but I want the reader to understand what I am saying, not to read new meanings into it.

Dame Elisabeth: Well, they can't. I think that is one of the wonders of science, that what you say is true.

RLG: I want them to understand what I am trying to say. Then they can disagree with it.

Dame Elisabeth: But you write in such a way that people do understand.

RLG: Does that make science different from art?

Dame Elisabeth: No, I think in a way it makes it similar, because you are communicating and hope that your reader is understanding precisely what you are saying.

RLG: But that is different from being evocative. You can have something that makes that person's mind switch on; on the other hand, you are communicating an idea. Which does art do? I think science is trying to communicate a specific idea, but art is more evocative — stimulating, rather than communicative.

Dame Elisabeth: Yes, there is a lot of difference there. There are a lot of similarities too — for instance communication. I only worry about people seeing something different in my work if it is so different that it becomes derogatory. So long as it is stimulating to them, that's all right, and I can live with that.

RLG: So there are differences between science and art?

Dame Elisabeth: Oh yes, but it is interesting that a lot of scientists are very interested in art. Perhaps particularly music. Music is very important to me and I listen to a lot of music in the studio. I had a very interesting conversation with Alfred Brendel, the pianist. Now he is a very visual man — most musicians aren't. They have a very low visual sense, they are more literary, perhaps. He came here and looked at my sculptures, and I was fascinated to hear what he had to say about them. We met at another friend's house, who had an amazing collection of old paintings, and after dinner I was fascinated because he didn't sit down with everyone else for coffee, but spent the whole of the rest of the evening looking at the paintings. He just couldn't see enough. It was wonderful. All the arts — music, writing, sculpture — all have different levels. Most artists love music, though.

RLG: Yes, I think most scientists do.

Dame Elisabeth: Yes and I have met quite a few scientists who appreciate art. Often much more than, say, architects, which is terribly funny. They often don't want art on their buildings, as if it would mess them up. Of course, the relationship between the art or the sculpture and the building is important — then it can be very good.

Fig. 20.8. Man with goggles.

RLG: Perhaps that's what stucco means — stuck on!

Dame Elisabeth: Brilliant! Did you just invent it? You could start a whole new dictionary.

RLG: If I may say so, you are far more than brilliant. Somehow in your art you illuminate the very depths of the mind. This is wonderful, miraculous. Thank you very much indeed for sharing your view of life, and what seems to be beyond life, represented in your art.

21 Portraits of artists and scientists

NICHOLAS WADE

All the illustrations presented here combine two elements — a portrait and a design. Most of the designs have been drawn, painted, handwritten, or typed and these include the geometrical patterns and letter shapes used in the majority of the illustrations. Others have been derived from printed text, diagrams or, in one case, a musical score. The designs have then been converted to high-contrast photographic images, as have the portraits. The conflation of the two elements has been produced using a variety of photographic techniques, the details of which are described in Wade (1990). The intention throughout is to marry the design with the portrait by drawing on some common thread expressed by each component. The common threads are mentioned in the captions that accompany the illustrations, together with brief biographical details of the people portrayed. These are perceptual portraits, as the artists and scientists are alluded to rather than presented in stark clarity. Because the portraits are not often easy to see it may be necessary to view the illustrations from a distance of a metre or so (or to defocus them by some other means, such as removing spectacles if they are normally used for reading) in order to recognize the faces they contain. More examples of perceptual portraits can be found in Wade (1995).

Copyright for the illustrations is retained by Nicholas Wade.

References

Wade, N. (1990). *Visual allusions: pictures of perception* Lawrence Erlbaum Associates, London.
Wade, N. (1995). *Psychologists in word and image*. MIT Press, Cambridge, Mass.

To the Reader.

This Figure, that thou here seest put,
It was for gentle Shakespeare cut;
Wherein the Grauer had a strife
with Nature, to out-doo the life :
O, could he but haue drawne his wit
As well in brasse, as he hath hit
His face ; the Print would then surpasse
All, that was euer writ in brasse.
But, since he cannot, Reader, looke
Not on his Picture, but his Booke.

B. I.

Droeschout's *Shakespeare*

William Shakespeare was born in Stratford-upon-Avon in 1564 and died there in 1616. His plays were collected and published in the First Folio edition of 1623, on the title page of which is the most familiar and frequently reproduced portrait of the bard, the engraving by Martin Droeschout. Opposite the balding and collared Shakespeare is a poem by Ben Jonson reproduced here. It is addressed to the reader of the plays and it muses on the difficulty of Droeschout's task: the portrait is acknowledged as being a reasonable likeness of Shakespeare, but it fails to capture his wit and wisdom. Jonson accepts the impossibility of any picture achieving this and so he entreats the reader to study Shakespeare's words rather than look at his portrait. Droeschout's Shakespeare is embedded in Jonson's poem in such a way that when the portrait can be seen the text is illegible and when the words are read the portrait can no longer be discerned.

Bach's Fugue

Johann Sebastian Bach (1685–1750) was born in Eisenach, Thuringia, and died in Leipzig. He was a prolific composer, but his music was not appreciated by his contemporaries. Many portraits of Bach exist and there has been much debate concerning which one is the best likeness. It is generally acknowledged that the painting by Haussmann is the only authentic portrait and it is a detail from this that is represented in this picture. Bach's face is embedded in the copy of a score for a violin sonata made in his own hand.

Pointillism

Georges Seurat (1859–1891)
was born and died in Paris. His
art was greatly influenced by
visual scientists like Helmholtz
and Rood, and he developed the
style of pointillism or neo-
impressionism in the 1880s.
Small dots of (principally
primary) coloured paint were
applied directly to the canvas so
that they could mix in the eye.
The technique was painstaking
and slow and Seurat only
produced seven major paintings.
Pointillism involves additive
colour-mixing, which was
considered to be more closely
akin to normal colour vision
than subtractive colour-mixing,
where the colours are mixed
beforehand on the palette. The
spectator needs to view Seurat's
paintings from a suitable
distance, so that the individual
dots cannot be seen. Seurat is
here represented in black dots,
with slight differences in their
sizes defining his face and
straggly beard. As with Seurat's
pictures, the brightness
averaging which will yield the
portrait works best when the
dots themselves cannot be seen.
In addition to the portrait, which
is darker than the background,
Seurat's signature is present, too.
It can be seen in the lower left
and it is lighter than the
background.

Cubist

Pablo Picasso was born in Malaga, Spain in 1881, but spent most of his artistic life in France, where he died in 1973. Early in this century Picasso invented, with Georges Braque, the style we call cubism. It involved representing and uniting different viewpoints of an object or person on the same picture plane and it was a radical departure from the traditional styles of figurative art. The cube represented in this picture is made up of letters spelling the artist's name; the letters are themselves like three-dimensional forms and the viewpoints taken for the letters in Pablo and in Picasso differ. Each face of the cube contains a portrait of Picasso: as a young man in the lower right (from a self-portrait), in middle age above, and as an old man in the lower left (both from photographs). He was most widely known to the general public in the middle phase of his life and so the upper portrait is more prominent than the others. Indeed, the portrait itself has been digitized or blocked, so that it is reduced to small squares of black and white.

Futurist (Marcel Duchamp)

Marcel Duchamp (1887–1968) was born and died in France, although he spent much of his adult life in America. He came to prominence before the First World War with a futurist painting entitled *Nude Descending a Staircase*: superimposed, cubist outlines of a mechanical figure gave the impression of a sequence of steps taken down a staircase, rather like a sequence of superimposed cinematic stills. The angular elements used to carry his portrait here convey a similar suggestion of a figure moving towards the centre of the picture. In the same decade Duchamp exhibited his ready-made art — everyday items like bottle-racks and bicycle wheels — that became art by virtue of their exhibition in a gallery. Among his first items of ready-made art was a porcelain urinal (entitled *Fountain* and signed with the name R. Mutt) which he submitted anonymously to an exhibition for which he was one of the adjudicators. When his fellow adjudicators would not take the piece he resigned! Duchamp's output was meagre and confined principally to the early part of his life, but his influence has been widespread. He broke down the barriers that separated art from artefact, and gave art the opportunity to laugh at itself.

The Age of Light (Man Ray)

Man Ray (originally Emanuel Rabinovitch) was born in Philadelphia in 1890 and moved to Paris in 1921, where he died in 1976.
He collaborated with Marcel Duchamp in 1915 in New York, after which he became a Surrealist artist and an accomplished
photographer. He adapted and extended two photographic techniques — the photogram and the Sabattier effect — to great effect.
Photograms are images created by placing objects directly on the film and illuminating with white light. The Sabattier effect is the
contrast reversal that takes place with gross overexposure of film, or with reexposure to light of film, or print paper during
development. The names of the techniques changed to Rayographs and solarization as a consequence of Man Ray's skill in
manipulating them. Both were used extensively in his collection of photographs entitled *The Age of Light*, published in 1934. One
photograph was a solarization of a matrix of circles behind which a dimly defined figure was visible. Multiple solarizations of a
profile view of Man Ray have been combined with circles to produce this picture.

Ceci n'est pas Magritte

René Magritte (1898–1967) was
a Belgian Surrealist artist, more
concerned with ideas than with
draughtsmanship. He was a
philosopher who used paint and
palette rather than pen and
paper. Many of his paintings are
directed to the paradoxes of
pictorial representation.
Prominent amongst these is one
(called *The Perfidy of Images*) in
which a curved briar pipe was
carefully painted on the canvas,
and beneath it were painted the
words 'Ceci n'est pas une pipe'.
The pictured pipe could not be
handled or smoked, but then nor
could the painted word. Both the
word and the image are
representations of the object, but
at different levels of abstraction.
In this picture, copies of
Magritte's signature are raining
down upon an anonymous
bowler-hatted man, which was a
common motif in his paintings;
this one is derived from his work
The Great War and the features of
the subject are hidden by a large,
leafy apple. The title is similarly
concerned with the relationship
between words and images: to
what does it refer? To the
unidentified subject? To the
signature? To the work itself?

Grafieker

Maurits Cornelis Escher (1898–1972) was trained as an architect in The Netherlands, where he spent most of his life. He described himself as a graphic artist — a *grafieker* in Dutch. His drawings and prints represent ambiguous or impossible worlds that can only exist on paper: fish define fowl and devils provide the outlines for angels, often with one shape metamorphosing into others. Artists and architects have been fascinated by his distortions of perspective, and mathematicians and physicists have been intrigued by his geometrical manipulations of repetitive patterns. He is popularly known for his adaptations of the various forms of impossible figure. Here, impossible triangles are used both to spell his name and to embed his portrait, which is derived from a woodcut self-portrait he made in 1926. (see Penrose, this volume, Chapter 16).

Towards plastic unity

Victor Vasarely (born 1908) is
Hungarian by birth but French
by adoption. He has constantly
experimented with geometrical
abstraction and he has tried to
remove the imprint of
personality from his work, much
of which can be mechanically
produced. His concern is with
simple geometrical shapes like
circles, squares, and triangles
and he varies the sizes and
colours of the relations between
these in many ingenious ways.
Vasarely produced a large
number of works in stark black
and white and these were often
visually vibrant — they would
tend to move or the shapes
would seem to reorganize
themselves into novel
configurations: these marked the
beginning of Op Art in the early
1960s. This picture uses
Vasarely's favoured elements,
squares and circles, as well as his
penchant for contrast reversal;
his name is defined twice by the
grouping of the squares in a sea
of circles and hovering in the
background is a bespectacled
portrait of the artist.

Abstract Expression (Jackson Pollock)

Jackson Pollock (1912–1956) studied art in both California and New York before settling in the latter. He was one of the foremost exponents of the Abstract Expressionist movement in America. In the late 1940s he developed his famous action painting (or *tachiste*) technique, which applied the paint to the horizontal canvas directly rather than via brushstrokes. The paint could be thrown on with a brush or stirrer or it could be dripped on to the canvas through a hole pierced in the bottom of a paint tin. Pollock used household paints rather than traditional oils and many of his paintings are already showing signs of decay. Pollock was smoking a cigarette in most of the photographs taken of him, even when he was painting and it is in this state that he is represented here. The cigarette is drooping from the right-hand side of his mouth, and it corresponds precisely with a white splash of paint in the underlying *tachiste* picture.

Räumliche Irritationen (Ludwig
Wilding)

Ludwig Wilding was born in
1927 at Grünstadt, Germany. He
produces works of art that
explore the nature of basic
perceptual processes. His works
include perspective paradoxes
and anaglyphs, but he is best
known for his moiré
constructions. Initially, these
were two-dimensional designs
printed by superimposing one
geometrically repetitive pattern
on another at a slightly different
orientation. Later he separated
the two periodic patterns so that
the moiré fringes seen by each
eye were in slightly different
locations. When the component
patterns are vertical gratings the
disparity between the monocular
moiré fringes can result in seeing
a surface at a depth greatly in
excess of the physical separation;
changing the relationship
between the spatial frequencies
of the front and back gratings
results in the stereo moiré
surface's appearing either nearer
or further away than the actual
surfaces. In this picture, Wilding
is portrayed in a two-
dimensional moiré pattern made
up from gratings in different
orientations. Such patterns
display a spatial irritation that is
characteristic of the way he
describes his work.

The Responsive Eye (Bridget Riley)

Bridget Riley was born in London in 1931 and is best known for her high-contrast, black and white paintings of geometrically periodic patterns. Movements and distortions of the patterns are seen even though none are occurring on the picture plane. The dynamic changes are a consequence of processes within the visual system of the observer and so they are truly interactive paintings. She came to international prominence when her work was shown in the *The Responsive Eye* exhibition, held at the Museum of Modern Art, New York, in 1965. Her portrait is embedded in a drawn design that displays many of the visual distortions seen in her paintings. The wavy radiating lines appear to shimmer and move, particularly around the inflection points of the curves; the contours fluctuate in clarity, being sharply defined at one moment and blurred at the next. These changes are a consequence of minor variations in the curvature of the crystalline lens, which produce transient astigmatism. It is when the contours are blurred that Bridget Riley's portrait can be seen.

Descartes' brain

René Descartes (1596–1650) was born in Touraine, France and lived much of his adult life in Holland; he died in Stockholm. In addition to his philosophical works he made several important contributions to vision. He developed Kepler's analysis of the dioptrics of the eye and suggested that accommodation was achieved by varying the curvature of the lens. Most particularly, he extended considerations of vision from the eye into the brain. In binocular vision he fused the geometry of retinal images and corresponding points to his speculative anatomy and physiology of the visual system: singleness of vision was achieved by union in the brain of messages from corresponding points in each retina. A portrait of Descartes is here presented in a diagram of the brain printed in his *Traité de l'homme*: the eye and optic nerve are shown and the site to which the messages from the two eyes were considered to be combined (the pineal body) is occupied by Descartes's right eye.

Minimum Visible (Bishop
Berkeley)

George Berkeley (1685–1753)
was born in County Kilkenny,
Ireland and died in Oxford. In
1709 he published *An essay
towards a new theory of vision*, in
which he examined the
perception of depth and distance
from an empiricist viewpoint. He
argued that a thin rod, extending
from the observer's eye along the
optic axis, would be seen as a
point. Thus, any one of the dots
in this illustration could
represent a line extending
indefinitely from the eye.
Berkeley said we must learn to
perceive distance by associating
it with touch or with muscular
sensations from accommodation
and convergence. He also
introduced the concept of the
minimum visible, which we
would now call the difference
threshold, in his *Commonplace
book*. Berkeley is presented close
to the minimum visible in this
illustration.

Astigmatism (Thomas Young)

Thomas Young (1773–1829) was born in Somerset and died in London after a distinguished career covering remarkably wide scientific interests. He was a physicist and a physician by training, but he was also a linguist and a cryptographer — he commenced the deciphering of the Rosetta Stone. In visual science he explained the process of accommodation and proposed a theory of colour vision based on three receptors, sensitive to different regions of the spectrum. He also described the optical aberration of astigmatism, the condition in which lines in different orientations cannot be brought to a focus in the same plane; when one set of lines are sharply focused the others appear blurred and vice versa. Young measured the astigmatism of his own eyes. Astigmatism is usually a consequence of the curvatures of optical surfaces in the eye not being parts of spheres. Most commonly it is differences in the curvature of the cornea in different orientations that lead to astigmatism, but there is another form that is due to slight changes in the accommodative state of the lens. The vertical and horizontal contours in this picture are not equally defined, but larger, transient changes will make the pattern pulsate. Thomas Young is enclosed within the contours that will expose any astigmatism.

Sehen in subjektiver Hinsicht
(Jan Purkinje)

Jan Evangelista Purkinje
(1787–1869), though born in
Bohemia, spent most of his active
research life in Germany; he
returned to Prague later in his
life and died there. In the 1820s
he wrote two influential books
on subjective visual phenomena
such as after-images, the
visibility of the retinal blood
vessels, and the distortions that
are produced when viewing
regular geometrically periodic
patterns. His portrait is here
hidden in a pattern of concentric
circles; if the pattern is observed
for some seconds the circles
themselves will appear to distort
and spokes will seem to radiate
from the centre and rotate.
When the whole pattern is out of
focus Purkinje's face can be seen.
He also described the difference
in the visibility of coloured
objects when seen in daylight
and twilight — blue objects
appear lighter and red ones
darker in twilight: this is now
called the Purkinje shift. When
he gained access to one of the
new achromatic microscopes in
1832 he put his observational
skills to good use, as is attested
by the Purkinje cells in the
cerebellum and the Purkinje
fibres in the heart.

Vieth–Müller Circle

Gerhard Ulrich Anton Vieth
(1763–1836) a mathematician,
and Johannes Peter Müller
(1801–1858), a physiologist,
both worked on the geometry of
binocular vision. Before the
invention of the stereoscope it
was considered that binocular
single vision followed from
stimulation of corresponding
points on the two retinae. With
binocular fixation on one point,
the region of space at which
corresponding retinal points will
be stimulated is called the
horopter. Vieth and Müller
provided independent
geometrical descriptions of the
horopter, in 1818 and 1826,
respectively and it became
known as the Vieth–Müller
circle. The concept was
introduced to English readers by
Wheatstone, in his paper on the
stereoscope published in 1838.
The Vieth–Müller circle shown
here is taken from Wheatstone's
paper, the text is from Vieth's
article, and the embedded
portrait is that of Müller.

Talbotypes (William Henry Fox Talbot)

William Henry Fox Talbot (1800–1877) was born in Dorset and later inherited the family seat of Laycock Abbey in Wiltshire, where he died. He was a gentleman scientist, having interests in mathematics, chemistry, and optics, as well as linguistics. He was also a keen artist, but his frustrations in attempting to represent landscapes led him to try fixing images, formed in a camera obscura, chemically. He worked on the problems associated with selecting and fixing images from the mid-1830s, but did not make public his endeavours until 1839, following the report in France of Daguerre's experiments. Daguerreotypes were positive images formed on a metal plate, whereas Talbot's system produced a negative image on paper, which could then be printed to yield a positive image by shining light through it. Talbot referred to his images as calotypes (printed by the sun), but his friends suggested that they should be called Talbotypes. The term photograph was introduced later by John Herschel. The negative and positive profiles of Talbot are in the orientations that would correspond to their printing: a negative was reversed, placed in contact with unexposed paper, and exposed to white light in order to produce a positive photographic image.

Hering Grid

Karl Ewald Konstantin Hering
(1834–1918) was born in Alt-
Gersdorf and died in Leipzig. He
succeeded Purkinje as Professor
of Physiology at the University of
Prague. His work in vision
concerned space perception,
colour vision, and contrast
phenomena. He represented the
phenomenological tradition in
studying perception, which was
contrasted to Helmholtz's
empiricist approach. Hering
proposed that both colour and
contrast phenomena are based
upon opposing activities in the
visual system. One of the
contrast phenomena he
described in 1878 has been
named after him—the Hering
grid. It consists of an array of
white squares on a black
background and illusory light
grey dots can be seen in the
intersections of the black lines.
Some of the black lines are
slightly thicker than others and
these define the portrait of
Hering.

Moiré mathematician (Lord Rayleigh)

John William Strutt Rayleigh (1842–1919) was born and died in Essex. He was a physicist who was awarded the Nobel Prize in 1904 for the discovery of argon. He also worked on aspects of auditory perception and colour vision, introducing the Rayleigh match for comparing a yellow with a combination of red and green. During his investigations of finely ruled gratings (used for calibration in telescopes) he accidentally displaced two photographic transparencies of gratings and noted that any irregularities in the separations of the lines were magnified in the moiré fringes produced by their inclination. He provided a mathematical description of the width of the moiré fringes based upon the separation of the lines in the original gratings and their inclination. Lord Rayleigh is here shown in the moiré pattern produced by two inclined gratings.

Ideologist (Sigmund Freud)

Sigmund Freud was born in
Moravia in 1856 and died in
London in 1939. His models of
motivation and personality
affected both art and literature in
the first half of this century. His
model of motivation was
essentially mechanistic and is
often represented graphically in
terms of concentric or
overlapping circles and it is
within such a graphical scheme
that his portrait is presented
here. The overbearing and
enclosing effects of socialization
define the superego; the ego, that
part of the self presented to the
external world, is orderly and
well-formed, unlike the id, which
is primitive and generally
unseen. These (oversimplified)
characteristics of his system are
also echoed in the scripts used:
the dominant and aggressive
forms of 'superego', the neat,
presentable 'ego', and the
unschooled 'id', which was
written with the left hand.

The recognition of identity
(Kenneth Craik)

Kenneth John William Craik was
born in Scotland in 1914 and
died in Cambridge, as a result of
a road accident, in 1945. He was
trained as a philosopher but
turned to the psychology of
vision when he went to
Cambridge. His only book *The
nature of explanation* (1943)
developed a mechanistic theory
of thought. He considered that
the predictive nature of thought
and action are based upon
forming an internal model of the
world. His ideas were greatly
influenced by self-correcting
machines, like gun turrets on
ships, and his work is taken as a
presage of artificial intelligence.
The text in this illustration is
taken from his book and it is
concerned with the nature of
recognition. A face can be
recognized in the text, but it can
only be identified as Craik's by
those who are familiar with
other portraits of him.

ABSTRACTION AND BRAIN MECHANISMS

As remarked above one of the characteristics of memory
and perception is the recognition of identity or of similarity.
To recognise a thing is surely to react to it, internally or
overtly, as the 'same thing' to which we reacted on a
previous occasion.

In the above sense mechanical devices can show some
degree of recognition. A photocell can respond in the same
way to apples having the same colour, a penny-in-the-slot
machine to similar coins, and so forth. Men and animals
are capable of this, but of much more. The progressive stages
of recognition may be classified as:

(1) Those in which all the conditions of stimulation are
identical, within the limits of discrimination of the organism;

(2) Those in which there are differences in the peripheral
stimulation, but in which these may be 'corrected' by other
sensory impulses so as to lead to the production of an identical
pattern of central stimulation;

(3) Those in which such correction is inadequate or
lacking, so that there are points of difference between the
stimulation on two occasions, these points of difference
being perceptible by the organism, yet the thing is recog-
nised as the same in certain important aspects; and

(4) Those in which the differences extend to all direct
sensory qualities and physical constituents, so that the same-
ness of the two objects is confined to some abstract charac-
teristic such as triangularity, number, and other spatial or
temporal relations or vague qualities such as intellectual
difficulty.

How should we set about designing a mechanism to
respond to these different kinds of identity, and identity in
diversity?

Gregorian eye and brain

Richard Langton Gregory was born in London in 1923, and stands in a long line of scientific Gregorians. He has written a number of books on science, technology, and perception that have been widely read and have introduced many people to the scientific fascinations of vision. He is best known for his book *Eye and brain*, in which a series of topics, such as movement, colour, and illusions, are placed in a historical context and interpreted in terms of modern theories. His own approach is in the tradition of British empiricism and he proposed that perception is like hypothesis-testing. His portrait is embedded in a design that presents a hypothetical eye and brain. The central radiating lines are like light rays that enter the eye through a small aperture and then strike the retina. Within the retina there are three neural levels consisting of receptors, bipolar cells, and retinal ganglion cells — all of which have lateral connections. The axons from the ganglion cells travel to the visual cortex, undergoing partial decussation, so that the temporal and nasal hemiretinae project to opposite hemispheres; however, there is some bilateral projection along the vertical midline. At the level of the visual cortex there is an organization in terms of vertical columns, within which are six horizontal layers. In the central region the circles represent the two overlapping monocular visual fields, in which there is binocular brightness enhancement.

Feature detectives (Hubel and Wiesel)

David Hunter Hubel was born in Canada in 1926 and his collaborator Torsten Nils Wiesel was born in Sweden in 1924. They were jointly awarded the Nobel Prize for Physiology or Medicine in 1981, in recognition of their neurophysiological studies of the visual system. Hubel and Wiesel discovered that single cells in the visual cortex respond to specific features of the light patterns striking the eye, such as oriented edges moving in a particular direction. These feature detectors have an orderly representation in the visual cortex and, in the monkey cortex, they project to clearly defined eye dominance regions. The patterns displayed in this picture are of the alternating patterns of eye dominance regions over the visual cortex, and the visual scientists are represented in different ones, Hubel on the left and Wiesel on the right.

Deep structure

Noam Chomsky was born in Philadelphia in 1928. He is a linguist who has introduced a wide
range of novel terms into the analysis of language, some of which are included in this picture.
In Chomsky's transformational grammar, one of the principal distinctions is between the
surface and deep structures of a sentence: the surface structure corresponds to the sequence of
words as written or spoken, whereas the deep structure refers to their underlying meaning.
The surface structure of the list is not punctuated, but the terms can be suitably segmented
with respect to its deep structure: although the individual words are not alphabetically
arranged, the novel terms are. The portrait is part of the deep structure, too, since it appears to
lie behind the words. The only words that are not related to Chomsky's theoretical edifice are
his name and the word 'verbarian', which means a coiner of phrases.

$2\frac{1}{2}$-D sketch (David Marr)

David Courtenay Marr
(1945–1980) was born in Essex
and worked in both Cambridges
— in England and
Massachusetts. He pioneered a
new approach to the computer
simulation of vision, by linking
concepts from physiology,
psychology, and artificial
intelligence. He has addressed
the problem of how an image of
a real scene, captured by a
camera, can be processed
through a sequence of stages to
recover a description of the
objects in the original scene. The
initial stages, referred to as early
vision, extract from the image
pattern primitives, like edges,
line endings, and blobs; these
tokens are then grouped to
produce a primal sketch.
Information from two views
(stereo) and from a sequence of
frames (motion) enable a two-
and-a-half-dimensional ($2\frac{1}{2}$-D)
sketch to be formed. This is a
description of the surface
orientations of the objects with
respect to the camera's
viewpoint. A cube, for example,
would be represented as a two-
dimensional shape with symbols
indicating the orientation of the
three visible faces with respect to
the viewpoint. Marr is here
represented by pattern tokens
signifying the contours of his
face and his portrait is embedded
in a representation of a cube;
there are slight pattern
differences to denote the
boundaries between the three
faces of the cube.

Index

(Bold entries denote figures)